THE SCURLOCK STUDIO

PICTURING THE PROMISE

and BLACK WASHINGTON

NATIONAL MUSEUM OF AFRICAN AMERICAN HISTORY AND CULTURE

in collaboration with the
National Museum of American History

CONTENTS

Published by the National Museum of African American History and Culture, Smithsonian Institution

Book Design by Service Station | Bill Anton

Produced by Smithsonian Books

Printed in China through Oceanic Graphic Printing Inc.

Library of Congress Cataloging-in-Publication Data
The Scurlock Studio and Black Washington : picturing the promise / by the National Museum of African American History and Culture in collaboration with the National Museum of American History.
 p. cm.
"Published in conjunction with the exhibition of the same name at the National Museum of American History, Washington, D.C., opening February 2009"–
 T.p. verso.
Includes bibliographical references and index.
ISBN 978-1-58834-262-1 (hardcover)
1. African Americans–Washington (D.C.)–History–Pictorial works–Exhibitions.
2. African Americans–Washington (D.C.)–Social life and customs–Pictorial works–Exhibitions. 3. African Americans–Washington (D.C.)–Portraits–Exhibitions. 4. Washington (D.C.)–History–Pictorial works–Exhibitions.
5. Washington (D.C.)–Social life and customs–Pictorial works–Exhibitions.
6. Washington (D.C.)–Biography–Portraits–Exhibitions. 7. Scurlock Studio (Washington, D.C.)–History–Exhibitions. 8. Scurlock Studio (Washington, D.C.)–Photograph collections–Exhibitions. 9. National Museum of African American History and Culture (U.S.)–Photograph collections–Exhibitions.
10. National Museum of American History (U.S.)–Photograph collections–Exhibitions. I. National Museum of African American History and Culture (U.S.) II. National Museum of American History (U.S.)

E185.93.D6S38 2009
779'.9975300496073--dc22 2008032847

09 10 11 12 13 OGP 10 9 8 7 6 5 4 3 2 1

Front endsheet: Addison and George Scurlock photographing the National Association of College Women at Howard University, c. 1930s, by Robert H. McNeill, © The Estate of Robert H. McNeill

Back endsheet: Black Washingtonians enjoy a day at Suburban Gardens, c. 1920s

Frontispiece: Three boys on the summer streets of Washington, c. 1970s

Page 4: Exterior view of the Scurlock Studio, 1968

Pages 6-7: Interior of the original Scurlock Studio, 1911

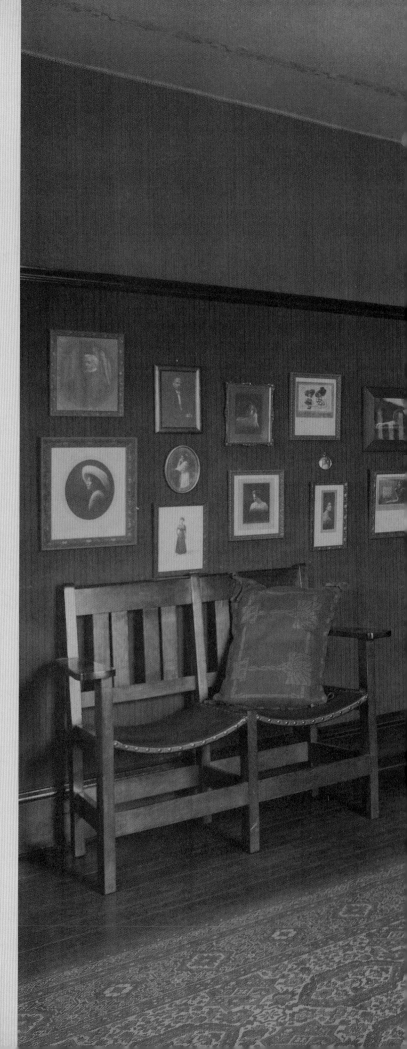

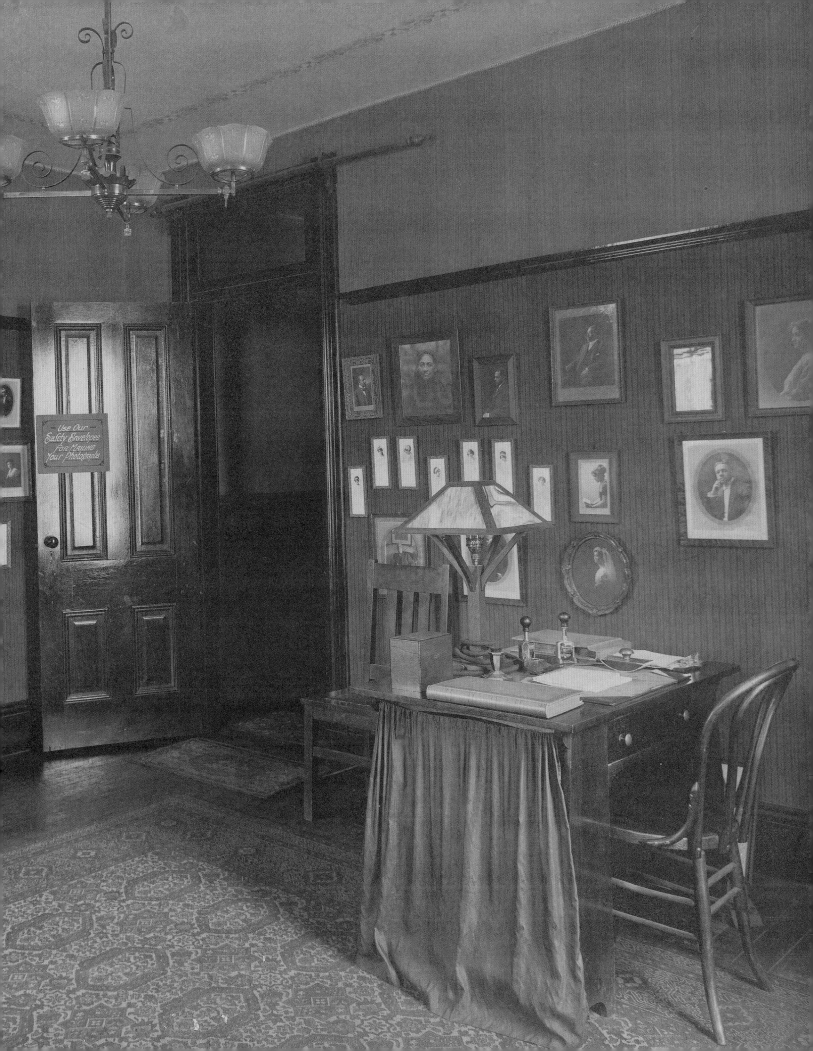

FOREWORD

by DEBORAH WILLIS

African American photographers captured and preserved the faces and places of their race, documented their culture and helped preserve their heritage through photographs. In several instances their photographic efforts reflected an understanding and mastery of photography as an art form...[1]

HARVEY S. TEAL

Reflecting their close relationship with clients, photographers gave direct expression to client visualizations....[The photograph] could document what was desired as well as what transpired, all according to the artistry of the photographer and the imagination of the client.[2]

BARRY GAITHER

Imagine stepping into Addison Scurlock's U Street studio in 1911. He welcomes his visitors with photographs that are both graceful and elegant—black Americans of all classes, educators, schoolchildren, civil servants, domestics, laborers, activists, lawyers, artists, mothers, and fathers. Many of the subjects are young; some are older; all are coming of age at the beginning of the twentieth century with the hope of a better life. Some of the portraits depict descendants of enslaved African Americans, others are of third-generation free blacks, but all seem to know that a photograph by Addison Scurlock represents a lasting transformation. The Scurlock Studio is a place where young men and women pose freely with a book or are surrounded by family photographs, constructing their own self-images for display in their homes and in black publications. The studio also documents aspects of university life, the quest for learning after slavery, and the need for expression in many forms. Photographs of sports clubs, whose off-campus counterparts often are closed to blacks, show the importance of such activities in the students' lives.

Scurlock photographed the interior of his first studio to preserve the memory of this place where African Americans transformed themselves. More than thirty framed photographs are visible on the walls and desk (see pages 6–7). Elizabeth Alexander, scholar and poet, writes that "in the spaces we designate and create, the self is made visible in the spaces we occupy, literal 'black interiors,' the inside of homes that black people live in. Are the living rooms of those homes, the spaces most consciously arranged and presented, representative of not only living space but of one's

8

self, one's aesthetic self?"[3] Within these black interiors is where we find the Scurlock image. The photograph of the studio offers a view of Scurlock's purposeful character as well as his ability to create desire. Scurlock constructed a context for the viewer, one that informed the interior space within the photograph and continues to provide a collective visual reference to black America today.

Born in Fayetteville, North Carolina, Addison Scurlock (1883–1964) began his photographic journey in Atlanta, Georgia, but he spent most of his career in Washington, D.C. He also was Howard University's official photographer. At the turn of the twentieth century, photography represented an opportunity for Scurlock and other black photographers to counter the predominantly negative representations of black people that circulated in American culture. By offering images related to education and family life, among other subjects, Scurlock's photographic studio helped black people experience and construct their private and public dreams and desires. A specialist in portraiture, he opened the Scurlock Studio in 1911, operating it first with his wife and later with his sons Robert and George.

According to historian Jane Freundel Levey, the black community in Washington, D.C., counted many generations of residents, including extended families that had lived as free people of color in the years before 1862, when Emancipation came to the capital. While the dominant spirit in the city was that of the South, and segregated schools, hospitals, and institutions were the norm, turn-of-the-century Washington also offered black Americans the economic and social opportunities of urban life.[4] During the 1920s and 1930s, U Street was a vibrant location for the studio. From there

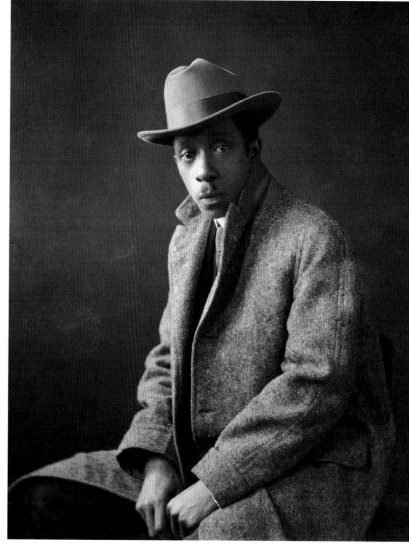

Photographer Addison N. Scurlock, relaxed in hat and overcoat, c. 1910s

9

Scurlock could easily document community life, including activities on the Howard University campus, conventions and banquets, sorority and social club events, dances, weddings, cotillions, and local business affairs. Throughout the Scurlock Studio's existence, it was known for creating striking portraits that preserved the subjects' beauty and dignity with a sense of self-empowerment. Clients ranged from families, grooms and brides, and high school and college graduates to community leaders and entertainers. Viewing the Scurlocks' photographs enables us to visualize an African American community that was active and engaged, despite blacks being subjected to laws that devalued their lives. Another Washington–based photographer, Robert McNeill, summed up Scurlock's role this way: "Addison Scurlock was of course the premier photographer of the era. It was said that if Scurlock didn't take your picture…at a wedding, you weren't married. Every school, every junior high and high school called Scurlock for their senior picture or their class picture and I used to watch what he did to take the pictures. A view camera, putting a hood over his head, looking through it to make it focus. If he knew I was snooping on him, he would never have showed me those little tricks."[5]

The black community of Washington, D.C., was both intellectually and artistically productive. Educator, club-woman, writer, and race leader Anna Julia Cooper, for example, often posed for the Scurlock Studio. In her autobiography *A Voice from the South*, she argues that black women, as a strong political and social force, could serve as spokespersons for their race. Scurlock's photographs of Cooper as educator and advocate demonstrated his understanding of his subject. The Scurlock photographs underscore this same sensitivity, pride, and determination in all the subjects.

The studio's lifestyle photographs and portraits formed a crucial part of the New Negro movement, which challenged then-popular cultural myths about African Americans. Consider, for example, this description of the New Negro as visualized by Anna Julia Cooper.

Everything to this race is new and strange and inspiring. There is a quickening of its pulses and a glowing of its self-consciousness. Aha! I can rival that! I can aspire to that! I can honor my name and vindicate my race! Something like this, it strikes me, is the enthusiasm which stirs the genius of a young African in America; and the memory of past oppression and the fact of present attempted repression only serve to gather momentum for its irrepressible powers....What a responsibility then to have the sole management of the primal lights and shadows!...[6]

In these politicized images, it is evident "what a responsibility" rested on the shoulders of black photographers during the first part of the twentieth century. It was their responsibility to define African American life and culture, to take black Americans beyond the shadow of the stereotype. The artists and intellectuals they photographed both displayed the black communities' accomplishments and marked their frustrations with the status quo.

According to anthropologist Lee Baker, "Implicitly and explicitly, the New Negroes were engaged in constructing an empowered racial identity or a race consciousness...."[7] Scurlock's early photographs visualized and constructed precisely the "empowered racial identity" that Baker describes. Based in urban centers and on black college campuses, the new black intellectuals emerged at a time when photographers were actively depicting artistic and political leaders, creating images of people who were proud of their race, self-reliant, and who demanded full citizenship rights.

The work of the Scurlocks—Addison, Robert, and George—speaks to the cultural perspectives of their individual communities. After high school, both sons apprenticed with their father and received extensive training in portrait photography under his direction. While Addison spent most of his time in the studio, Robert (1916–1994) and George (1919–2005) did both documentary and portrait photography. Their

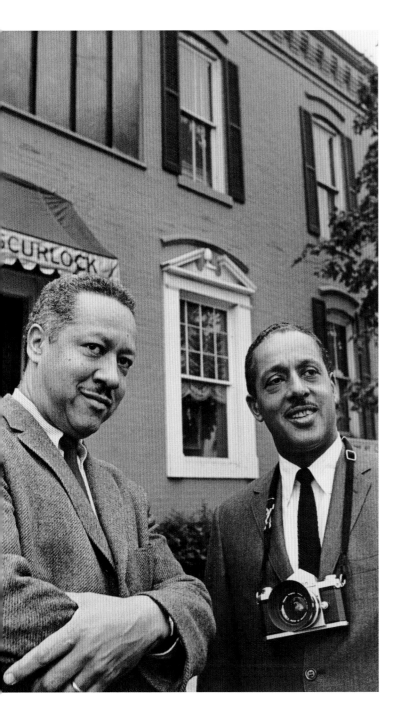

Brothers Robert and George Scurlock outside the Scurlock Studio, 9th and U Streets, NW, Washington, DC, c. 1950s

photographs appeared in black newspapers, such as the *Afro-American*, *Philadelphia Tribune*, *Pittsburgh Courier*, *New York Amsterdam News*, *Norfolk Journal and Guide*, and *Chicago Defender*. Robert also went on assignment for the black magazines *Our World, Flash!*, and *Ebony*. In 1948 Robert and George established the Capitol School of Photography, where they paid homage to their father's legacy by training young photographers.

All over America, black studio photographers Addison Scurlock, Daniel L. Freeman, Cornelius Marion Battey, James VanDerZee, Arthur P. Bedou, Poole Studios, and others played an integral role in shaping how black people visualized themselves. A significant number of black photographers contributed in making the black community visible during the first two decades of the twentieth century. Since 1997, the National Museum of American History has owned and preserved the massive Scurlock Studio Collection. With a core selection of images from the collection, this publication honors the lives of the famous and the anonymous men and women who posed for the Scurlock Studio. It also explores social conditions in Washington, D.C., as well as the lives of the photographers themselves. In doing so, it celebrates the photographers and the images that made them immortal.

Notes
1. Harvey S. Teal, *Partners with the Sun, South Carolina Photographers: 1840–1940* (Columbia: University of South Carolina Press, 2001), 286.
2. E. Barry Gaither, "Imagining, Identity and African American Art, or, It's Me You See!" in *Convergence: 8 Photographers* (Boston: Photographer Resource Center, Boston University, 1990), 10.
3. Elizabeth Alexander, *The Black Interior* (St. Paul: Graywolf Press, 2004), 9.
4. Jane Freundel Levey, "The Scurlock Studio," in *Visual Journal: Harlem and D.C. in the Thirties and Forties*, eds. Deborah Willis and Jane Lusaka (Washington, D.C.: Smithsonian Institution Press, 1996), 150.
5. See "Duke Ellington's Washington, at http://www.hedricksmith.com/ PBS doc/dukeEllingtonsWashingtonTranscript.shtml (access April 2008).
6. Louise Daniel Hutchinson, *Anna Julia Cooper: A Voice from the South* (Washington, D.C.: Smithsonian Press and the Anacostia Neighborhood Museum, 1981), 196.
7. Lee D. Baker, *From Savage to Negro: Anthropology and the Construction of Race, 1896–1954* (Berkeley: University of California Press, 1998), 139.

REMEMBERING BLACK WASHINGTON

It is not what you call me. It is what I answer to.[1]

WEST AFRICAN PROVERB

**They ask me to remember
but they want me to remember
their memories
and I keep remembering
mine.**[2]

LUCILLE CLIFTON

For a significant portion of the twentieth century, the photography of Addison Scurlock—along with that of his sons Robert and George—captured and captivated black Washington, D.C. With a photographic style that bespoke pride, achievement, and possibility, the Scurlocks' imagery recalls a time when Howard University was the undisputed "capstone of Negro education"; when national leaders of the African American community sought a presence in the nation's capital; when the Shaw neighborhood was a community of middle-class strivers whose very existence countered notions of black inferiority; and when U (or "You") Street, often called the Black Broadway, was the commercial, cultural, and community center of a thriving African American populace. While the Scurlocks are rightly celebrated for their portraits of luminaries, from educator Booker T. Washington to actress Fredi Washington to boxer Muhammad Ali, their expansive body of work also chronicles a dizzying array of business openings, baptisms and other religious rites, sporting events, and social and cultural organizations. Often these images also illuminate how black Washingtonians responded to and countered the racial discrimination that was part of daily life in the nation's capital.

In many ways, the Scurlocks spent their careers not simply photographing sitters but picturing the promise of a changing black Washington. As a result of this work, a part of Washington is remembered, one that was less visible and often anonymous to the majority of Washingtonians but still replete with meaning for many African Americans.

Group baptism on Elder Michaux's flag-bedecked barge along the Potomac River, 1932

by LONNIE G. BUNCH III

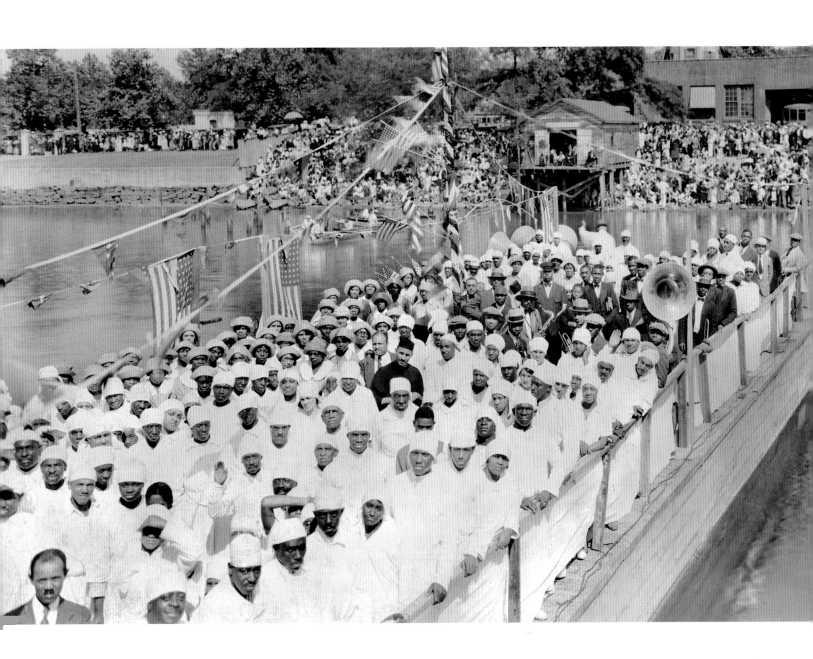

Much is revealed about a people, a city, and a nation by what it chooses to remember. What is celebrated, what is memorialized with monuments, what graces the walls of museums, and what myths are cherished tell a great deal about who we are and how we hope to be perceived. Yet we learn even more by what a country chooses to forget. Often the culture and the history of black America are forgotten or underappreciated. It is essential to remember, because as James Baldwin has written, "History does not refer merely or even principally to the past. On the contrary, the great force of history comes from the fact that we carry it within us, are unconsciously controlled by it in many ways, and that history is literally present in all that we do."[3] Thus we need to remember, not out of nostalgia or a need to assess blame, but rather to understand the roots of our contemporary lives, to contextualize current challenges, and to create a useful and useable past.

Photography, like that of the Scurlock Studio, plays an important role in constructing memory. Images from the Scurlock Studio act not only as repositories of memory but also as stimulants and beacons for remembering. My earliest interest in the past was shaped by examining "old" photographs with my grandfather. Once, while looking at an image of school-age children taken during the nineteenth century, my grandfather casually noted that these children "are probably dead, and isn't it a shame that the caption reads 'unidentified'?" I was so taken by their anonymity that I spent hours looking at the faces, trying to guess whether they had happy lives, families, and jobs. That photograph became the talisman that led me to a career in history.

More recently, my own memories of the days after the murder of Martin Luther King Jr. were prodded when I was reviewing the photographs that George Scurlock took outside his studio following the 1968 riots that devastated significant portions of Washington, D.C. My family was returning to New Jersey after spending the spring holidays visiting relatives in North Carolina. Since we had left later than planned, my parents decided to spend the night with relatives who lived on Georgia Avenue and Otis Place, NW, near the heart of the destruction. As we approached Washington, we saw smoke but thought little of it. By the time we reached Otis Place, the city was engulfed in flames and rioting. I remember hiding in a bed while the sounds of breaking glass and screaming filled the room. Then I heard someone shout, "They killed the dream, they killed the dreamer." I had not thought of that night again until I saw George Scurlock's attempt to document those days of rage. One of the important contributions of the work of Addison, Robert, and George Scurlock is their ability to stimulate our memories, both personal and historical.

Black Washington has historically been a place of contradiction and ambiguity. The African American community has been divided by issues of class, color, education, and length of residency, thus creating many black Washingtons. With a few notable exceptions, such as George's depiction of the riots in 1968 or life in the city's alleys, most of the work of the Scurlock Studio focused on *picturing the promise*, that is, capturing a middle-class ethos that often smoothed over the rough edges of black life in the District. Another way to view the photography of the studio is to consider these images as aspirational. While photographs of Ernest Just or women leaving the Miner Teachers College depict the strength, pride, and achievement of the middle class, they represent only a fraction of black life in the District. Images from the Scurlock Studio often suggest a promise of success that was more myth than reality.[4]

Yet we should not dismiss these images as simply being a celebration of a small number of fortunate individuals. At a time when most of the offerings in media, advertising, and entertainment depicted African Americans as inferior beings who contributed little to a country awash with whiteness, photographers such as Addison Scurlock, P. H. Polk, and James VanDerZee provided images that confronted and

Scurlock Studio window with "Soul Brother All the Way" sign during the 1968 Washington riots following the death of Martin Luther King Jr.

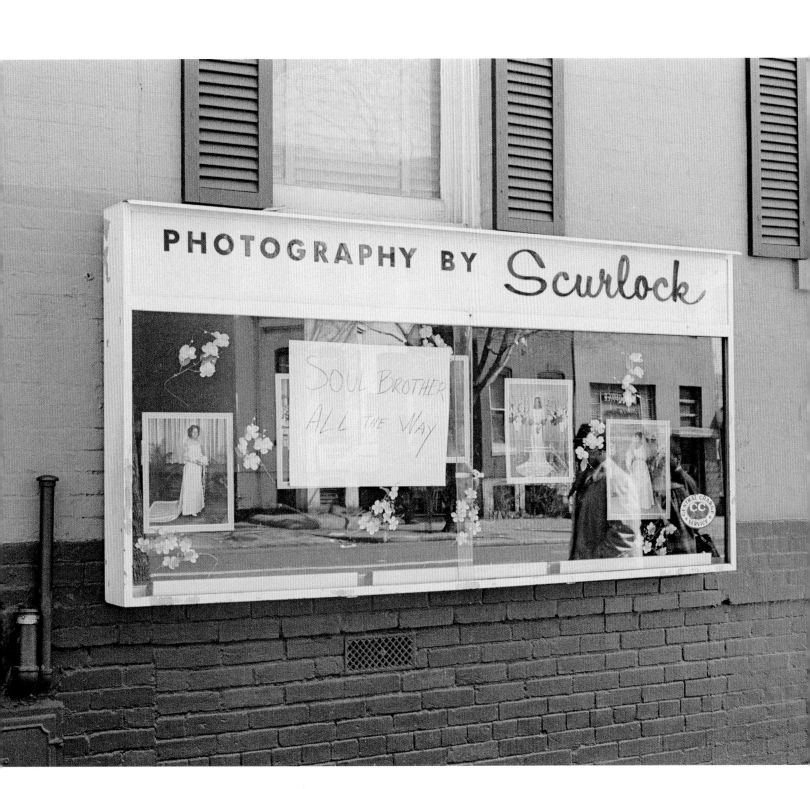

discredited racist depictions of African Americans. At a time when African American leaders, sensitive to the racial discourse in the Jim Crow era, felt the need to develop strategies that would prove blacks were worthy of citizenship and equality, images from the Scurlock Studio were a valuable document of black progress and an effective tool in the struggle for racial justice. At a time when many reduced the African American community to caricature, the work of the Scurlocks lent richness, depth, complexity, and meaning to black Washington.

When reviewing nearly a century's worth of Scurlock photography, these images help us to remember the expectations, challenges, personalities, strategies, and triumphs that shaped one of the many black Washingtons. On the one hand, Scurlock reveals a world in which the black middle class refused to be defined or held captive by discrimination. In this light, photographs of a Twelfth Street YMCA Halloween party or the opening of the Murray Brothers Printing Company are more than documents of celebrations. They are examples of how controlling one's destiny and establishing positive interactions help a community believe that its members are more than victims of discrimination. Photographs of a Peoples Drugstore protest and Marian Anderson's Easter morning concert at the Lincoln Memorial encourage us to remember that the struggle for equality has roots deep in black Washington that far antedate the post–World War II civil rights movement. Portraits of luminaries, such as Ralph Bunche, Mary McLeod Bethune, Carter G. Woodson, and Lois Mailou Jones, are testaments to the intellectual and cultural communities that were essential elements in the creation of black Washington. Images of an array of businesses, self-help organizations, and women's groups confirm that this was a community that actively worked to improve its status. The photographs of "Sweet Daddy" Grace and Elder Solomon Michaux illustrate the rich religious diversity that sometimes divided but often brought together elements of the community in a concerted effort to strive for racial justice. To paraphrase author Lucille Clifton, the photography of

the Scurlock Studio helps us "to keep remembering" the memories that we need of a rich and layered community.

These Scurlock images, powerful as they are, obscure as much as they reveal when illuminating the rich black presence in the District. Much about this slice of the African American community is instructive and illustrative, but much is left outside the camera lens. During the first half of the twentieth century, the period of greatest productivity for the studio, the population of black Washington increased dramatically as new residents from Virginia and the Carolinas flooded the District. From 1910 to 1920 alone, the District's black population doubled. The lives of

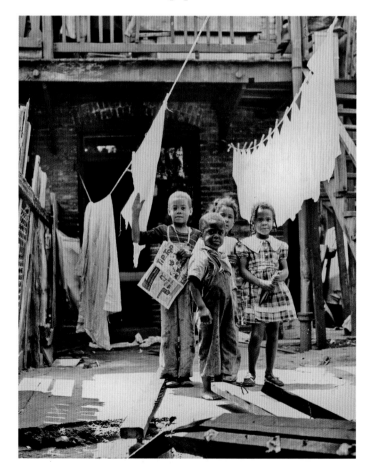

Children playing near alley dwellings, n.d.

most black Washingtonians were shaped by the struggle to find adequate housing that was not overcrowded or ridden with disease. Rarely seen is the poverty that new migrants faced as they packed into Snow's Alley in Foggy Bottom or Carlin Alley in Southwest Washington.[5] Middle-class optimism was lacking when working-class migrant Beulah Nelson moved to Washington in the early twentieth century and noted that the District "was not good like home, crowded smelly streets, noise and confusion was all I saw. And people talked like it was something near 'bout heaven."[6] Mrs. Nelson was one of thousands of women who migrated to the District to work as a domestic. While the Scurlocks photographed scores of women, they made few attempts to capture the lives of the working class. The conditions that most blacks experienced in Washington were usually outside the realm of the Scurlocks, despite the photographers' repeated tries at documenting life beyond the Shaw neighborhood and U Street. The images of a homeless woman pushing a makeshift cart and children playing amidst the poor housing within the shadow of the United States Capitol represent efforts to look beyond their usual scope. We can only wish that the prodigious talents of the Scurlock Studio had turned their cameras more frequently onto those Washingtonians whose daily experiences mirrored the lives of millions of black urbanites throughout the country.

Ultimately, the Scurlock Studio presents an incomplete but crucial portrait of the African American experience in the District. If historian John Henrik Clarke is correct when he writes that the "image is what colonizes the mind," then the work of Addison, Robert, and George Scurlock was an important corrective to the prevailing racially driven images. Often, the significance of the visual image as a way to delineate "the other" in the era of segregation is underestimated. Cultural critic Nicholas Mirzoeff believes that "the definition of the other as wholly different from the self was, of course, haunted by anxiety that difference was more apparent than real. It was therefore crucial that difference should not only be known, but be visible."[7] What the Scur-

locks represent is an effective counter-narrative to racial imagery. It is not surprising that their work tends toward the aspirational and the exceptional. They were, after all, businessmen who documented a reality that was then modest in scale, but they hoped would not be too far distant.

In many ways, the goal of the National Museum of African American History and Culture is to help America remember the richness and the power of African American culture and its centrality to American history. With this publication, we hope to stimulate memories and examinations of the history of black Washington. Beginning with A. J. Verdelle's "Good Light, Fine Regard," and in several reflections by notable scholars, artists, writers, and Washingtonians, we present a tapestry of responses to the photography of the Scurlock Studio. These individualized and highly personal thoughts present specific Scurlock images in a different light, introducing new and important meanings. Most importantly, they, like the photographs they interpret, help us to remember.

Notes

1. Quoted in Michael Harris, *Colored Pictures: Race and Visual Presentation* (Chapel Hill: University of North Carolina Press, 2003), 189.
2. Lucille Clifton, "Why Some People Be Mad at Me Sometimes," in *Next: New Poems* (Brockport, NY: BOA Editions, 1987).
3. James Baldwin, *The Fire Next Time* (New York: Dial Press, 1963). For a more detailed discussion of the intersection of race and memory see Lonnie Bunch, "The Fire This Time: Race, Memory, and Museums," *Museum News* (November 2005), 50–53.
4. For a description of the racist images and attitudes that African Americans faced see Leon F. Litwack, *Trouble in Mind: Black Southerners in the Age of Jim Crow* (New York: Alfred A. Knopf, 1998) and Harris, *Colored Pictures*, 7.
5. James Borchert, *Alley Life in Washington: Family, Community, Religion, and Folklife in the City, 1850–1970* (Urbana: University of Illinois Press, 1980), 24-28.
6. Elizabeth Clark-Lewis, *Livin In, Livin Out: African American Domestics in Washington, DC, 1910–1940* (Washington, D.C.: Smithsonian Institution Press, 1994), 75.
7. John Henrik Clarke in a speech given at the City College of New York on October 11, 1980; Nicholas Mirzoeff is quoted in Harris, *Colored Pictures*, 2.

GOOD LIGHT, FINE REGARD

From a writer's perspective, good photographers are mysterious visionaries and silent people. Their spoken words are few. They run around with all manner of complex equipment. They hold light above you, or below you, or backlight you. They see light where you see only day. They work with hot light in ways you can't predict but can well appreciate. They shoot.

You can spend an artist's lifetime poring over a photographer's vision—and never crack the code of their discerning eye. Addison Scurlock took photographs at the White House twice. Or so the record says. On one of these occasions, he moved President Coolidge into another position to better frame the photograph with the Dunbar Cadet Corps. People were surprised; the Secret Service was upset. Addison Scurlock, moving the president to enhance a picture with Dunbar Cadets.

Addison saturated his images with his sense of beauty and dignity—from light, to setup, to processing. His quiet determination was part of his mystery, and here we are, staring hungrily, and happily, at his copious photographs—after a hundred and five years have gone by.

In 1900, when Addison Scurlock came here, Washington, D.C., was a city full of determined freed people. Scurlock came to apprentice with Moses Rice, a photographer who had studios on Pennsylvania Avenue and who taught Addison basic portraiture and the full range of laboratory work. Another mystery: how this seventeen year old from North Carolina negotiated an apprenticeship in this highly technical field and made of himself an artist for the next age. This was the turn of an earlier century, when photography was still relatively fresh and still somewhat rare. Images of "colored folk" were mostly problematic and, like opinions of colored folk, outside of their control. Addison Scurlock's vision and his purpose and intention shaped the panoramas and the portraits that documented members of free black Washington—their society, their outlook, their occupations, their lives. Free black Washingtonians were all about uplift. Addison Scurlock stood among them: smart, artistic, trained, ready—and all about uplift, too. See the brown folk, see the doctors, see the graduates, see the dignity? *Snap. Here's the shot.*

For decades on the Gold Coast and in LeDroit, up and down Meridian Hill, on Capitol Hill and Douglass Court, on S and T and Caroline Streets, on the corner of Ninth and U, in Northwest and Southwest, in Southeast and Georgetown—Scurlock's was the light to stand in, his was the eye to catch. His was the portrait that made you. Some of us Washingtonians grew up looking at Scurlock portraits. Aunt or Uncle, Mom or Dad—bedecked and hung on the living room wall, propped on the living room table. A face or two or three smiling above the gold Scurlock stamp. Some of us now are too young, perhaps, to realize that Scurlock was a name, and not a brand, and not a country visited, not a town down South.

To realize that Scurlock was three men, two generations, father and sons can make you wonder: who took what, who saw what, who envisioned whom among the many in their wedding dresses, on their lawns, in front of their fine houses or cars, on the way to the beach, advertising their paper routes, protesting, parading. More mystery. And then you come to find out that the three men made no distinctions. There was Scurlock continuity. All the thousands of images

by A. J. VERDELLE

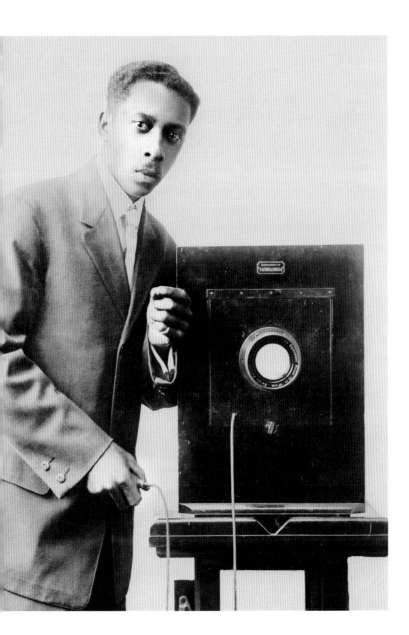

Addison Scurlock with large view camera, c. 1920s

bear one name, even though the father and his sons photographed across six decades. That's enough time for thousands upon thousands of photographs, and their business records, meticulously kept, show that they did indeed make and catalog enough images to span miles of Washington, laid end to end.

In our time, they *are* a brand: three artistic African Americans from one family, who captured Washington, the District, this community of freedmen. Their images spoke clearly: here are our efforts, our military men, our debutantes, our ministers, our friends, our tuxedos, our cotillions, our geniuses, our great minds, our children. Our lights, our cameras, our work.

Married and in spats, I'll sit here and look there.
You stand beneath the dark blanket and catch me
in the light. I'll hold my hat, I'll hold my daughter,
I'll hold her hand, I'll hold this pose, you arrange
the light around me. Snap.

In spite of any silence I may observe, regardless of any absence of spoken or written word, Scurlock images are nowhere near silent. Their photographs endure because stories leap from their stills. First and farthest back there are the miraculous Underdowns: mysteriously named, meticulously attired merchants in a new world. In the historic 1910s, we see ourselves recreating, boating on the waterfront. Folk—like Addison—were drawn to this city of freedmen seeking the heat and light and promise of a place to live,

find pay, and thrive. That was when that waterfront was ours. Through the 1920s and the 1930s, there were profiles, and croquignoles, and hoop skirts—our forays into fashion, made permanent on film. In the 1940s, there was war, open-air churches, attentive persons all assembled; stack heels and nurses and the truck with the painted cross. Dr. Charles Drew, flanked by a white snow bank. Up through the postwar 1940s and into the 1950s and 1960s, we find dance troupes and team sports, machinists and square dancers—social arrangements that survive but in vastly different forms. We also find the lone cleric in front of Peoples Drugstore, protesting, resisting, standing for a good cause. There is Shiloh and Easter and Lincoln, and stores where we could or couldn't eat or buy goods. Signs so well metered that they show clearly in the pictures. Prices so low—from times long gone—prices we either could or couldn't pay.

We bend over these images, we hover over this record—our people come through times we have struggled with, prayed for, preached about. Victories clearly won.

See the children and their mother. Look, those colored folk can read. The bride and her bouquet and her short sleeves and her long gloves, she stands ready, veiled in flowers looking softly ahead. Women gather with their documents in their business finery, their faces composed and reflected in the shine and gloss of the clean conference table. Look, those colored women can assemble and get Council work done.

In kitchens, and in living rooms, and in our first pair of shoes—we walk toward the sunlight that Scurlock sees surrounding us. We assemble as he instructed and we wait. He loads plates, examines his sight lines. We imagine what we'll look like through his eyes.

Education was considered key to living free. Addison Scurlock sent his sons to Howard when he himself was the official photographer for our great university on that Wash-ington hill. There's our university, with its stacks and its students, with its thespians and its painters, its intellectuals. Its muscled men and Latin professors, its team sports. Its august visitors. All weighty, all significant, all doing the work of liberation. All holding still for Scurlock. Our Miner Teachers and its fine women. Each one will teach one. Their Capitol School, sons Robert and George, acolytes, professional retouchers. Make each image the best image. Use every tool. Use each opportunity. Take up your brush and your inks.

Scurlock captured all manner of equal heroes, early and late in their lives: daring Eleanor R. and chieftess Mary McLeod. Purposeful, lean, young Martin; John and Jackie, Professor Bunche, and E. Franklin with his tome. Fresh-faced P.L. Dunbar. Serious Booker, barrister Charles T. Duncan, planful Carter G., playful Duke, diminutive Strayhorn. Poet Alain, business wizard Madame C. J. Activist and linguist Mary Church, who laid claim to Italian, French, and German, and her neighbor, *über*-teacher Anna Julia—who mastered French and earned her doctorate at the Sorbonne. Lillian Evans turned Madame Evanti, dressed operatically as Lakmé. Ball-playing Ducky Kemp, Sweet Daddy full of grace, world-changing William E. B., Hollywood Fredi, General Benjamin O., Muhammad né Cassius, Sidney with his *Mirror* book, Marian with her contralto, their reverential throngs of admirers.

Night always takes away daylight, and less blanketing lights emerge. But even once the night has dawned, Scurlock finds sporadic bright lights, city globes to be captured, night streets to be shown, reflections to hunt down. Quiet women framed by cherry blossoms, free to sit undisturbed outdoors, free to chat at the tidal basin, free to see themselves reflected before this nation's mirrored monument. Stories of this city speak from behind them—the progress of a free people—shown frame by frame.

Addison Scurlock brought himself to this large colored city and made it his business to put colored folk on film. Metered properly, *hallelujah*. Lit carefully, *glory be*.

Every detail attended to, such technical efficiency. Scurlock could see us as we see ourselves. Scurlock laid down his roots, and raised his sons, here among the ready freedmen.

For decades strung together, the Scurlocks held our people in good light and channeled their fine regard for us, through their lenses, their laboratory, and their legacy. The Scurlocks made art with our kind as subjects. Addison started early, seizing a technical medium and applying it to his culture, quiet yet unafraid. The Scurlocks documented our place in Washington, daring to reflect us—who we are, how we look. Every Scurlock image almost shouts:

Look how far we've come. Look how put together we are. Look, our boys get to play—and not slave—in the hot light of summer. Look, these are the faces of freedmen. Look at our reflection, here in the capital of our country. Here. Look. See.

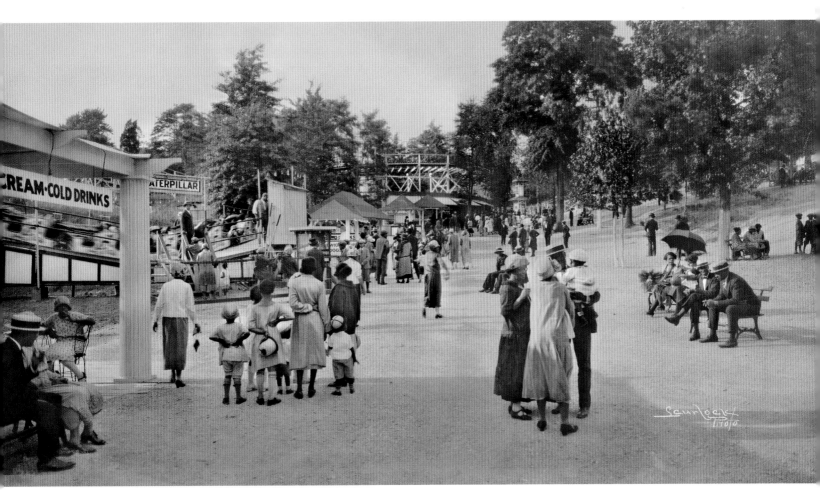

Black Washingtonians enjoy a day at Suburban Gardens, a popular black-owned amusement park in the Northeast neighborhood of Deanwood, c. 1920s

PICTURING THE PROMISE

PORTFOLIO

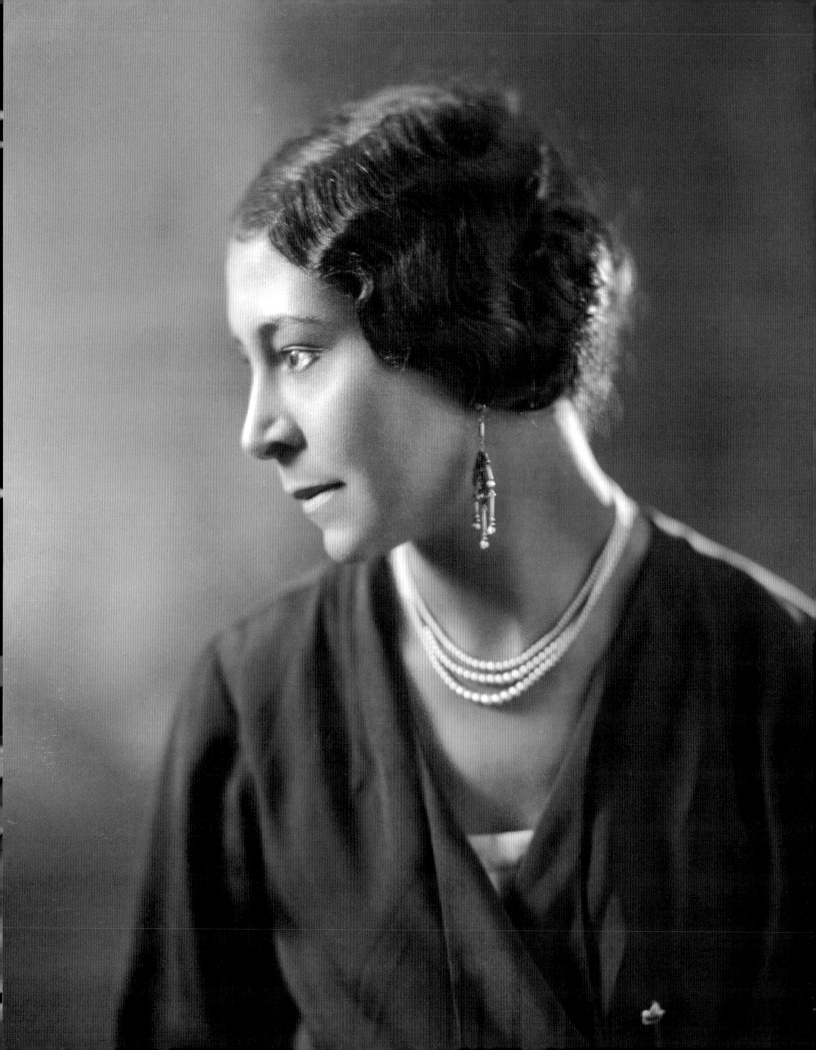

PORTRAITS

with reflections by

JEFFREY JOHN FEARING

Mrs. Louia Vaughn Jones, c. 1920s

Throughout much of the twentieth century, Washington contained a larger black middle class than other comparable American cities. The family-owned and family-operated Scurlock Studio provided a lens through which to view this key aspect of the city's life. Situated in the hub of a strong urban community comprised of an all-black residential area, a burgeoning commercial district, and a world-class university, the studio thrived in a unique location where it could record the lives of this large and expanding black middle-class population. Scurlock portraits not only succeeded in capturing the city's identity and complexity, but they also helped to negotiate and define its social boundaries.

Early in the century, Addison Scurlock's photography of this educated and influential population created a visual record of W. E. B. Du Bois' strategy for the political and economic uplifting of black America by a "Talented Tenth." This upwardly mobile group of strivers was an important element in the struggle for a positive black identity in a deeply racist society. Du Bois' vision entailed an active and successful middle class whose model behaviors and practices bespoke modernity and progress. Its stellar members would effectively counter prevailing racial stereotypes about African Americans, especially those attitudes that were institutionalized in and advanced by dominant white culture. Scurlock's camera became a tool to advance this strategy for racial justice. His portraits emphasize the dignity and integrity of individuals, families, and an entire community. They underscore the construction and visualization of this new black middle class, and in some ways foreshadow the New Negro movement of the 1920s, with a commitment to racial pride, solidarity, and a demand for fairness in the public sphere.

The men and women of the Scurlock family did more than document this community—they fully participated in it. Addison set the example by joining the all-male Mu-So-Lit Club, whose membership included black intellectuals from across America. An exclusive club, its name refers to the musical, social, and literary endeavors of its members. Reflecting the Du Boisian need to prove that African Americans were worthy of equality, the public image of its club members was of utmost importance, especially their dress and public demeanor. Separate from their husbands, many wives enjoyed participating in similar social clubs, such as literary associations, educational and self-help organizations, historical societies, sororities, and church groups.

Like the Scurlock family, hundreds of black Washingtonians joined and supported these organizations and clubs. Higher education combined with economic and cultural activities reinforced the status of the black middle class living in the nation's capital. As elite black Washington lawyer Archibald Grimké claimed, the District of Columbia contained "more wealth, more intelligence, and a much larger number of educated and refined colored people than any city in the country." Yet most blacks, including Grimké, realized that even social clubs were part of a complex strategy to achieve racial justice, and they understood their tenuous grasp on middle-class status. In reality, they held less economic and political power than even lower middle-class whites because of the rigid inequalities of segregation and the lack of legal protections.

Longtime black residents, so often photographed by the Scurlocks, nevertheless evolved a social hierarchy that left little room for those less-affluent newcomers who

arrived in the city from rural communities in the deeper South during the Great Migration of the first half of the twentieth century. Black Washingtonians who enjoyed access to education at elite schools, such as Dunbar High School and Howard University, saw themselves in a category distinct from those of a more modest background who settled in the District. Subsequently, Scurlock portraits sometimes reveal a great deal about the fears, needs, and composition of the black middle class in Washington. One of the most striking and complicated features is the role of color in determining status within the African American community.

Color—the lightness of one's skin or the straightness of one's hair—was often a multifaceted and highly prized marker that could constitute "beauty," signify class, and reaffirm status in an intraracial hierarchy. "If all Colored people look alike to some folks, they all do not look alike to one another, when it comes to drawing the social line," claimed civil rights and women's rights activist Mary Church Terrell. This simple statement simultaneously defends a color-coded social hierarchy while it fights racial stereotyping. To Terrell and other black Washingtonians, features and skin color that more closely resembled those of white Washingtonians signaled a level of refinement and possibility that positioned them above many working-class African Americans. Yet to others, these differing hues embodied the history and the realities of interracial relationships in this country. Scurlock Studio portraiture did not invent the class divisions based on color that traditionally shaped black Washington, but it did work to reinforce boundaries and social stratification.

Together, the Scurlocks built a business that at its heart was based on portrait clients. Widely known for its classic "Scurlock look"—a dignified, mature, and sophisticated likeness of black sitters, whether they were from the elite, middle, or working class—the studio expanded upon and pursued all avenues of portraiture. For decades the Scurlocks photographed individuals, families, groups, and businesses at weddings, graduations, and meetings, and in the process they created a vital body of portraiture of important Washingtonians and visitors to the city. Clearly, the "Scurlock look" was a crucial element in constructing the image of middle-class respectability.

The Scurlocks were much more than good community photographers. Their style, eye for composition, and sense of the importance of racial representation place the work of Addison and his sons at the epicenter of the leading photography of the early to mid-twentieth century. Their skill at portraiture rivals and even exceeds many of their contemporaries, such as James VanDerZee, P. H. Polk, Lewis Hine, and Alfred Steiglitz. The "Scurlock look" influenced generations of photographers who sought to replicate their ability to elicit meaning, authenticity, and beauty in the wonderful dance of negotiation between photographer and subject.

With these images, the Scurlock Studio composed a pantheon that represented a positive self-image of blacks. This image proved to be an effective weapon in the struggle against discrimination. It inspired resiliency and optimism within the African American community of Washington, and it clearly delineated the aspirations that were not yet realized. Yet they were not created merely in response to racist stereotypes. Instead, they were a testament to the dreams and hopes of those pictured and how they wished themselves to be known and remembered.

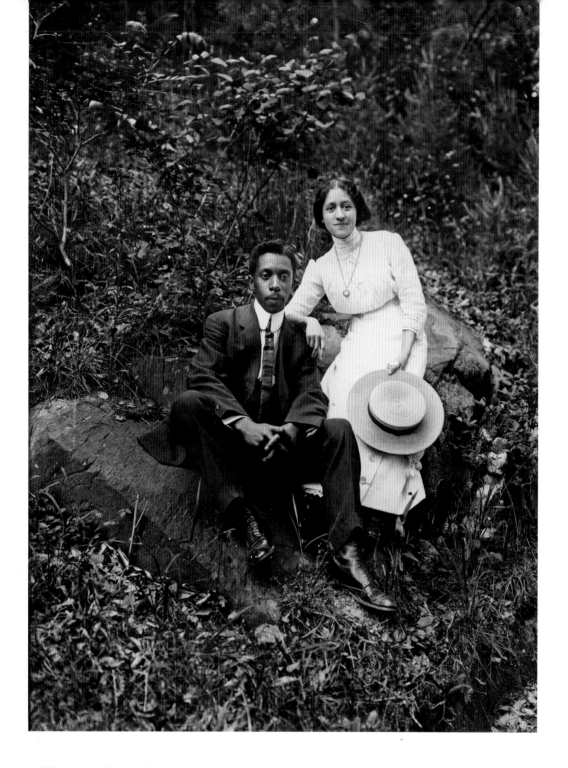

Addison and Mamie Scurlock, c. 1910s

Part of the key to Addison Scurlock's middle-class respectability was his business. For more than fifty years he worked diligently alongside his wife Mamie to establish and run a successful portrait studio. Addison stayed behind the camera, artfully composing the photographs, while Mamie managed the business and finances. She meticulously kept the invoice logbooks—numbering customer orders, entering negative sizes, listing print sizes ordered, and maintaining the petty cash account (usually about $40). Portraits of Addison and

Mamie record their long marriage. The earliest images of the two apparently were taken at Great Falls, Virginia. This is just one of many casual portraits made of the couple away from the rigors of city life. Settled close to each other on the rocky shore at the water's edge, they are well dressed for such an outing. United in all aspects of their lives, the Scurlocks were the quintessential young African American middle-class couple living and working in Washington, D.C., during the early 1900s.

Mamie Fearing Scurlock with wildflowers, c. 1910s

Few examples like this portrait of Mamie Fearing Scurlock exist in the Scurlock Studio Collection. This very personal portrait is one of a small selection from Addison's photographs taken on an afternoon outing with his wife and friends. He experimented with his camera when out of the studio. These images could be classified as pictorialist, or art photography, a popular movement at the turn of the twentieth century. Addison photographed distant landscapes, similar to that of European master art photographers, and he also posed small groups, such as Mamie and her female friends who were along for the trip. Their long white dresses resemble the Grecian costumes that female models wore in many American pictorial photographs of the time. Among the most successful of Addison's attempts, however, is when he used the rural landscape as a backdrop to frame Mamie in a casual pose holding a bouquet of wildflowers. Her carefree glance into her husband's lens is gentle and approving.

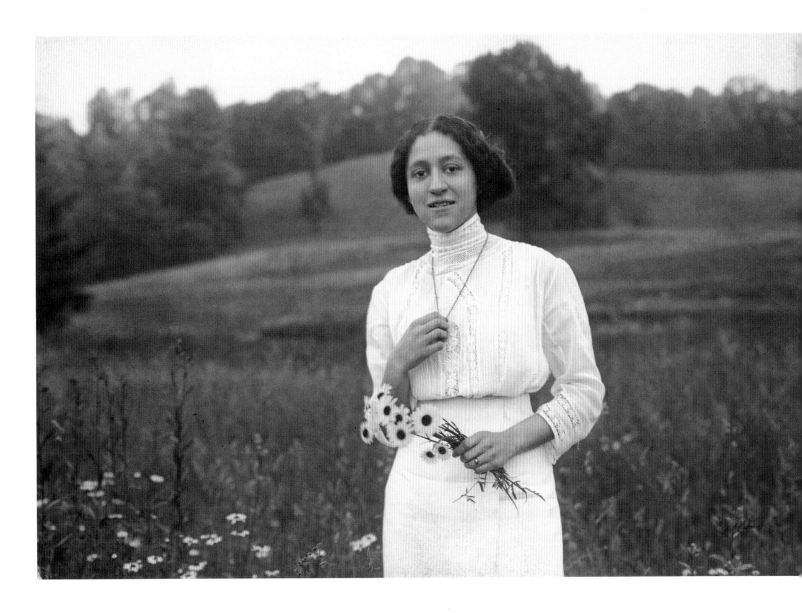

By all accounts, Addison Scurlock was a meticulous craftsman, an artist who was a perfectionist about every detail of his work. He had a way of imbuing his subjects with an unmistakable air of dignity and with a presence that bespoke a quiet, understated power. Scurlock was also renowned for his ability to render accurately the complete range of black skin tones, and so his largely black clientele would sit before his cameras in complete confidence that the resultant images would capture them accurately and in the best light possible.

Here, the artist is at work posing a young man. It became a sign of status to sit for a Scurlock portrait, and the greatest status was accorded to those whose portraits were featured in the display window of the studio. George Scurlock recalled the promotional benefit of the window portraits.

Our father would put photographs of famous people and not-so-famous people out there, and people saw this nice display and just walked in and asked if you could make them look as beautiful as the people in the case.... There'd be a picture of somebody's cousin there, and they would say, "Hey, if you can make him look that good, you can make me look better."

Something about the Scurlock style was difficult to articulate, but it made a Scurlock portrait unique and unmistakably recognizable. George attributed the Scurlock style to three qualities—posing, lighting, and retouching—with the final image being fine-tuned on the negative itself. The Scurlocks started with large-format five-by-seven-inch view cameras with five-by-seven-inch film backs. This both allowed the use of special portrait lenses and yielded a large enough negative to permit retouching. According to George, the lighting was crucial as well.

The lights we would use mostly, before we used Speedlights [electronic flashes], were banks of fluorescent tubes. That produced a softer light than incandescent lights. Eight forty-inch tubes, or six, would comprise the directional light, a smaller one opposite the other one for the relief light, for the reduction of the shadow created by the directional light.

The effect was that of natural window light, a highly directional source of diffuse light, that was moved about the subject until it highlighted precisely the desired portions of the face. Arthur Fearing, a cousin and classmate of Robert Scurlock, and one of the last subjects photographed by Addison Scurlock, remembers the precision with which the elder Scurlock positioned his head before taking his photo in the spring of 1963.

There was a certain touch that he had,...a certain method...of positioning the head of the individual.... I remember Uncle Ad...would position my head, then he would go to the camera and say, "Wait a minute, Arthur, you moved your head. I want [your] head to be in this position." And he would come back and turn my head to just the position he wanted, and said, "Now don't move." And if I moved that position, he would not snap the picture until it was there.

That Addison Scurlock instinctively knew where to position the head (and hands and shoulders), differently from subject to subject and photograph to photograph, is what made him the portrait artist he was. That he was consistently able to repeat himself, creating a new and unique work of art each time with each subject, is what kept him and his sons in demand for over fifty years.

JEFFREY JOHN FEARING

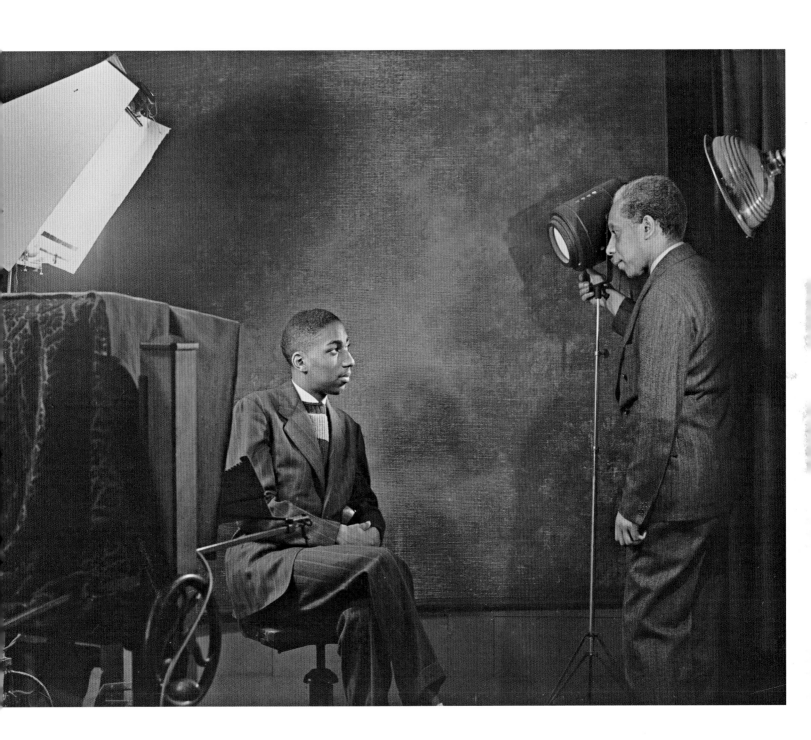

Charles Tignor Duncan, c. 1930s

Charles T. Duncan (1924–2004) is captured as a self-aware, sophisticated boy in this photograph by Addison Scurlock. Charles was the adopted son of celebrated opera singer Todd Duncan, whose portrait was also made by the Scurlock Studio in the 1930s (see page 172). He started his schooling in the D.C. public schools system and then attended Dartmouth College and Harvard Law School, graduating in 1950. Following his education, Duncan had a long and distinguished law career, including his work on the U.S. Supreme Court case of *Brown v. Board of Education*, and he served as principal assistant U.S. attorney for the District and the first general counsel of the U.S. Equal Employment Opportunity Commission. He filed a lawsuit challenging racial segregation at Glen Echo Park on behalf of Howard University students and neighbors who were protesting the park's policies. The amusement park opened its gates to African Americans in 1961 rather than go to trial. Duncan served as dean of the Howard University School of Law in the 1970s and advised Walter E. Washington during his tenure as mayor of the District of Columbia.

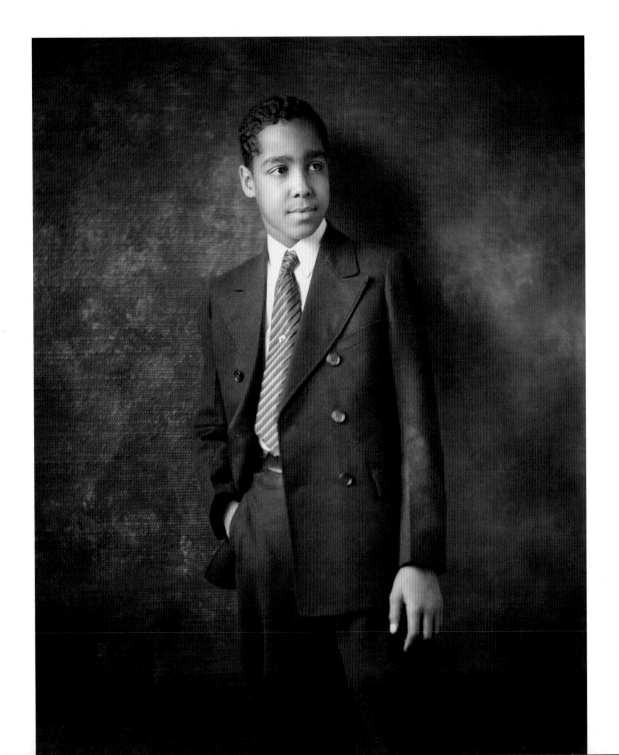

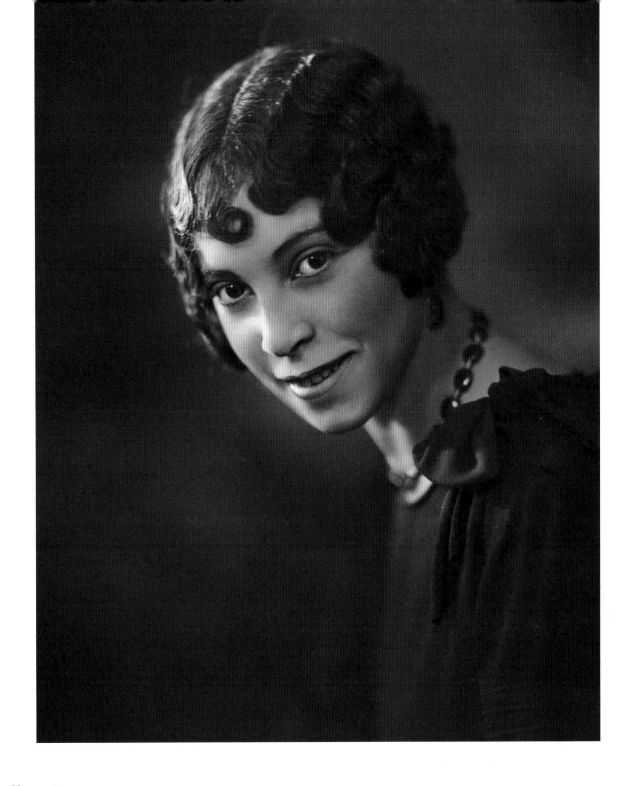

Miss A. Marshall, c. 1920s

In an 1897 academic paper titled "The Conservation of Races," scholar, activist, and author W. E. B. Du Bois rhetorically wondered, "What, after all, am I? Am I an American or am I a Negro? Can I be both? Or is it my duty to cease to be a Negro...and [just] be an American?" The effect that Addison Scurlock attained through the combination of light, shadow, posing, retouching, and printing that has since become known as the "Scurlock look" affirmed Du Bois' contention that African Americans could be both "American" and "Negro." Scurlock portraits constructed a dignified vision of black Washingtonians that was urban, urbane, and modern. They turned the derogatory label of race into a source of dignity and self-affirmation for African Americans. Today, they offer proof positive of the phrase "black is beautiful" well before it came into vogue.

Major James E. Walker, World War I, c. 1917–18

James Walker (1874–1918) grew up in Washington. He attended public schools and graduated from M Street High School in 1893 and Miner Normal School the following year. He worked in the school system and became a principal in 1899. Walker later joined the military and was eventually commissioned a major in the First Separate Battalion of the National Guard of the District of Columbia, which under his command included guarding the essential facilities in the nation's capital during World War I. Unexpectedly, Walker's health deteriorated, and he died on April 4, 1918, after receiving treatments at the Army Hospital at Fort Bayard, New Mexico. For many African Americans, the military was held in great esteem. Not only did the service provide increased career opportunities and stability, but it also allowed black soldiers to prove their worth as productive citizens. A tribute to Walker was published in the June 1918 soldiers' issue of the *Crisis*, the journal of the NAACP. In it, the superintendent of the public schools of Washington, D.C., reflected on Walker's life and patriotism as a tremendous example to young people.

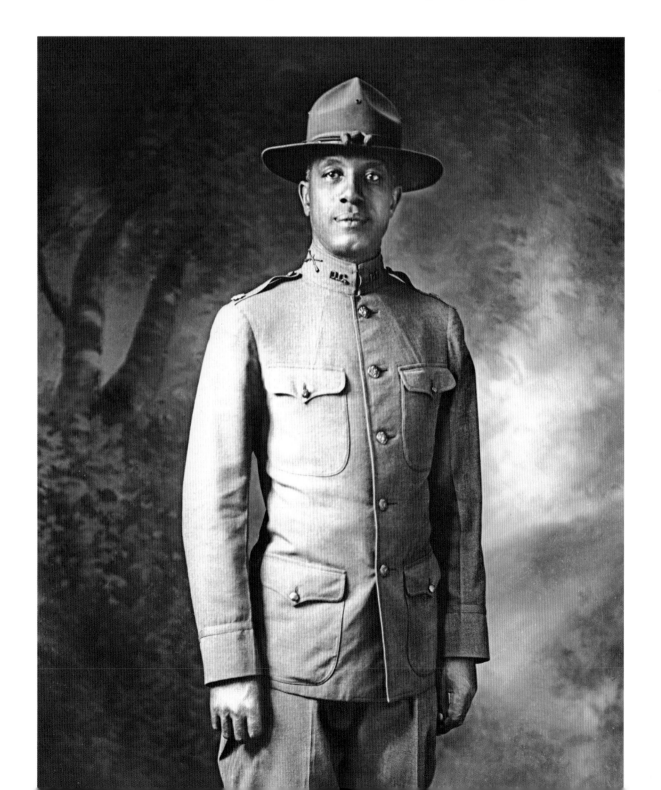

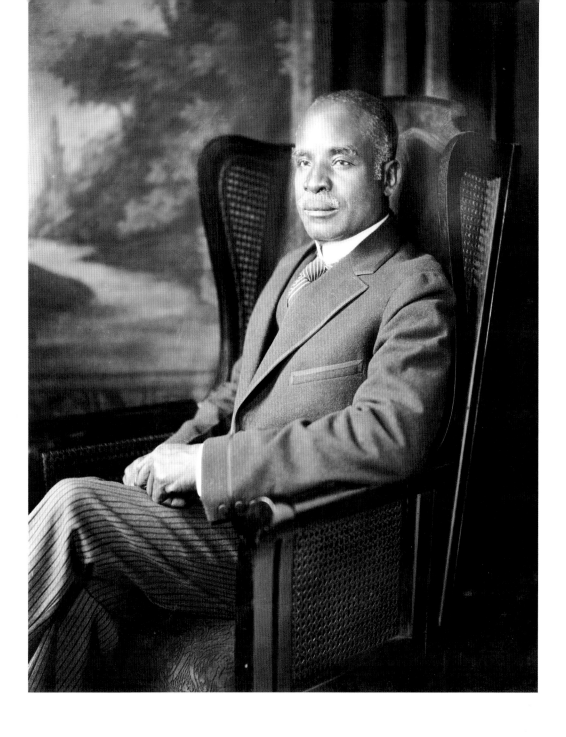

Kelly Miller, c. 1910s

Kelly Miller (1863–1939) was professor of sociology and dean of the College of Arts and Sciences at Howard University for forty years. Like W. E. B. Du Bois, Miller championed the belief that African Americans could obtain social justice and political inclusion through cultural recognition. Yet Miller also maintained a pragmatic streak, mediating the difference between the accommodationist racial stance taken by Booker T. Washington and that of the more demanding Du Bois. Photographed several times by Addison Scurlock over the course of the four decades they shared together in Washington, Miller was a staunch defender of his home city.

Reviewing the white photographer Carl Van Vechten's controversial 1926 novel *Nigger Heaven*—partially inspired by black Washington society—Miller proclaimed that although "the social breach between the masses and the classes of Negroes in Washington is more pronounced than [elsewhere]...Washington furnishes the best opportunity and facilities for the expression of the Negro's innate gaiety of soul." Harlem, in comparison, was "mainly effervescence and froth without seriousness or solid supporting basis" and not the "blissful bode of tradition" found in the District.

Wedding of Annabelle Howard's mother, c. 1920s

The Scurlock Studio was famous within black Washington for its classic wedding photography. Beautiful brides and wedding parties were frequently photographed throughout the entire history of the studio. Many couples and families wanted their weddings documented, and they hoped to have their portrait selected for the coveted center position of the display box outside the studio at 900 U Street, NW.

Effie Moore Dancers, c. 1920s

Vaudeville dancers and entertainers performing at local theaters in black Washington often posed for Addison Scurlock. Early painted backdrops were hung to cover the studio walls, and Scurlock experimented with various arrangements and dramatic poses for the performers. Little is known about Effie Moore and her dance troupe, but several photos of them posed in costume exist in the Scurlock Collection. Such portraits provide a glimpse into changing styles of women's fashion and roles in the entertainment world early in the twentieth century.

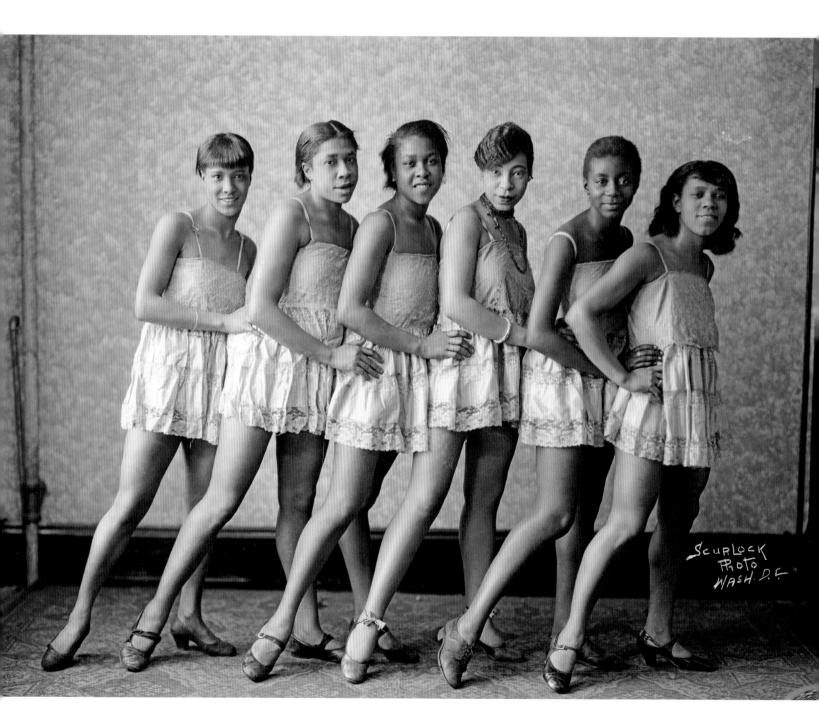

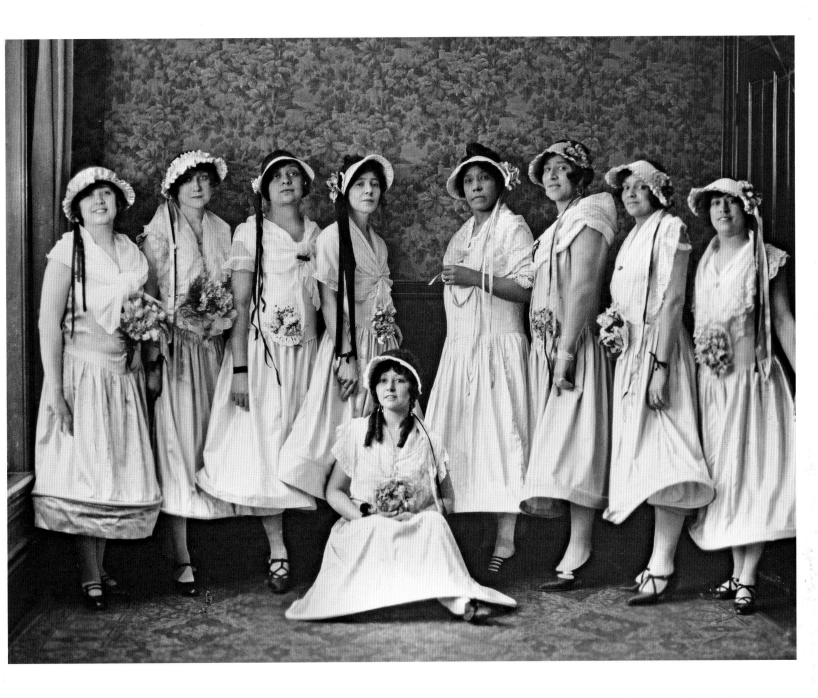

Women's Service Group, National Association for the Advancement of Colored People, 1921

Since early in its history, the National Association for the Advancement of Colored People (NAACP, founded in 1909) has included the strong support of its female membership, despite a traditional male leadership. Throughout the civil rights movement, NAACP women's service groups orchestrated rallies, made phone calls, visited homes, organized community meetings, and mobilized supporters. Three of the first executive secretaries to the organization's president were women. Here, the local Washington group, dressed for a special celebration, poses for Addison Scurlock in his studio.

Hand-colored portraits of a woman, c. 1920s

The Scurlock Studio, with Addison in charge, perfected hand-colored retouching techniques for negatives and prints as a specialty service to customers. These portraits of an unknown woman are part of a series of six made during a sitting. She changed clothes and repositioned her shawl, striking a dramatic pose in each. Addison used lights and shadows to enhance his subject, and afterward in his retouching room he added color to the dress and shawl. He later taught these skills to his sons and assistants, establishing a tradition that lasted throughout the studio's history. Despite the advance and popularity of color photography, Addison remained faithful to black-and-white photography and to the retouching and hand-coloring processes until his death in 1964.

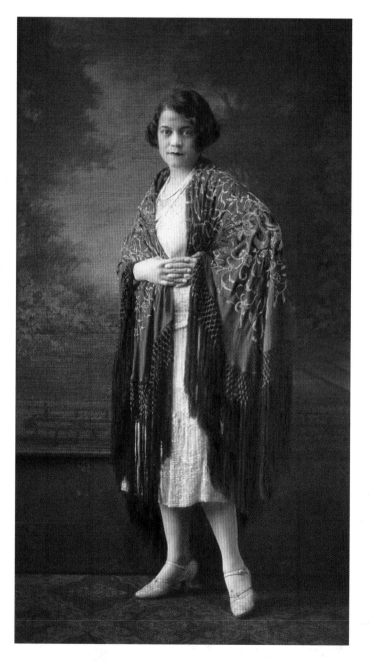
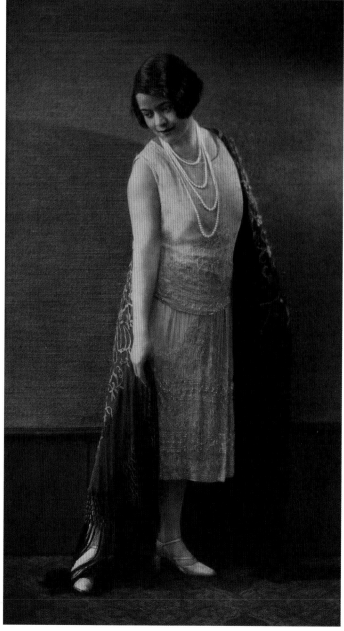

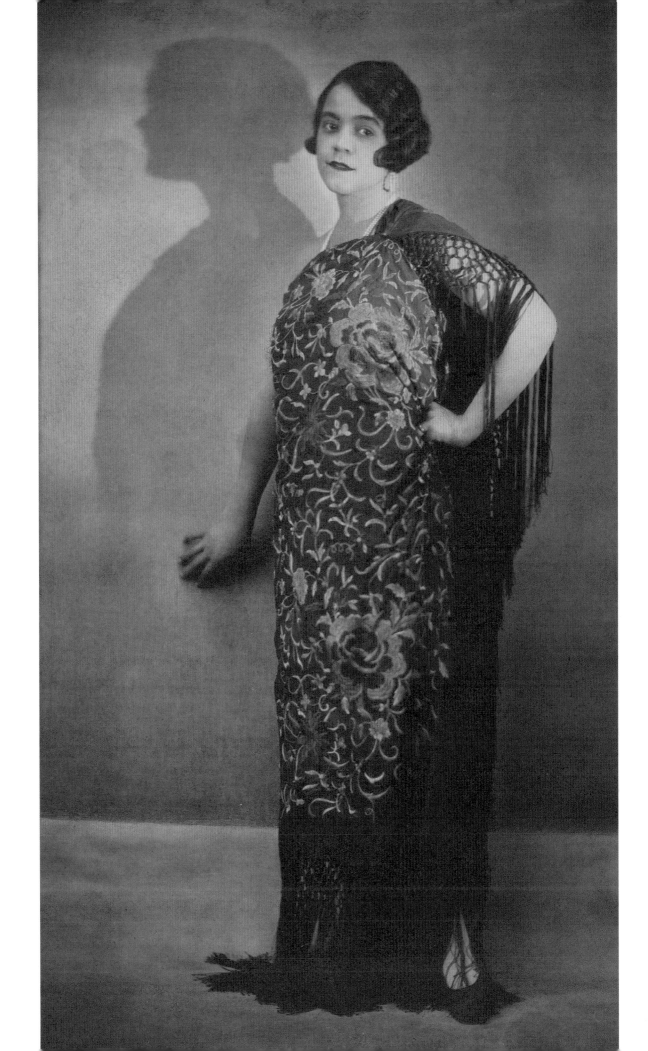

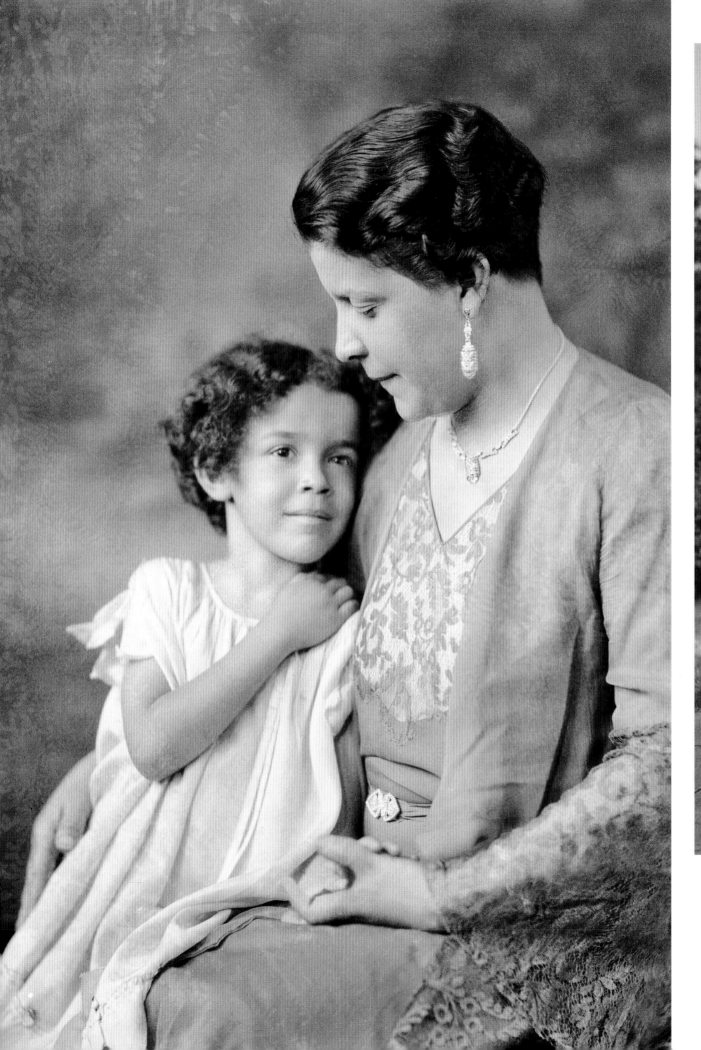

Mrs. Esther Popel Shaw
and daughter Patricia, 1930

Esther Popel Shaw (1896–1958) was an accomplished teacher, author, activist, and poet. Originally from Pennsylvania, she was a sometime member of Georgia Douglas Johnson's Saturday Nighters literary salon, and her own poetry appeared in the pages of the journals *Opportunity* and the *Crisis*. Her 1934 poem "Flag Salute" starkly juxtaposes the voices of schoolchildren reciting the Pledge of Allegiance with a blistering news account of a lynching and riot that occurred in the town of Princess Anne on Maryland's Eastern Shore. As political options were circumscribed for most African Americans in the early part of the century, the home and family remained the crucial site of race-building, as this image suggests. This intimate view of Mrs. Shaw nestling her daughter Patricia protectively in her arm suggests the care with which the Scurlocks composed their photographs to emphasize cultured respectability, family stability, pride, and love. After she grew up, Patricia Shaw married and moved to Europe, where she settled in Norway.

Lillian Evans Tibbs (Madame Evanti)
and son Thurlow, c. 1920s

Addison Scurlock perfected his signature look for portraiture in the studio, but he brought many of the same qualities to his work outdoors. Here, he captured the dignified air of Lillian Evans Tibbs (1890–1967) promenading in Meridian Hill Park in Washington, D.C., with her son Thurlow. Known to the world through her stage name, which melded her maiden and married names (Evans and Tibbs) into an artful, Italianate composite, Madame Evanti clearly understood the power of performance and the mystique of artifice (see page 171). Scurlock presents her here in a seemingly carefree moment of repose with her son. Her clothing, demeanor, and posture, however, demonstrate how Scurlock constructed the visual image as both a private and a public performance where various identities of race, class, and gender were negotiated. As an adult, Thurlow Tibbs supported the cause for Ethiopian independence and later traveled to Addis Ababa to teach school as part of the country's reconstruction effort after World War II.

Lt. and Mrs. U. S. Ricks, c. 1942–45

I n the 1940s the Scurlocks frequently photographed military men serving in the segregated units of the U.S. armed forces. This patriotic image of a young couple during World War II exemplifies the many family portraits that the Scurlock Studio made in this era. Whether the soldiers and sailors pictured with their families had just enlisted, were at home on furlough, or were preparing for a wedding before shipping out to war, each sitter desired a special portrait memory before leaving his home and community for service and combat.

Military training and drills were part of the high school experience for numerous students at local black high schools during this time. The annual competitive "Drill Day" started in May 1893 as a means for local groups of "cadets" to show their study of and expertise in military formations and techniques. Rivalries and the desire to be the best motivated team members who studied military science as part of their schooling. These competitions eventually became so large that they were held in Griffith Stadium, adjacent to Howard University, and continued at the college level as part of ROTC (Reserve Officers' Training Corps) training.

Much debate on the Howard campus focused on the situation of African Americans having to serve the nation in segregated units. Most people did not question supporting the war effort, although some female students organized sit-in protests in 1943 to oppose men having to serve in separate armies. The Scurlock family remained committed to military duty, whatever the conditions. Both Robert and George Scurlock enlisted in the ROTC as part of their college curriculum. The boys attended training sessions at Howard, and they probably participated in the rigorous exercises at Fort Howard, near Baltimore, where U.S. Army officers trained black ROTC students from the Third Corps area. Robert Scurlock's photographs of the Fort Howard ROTC training appeared earlier in *FLASH!* magazine on July 12,

1937. He documented daily practices in military tactics and on the machine gun range, as well as recreation (boxing matches) and students setting up tents for the camp.

During World War II, while Robert served in the armed forces, Addison and George Scurlock worked together to produce portraits of the era. Their thousands of negatives provide in-depth documents of families in black Washington. Individual soldiers and sailors, couples, families (with one or more military sons included), and single and double weddings parties were all captured for future memory. Each portrait conveys the Scurlocks' usual attention to detail and respect for all their customers. Addison's reputation was well established after his thirty years in business. George honed his skills as a young professional photographer, keeping up with the stamina of his father in business and practice. The end result is a lasting visual archive of a community serving the nation.

MD

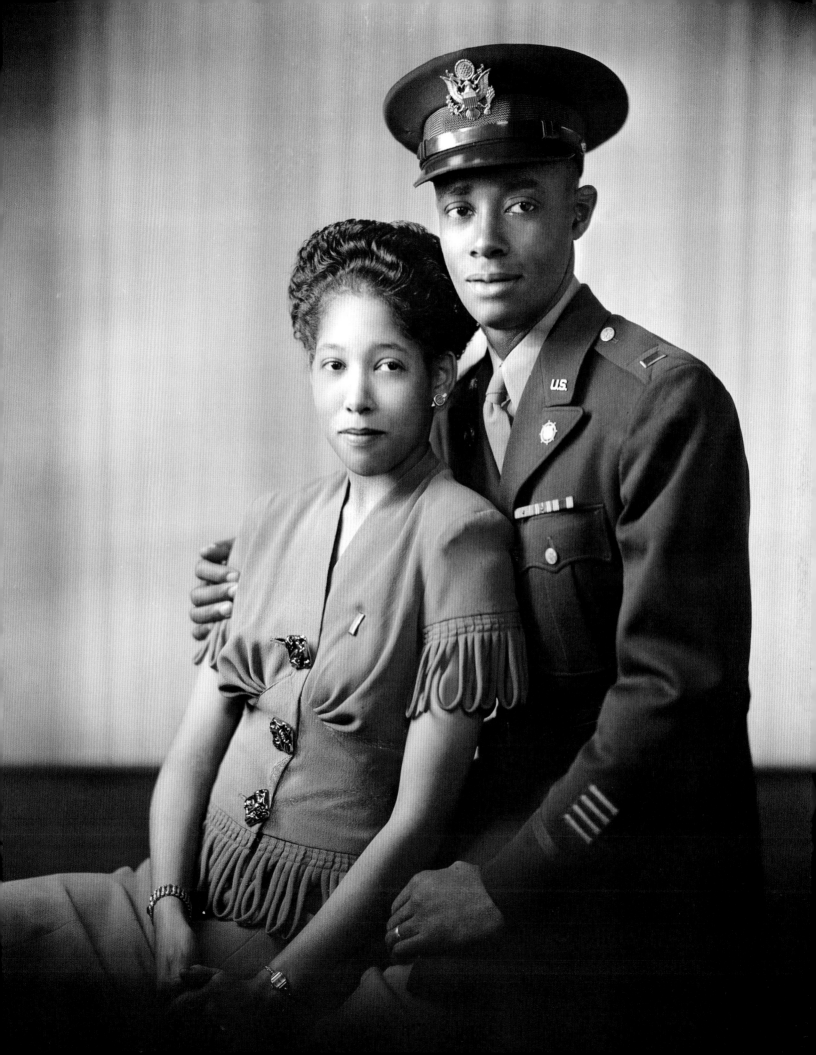

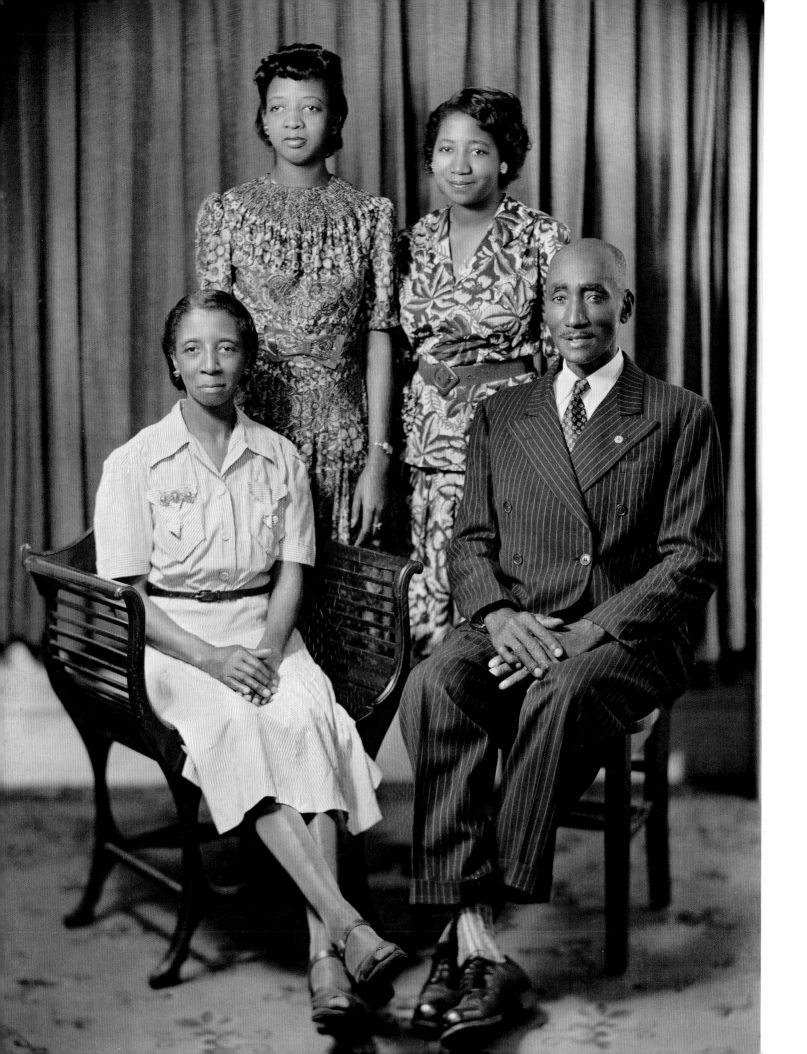

Griggs family studio portrait, 1940

The Scurlocks' reputation as Washington's premier portrait photographer was long solidified by the time Miss Ann Griggs, pictured here with her family, contracted the studio to provide a portrait that could be proudly displayed in their home. Scurlock portrait photographs like this one adorned the homes of an economically diverse and expansive black middle class in Washington. Such images transformed perceptions of African Americans to correspond with the realities, hopes, and aspirations of their own lives.

Sharon Jones' birthday party at Mrs. Howard's daycare, 1949

Local Washington families hired the Scurlock Studio to photograph many special gatherings and community events, including birthdays, anniversaries, holiday and dinner parties, and school groups, but few preschool groups were among them. Seated at tables in a large basement playroom, Mrs. Howard's preschoolers patiently wait for Sharon Jones to cut her birthday cake. Unlike most Scurlock group portraits that are organized and tightly posed, this candid image captures a precious moment in which one little girl at the front table cannot keep from giggling.

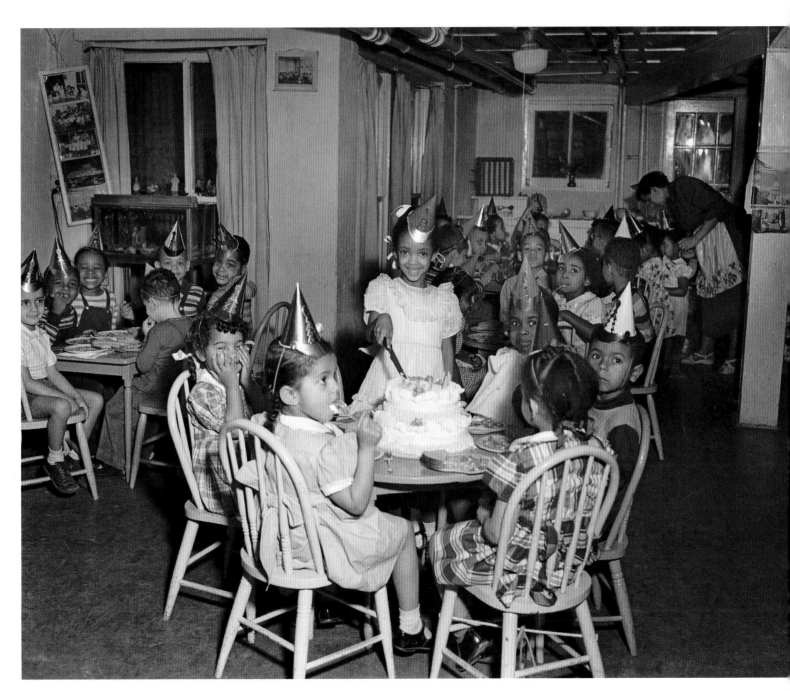

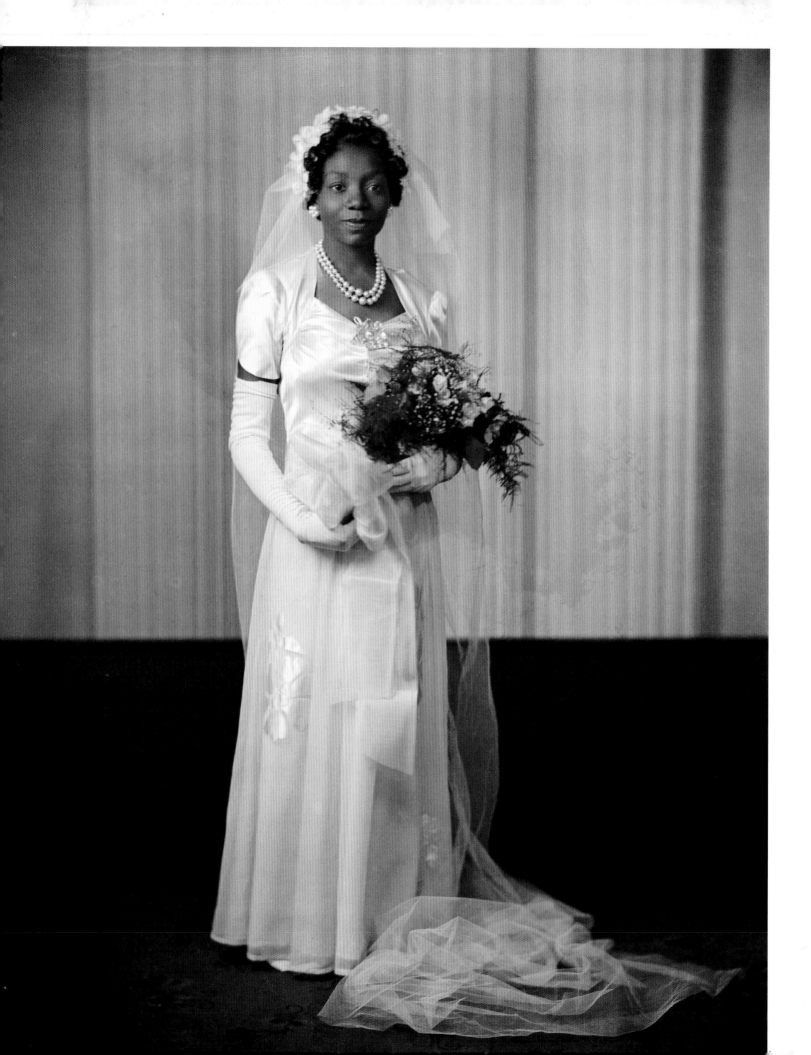

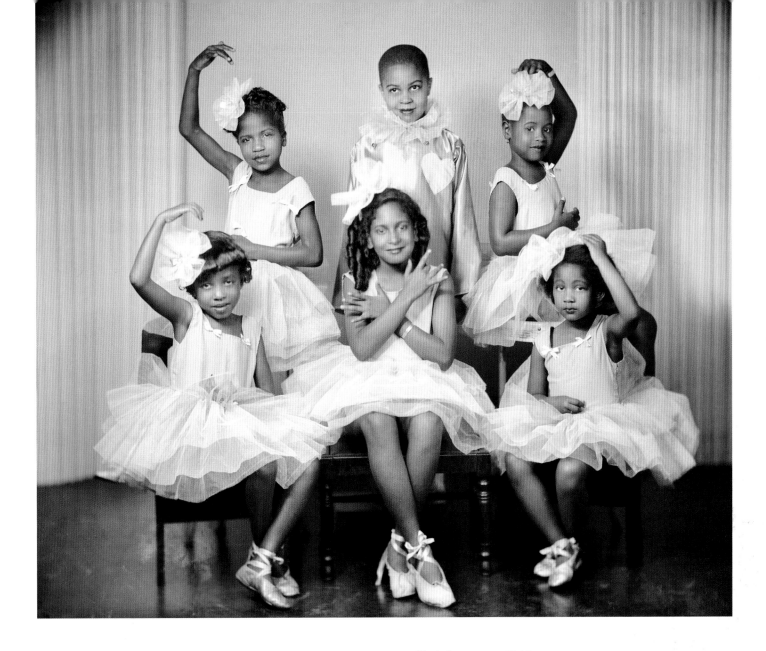

Mrs. Rosina Williams, 1945

Wedding photography provided continual work for the Scurlocks, especially during the World War II era. They photographed individual brides, wedding couples, and bridal parties in the studio, at church, or in the family home. Scurlock Studio invoice books list customer information, orders, dates, and prints received. George's daughter Jacqueline remembers working for the studio as a teenager and preparing "proof" print books from which wedding couples selected their favorite poses for purchase.

Ballet dancers, 1948

Perfectly poised and posed, these young dancers may have been students of Doris Patterson, whose name appears on the original negative. Using dramatic poses and theatrical lighting, the Scurlock Studio artfully photographed many African American dance schools, their special troupes, and community performances. Finding schools to provide their children with the opportunity to study a variety of dance forms, including classical ballet, was a challenge for African American parents in segregated Washington. The Doris N. Patterson School of Dance was located on Minnesota Avenue in Northeast D.C. An advertisement in the *Washington Post* on December 17, 1947, for the school promotes "Courses for Children, Adults and Teachers in Russian Ballet, Toe, Creative, Tap, Spanish, Acrobatic and Ballroom. Transportation furnished."

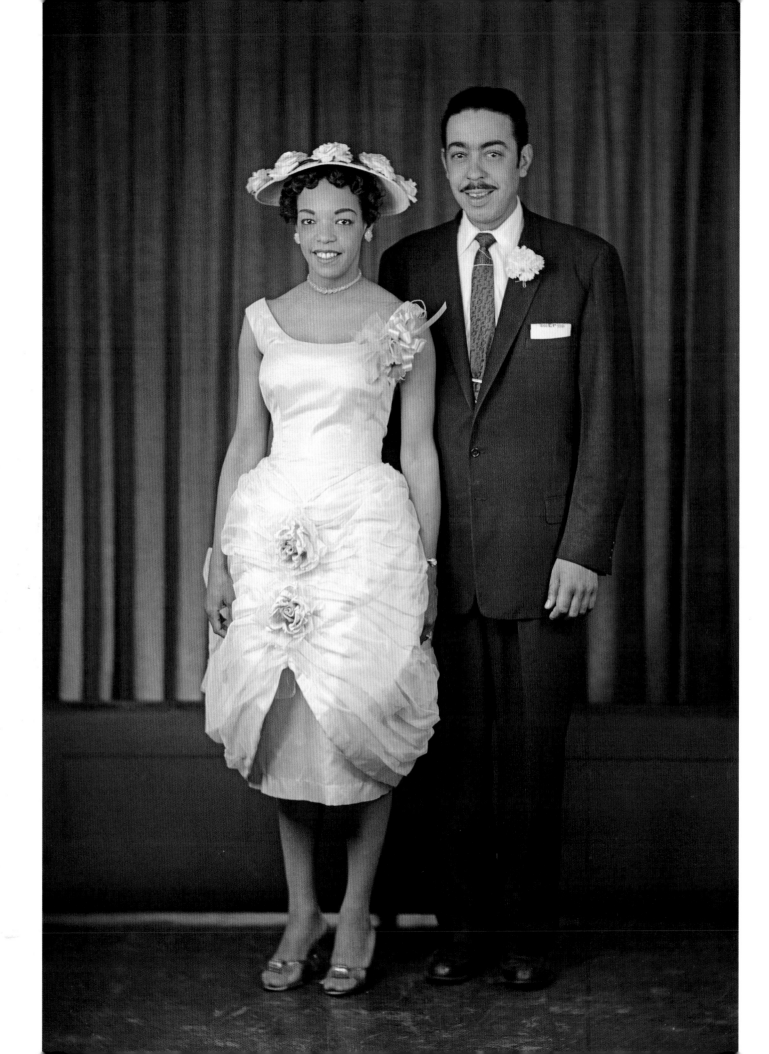

Mr. and Mrs. Earl Fisher, 1959

When this portrait of the Fishers was taken, Addison had been operating the Scurlock Studio for almost fifty years. It was an established tradition for local black families to have their portraits taken to commemorate marriages, graduations, and other special occasions. The classic curtain backdrop of the 1940s and 1950s is seen in this Scurlock portrait of the Fishers.

Dr. Clarence Greene and family, c. 1950s

Dr. Clarence "Spoof" Greene (1902–1957), his wife Evelyn, and children Clarence Jr. and Carla lived in this house on Military Road, near Reno Road, in Northwest Washington, D.C. The Greene family was one of the first black families to move into this neighborhood. The Scurlocks photographed them inside their home as well, possibly for an article on Dr. Greene. He attended Dunbar High School in the District, obtained several degrees from the University of Pennsylvania, and as a member of the Howard University Medical School, became the first black physician to be board certified as a neurosurgeon. The family still lived in the home when Dr. Greene died in 1957. Such images effectively countered prevailing notions of black inferiority and poverty.

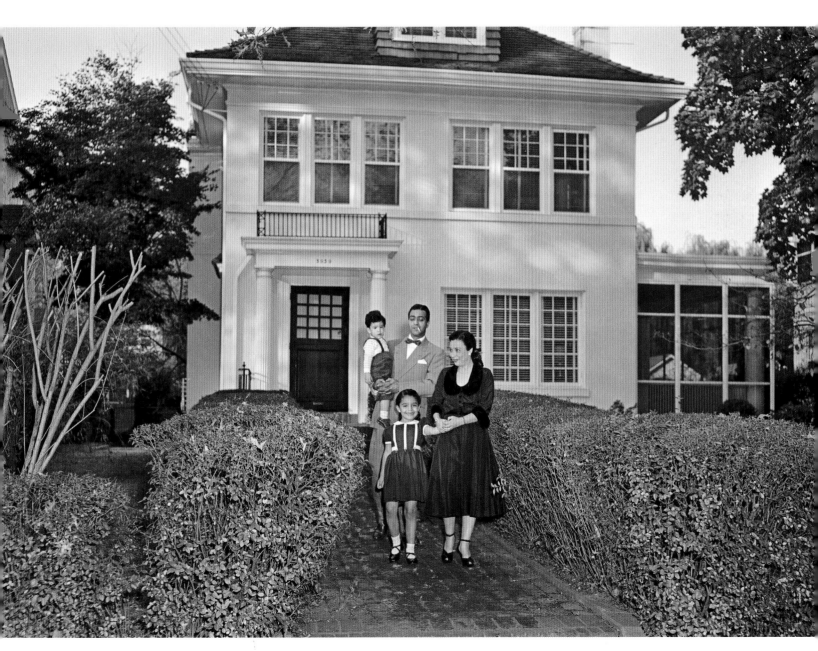

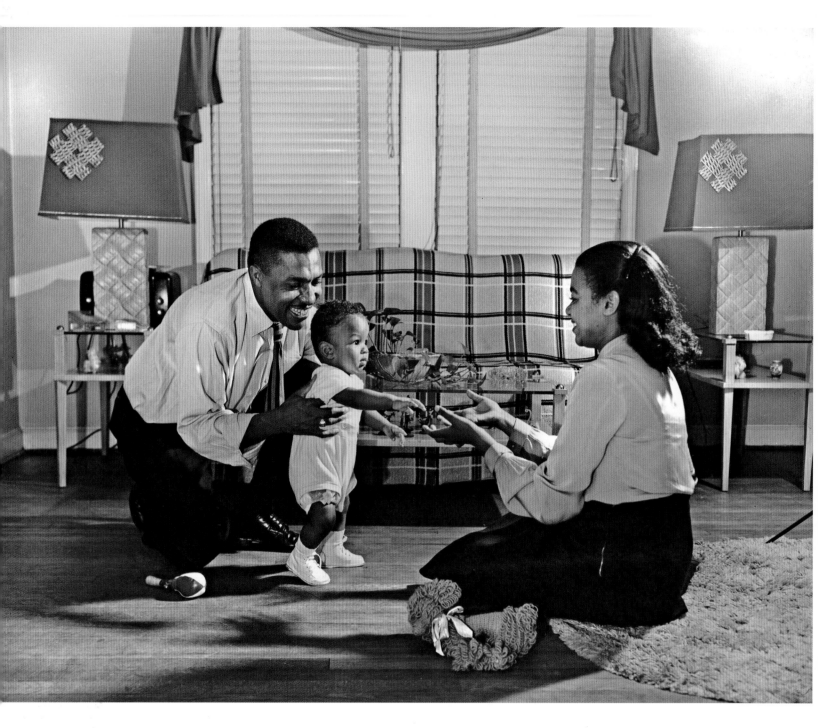

Baby's first steps, c. 1960s

This "candid" family portrait showing a baby's first steps is most likely a carefully composed photograph. The Scurlock Studio, and especially Robert, accepted photo essay assignments from *Ebony* magazine in the post–World War II era and submitted images to black newspapers and journals. Scurlock family photographers were trained to compose such appealing individual and group portraits for clients. This unusually casual view was probably intended for publication as part of a photo essay on middle-class African Americans and family life.

Howie Williams and family, c. 1960–62

Howard University football player Howie Williams (born 1936) posed with his family at their home shortly before he was drafted into the National Football League by the San Francisco 49ers. After being released by the 49ers, Williams played with the Oakland Raiders from 1964 to 1969. Athletics were often viewed as a path toward middle-class respectability, and Williams and other talented college players took advantage of burgeoning opportunities to participate in professional football in the late 1950s and 1960s. This portrait of the Williams family also demonstrates the ways in which the black community continued to reshape and redefine itself across racial lines in the civil rights years.

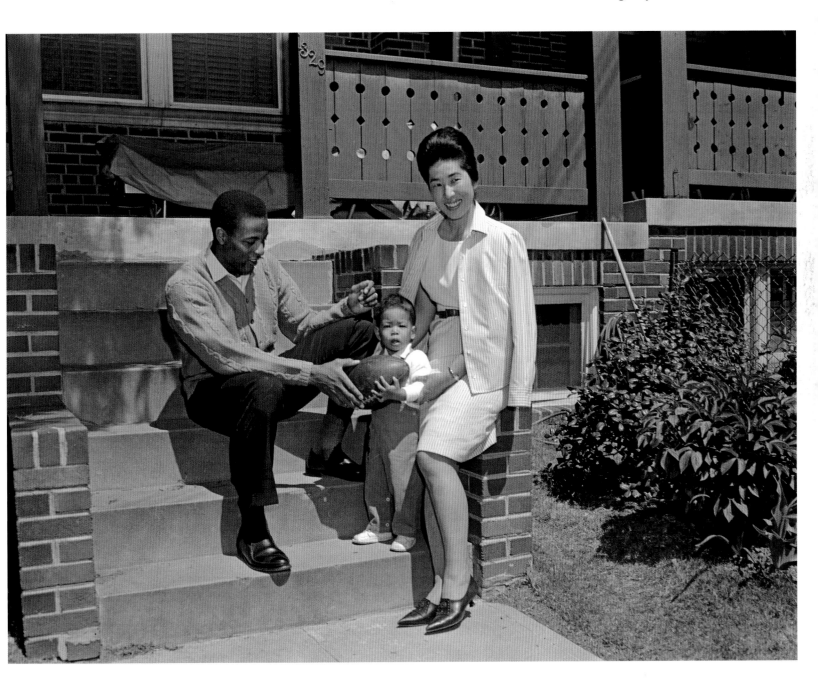

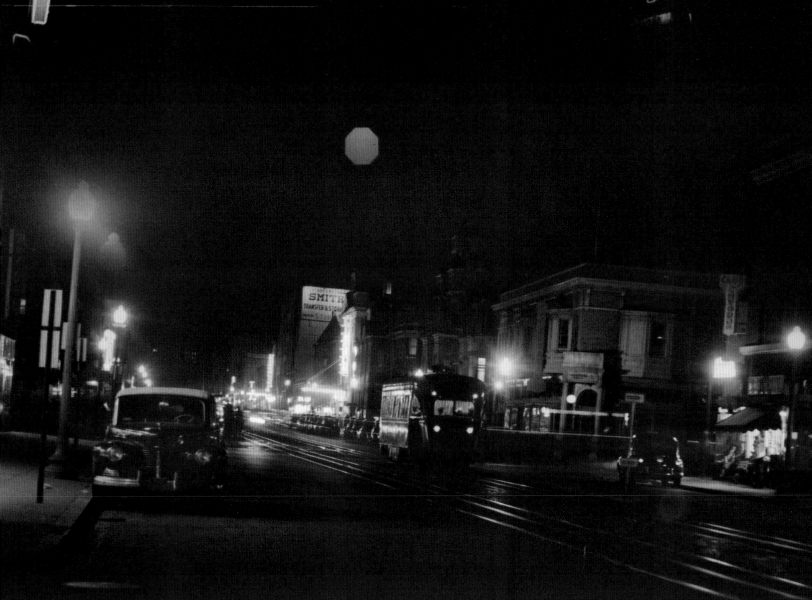

CAPTURING THE CITY

with reflections by

JEFFREY JOHN FEARING

BRIAN GILMORE

MARYA A. MCQUIRTER

HILARY SCURLOCK

A.J. VERDELLE

with STEVEN CUMMINGS,

SHARON FARMER, and ROY LEWIS

U Street photomontage with Billie Holiday (detail), c. 1940s

Rightly renowned for their dignified portraits of African Americans, both famous and unknown, the Scurlocks were also among the very best of twentieth-century photographers who recorded the substantial changes that altered urban black neighborhoods nationwide. Similar to James VanDerZee and later Roy De Carava in New York, Frank Cloud in Los Angeles, Teenie Harris in Pittsburgh, and P. H. Polk in Alabama, the Scurlocks sought to depict a world of urban possibilities enriched by the presence of a forward-looking African American community. Primarily focusing on the neighborhoods that surrounded their studio—Shaw, the U Street district, Striver's Row, LeDroit Park—the Scurlocks captured many of black Washington's social, cultural, and political rhythms for nearly a century.

Exploring their archive today reveals how the Scurlocks, over most of the last century, envisioned the promise of a respectable, expanding, and diverse black middle class. Their sitters laid claim to their city and defined their worlds of leisure and entertainment, art and literature, politics and protest, spirituality and social activism. As a consequence, the Scurlocks' body of work demonstrates that black Washington was central not only to the city's story but to the African American story throughout the twentieth century.

Addison Scurlock established his business and developed his art in an environment of enormous flux on the one hand and increasing rigidity on the other. The black population of Washington, D.C., nearly doubled each decade beginning in 1880, resulting in a population of well over a hundred thousand black residents by 1920. In subsequent years, more migrants poured in from the rural South each year, giving Washington (after New York and Chicago) the third largest African American population in the country. Yet it was an unequal environment for blacks who were socially, economically, politically, and geographically circumscribed and segregated from the white community. Just at the time when Washington was developing into a twentieth-century urban metropolis of massive contradictions, Addison Scurlock began to document its vibrant black life.

Scurlock provided an insider's perspective of Washington as the mecca of African American life before Harlem came into vogue. Depictions of successful businesses (see the Underdown Delicatessen), churches (the construction of the Lincoln Temple), and a myriad of community and leisure events (a summer scene at Highland Beach in Maryland and various activities at Howard University's Griffith Stadium) demonstrate Addison Scurlock's equal interest in recording the city outside his studio and photographing the meticulously posed and softly lit faces of its denizens.

Addison also recognized the power that both his individual portraits and his images of black life in Washington wielded in constructing a visual record of accomplishment for African Americans. Rooted in his community yet reaching beyond its geographic borders, Scurlock took advantage of the burgeoning print media to publicize his vision of black success and aspiration on the pages of various monthly and weekly African American periodicals—the *Crisis*, the *Afro-American*, the *Chicago Defender*, and the *Pittsburgh Courier*, among others.

As the 1920s, 1930s, and 1940s unfolded, Addison Scurlock passed his craft, business acumen, aesthetic sensibility, and political ideologies to his children. Robert and

George Scurlock, along with their father, continued the family tradition of photographing aspects of black life in Washington and broadcasting them as widely as possible through the black press. Scurlock images of the city illuminate the richness and diversity of black Washington even during the harshest era of Jim Crow. They demonstrate how the community characterized the reality of racial segregation throughout much of the twentieth century, yet they also recorded the congregational qualities of African American social life and endorsed black Washington's cultural vitality. Celebration merged easily with confrontation in these images since both were united in a vision of racial advancement.

As a generation of African Americans insisted more vociferously on pursuing the constitutional rights guaranteed to all Americans, the Scurlocks depicted some early faces of the modern movement for civil rights. They connected neighborhood protests at Peoples Drugstores and gatherings of sleeping car porters at the Twelfth Street YMCA with national events, such as Marian Anderson's Easter Sunday concert on the steps of the Lincoln Memorial in 1939. When World War II brought change and spurred further immigration, thus profoundly reshaping the city again, the Scurlocks depicted the patriotism of Washington's black residents on the home front and those who served in the armed forces abroad. They detailed the development of some of the city's newest African American "suburban" neighborhoods east of the Anacostia River. Later, they recorded the complexities and repercussions in the neighborhoods around their original studio after segregation was legally ended, and they continued their work through the turbulent 1960s and 1970s.

Images from the Scurlock Studio throughout this time also indicate how race is deeply intertwined with issues of class in black Washington and, by extension, in America. For all its ills, racial segregation created an environment in which black elites and members of the middle and working classes lived and worked, went to school, and played alongside each other. Professors and police officers, poets and domestic workers forged a way for themselves and for the greater community—admittedly not without tensions, rivalries, and social stratification, but together. As legal segregation ended, and urban flight and decay followed, the economically and socially diverse black community was held together, ironically in part, by the limitations imposed by a racist society. As this began to shift and change, some inequalities worsened and other challenges reverberated into the twenty-first century. Scurlock images of black Washington remain important, not simply as sources of nostalgia but also for how they show the past and, in some ways, continue to shape the present.

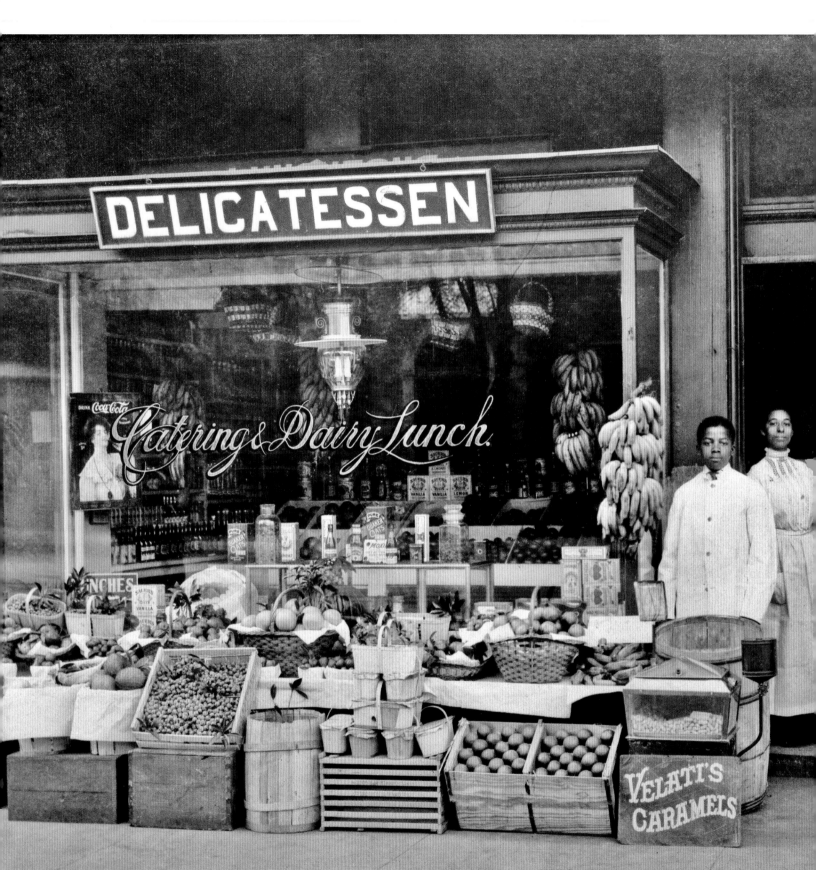

Underdown Delicatessen, 1904

Owner Alexander Hamilton Underdown and his wife, Margaret Clark Underdown, pose with employees in front of their store, the Underdown Delicatessen at 1742 U Street, NW. A member of the National Negro Business League, Underdown participated in the organization's 1906 national convention in Atlanta, where he represented "fruits and delicatessen" proprietors. Addison Scurlock's image is a captivating portrait of a successful black entrepreneur in turn-of-the-century Washington. It also provides a sense of the multi-ethnic culture of U Street. Signs for Italian caramels, pure olive oil, and Coca-Cola not only mingle with a bounty of fruit and produce but also contrast with the script lettering of the delicatessen's own advertisement for "Catering and Dairy Lunch," a possible appeal to Jewish patrons.

Waterfront, Washington, D.C., 1915

Perhaps photographed along the Potomac River, this attractive maritime scene by Addison Scurlock is an unusual example from the early work of the Scurlock Studio. Primarily engaged with taking individual portraits and documenting the development of black enterprise and institutions, Addison did not often take such photographs since a client was not directly involved. Judging by the lack of tackle or equipment in their craft, this possibly posed trio of boaters seems to be preparing for a pleasurable excursion on the river.

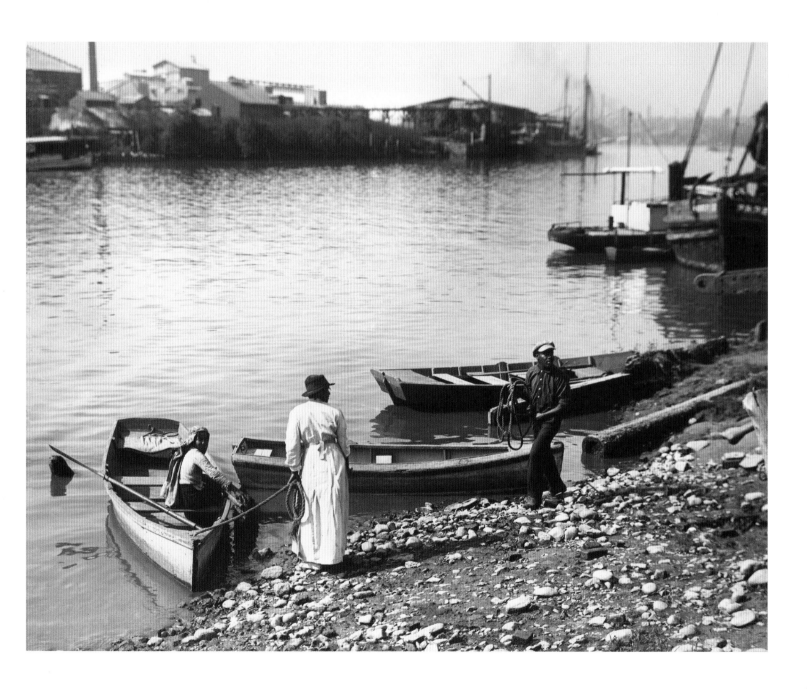

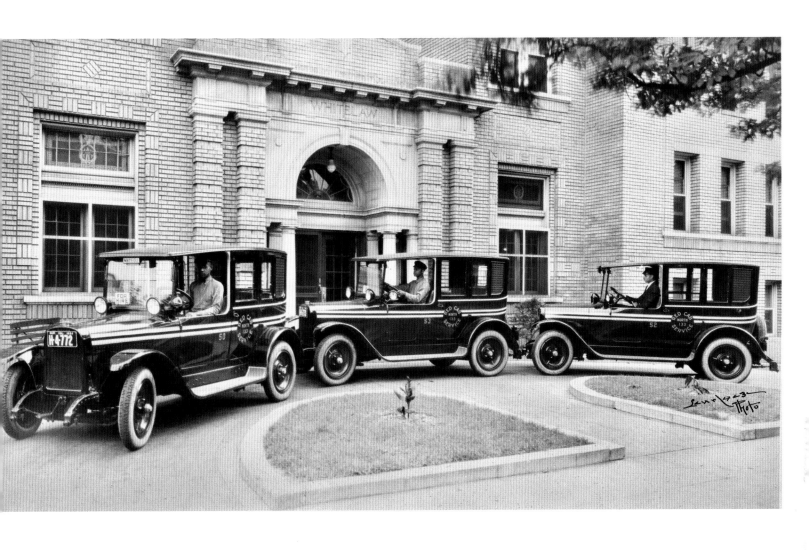

Whitelaw Hotel with three cabs in driveway,
c. 1920s

Located at 1839 Thirteenth Street, NW, the Whitelaw Hotel was Washington's only hotel for African Americans during the early and middle years of the twentieth century. A luxury venue, the Whitelaw became an important social center for black Washington. It hosted many African American celebrities and luminaries who visited the nation's capital. As an apartment-hotel, it also catered to long-term guests of the city. Black entrepreneur John Whitelaw Lewis built the hotel in 1919 for $158,000 with architect Isaiah T. Hatton, a black Washingtonian and a graduate of M Street High School. Two years earlier, Lewis constructed the Industrial Savings Bank, the city's only African American bank, on Eleventh and U Streets. The Whitelaw currently exists as a low-to-moderate housing complex and is listed on the National Register of Historic Places.

Dunbar High School
championship basketball team, 1922

Paul Laurence Dunbar High School, founded in 1870 and formerly named the M Street School, was the first public high school for African Americans in the United States. A lack of opportunities for black professionals due to racial segregation resulted in an extremely high concentration of African Americans who administered or taught school and advocated for the highest quality education for black students. This Scurlock image profiles Dunbar's championship basketball team and thus demonstrates the school's commitment to athletics and academics. Charles Drew, who later became renowned as a physician and medical researcher (see page 139), is fourth from the right, and third from the left is teammate Harry Mickey. Assistant coach and Latin teacher Clyde McDuffy stands on the far left, with head coach Edwin Henderson flanking him on the far right. Little known today, Henderson was among the fathers of organized black basketball in the twentieth century and introduced the game to Washington in 1907. He envisioned the sport as more than a form of competition—it was an instrument to advance the causes of public health and civil rights. Until he retired in the 1950s, Henderson taught and influenced thousands of Washington school children in sport and life.

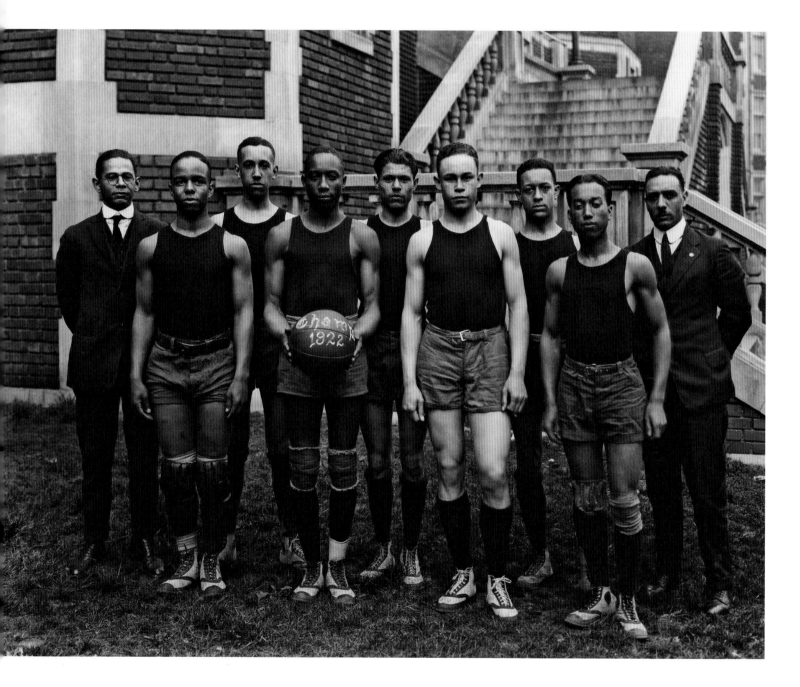

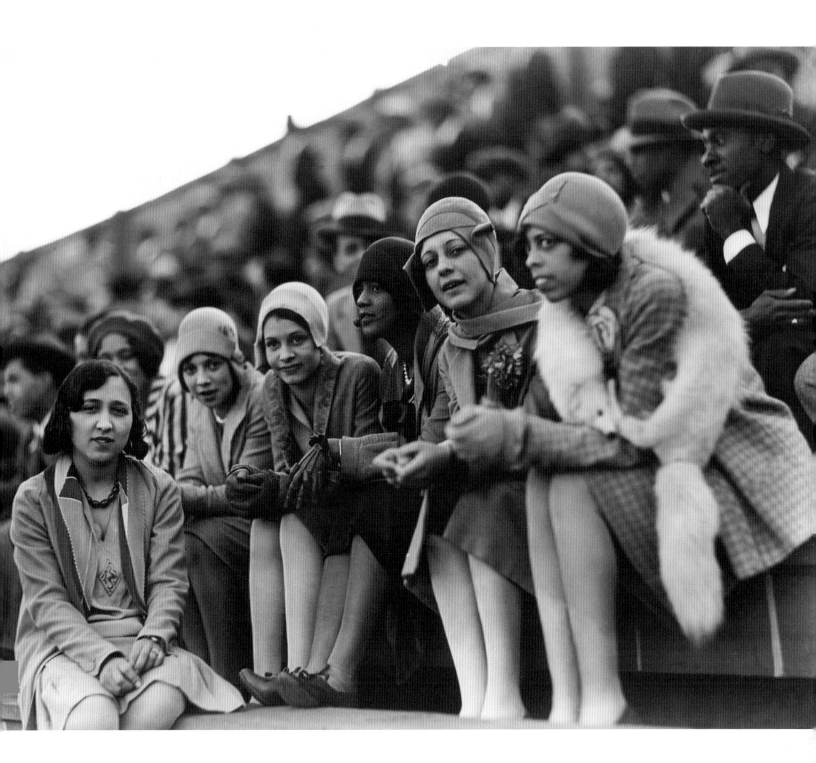

Young women at Griffith Stadium, c. 1920s

Elise Dowling (on the far right) and her friends pose for a photograph as they enjoy an outdoor event most likely held at Griffith Stadium at Seventh Street and Florida Avenue, NW. Fashionably attired young women and men like these were typical Griffith-goers of the era. In a segregated city, Griffith Stadium was an important social and civic space for African Americans. It hosted a wide variety of popular events and activities, from Negro League baseball and Howard University football games, to the Capital Classic beauty pageant and local high school drill competitions, to religious spectacles and mass baptisms. Lillian Gordon, a former Miss Capital Classic, recalled having "so much fun there...it was a lot of clean fun." She pointed out that the stadium itself was segregated for many events. This Scurlock image substantiates historian Henry Whitehead's claim that Griffith Stadium "was sort of like outdoor theater for the black community," not only a place to witness events but also a place to see and be seen.

Murray Brothers Printing Company, 1925

From 1886 to 1920, the number of businesses owned by African Americans in the U Street area rose from fifteen to more than three hundred, with the bulk of new businesses established between 1910 and 1920. This printing company was founded in 1908 by F. H. Morris Murray and his three sons, F. H. Morris Jr., Raymond (the three men in the front on the far left), and Norman (center front with a mustache). Murray Brothers eventually became the city's largest African American printing business. In 1921 the Murrays began publishing the *Washington Tribune*, which followed Calvin Chase's *Washington Bee* to become the city's most influential black newspaper, with a peak circulation of thirty thousand copies. Also pictured are William O. Walker (next to Norman, with glasses), who began his career with Murray Brothers and then established the *Cleveland Call and Post* newspaper, and Sam Lacy (in the doorway to the far right), who became national editor of the *Chicago Defender* and sports editor of the Baltimore *Afro-American*. The Murrays also ran a popular nightclub, Murray's Palace Casino, nextdoor to their printing shop at 922 U Street, NW.

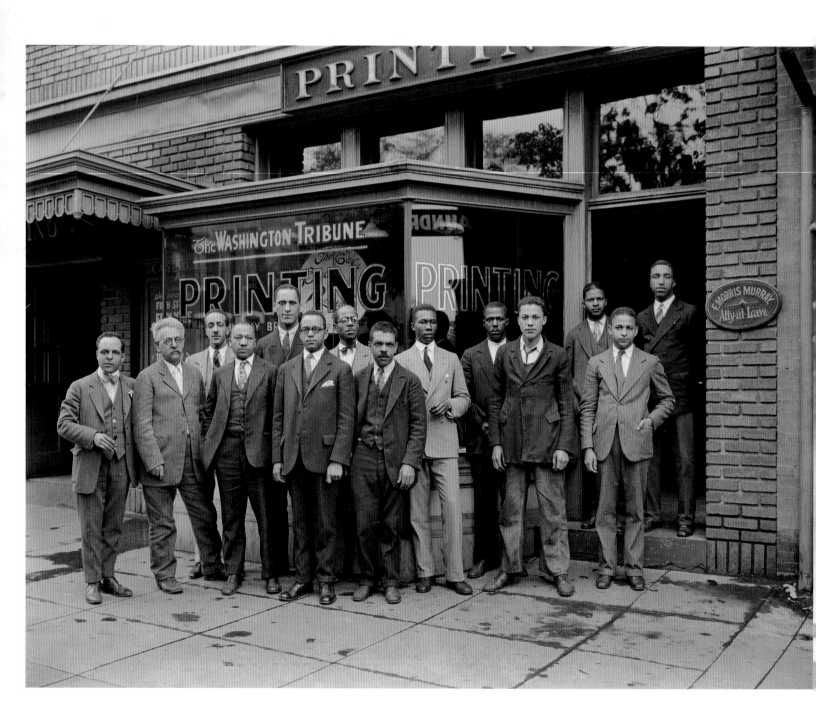

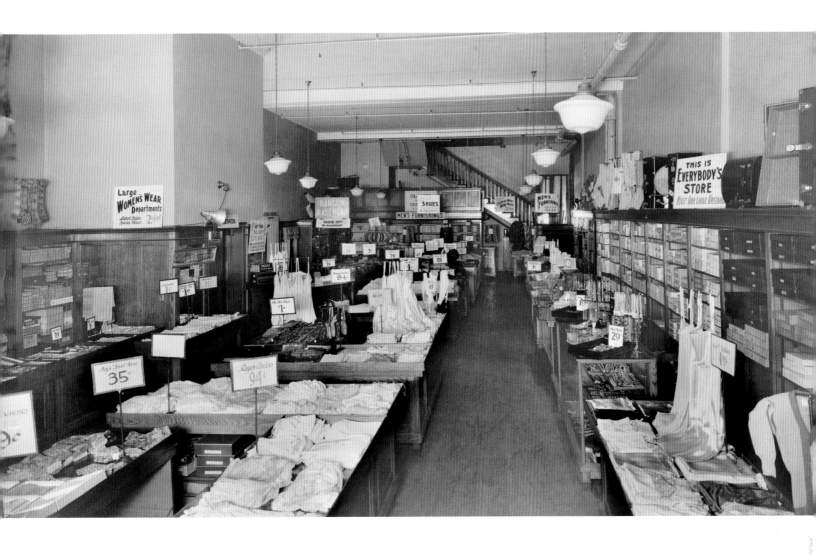

Shop floor in the Fair Department Store, 1930

Throughout the twentieth century, downtown department stores formed a crucial part of modern urban life. More than just palaces of leisure and material consumption, department stores also became battlegrounds where issues of racial equality were inextricably linked with public purchasing of goods. The ability of African Americans to patronize any merchant of their choosing in order to buy goods freely came to be seen as an essential civil right and a crucial American value. Scurlock's image of the grand opening of the Fair Department Store at 820 Seventh Street, NW,

demonstrates this connection between consumption and full civic participation. The sign on the upper right that proudly proclaims "This is Everybody's Store—Visit our large upstairs" implicitly comments on racist policies at Garfinckel's, Woodward and Lothrop, and other large D.C. department stores where black patrons were not permitted to try on clothes before buying them. Other Scurlock images from this day depict customers trying on coats and the staff posing in front of the store prior to its opening.

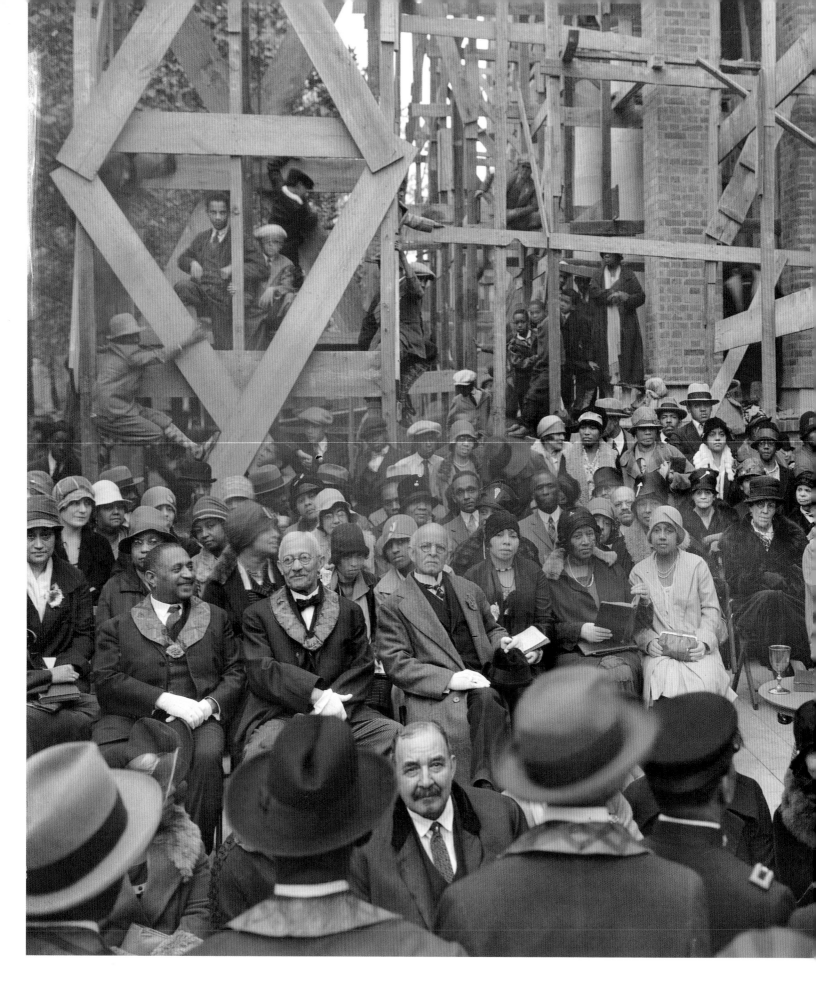

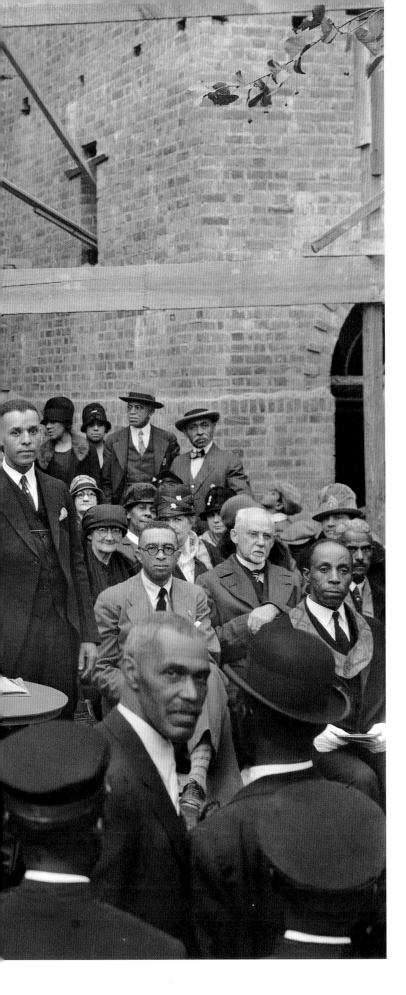

Cornerstone Ceremony, Lincoln Congregational Temple United Church of Christ, 1928

Lincoln Temple is the oldest African American Congregational church in Washington. Its notable parishoners include the Reverend Sterling Brown (father of the poet), activist Mary Church Terrell, and opera singer Jessye Norman, who sang in the church choir. In 1897 the church was the site of pan-Africanist Alexander Crummel's inaugural address to the American Negro Academy, the nation's first society of black scholars. The Reverend Robert Brooks supervised construction of the "new" church building at Eleventh and R Streets, the old site of the American Missionary Association's Colfax Industrial Mission, in 1929. Here, Addison Scurlock recorded the dedication and cornerstone ceremony of the structure.

Picnic group, Highland Beach, Maryland, 1931

One could retitle this photograph *Twenty Girls, a Guy, a Boy, and a Car.* Although described as a shot of the girls from the nearby YWCA Camp Clarissa Scott (named after the writer and poet Clarissa Scott Delaney), the seated figure to the right, atop the spare wheel, holding a baseball, and wearing high-top sneakers, looks suspiciously like a camper's little brother.

What a festive summer scene! Addison Scurlock achieved this memorable tableau, set against the backdrop of a clear, bright sky, by joining the gaggle of handsome youngsters with the fancy touring car. The campers look happy, confident, and completely at ease, despite the formal pose. And why wouldn't they? Removed from the rules, restrictions, and discrimination circumscribing black life in the city, these children are at liberty to enjoy summer pleasures at Highland Beach on the shores of the Chesapeake. There they found an oasis offering social comfort as well as a healthy sea environment.

The country was well into the Depression by 1931, but there is no sign of want or deprivation amongst this healthy, fashionably clad little group. The car is particularly notable as a symbol of conspicuous consumption. The buyer could customize this luxury model 1929 Packard by selecting from a variety of body options.

Highland Beach, located south of Annapolis, has been a haven for African American families since the late nineteenth century. It was founded in 1893 by Charles R. Douglass, the forth child of Frederick Douglass and his first wife, Anna. Reputed to have purchased the land after he was rebuffed by the white resort nearby, Charles transformed forty acres of farmland into a scenic beach community for African Americans. The Douglass residence is still intact, located just across the street from the beach. Charles designed the house with a small balcony so his father could take in the sea air while he viewed the Eastern Shore across the bay.

Over there was Wye House, where Frederick Douglass had been enslaved as a young man. Unfortunately, the elder Douglass died in 1895, before he could enjoy his son's elegant waterfront property.

When Highland Beach was incorporated in 1922, it became the first township in Maryland chartered by African Americans. Imagine a place situated in the middle of Jim Crow Maryland entirely controlled by its black property owners. Black professionals could not resist the appeal of this autonomous community so close to Washington, D.C. and Baltimore. Many residents, such as Mary Church Terrell and her husband Robert Terrell, Anna Julia Cooper, the Wormleys, and the Charles Drew family, made it the center of their summer social life. The Scurlocks frequented this locale as well, often joining their cousins, the Herbert Scurlocks, at their beach house affectionately known as Bide-a-Wee.

The 1920s ushered in the heyday of Highland Beach that lasted throughout the twentieth century. Even today, when affluent African Americans can vacation almost anywhere, the town remains a retreat for many families whose beach houses have been handed down through the generations. During my own high school years, I was a sometime visitor to family members in Washington, D.C., and I still remember a glorious excursion with friends who skipped school in favor of an outing to Highland Beach. It was a carefree day of fun and companionship, much like the day captured in this photograph.

JDS

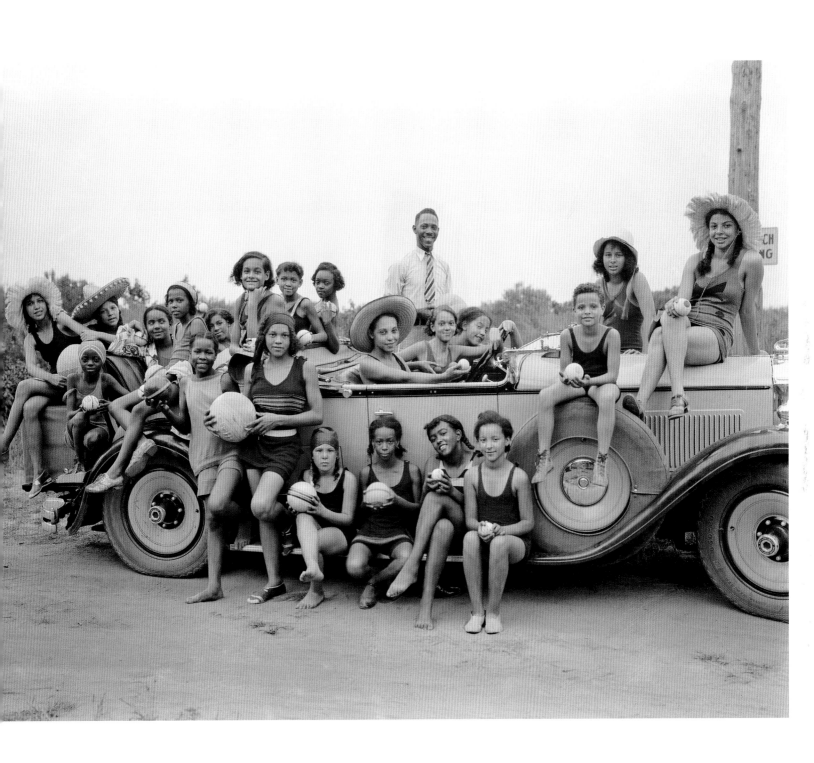

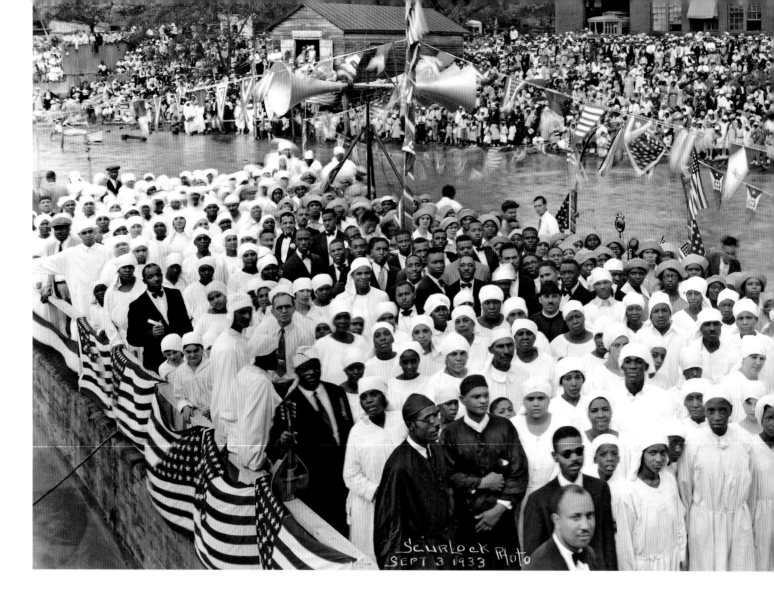

Group baptism, 1933

Before Elder Solomon Lightfoot Michaux orchestrated pageants at Griffith Stadium, he hosted similar spectacles along the Potomac River. The day following this baptism on September 3, 1933, the *Washington Post* reported on the mass-mediated event.

> Sunny skies above, muddy waters beneath, Elder Michaux's flag bedecked barge, floating at the foot of Water and O Streets yesterday with 250 white-robed candidates for baptism thereon, brought out 10,000 to witness the evangelical spectacle. They crowded the pier of the 260th Coast Guard Artillery, roofs of the boat house…and decks of the steamer E. Madison Hall [an excursion boat owned and operated by African Americans], which held the elder's barge in tow. Motorboats and other craft held film and radio operators….Motion picture operators, immersed to their shoulders…bowed their heads when Elder

> Michaux said: "You must be born of water as well as the spirit. I shall do you like John did Jesus."… [Congregants] of every age and size passed through the watery line, swimming, floating, shouting, wading, waving hands in response to the elder's exhortation, until he clasped them in his arms and dipped them beneath the Potomac's muddy waters. Up they came, shouting, splashing, leaping, waving hands and praising Heaven, while the choir chanted incessantly "O Wonderful Freedom."

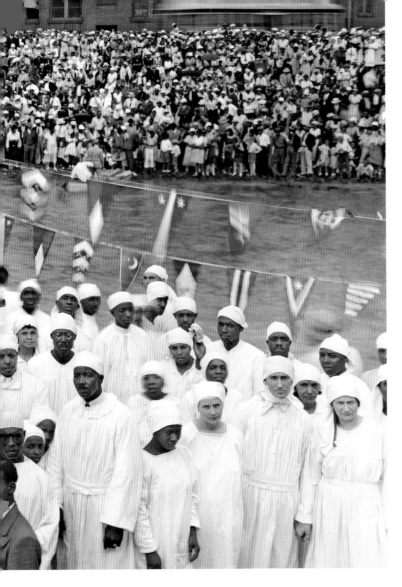

Annual Church of God mass baptism at Griffith Stadium, c. 1940s

Beginning in 1938 and for years following, the Gospel Spreading Church of God and its charismatic leader Elder Michaux (front right) conducted mass baptisms in Griffith Stadium, across the street from the church. Michaux, who grew famous through his Depression-era CBS radio show and his motto "Happy Am I," led congregants to baptismal tanks filled with water reputedly from the Jordan River. Michaux then coaxed formerly "lame" individuals to run the bases of the baseball stadium in Jesus' name. Featuring preaching, singing, and performances of biblical scenes punctuated by fireworks, Michaux's "spectaculars" elicited derision from members of established middle-class churches who questioned his sincerity and decried the apparent lack of piety on display. Nonetheless, Michaux's events were wildly popular. Drawing predominately African American audiences of upwards to twenty thousand participants, his spectaculars rivaled the attendance figures of the stadium's most popular sporting events. Baptisms held by the church also attracted white celebrities, such as First Lady Mamie Eisenhower (another Scurlock client), who attended in 1949.

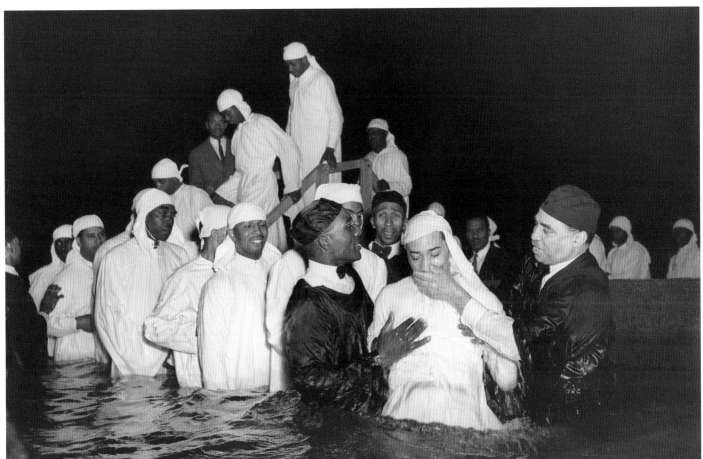

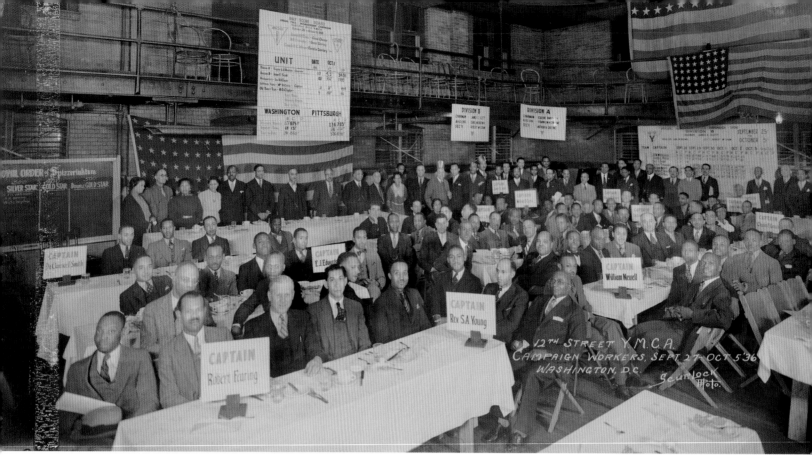

Fall membership meeting, Twelfth Street YMCA, 1936

The Young Men's Christian Association located at 1816 Twelfth Street, NW, was the first African American Y in the United States, founded by former slave and abolitionist Anthony Bowen in 1853. The building, designed by black architect William Sydney Pittman, was constructed from 1908 to 1912 with funds from Julius Rosenwald, philanthropist and president of Sears, Roebuck and Company. This photograph of the 1936 fall membership campaign indicates the longstanding dedication and philanthropic care that Washington's African American community showed toward the organization. Membership "captains" Robert Fearing, the Reverend S. A. Young, William Newell, and others represent upstanding families in the community, and the "daily scoreboard" signs hanging from the ceiling and in the rear of the room chart the progress of the group.

Shiloh Baptist Church, Easter Baptising, 1937

Located at Ninth and P Streets, NW, in the Shaw neighborhood, Shiloh has been an institution since the Union Army gave a group of freed slaves safe passage from Fredericksburg, Virginia, to Washington in 1861. The congregation officially established itself two years later. Dr. Earl Harrison, pictured here with his congregation on Easter Sunday in 1937, was the fourth pastor of the church, which served more than three thousand families each week from 1930 to 1971. In 1985 congregation member Shirley Ridgeley Banks wrote in the *Washington Post* of her experiences growing up with Shiloh as a cornerstone of her childhood and a gateway to the rest of Washington.

Let's run! We want to be first in line and it's getting late. We wanted to be in the first row up at Shiloh Baptist Church, so we ran! All of us, boys and girls, sometimes four or five, sometimes eight and nine or ten, going to see the free movies Shiloh showed on Saturday evenings. This was in the late Thirties and Forties when I was young. At the church we'd line up against the fence on P Street NW and some-times the line went around the corner and on down Ninth Street. All the neighborhood kids for blocks around [loved going] to something we all enjoyed so much. At the end of the program, we sang "Now the Day Is Over," and on the way out we were given lollipops. Then we strolled back down to Marion Street, where most of us lived, savoring the treat and feeling warm and wonderful. And even now, I sometimes feel that same warm glow when I visit Shiloh. We were all poor and didn't know it. Even when we sometimes missed one of the gang who had moved away, we did not know till we were older that the reason some of us moved so often was that the parents were getting away from the rent man. Nevertheless, we took advantage of all the things we had here in D.C.

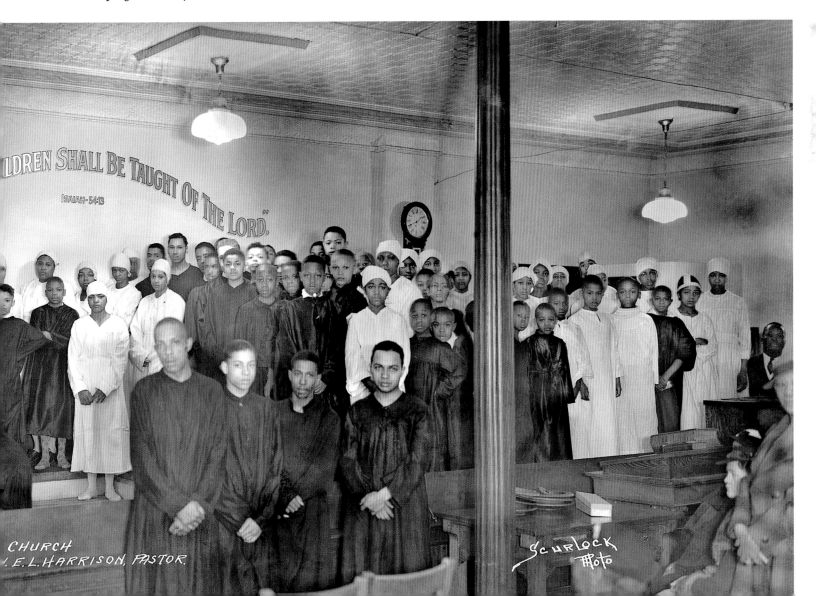

LDREN SHALL BE TAUGHT OF THE LORD.
ISAIAH 54:13

CHURCH
I.E.L. HARRISON, PASTOR.

SCURLOCK PHOTO

**Shep Allen with news carriers
in front of Howard Theatre,** 1936

Built in 1910, the Howard was the first theater building in
the nation erected specifically for African Americans. Its
location right off the corner of Seventh and T Streets, with
its assortment of pool halls and nightclubs, immediately
helped bolster the venue's official billing as a "Theater for
the People." It offered vaudeville acts and motion pictures
during its first two decades. In the 1930s, the Howard solidi-
fied itself as one of Washington's hottest spots for top-drawer
entertainment, due in large part to the efforts of theater
manager Shep Allen, seen here (center) with many of the
city's African American newsboys and girls. This panoramic
Scurlock photograph shows off the Howard's headliners of
the week: Cab Calloway and Lucky Millinder. The theater
continued as a major African American performance venue
well past World War II. A generation later, singer Marvin
Gaye, a native Washingtonian, recalled that "the Howard
was my real high school. I studied the singers like my life
depended on it." Designated as a National Historic Landmark,
the Howard is currently undergoing restoration.

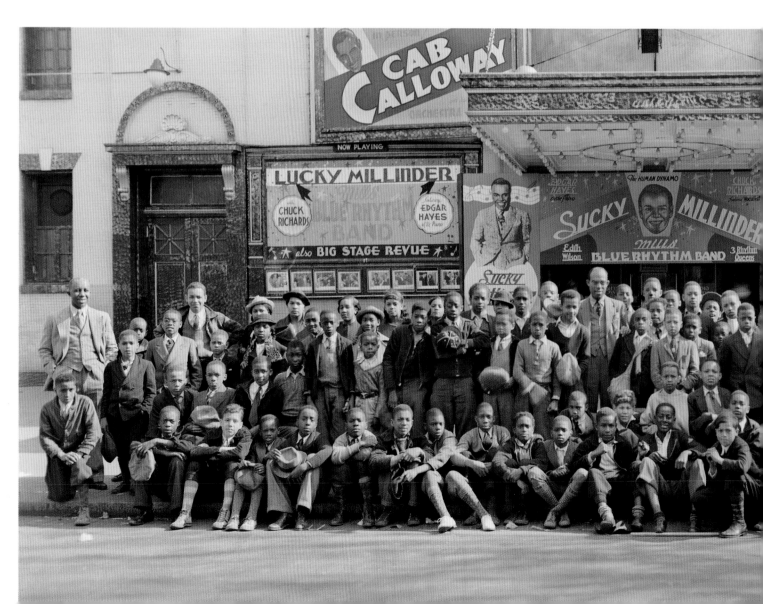

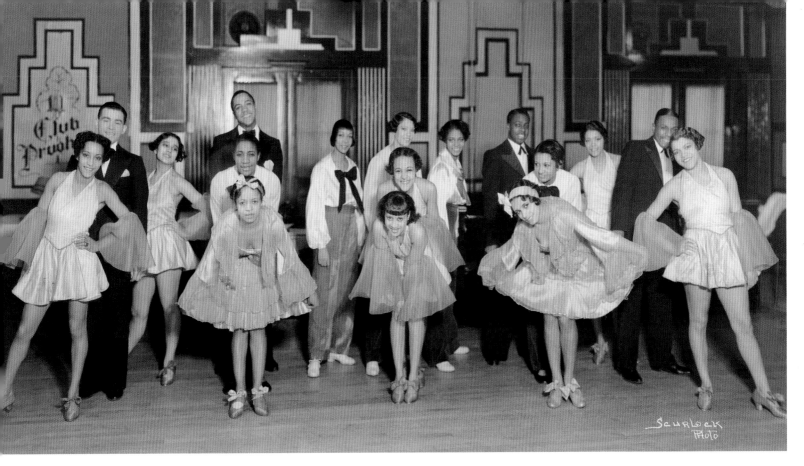

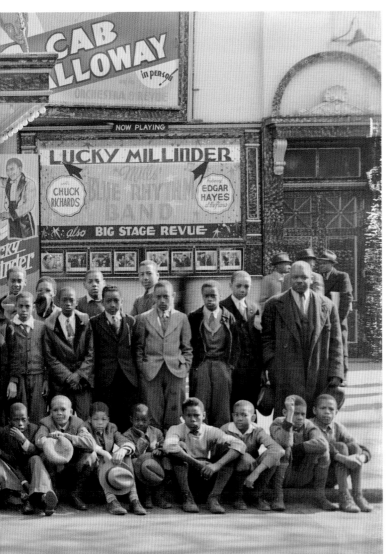

Dance Troupe at Club Prudhom, c. 1930s

In the first half of the twentieth century, U Street was home to a wide variety of theaters that extended from Seventh to Fourteenth Streets. The Minnehaha Theater—now the site of Ben's Chili Bowl—opened as a nickelodeon theater in 1909 at 1213 U Street, NW. The Hiawatha Theatre at Eleventh and U Streets followed, along with the famous Howard Theatre in 1910. A variety of nightclubs pervaded the U Street corridor as well. Club Prudhom, at Eleventh and U Streets, NW, was among the most popular of these. It competed with Club Bali, the Bohemian Caverns, the Off Beat Club, and the neighborhood's top dance spot, the Lincoln Colonnade, located beneath the Lincoln Theatre. Bandleader Elmer Calloway, younger brother of Cab Calloway, performed here with his famous Club Prudhom Orchestra throughout the 1930s, and he had several portraits taken by Addison Scurlock (see page 173).

The New Negro Alliance (NNA) was founded in 1933 from grassroots protests that followed the firing of three black workers and their replacement with whites at William Flintjer's U Street Hamburger Grill. One of its earliest "Don't Buy Where You Can't Work" campaigns inspired African Americans to hold similar protests in neighborhoods across the nation. Over the course of the 1930s, the NNA developed under the leadership of John Aubrey Davis into a well-respected organization, headquartered at 1333 R Street, NW, that kept its activities firmly planted in grassroots protest surrounding issues of racial inequality.

In a case argued in part by members of the Howard Law School, including William H. Hastie and Thurgood Marshall, the NNA won a Supreme Court battle that recognized its right to picket legally. The organization then electrified Washington in 1938 and 1939 with a thirteen-month protest against white-owned Peoples Drugstore, enlisting prominent Washingtonians to picket, protest, and distribute leaflets. Scurlock captured this image of a clergyman protesting outside Peoples at Fourteenth and U Streets, NW. A second image of Mary McLeod Bethune, then a leader in President Franklin Delano Roosevelt's Black Cabinet, picketing the store was printed on the front page of the *Chicago Defender*. An NNA handbill from the protest proclaimed:

> To All FAIR-MINDED PEOPLE
> JUSTICE is essential to Americanism.
> For one year (since June 25, 1938) The New Negro Alliance has picketed two neighborhoods because the firm has refused to employ or promote colored persons or clerks in these stores where the preponderance of their trade is colored. They insist on keeping their colored employees in the most menial positions and at the average salary of $15.79 per week, although seeking the colored trade which keeps these stores profitable.

> Peoples Policy is
> Essentially Unfair and Un-American.
> What you can and Should do
> STAY OUT of all PEOPLES DRUG STORES.
> Write the management in Protest.
> Fight always for Justice and Americanism.

The NNA disbanded in 1941, but in the organization's short existence members estimated that they protected more than five thousand African American jobs from discriminatory hiring practices. This branch of Peoples Drugstore continued to be an anchor store on U Street, but it became one of the initial focal points of the rage and rioting that followed the assassination of Martin Luther King Jr. in 1968. Considering this protest movement of thirty years earlier, the later destruction at Fourteenth and U Streets reveals the roots of racial and economic tensions and inequalities on U Street to be, perhaps, deeper and more complex than the immediate despair and frustration of a single dark moment.

PG

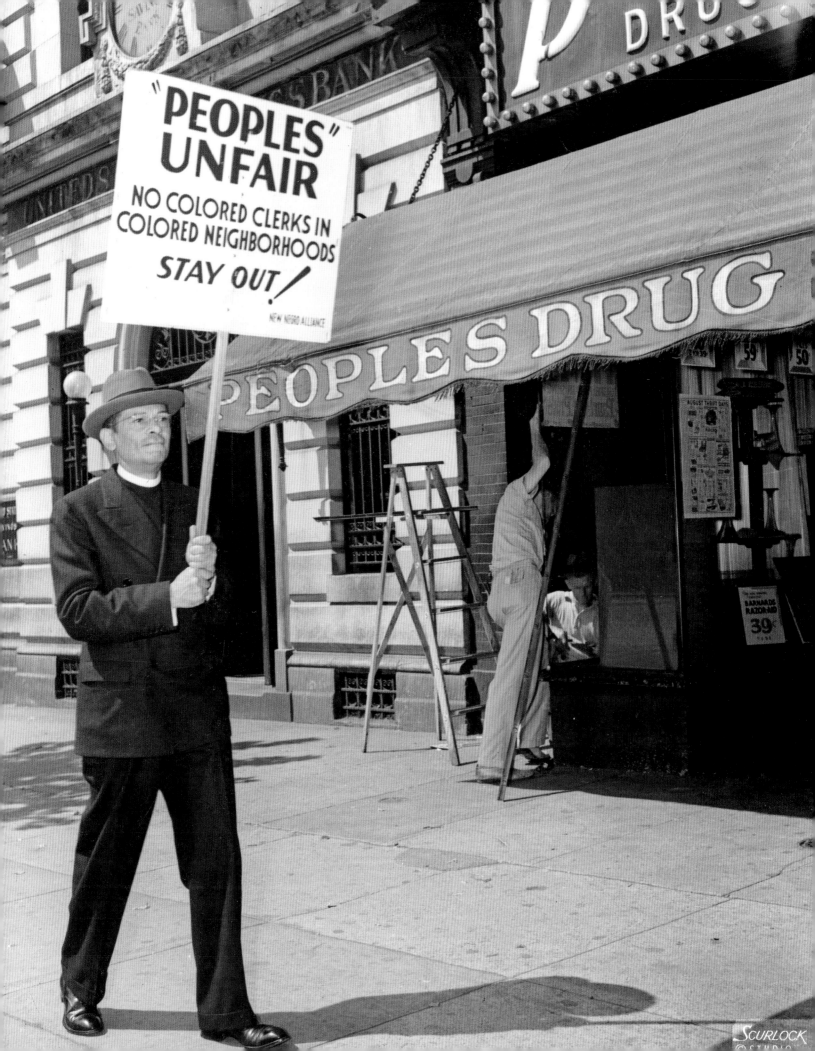

Homeless woman with cart, c. 1940s

In their body of work as portrait photographers, Addison
Scurlock and his sons largely ignored the plight of the home-
less and the poor. Two exceptions are Robert Scurlock's
photograph of children in an alley (see page 114), likely shot
in the early 1970s, and this image from an earlier era, show-
ing a homeless woman pushing a baby carriage with a
reused cardboard box to hold her valuables. This reality
was more fully documented by Gordon Parks and other
photographers, who were interested in both photojournal-
ism and the social issues of poverty.

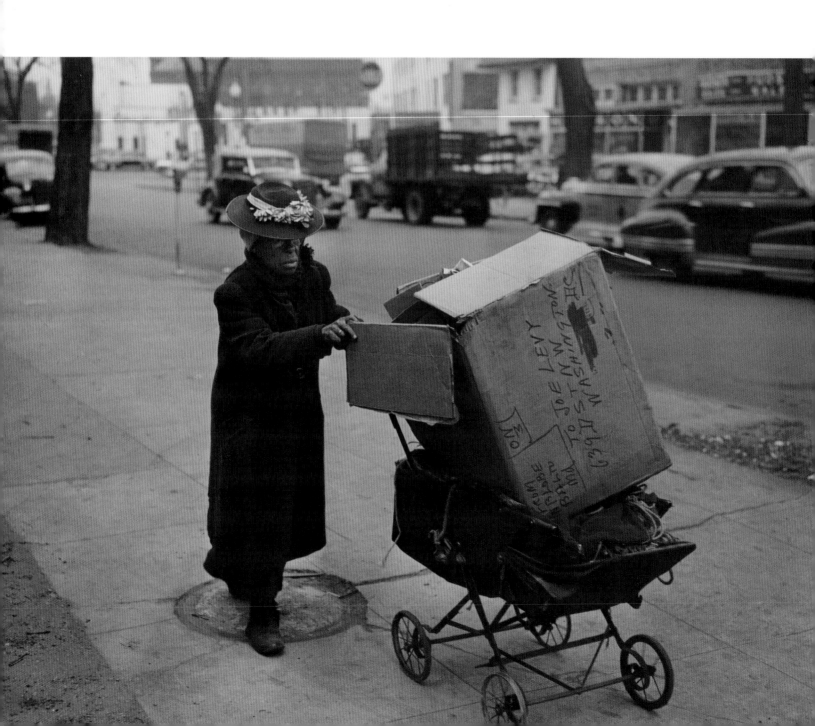

Seventh and T Streets, NW, 1939

Poet Langston Hughes gathered much of the material that shaped his collection of poetry, *The Weary Blues*, in the working-class neighborhoods surrounding Seventh and T Streets. Hughes recalled that "from all [the] pretentiousness [of elite black Washington], Seventh Street was sweet relief.... I tried to write poems like the songs they sang on Seventh Street—gay songs, because you had to be gay or die; sad songs, because you couldn't help being sad sometimes. But gay or sad, you kept on living and you kept on going. Their songs—those of Seventh Street—had the pulse beat of the people who keep on going."

Addison Scurlock was primarily interested in depicting the burgeoning business life of U Street rather than the poverty or street life of Seventh. Here, he presented Seventh Street as a quiet, snowy corner rather than as the earthy refuge that inspired Hughes. Twenty years after white mobs violently attacked African Americans in bloody riots at this intersection, the quiet corner is the site of three competing cafés: the National Grill, S. W. Keys Luncheonette, and the Harlem Grill. Down the block in the distance is the marquee for the famous Howard Theatre.

Marian Anderson concert at Lincoln Memorial, Easter Sunday, 1939

Easter Sunday 1939 has evolved into an iconic moment in American social, political, and artistic history. On that April 3, acclaimed American contralto Marian Anderson performed a recital before seventy-five thousand people assembled on the National Mall. Due to the work of civil rights activists, Howard University officials, and members of the Roosevelt administration, Anderson sang from the steps of the Lincoln Memorial, one of the nation's most beloved monuments. The venue for the concert resulted from a lengthy furor—here's a short version of events.

Marian Anderson routinely sang an annual concert at Howard University. By 1939 she had completed two European tours and had sung at some of the finest concert halls in Paris, The Hague, Vienna, Budapest, and London. As her reputation grew internationally, Howard University sought a larger and more resplendent venue for her concert. Constitution Hall was considered a preferred alternative, but the Daughters of the American Revolution (commonly known as the DAR) shamefully rejected this opportunity to showcase Anderson, because the DAR did not welcome or permit "Negroes" to perform, or even to attend events, at Constitution Hall. This affront to Marian Anderson, who was universally deemed one of the greatest voices of her time and was viewed by all as a jewel of American talent, created a political firestorm through which the singer emerged with grace and dignity.

The DAR's refusal turned into an "incident" of national significance, with the story of the slight appearing in the local, national, and international press. Anderson had already performed twice at the White House: once for President Franklin Delano Roosevelt's guests, and on another occasion for the king and queen of England. As a result of the Constitution Hall rebuff, First Lady Eleanor Roosevelt resigned from the DAR. Through the efforts of many, the stage was finally set for a free public performance on the steps of the Lincoln Memorial. The weather smiled, and the show went on. Civil rights leaders, members of the Roosevelt Cabinet, the press, and members of Howard University's administration and faculty were among the seventy-five thousand people present. Also present: Robert Scurlock, photographer.

Notably, twenty-four years later, Martin Luther King Jr. delivered his world-famous "I Have a Dream" speech, standing at virtually the same place where Marian Anderson sang on this Easter Sunday. As time passes, the locus of civil rights actions reaches back into history to include this argument over Negro rights to enter and to work in "private spaces." Anderson's signature performance brought attention to intolerable limits and restrictions on even the greatest of America's talents.

Almost seventy years after Anderson's Easter Sunday concert, three contemporary photographers—Sharon Farmer, Roy Lewis, and Steven Cummings—convened to discuss Robert Scurlock's images of this historical event. Here are some of their memories.

For Sharon Farmer, Robert Scurlock's photographs of Anderson present a human story. She describes the Anderson concert as an event most people only know politically. We see Marian Anderson as she enters, we see thousands in her audience, we observe the crowd of microphones assembled to broadcast her voice. We see a powerful long shot of the artist—facing all who've come to the National Mall to hear her—the monument of Lincoln, still as stone behind her. Scurlock's photographs show artistry, storytelling, and technical ability, according to Farmer. Scurlock showed the environment, and he showed what he saw, what he liked. He worked to compose the Anderson photographs from different angles. That's what photographers do, Farmer notes.

Roy Lewis recognizes the actions Scurlock took to create his imagery: how Scurlock captured entire scenes, or the way he constantly moved to be able to photograph all aspects of the event. Lewis notes that Scurlock was not pinned down to one spot, which permitted him to shoot from multiple angles. All three photographers discuss how Scurlock used a large format camera that required both plate and bulb be changed with every shot. Reading the photographs, Lewis believes Robert Scurlock was working for Howard University, especially with Mordecai Johnson present. He did not focus on money shots, those images of most interest to publishers, Lewis comments. Robert concentrated on portraying "the inside of the day."

Photographer Steven Cummings agrees that Robert Scurlock did not just go for standard "grip and grin" shots. Cummings acknowledges that this series is part of the large body of Scurlock work, and that to amass such a body takes dedication and the hard work of *being there*. Other artists—writers, musicians, painters—can reflect on an event and then produce their art, but photographers, Cummings asserts, must be there. The image must be put on the film at the time. This series also shows Scurlock *working*—but working means more that the act of shooting film. Building and maintaining the business across generations, keeping order and records of negatives, spending years on end taking photographs, documenting how people lived, and the work they did are aspects of photography that Cummings insists we remember in addition to the images themselves. The Scurlocks worked diligently and consistently over time, Cummings states, and now time returns their favor, making the Scurlocks' work ever more powerful.

A.J. VERDELLE
with Washington-based photographers
SHARON FARMER, ROY LEWIS, and STEVEN CUMMINGS

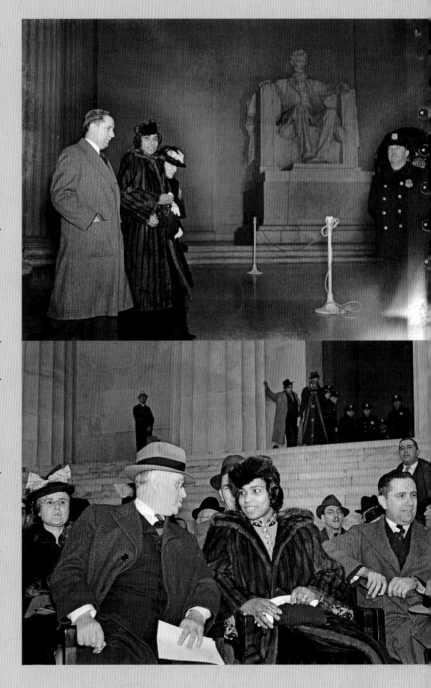

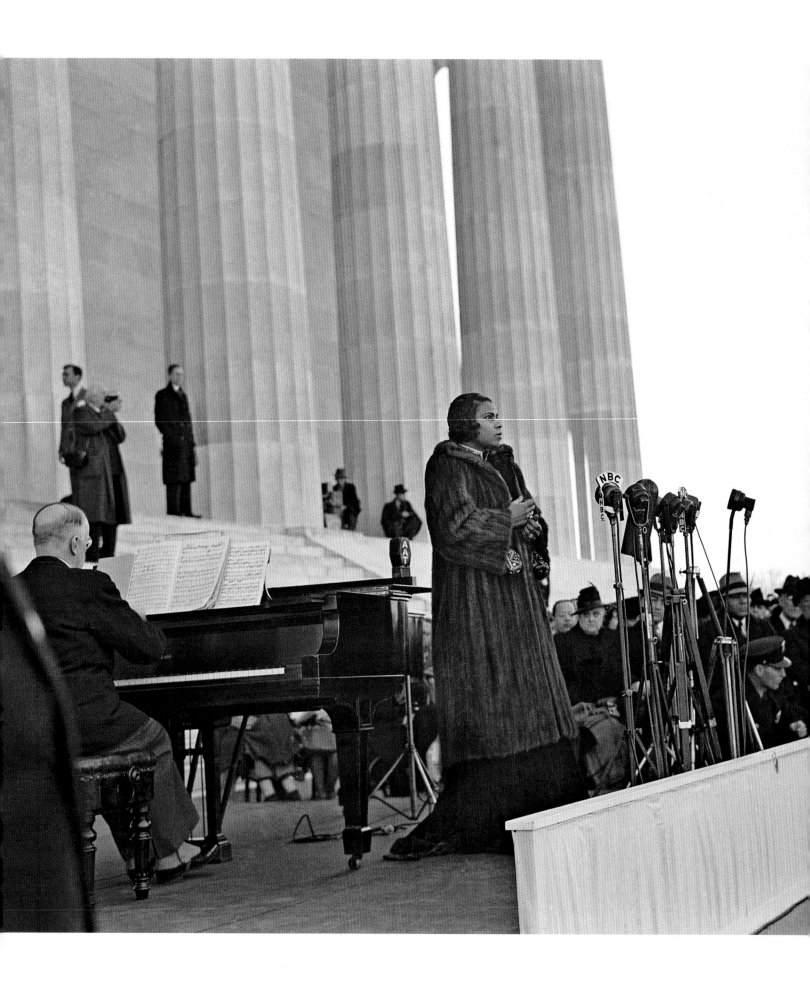

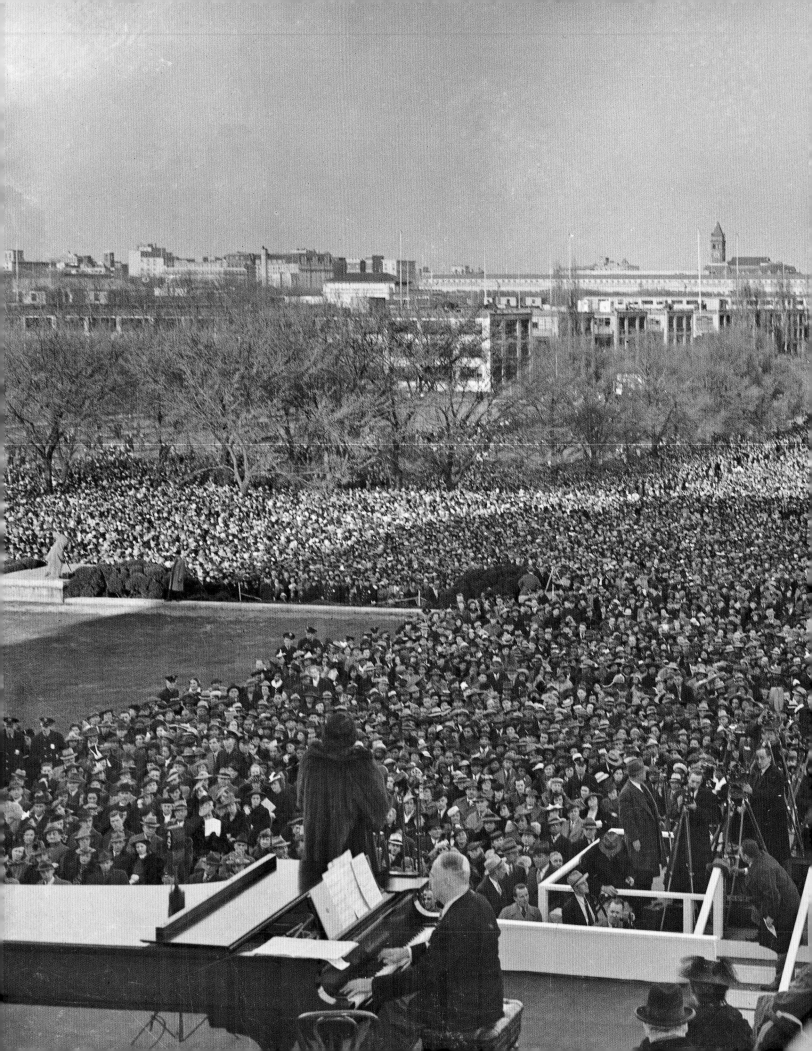

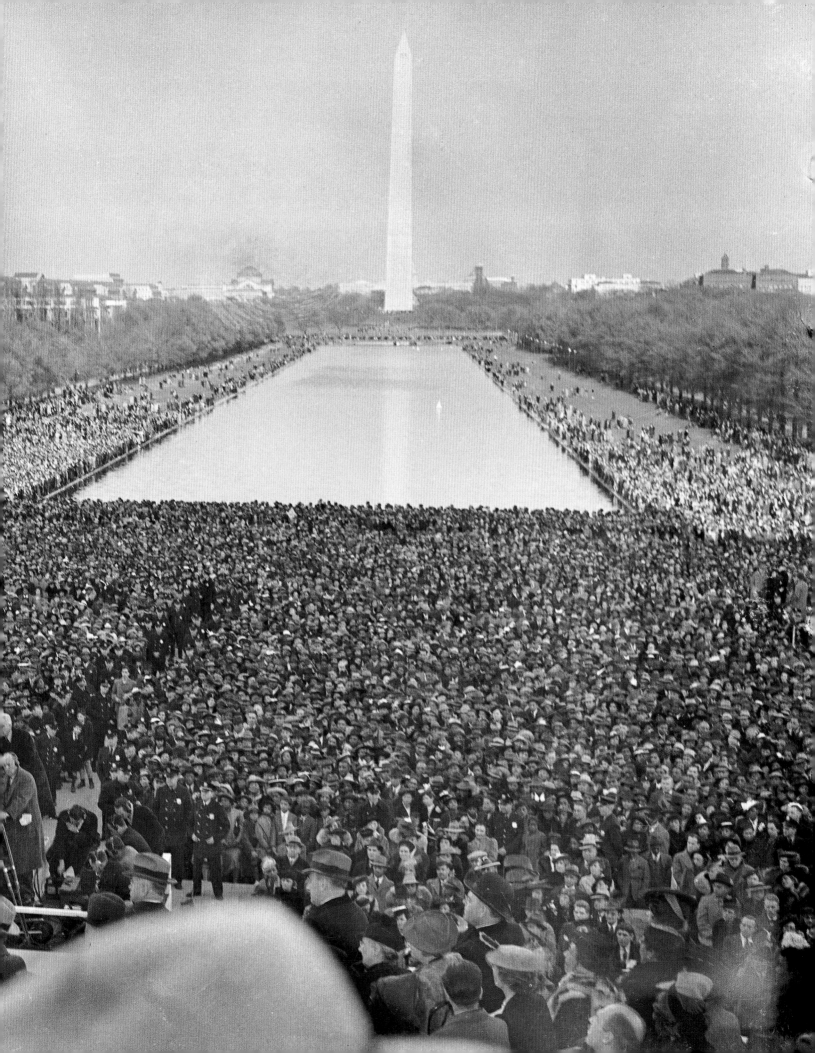

Homestead Grays at Griffith Stadium, c. 1940s

Beginning in the 1940s, the Homestead Grays, a Negro League team that originated in western Pennsylvania's steel country, relocated to Washington, D.C., and for a decade played their "home" games at Griffith Stadium. The Grays, who boasted some of the world's best baseball talent in players such as Josh Gibson, Buck Leonard, and Luke Easter, thrilled African American audiences. In wartime Washington, fans flocked to the ballpark to see the Grays play Satchel Paige's Kansas City Monarchs. The hapless American League Senators paled in comparison. Championed by a burgeoning black press and heralded by dedicated sports writers, among them Sam Lacy of Baltimore's *Afro-American* (see page 64), the Grays pushed beyond the boundaries of mere sport. "The Grays' popularity and on-field success transformed Washington into the front lines of the campaign to integrate major league baseball," claims historian Brad Snyder. The Scurlocks took part in photographing the Grays during their historic run at Griffith Stadium, profiling Gibson, Leonard, and other sluggers in action. This posed publicity shot depicts the Grays' Ducky Kemp in heated debate with umpire Eulogio Peñalver, one of the few salaried arbiters in the Negro National League.

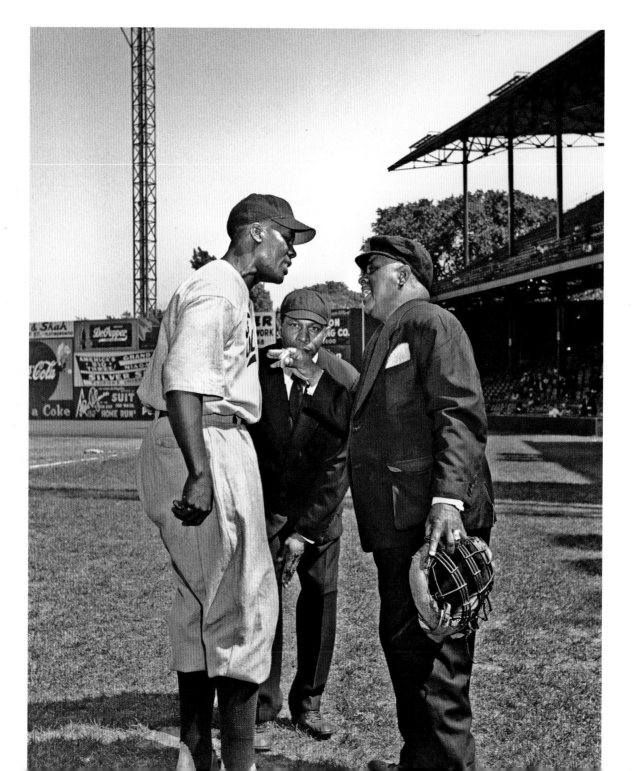

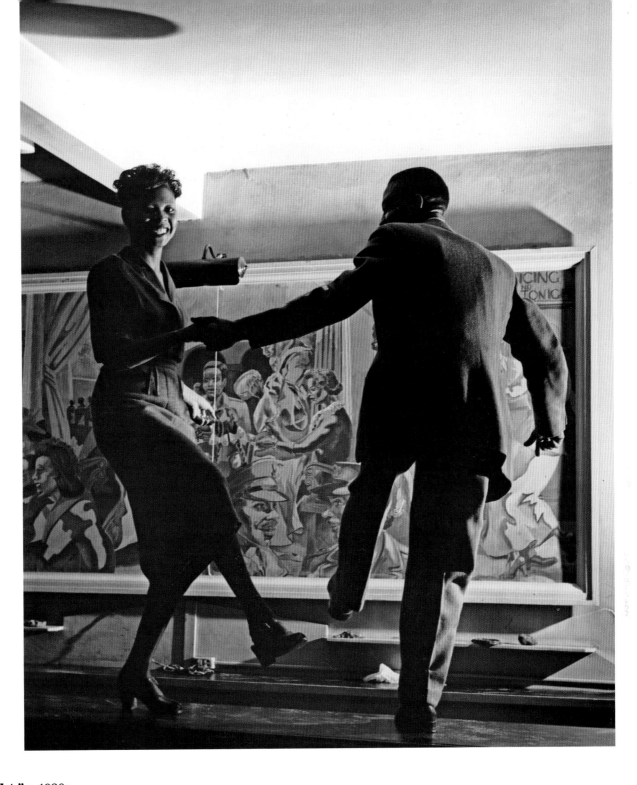

"Dancing Tonight," c. 1930s

Just where did the Scurlocks photograph this couple doing the jitterbug? Was it at one of the dance clubs on U Street, which was known as D.C.'s Black Broadway? Or was it an impromptu dance on a stage in a community center? The large mural in the background, titled "Dancing and Games Tonight" at the upper right, is similar to works commissioned by the federal Works Progress Administration during the Depression. Skilled technicians with lighting and flash techniques,

the Scurlocks created the photograph's mood by precisely placing lights to illuminate the mural and background, and then posing the couple. Perhaps Robert or George Scurlock composed this photograph when they were out with their friends at a club event for the What Good Are We's. The "Whats," a club for local black college men founded in 1913, sponsored annual dances for the community at the Lincoln Colonnade.

Gold Star Wives, c. 1941–45

Wartime spent away from loved ones is always difficult. This image of a young African American mother and her children comes from Robert Scurlock's photo essay for *Ebony* on the Gold Star Wives of America. Founded in 1945 before the end of World War II, this organization assisted military widows and widowers whose spouses had died while on active duty or as a result of a service-related injury. Membership in the Gold Star Wives grew across the nation in an effort to support the needs of grieving spouses and children, whose lives were forever changed by the war. Here, a family looks fondly at the handsome portrait, possibly a Scurlock photograph, of their husband and father who was killed while serving his country.

World War II was a turning point for the Scurlock Studio as well as for African Americans throughout the country. Robert Scurlock enlisted in the armed services and witnessed the war firsthand with the highly regarded Tuskegee Airmen. He photographed the officers, including Benjamin O. Davis Jr. (see page 181) and his fellow airmen. His images of them at work on their planes and resting and playing at the base reveal how this segregated unit lived on a daily basis. His documentation of the valor of these American war heroes, as well as of the sacrifice of their families on the home front, demonstrates with strength and poignancy the love that African Americans showed for their nation's ideals of liberty, equality, and democracy, despite the realities of racial segregation and violence. Such photographs create a powerful argument about how African Americans sought to achieve victory against the forces of injustice abroad and at home during the war years. After the war, African Americans from Washington to Los Angeles to the Mississippi Delta expected the nation to live up to its wartime rhetoric. They demanded justice and fairness for all, regardless of race.

When the war ended, Robert returned home to Washington and was again employed at the U Street studio. The family's dynamic working relationship, however, would never be quite the same. Robert's interest in photojournalism and documentary photography endured, and his attempts to increase the studio's sale of images to *Ebony*, *Jet*, *Look*, and *LIFE* succeeded to a limited extent. He continued to reach for projects like this photo essay throughout his career.

MD

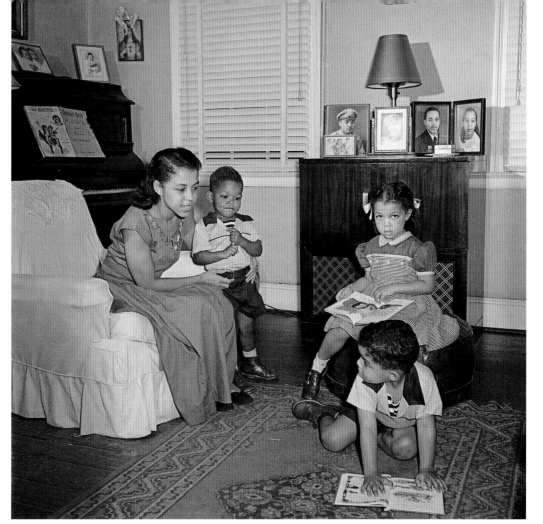

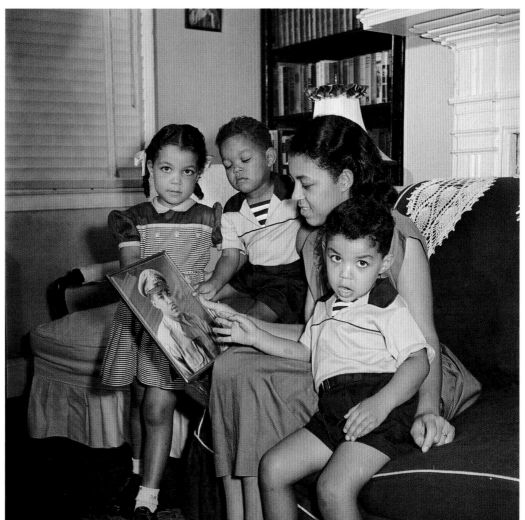

The Capitol School of Photography, c. 1947–52

The ten men carefully posed outside of the Capitol School of Photography (CSOP) were typical of the time and the clientele: young men just back from service in World War II, all but one of them black, two smoking cigarettes, and three sporting brims (hats). All were intent upon mastering the art of photography in the hopes of making a career in the field. That all but two have their faces clearly visible attests to the care with which the Scurlocks composed their photographs.

After the war, Robert Scurlock returned to work at the Scurlock Studio. In order to take advantage of the G.I. Bill program and its vast pool of eligible students, he soon left to open the Capitol School of Photography in a building he bought at 1813 Eighteenth Street, NW. George followed, although he limited himself to teaching the evening courses so he could remain involved in his father's studio.

Although the coed clientele was integrated, it was largely black and male, and for the most part it included former servicemen who were seeking to jump start new careers through their G.I. Bill benefits. One of the school's most successful students was Ellsworth Davis, who used the G.I. Bill to fund his matriculation at the Capitol School of Photography. Most of the students, like Davis, worked full-time jobs and attended CSOP in the evenings. Robert Scurlock ran the school, while George and their father Addison were busy with the Scurlock Studio at Ninth and U Streets. Both Robert and George also taught classes at CSOP along with other professional photographers. CSOP courses included basic photography, portraiture, photo-journalism, photo and negative retouching, and darkroom techniques. Davis, who began to dabble in photography after the war, recalled that he was among a strong group of about six students who were talented enough and serious enough to pursue photographic careers upon graduation. He delivered the *Washington Post* as a teenager and ultimately enjoyed a thirty-year career (1961 to 1991) as the first African American photographer on the staff of the *Washington Post*.

Undoubtedly, the most famous student at the Capitol School of Photography was Jacqueline Bouvier (later known as Jackie Kennedy). While working for the *Washington Times Herald* in the early 1950s, she was sent to the school to learn how to shoot her own photos for the "Inquiring Reporter" column to which she had been recently assigned.

The Capitol School of Photography closed in 1952 after four years in operation. The building itself re-opened, however, the same year under the name Custom Craft Studio and remained a part (ultimately, the last remaining part) of the Scurlock Studio. Custom Craft took the studio into the realm of color photography, emerging as a pioneer in the challenging art of dye-transfer printing and providing photographic services and lab work for businesses and government agencies alike.

JEFFREY JOHN FEARING

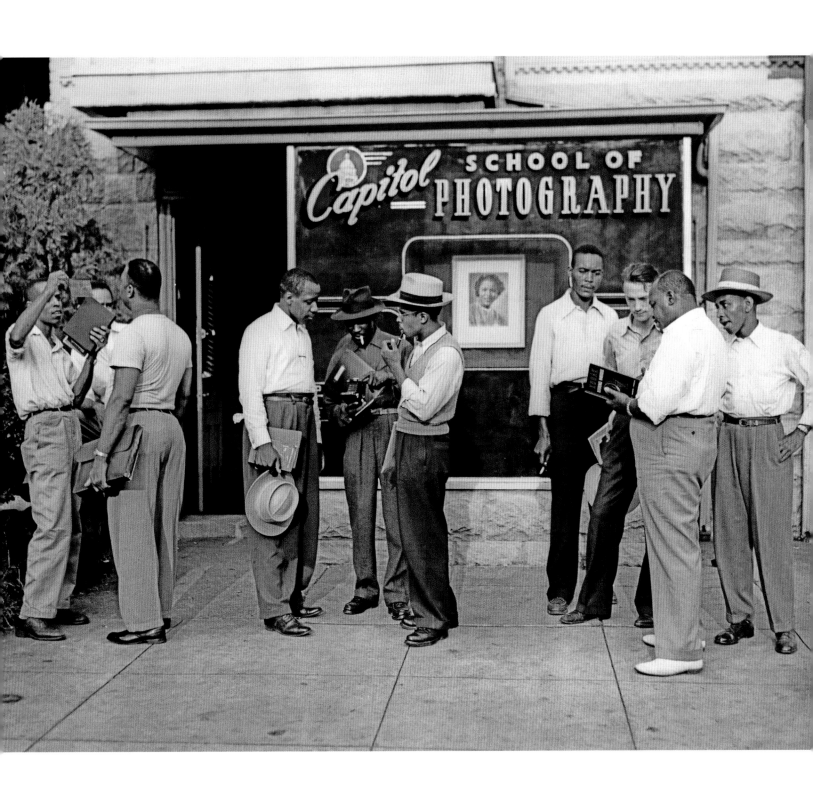

Dining car cooks, 1949

The Scurlocks are widely known for documenting the activities of African American businesses on and around U Street. In the years following World War II, Robert and George spent more time profiling the lives of working-class and professional blacks in different locations. This portrait of four cooks pausing in their crowded compartment to pose for the photographer is part of a series on train workers that includes similar images of waiters, porters, and conductors.

Apex College of Beauty Culture, Washington branch, 1947

In 1913 Sarah Spencer Washington founded a hairdressing business in Atlantic City, New Jersey, where she operated a salon, taught students, and developed beauty products. Eventually, Madam Washington's business grew into the Apex News and Hair Company, with beauty colleges located in twelve states and with thirty-five thousand agents worldwide. The Scurlocks took formal class portraits and documented graduations at the Apex College of Beauty Culture in Washington. They also recorded more casual events, such as this photograph of a woman getting her hair done, surrounded by Apex beauty products.

U Street photomontage with Billie Holiday, c. 1940s

Washington, D.C. has two streets known above all others: Constitution Avenue, down which all dignitaries parade en route to the White House, and U Street, a perpetual parade of sepia Washington en route anywhere and nowhere. For a bustling, teeming mile from Scurlock's Photo Studio at 9th St., to Schlossberg's Hardware Store at 18th, the main stem of technicolor Washington is crowded with the business enterprises of whites and blacks, Jews, Italians, Greeks, and all possible polygot combinations.

"WASHINGTON'S 'YOU' STREET"
NEWSPIC, APRIL 1946

By day, U Street featured hundreds of black business owners and their patrons who populated the various restaurants, boutiques, and services that lined the street. At night, the street turned into a raucous club and theater scene, where musicians, dancers, actors, and other entertainers performed and mingled with the hippest and most fashionable people on the scene in D.C. This photomontage of U Street conveys the great excitement of the neighborhood's nightlife. The bottom half of the image shows the street lit up at night. The diagonal perspective of the cars and trolley tracks gives the illusion of the street going on for miles and miles, when the reality was that U Street was a closed-in neighborhood of several blocks that blacks were obliged to occupy because white restaurants, shops, and theaters downtown barred them.

The top half of the image is a collage of neon signs indicating the many clubs and restaurants that beckoned visitors at night. Featured prominently in the center is the trademark Howard Theatre. The various neon signs, seemingly lit up like stars in the night sky, underscore the lights and excitement found on U Street at night. The other "star" found in the sky is a superimposed photograph of singer Billie Holiday, who was a frequent headliner in U Street's jazz clubs. Depicted alongside Holiday and the sign for the Howard Theatre are neon advertising for "Gores' Grill," "Joe Hurd's Bar and Grill," and "Harrison's Café," businesses named after their owners. The Scurlocks specifically chose these names for this montage to highlight the fact that U Street was a major commercial and entertainment center.

U Street was often referred to as Black Broadway, or as one neon sign in a Scurlock image of the neighborhood suggests, "Little Harlem." Longtime Washingtonians were quick to point out their city's central role in black cultural, social, and academic life before Harlem came in vogue. Proud of Washington and its denizens, many easily believed, as May Miller Sullivan, daughter of Howard University professor Kelly Miller, plainly stated, "People talk about the New York Renaissance, well we didn't have to have a renaissance." Scurlock photographs of the U Street neighborhood by day and night showcase a certain opportunity and value in black business and leisure. These images, however, also hid socioeconomic realities in and around the neighborhood, such as a desolate alley community, the limited success of black business, and the cultural diversity of the street itself.

HILARY SCURLOCK

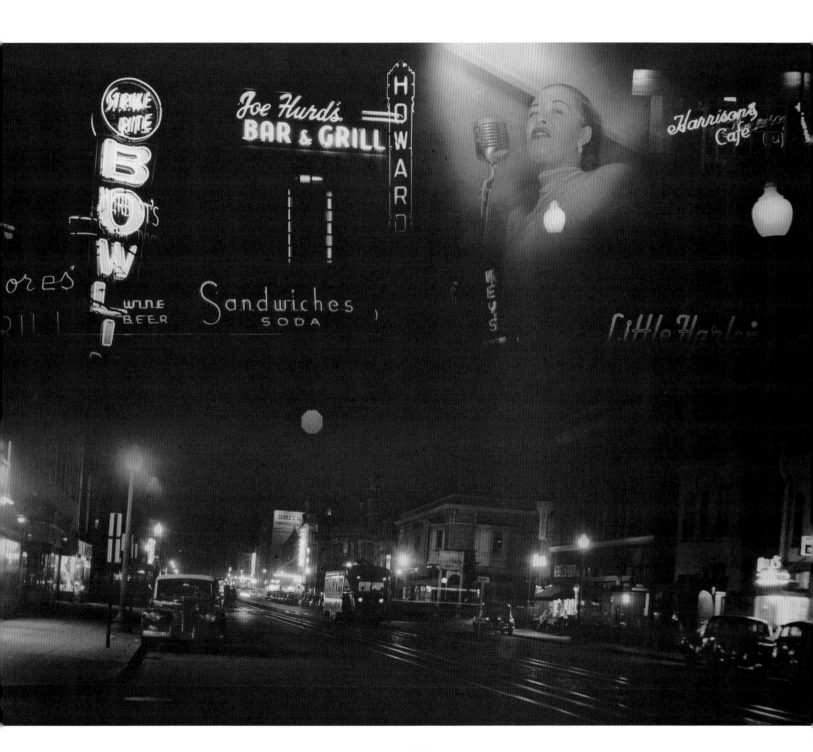

Picketing *Gone with the Wind* outside Lincoln Theatre, 1947

Immediately following the release of MGM's blockbuster *Gone with the Wind*, based on Margaret Mitchell's bestseller, a raft of editorials in the black press and elsewhere, blasted the film as "vicious," "reactionary," "inciting to race hatred," a "slander of the Negro people," and "justifying Ku Klux Klan activities such as lynching." Two of the most incisive early critiques in the black press came from the pen of *Washington Tribune* film reviewer Melvin Tolson (the hero played by Denzel Washington in the 2007 film *The Great Debaters*), who claimed that "*Gone with the Wind* was more dangerous than *Birth of a Nation*." African American leaders in Washington, New York, and Chicago, as well as in several Southern cities, condemned the film, which reimagined the antebellum South as a gallant and Arcadian place where slavery was depicted as a quaint and bloodless institution. The National Negro Congress issued press releases and handbills and joined with other African American, interracial, and labor groups to picket theaters where the film was shown. The Howard University Law School bravely ran a picketing campaign of its own in the spring of 1940, despite the film's popularity among much of the student body.

While the NAACP successfully campaigned to dampen some of the most egregious racist language in the film, the wider effort to have the film banned or withdrawn was unsuccessful, even in urban black neighborhoods like U Street. NAACP head Walter White stated that whatever sentiment there had been in the South for a federal anti-lynching law evaporated during the *Gone with the Wind* vogue. And a long vogue it was. Although the film was first released in late 1939, it quickly went into repertory, running for years in theaters across the United States and around the globe. It ultimately became one of the most successful motion pictures of all time. Despite its popularity, direct protest against the film's racist imagery, language, and ideology continued through and beyond the late 1940s, as Scurlock's 1947 photo in front of the Lincoln Theatre at 1215 U Street shows.

Built as a first-run movie house in 1922 with a seating capacity of 1,600, the Lincoln was praised as "the largest and finest theater for colored people exclusively anywhere in the U.S." It boasted ten dressing rooms for live performances, four lavatories for men and women, and heating and cooling systems—the latter a thankful relief from the city's muggy summers. The theater's importance as a quality first-run movie house cannot be underestimated during a time when Washington's segregated white-only theaters (those that typically screened the newest and brightest motion pictures from Hollywood) hired "Negro spotters" to profile and eject patrons suspected of not being white. Regardless of accommodations, many African Americans decided that first-run Hollywood films promoting poisonously mythic versions of the past, which substantiated racist practices in the present, were not worth the price of the ticket, as this Scurlock photograph verifies. Here, theater manager Rufus Byars looks on, resplendent in his tuxedo and carnation, as determined picketers parade with signs that connect *Gone with the Wind* to the continuing persistence of lynching and racial violence in America. Their signs proclaim the film "Hangs the Free Negro" and entreats it to "Never Return!"

PG

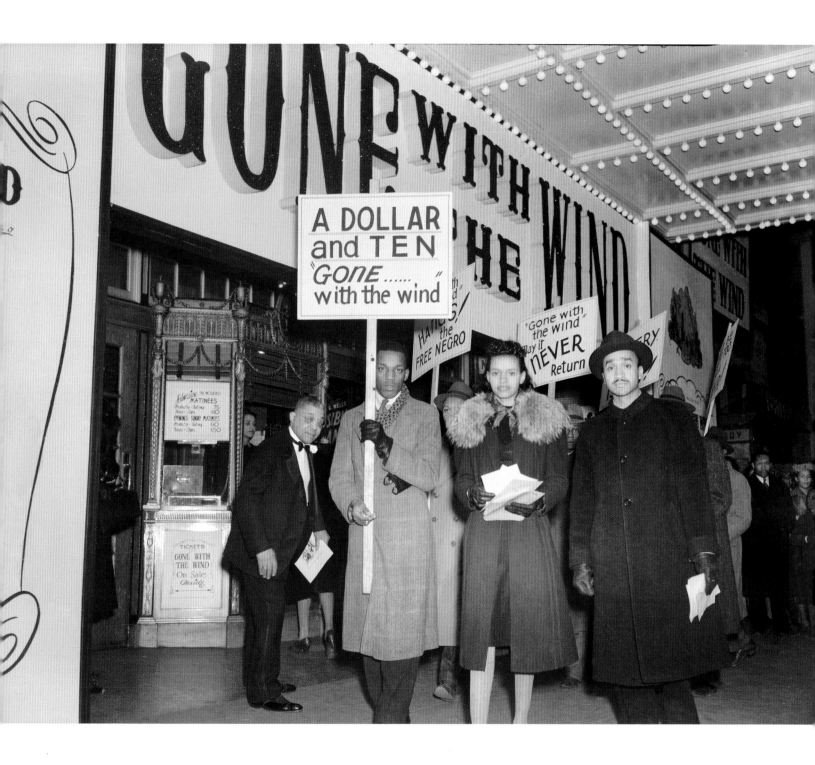

Poetry Week, Miss Duckett's class, Monroe School, 1947

While Washington, D.C., is often described as a political city due to the location of the Capitol here, it has long been a literary city, and more appropriately, a city of poets. Poetry has always thrived here. The humble nature of the city's various poetry scenes long ago rendered it fertile ground for poets, both famous and rising, to find their voices free of the commercial pressures of bigger and more competitive literary markets.

This Scurlock photograph pays tribute to poetry's deep connection to Washington by juxtaposing a young girl reading intently as she stands next to a display of illustrious poets. Three of the four poets—Langston Hughes, Paul Laurence Dunbar, and Walt Whitman (the fourth individual is the renaissance man James Weldon Johnson, who was also a great poet, among many other things)—have unique places in the history of poetry in Washington, D.C. All three came to the city at an important time in their lives, lived in the city, wrote, and left their mark.

Walt Whitman arrived during the Civil War in late December of 1863. He was looking for his brother, who was fighting in the brutal conflict over slavery. Whitman remained for ten years, serving as a volunteer nurse in Union hospitals and later as a clerk with the federal government. Of course, he wrote and published poetry. Most notably, a collection called *Drum-Taps* appeared after the war in 1865. The collection contained writings that documented the horrors of the Civil War and its impact upon the nation.

Paul Laurence Dunbar (see page 161), the "Afro-American laureate" of his time, visited Washington for the first time in the early 1890s. Dunbar eventually returned on a more permanent basis when he held his first poetry reading at the Church of Our Father on October 19, 1896. Dunbar was a star poet by this time, and the event was well received throughout the city's literary and cultural community. It was a huge moment for black poetry nationally in terms of the legitimacy Dunbar achieved for all black writers. The *Washington Post* published a review of the reading the following day. Eventually, Dunbar married and settled in the city in March 1897. He took a job at the Library of Congress and became a part of the city's black community along with his wife, the writer Alice Dunbar-Nelson. A high school was named in his honor in 1920. Dunbar's impact upon the city's black poetry scene is still felt today.

Langston Hughes spent fourteen months in Washington, D.C., in the 1920s. He initially hoped to be admitted to Howard University, but most famously, Hughes took a job as a busboy at the Wardman Park Hotel. He gained brief fame when he slipped a few of his poems to the famous poet Vachel Lindsay, who was in town for a literary conference. As a result Hughes received some notoriety in the national media as the busboy poet. Ultimately, Hughes had ambivalent feelings about the city, and his stay was brief. His contribution to the black poetry scene in Washington, nonetheless, remains today.

Poetry Week, the occasion on which this young bard from Miss Duckett's class in Bruce Monroe Elementary recites her work, started in Washington, D.C., in May 1926. Its aims were simple: "To pay tribute to poets, to encourage more people to write poetry, and to develop a higher standard of appreciation." By 1939 Poetry Week featured a "poetry festival," and as late as 1963 local groups still recognized "Poetry Week" with activities in the city.

BRIAN GILMORE

Halloween party, Twelfth Street YMCA, n.d.

The Scurlocks photographed many different activities and gatherings at the Twelfth Street YMCA, including this image of children celebrating at a Halloween party. The Y served young and old alike as a community center, exhibition space, gymnasium, and venue for civil rights meetings, organization, and debate. It also provided short- and long-term living accommodations at low cost to those in need. Langston Hughes wrote of living here as a young man while on an extended stay in the 1920s. Renamed the Thurgood Marshall Center for Service and Heritage in honor of one of its most notable members—in this building Marshall drafted his opinion for the landmark *Brown v. Board of Education* case in 1954 that desegregated public schools—the center continues its dedication to civic and social service, and it houses several not-for-profit organizations that serve at-risk families and children.

**Eastland Gardens, two boys walking
with baseball equipment,** c. 1940s

Robert Scurlock photographed various scenes during the
construction of Eastland Gardens, a housing development
in Northeast Washington. In these photos of families taking
a break from the construction of their home or of a woman
amidst the luxuries of her modern kitchen (see page 103),
Scurlock attempted to create an idealized visual profile of
the postwar African American experience, one not dissimilar
from white suburban life.

Kitchen in Eastland Gardens, c. 1940s

Wait a minute! Black women were *happy* in the kitchen? Black women had their *own* kitchens? Black women were sometimes *alone* in their kitchens? *Skinny* black women were allowed to cook?

The very existence of this image seems implausible. Thanks to Tyler Perry, almost any twentieth-century book, movie, or television show about black women, and the multitudes who purchase Aunt Jemima figurines and images on eBay, we have almost no cultural references in which to contextualize this "woman in kitchen" except as an anomaly, a curiosity.

Scurlock photographed this anonymous black woman in her home in Eastland Gardens, a private housing development and neighborhood located in far Northeast Washington. Eastland Gardens was developed in 1928 by Eastland Gardens, Inc., on land sold by the owners of the Benning Race Track, a late nineteenth-century cultural space traversed by black jockeys and white dilettantes.

White real estate developer Howard Gott and black builder Randolph Dodd worked together to provide a modern living space for first-time homeowners. Hannah Williams remembered giving "Mr. Gott something like $5 down for a lot. Once you got up to $250, Mr. Gott would give you a frame house and finance it. Five hundred dollars would get you a brick house." Owen Davis and Rheudine Davis remember moving into their new house on their wedding day—October 14, 1939—soon after Mr. Dodd had finished building it.

The design and the appliances here suggest it was built in the late 1930s or early 1940s, when modernity signaled cleanliness and efficiency and, if you were lucky, luxury. This anonymous black woman, probably photographed post–World War II, was lucky: a gas stove, metal cabinets with doors, a wall vent, a window above the sink, stainless steel, linoleum (no permeable wood here), and generous counter space.

Scurlock adds to the seemingly perfect fit of the anonymous woman in the kitchen by making her face appear powdered and pale, having her blend in seamlessly with the kitchen's palette.

I bet she wasn't cooking fried chicken.

MARYA A. MCQUIRTER

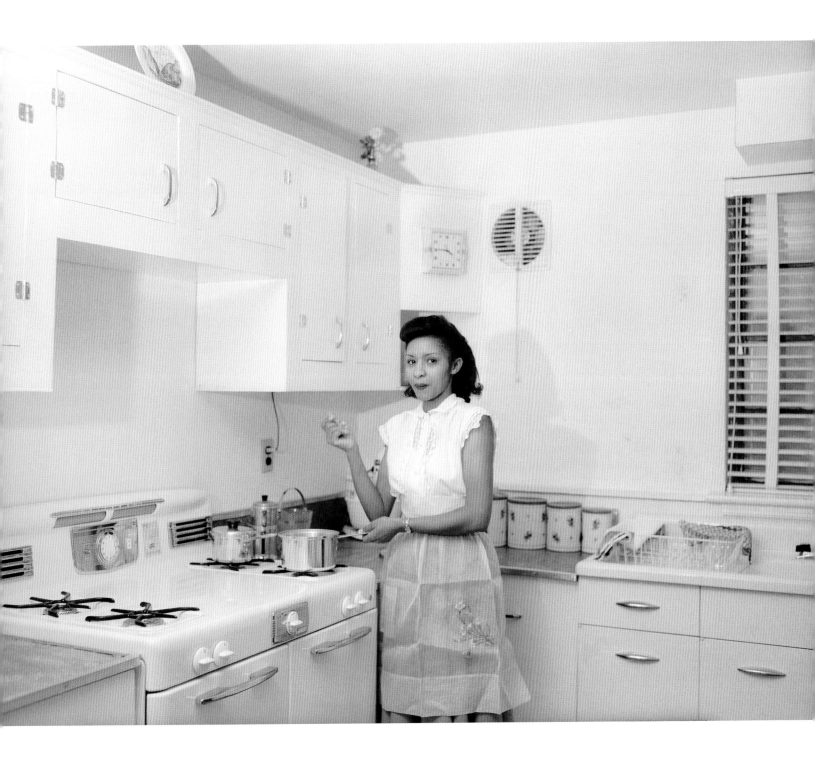

Women outside Miner Teachers College, 1949–53

Miner Teachers College, located on Georgia Avenue, NW, was the major school in Washington for training African American teachers from the end of the nineteenth through the better part of the twentieth century. Its alumni include Emma V. Brown, the first African American to teach in D.C. public schools, and Major James E. Walker, a World War I veteran. In this photo, students Laurice Patterson and Jackie Branch (front left and center, respectively) descend the stairs of Miner Teachers College with a third friend after class. Longtime Scurlock client Ellen Robinson David recalls that Laurice taught school in D.C. Jackie taught as well in the

beginning of her career, but she married an Army officer and moved with him to various posts. After Miner Teachers College merged with the Wilson Teachers College, for white teachers, in 1955, the school's name changed to D.C. Teachers College. It was incorporated into the University of the District of Columbia in 1977. The original building remains at 2565 Georgia Avenue, NW, on the edge of the Howard University campus.

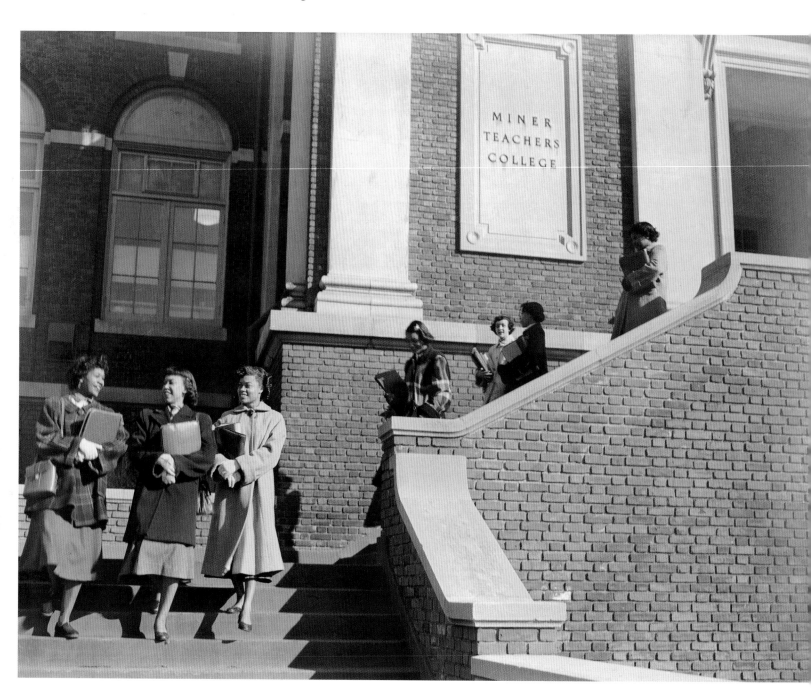

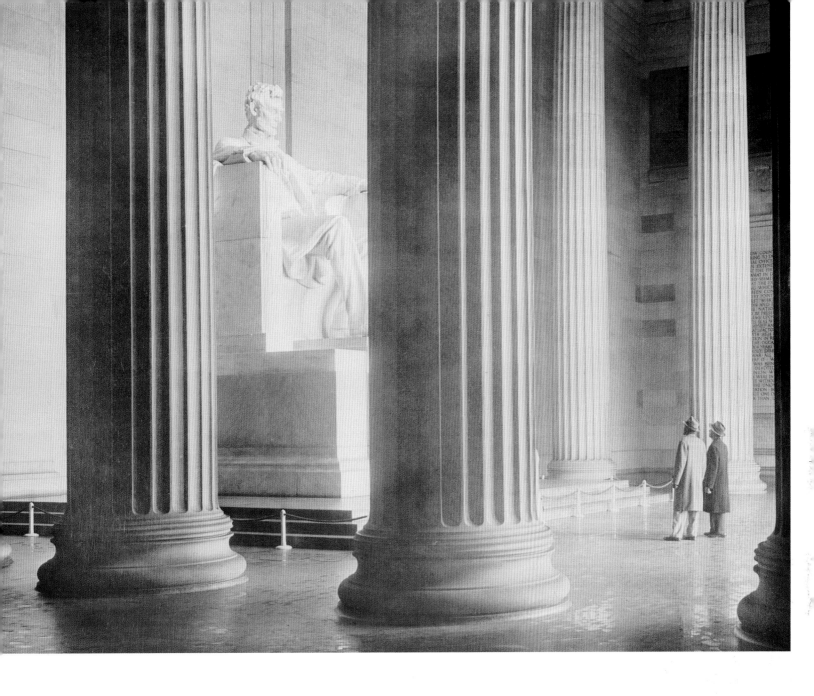

Two men viewing the Lincoln Memorial, n.d.

The Scurlocks' tagline in their photography school's brochure during the immediate post–World War II years was "The nation's capital...a photographer's paradise!" Scurlock images of monumental Washington demonstrate the same formalistic techniques of line and perspective that Addison developed through decades of photographing the architecture of Howard University and the U Street neighborhoods. In this reverential image of the Lincoln Memorial, two men are dwarfed by the imposing figure of the president as he is framed discretely by the clean white forest of marble columns that surrounds them.

My mother says she thinks she knows what the women are doing.

"It looks like they are tissue separators," she says. According to my mother, when the money is printed, the sheets are separated by tissue so the ink can dry. This is what she tells me upon first glance at the photo. You can see the tissue sheets in the photo between the stacks of money.

But then later my mother calls and says that maybe the women are trying to pick out bad money, the bills that need to be removed. "I did that too," she says.

"Are you sure?" I ask.

"Not really."

Ultimately, my mother believes the women are tissue separators because she knows that job intimately: she was a tissue separator at the Bureau of Engraving and Printing in the 1950s.

On April 4, 1950, Dorothy Pearl Shelton (now Dorothy Gilmore), a graduate of Dunbar High School in 1948, was appointed as a "Tissue Separator" at the Treasury Department's "Engraving and Printing Examining" headquarters in Washington, D.C. My mother says she will never forget the date.

She was appointed a "Tissue Separator" at the pay rate of $1.10 per hour after qualifying for the position on the Printer's Assistant Examination in 1948 through the Civil Service Commission. This was fifty-nine years after the first "colored girl" was appointed to work at the bureau by President Benjamin Harrison. By June 1908 there were at least two hundred colored women working at the bureau.

By June 1950 my mother was making $1.31 per hour, but now she was a "Receiver (Wetting Machine)." When the money came off the printers at the bureau, it was wet, as she recalls. Eventually, my mother advanced further, becoming an "Assembler-Salvager (Mutilated Money)," and then to the ultimate goal of many women working there—"Plate Printer's Assistant." She was earning $1.45 when she was a victim of a "Reduction in Force" in July 1953.

My mother says the smiling man in the middle with the cart is probably collecting or dropping off the money.

"Don't the women look as if they are dressed up for the photo?" I ask.

It is possible, she tells me, but more than likely those are just smocks to guard their dresses from the damp ink that comes off the money. So while it is possible that some women tried to dress up for the photo, most of the women are probably wearing something to protect their clothes.

When I ask her was the work segregated racially, she says, "Not officially." However, for the most part she worked with only black women, as in this photo. There were whites working there but not too many amongst the colored women.

As for the agency overall, black men wanted to move up and be allowed to run the printing presses, the best jobs in the agency. Whites for the most part held those positions. But by 1950, the qualifying exam was to be opened to all due to a recommendation from the federal government.

BRIAN GILMORE

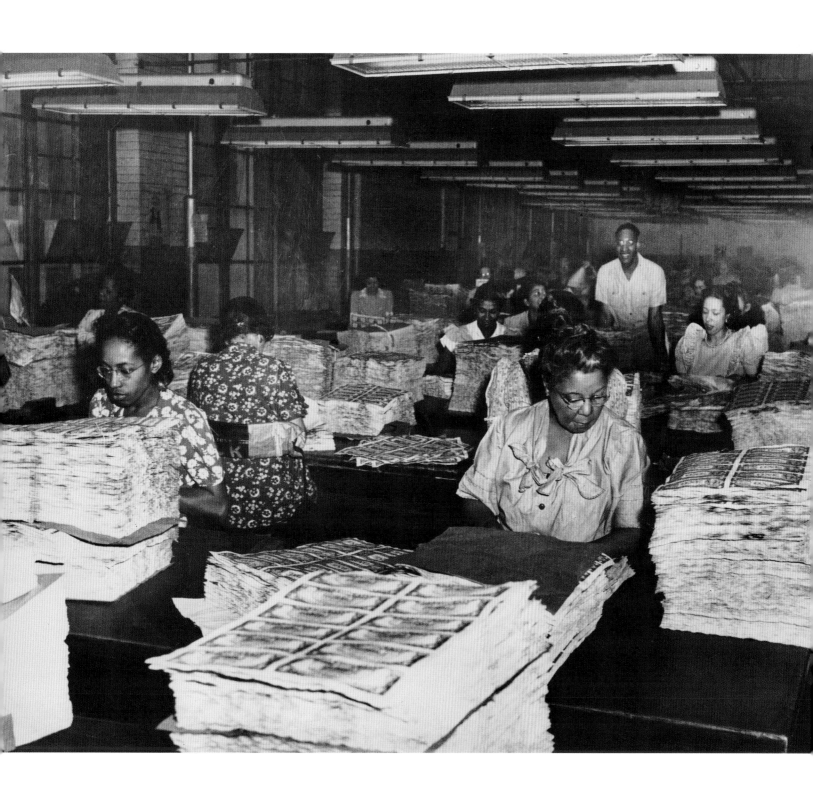

Ethical Pharmacy, 1950

Located at 518 Florida Avenue, NW, Dr. Lou Terry's Ethical Pharmacy was among the more than three hundred black-owned businesses that spanned the corridor from U Street to Florida Avenue. Despite the actual limited economic impact of black businesses in the District of Columbia as a whole, Scurlock images of U Street businesses emphasize the economic independence of the black community. Just as they took many portraits of D.C.'s black community, their photographs of U Street served as "portraits" of black-owned businesses. Of the collection of U Street images by the Scurlocks, dozens depict storefronts, like this one of the Ethical Pharmacy. Established in 1929 by Dr. Lou Terry and his business partner Dr. Williams, Ethical handled the prescription service for some 167 black physicians in Washington.

Scurlock often photographed the storefronts in lieu of the store owners because, for U Street's black business owners, the presence of the business was the ultimate sign of success. Although Dr. Terry himself does not appear in the photograph, his name is printed under the Rx on the door to the pharmacy, signifying his presence in the portrait as the business owner.

The name of the business is telling as well. At the time, the pharmacy was considered "ethical" for its old-fashioned apothecary treatment of medicine. A 1938 profile of the pharmacy in *Flash!* magazine writes, "This unique establishment ranks as one of the finest of its kind in the U.S., playing particular stress on the fine art of the apothecary." Washington native Ellen Robinson David reiterated this high regard for Ethical Pharmacy, remarking that it was called "ethical" because "it was not a drugstore." She recalled Dr. Terry would fill prescriptions at midnight if it meant the customer was getting care.

In this Scurlock portrait, where the name "Ethical" is prominently displayed twice, the term takes on another meaning. Around the same time, a drugstore chain named Peoples Drugstore began to move into D.C.'s black neighborhoods, and it initially hired black employees within the community. When jobs became scarce after the Depression, the owners of Peoples fired the black employees and offered their jobs to whites, causing an uproar. The black community's protest of Peoples became known as the "Don't Buy Where You Can't Work" campaign (see page 77). Through this all, images of Dr. Terry's Ethical Pharmacy stood as a foil to Peoples Drug, a reminder that it is "ethical" for African Americans to own and work in businesses within their own community in order to create a self-reliant reality for themselves.

HILARY SCURLOCK

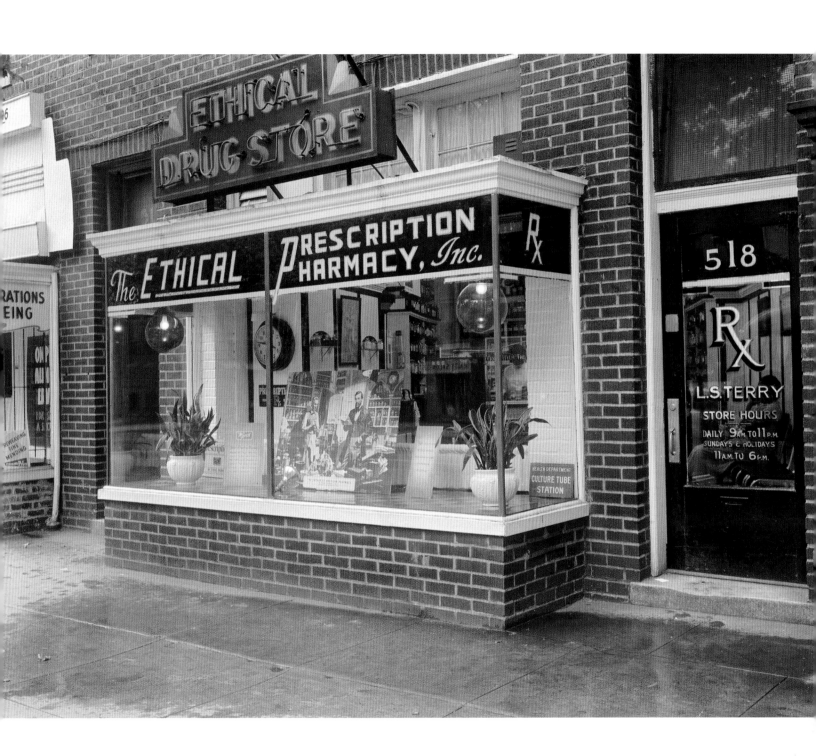

March on Washington for Jobs and Freedom, 1963

The Scurlocks documented a good deal of the March on Washington. Unlike Robert's earlier documentation of a protest on the National Mall—his photographs of the 1939 Marian Anderson concert held at the Lincoln Memorial chronicle her performance and the dignitaries who surround the stage (see pages 80–85)—many of the 1963 images were taken within the crowd. This photograph details the diversity of the crowd, where marchers stand in solidarity and display handmade and machine-printed signs from the Rock Creek Neighborhood League, the UAW, Bethlehem Baptist Church, and the Alpha Phi Alpha fraternity.

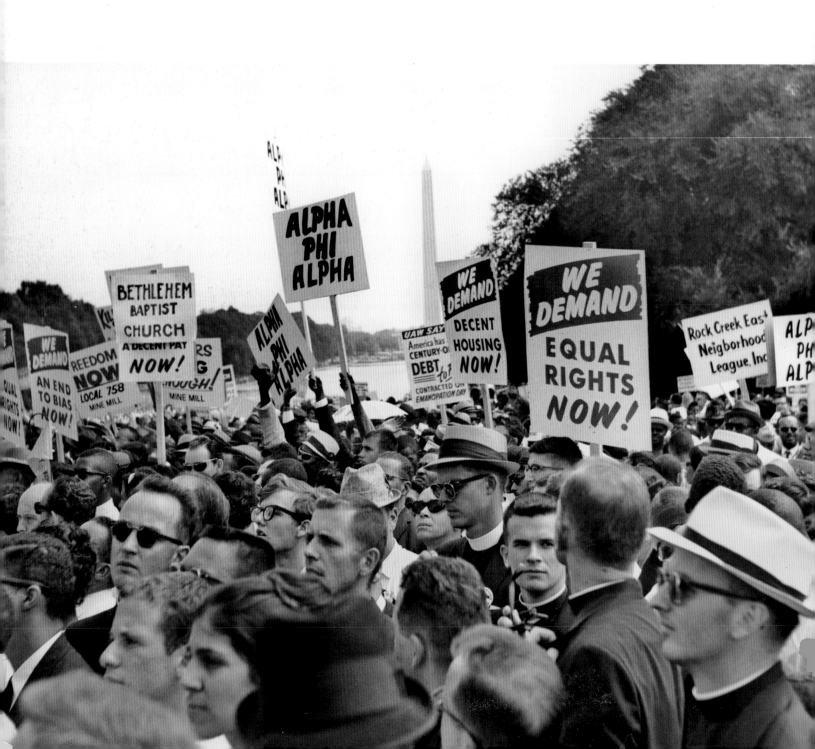

Poor Peoples Campaign Headquarters, 1968

Located in a vacated bank building, blocks away from the Scurlock Studio, the Poor Peoples Campaign established its headquarters at Fourteenth and U Streets, NW, as it prepared for the 1968 protest in the nation's capital. Dr. Martin Luther King Jr.'s last sustained project, the multiracial Poor Peoples Campaign, under the umbrella of the Southern Christian Leadership Conference, signaled an evolution of King's ideas from those espoused earlier in the civil rights movement. Now racial inequality was understood to be a national problem with economic roots and international ramifications. The campaign, labeled by King as the "second phase of the civil rights movement," equated challenging the U.S. war effort in Vietnam with creating a successful "war on poverty" at home. "America is at a crossroads of history," he claimed in a press conference announcing the campaign. "It is critically important for us, as a nation and society, to choose a new path and move upon it with resolution and courage." King was assassinated on April 4, 1968, as preparations for the March from Marks, Mississippi, to the National Mall were under way.

Outside the Scurlock Studio, Ninth and U Streets, NW, 1968

It has been forty years since George Scurlock took these six shots of Ninth and U Streets, NW, near his business—the Scurlock Studio—in April 1968. His sons George Jr. and Tim believe he shot this proof strip while waiting for them to pick him up from the studio. Their father normally drove to work and parked his car at Manhattan Auto at Seventh Street and Rhode Island Avenue, NW. On this day, however, when he went to pick up his car, he discovered the owner of Manhattan Auto had locked the gates early because of the myriad responses *on the ground* to the assassination of Reverend Doctor Martin Luther King Jr. on April 4.

George Scurlock's response to King's assassination was to continue working—to photograph what he saw through his camera lens as he stood in one of the upstairs windows of his office building and as he walked around the immediate vicinity of his studio. In the first shot, George looks east onto U Street, with a liquor store on the right side of the frame and Uptown Billiards on the left. (Would this scene have looked much different on April 3?) In the second, George faces north onto U Street at Sabin's Records, which stood on the northwest corner of Ninth Street. In the third shot, he stands on the south side of U Street in front of his studio, looking east as four white National Guardsmen with rifles walk toward him. The remaining three shots are of firefighters putting out a fire in an alley. (Perhaps he took the shot in the alley located on the south side of Ninth Street between U Street and Vermont Avenue, a few doors down from the studio.)

Looking at these images forty years later, particularly in the context of an over-determined racialized view of "the 1968 riots," I am struck by how personal and ordinary they are and how that combination both subverts and strengthens our collective mediated memory of Washington, D.C., in April 1968. Textures and layers suggest something other than "chaos" and "disorder" and "lawlessness," even when we look at the National Guardsmen and firefighters. These and other photos that George Scurlock took during the same time—one with a "Soul Brother All the Way" sign in the studio's glass display case anchored on the side of the building—stand out from more conventional black-and-white images taken by other professional photographers that typically suggest the city was being irreparably destroyed.

For the Scurlock Studio, 1968 did not portend a business downturn, as most historical accounts of U Street and the city document. George Jr. and Tim remember their

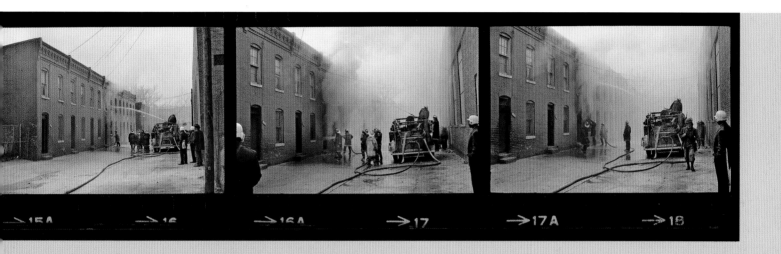

father stating that it was business as usual soon after King's assassination. The major turning point for the Scurlock Studio had happened more than a decade earlier, when Robert Scurlock decided to open Custom Craft Studio in the upper Northwest section of the city, eschew black-and-white film for color film, and focus on news photography, catalog work, and stock photography. He was not interested in continuing the tradition of the "people's photographer" as his father Addison had done for decades at the corner of Ninth and U.

This different approach is clear in *LIFE* magazine's use of one of Robert Scurlock's color photographs for its April 19, 1968, issue titled "America's Farewell in Anger and Grief," which focused on the assassination of King and its aftermath. (On the cover is Flip Schulke's famous photo of Coretta Scott King wearing a black veil at her husband's funeral.) Robert was given a full two-page spread for his color photograph of women, men, and children retrieving items from Grayson's clothing store at 3120 Fourteenth Street, NW. While Robert's photograph is a more conventionally or stereotypically mediated representation of responses to King's death—the "looting" scene is a common trope—the fact that it is in color subverts the seemingly inherent chaos,

lawlessness, and dreariness that typically undergird black-and-white negative imagery.

This *negative* trope prevails today. The cover story for the *Washington Post* on April 6, 2008, illustrates how much the black-and-white image of 1968 has become a too-easy cliché. Titled "From Ruins to Rebirth," the article assesses the changes that have taken place, especially in the U Street and Columbia Heights neighborhoods where George and Robert, respectively, photographed. The changes are illustrated with two photos of Fourteenth and U Streets, NW, a midpoint between George and Robert's imagery. The 1968 photo shows a lone man standing in front of fallen buildings, and the 2008 image shows numerous passersby enjoying booming streetscapes in glistening color.

George's images, especially when paired with Robert's, underscore how the Scurlock Studio still has so much to teach us about the complexity of our city's history if only we really look.

MARYA A. MCQUIRTER

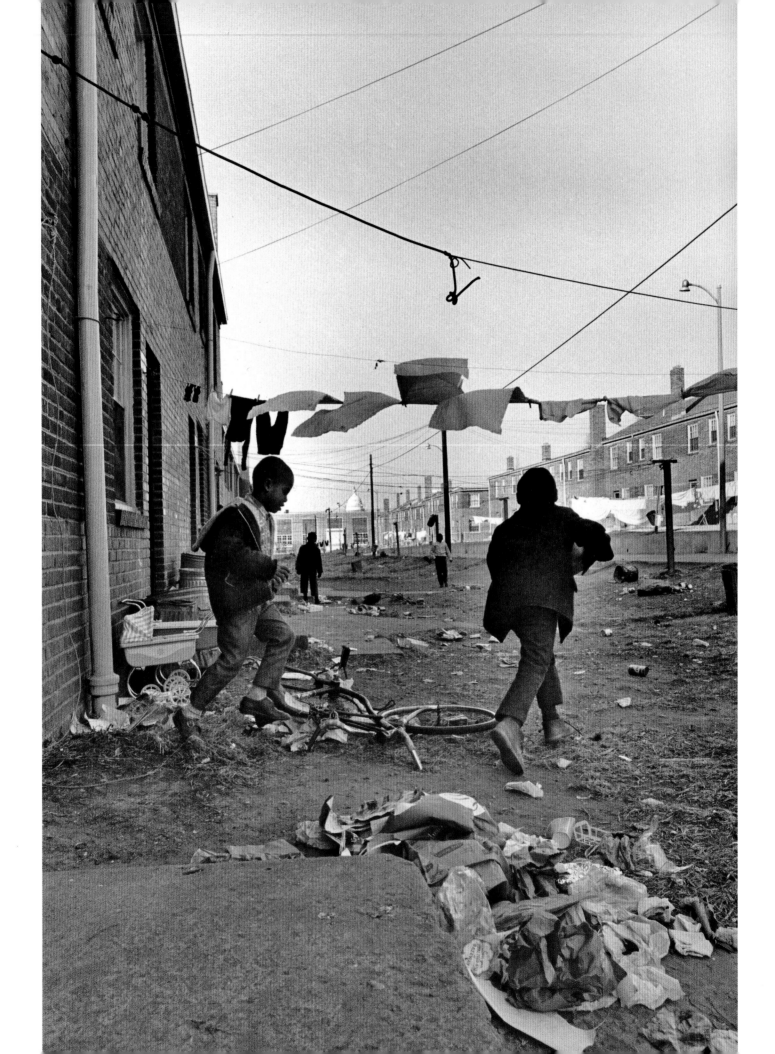

Children playing behind houses, Capitol dome in background, n.d.

In the first half of the twentieth century, Addison Scurlock's photographs of black Washington captured an optimism that was not apparent in most depictions of African Americans living in a segregated society. They most often purposefully portray the allure of African American economic success and the self-reliance of the black middle class. The reality of African American life in Washington, however, was broader than Scurlock's portraits of the middle class. Historian James Borchert, in a detailed study of the area's alley life, noted that "Washington's 'mini-ghettoes' were spread throughout the city, often in close proximity to the most expensive and elegant houses." A majority of black Washingtonians lived in poverty, as this image, likely taken by Robert Scurlock, suggests.

Children running, bus in background, n.d.

Robert Scurlock took this photograph for *Ebony* magazine as part of a series of images documenting Bison Bus Lines and its drivers, mechanics, and customers on excursions. Bison was the only black-owned and black-operated bus company in America, with routes serving Maryland and the greater Washington area. By 1960 Bison, along with other suburban operators, became incorporated into the D.C. Transit System. Robert's photo essay of Bison exists along with other series he shot for *Ebony* (though possibly never published), including profiles of black professionals and the construction of African American suburban homes. Taken at the eye level of a child, this image conveys the sense of play and movement expressed by these children, who are happy to have arrived at their destination.

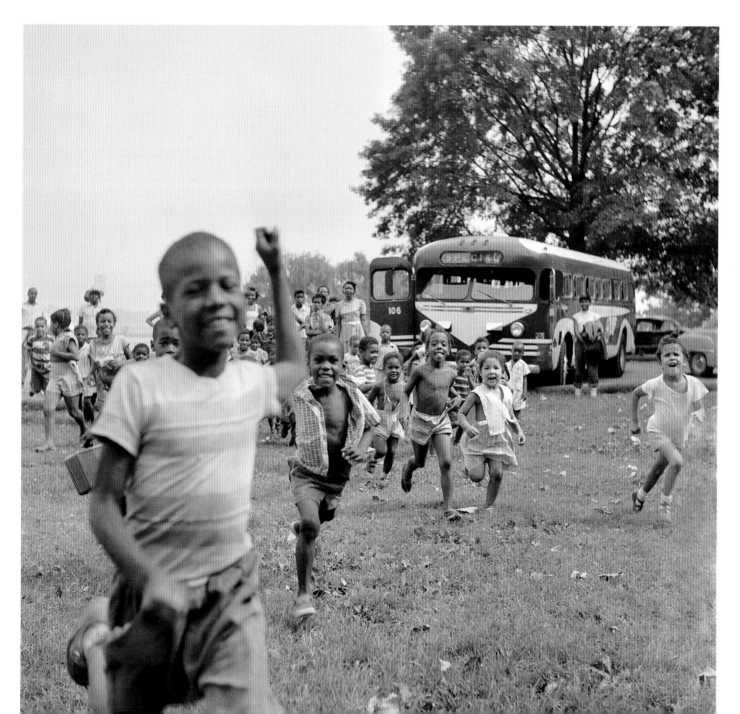

Three boys on summer streets of Washington,
c. 1970s

Robert Scurlock ventured onto the streets of black Washington to document the people and places of the community in a way that differed from the approach of his father or brother George. From early in his professional career, Robert was committed to incorporating photojournalism and documentary photography into his resume. He sold photos to *LIFE* and *Ebony* but achieved limited success in these areas. Portraiture and later, color photography and duplication were the primary services of the studio. This tightly framed shot of three boys with popsicles captures the heat and humidity of summer on the streets of Washington, D.C.

Viewing cherry blossoms from the Tidal Basin at night, n.d.

The field of commercial photography had expanded by mid-century and offered more opportunities for African American photographers. The Scurlock Studio broadened the scope of its activities to include picturesque photographs of monumental Washington. In this shot of two women viewing the cherry blossoms at night, the Washington Monument, situated directly at center, is framed by a natural gap between the blossoms of two foreground trees. Its strong vertical line is mirrored in the reflection that bifurcates the two seated figures.

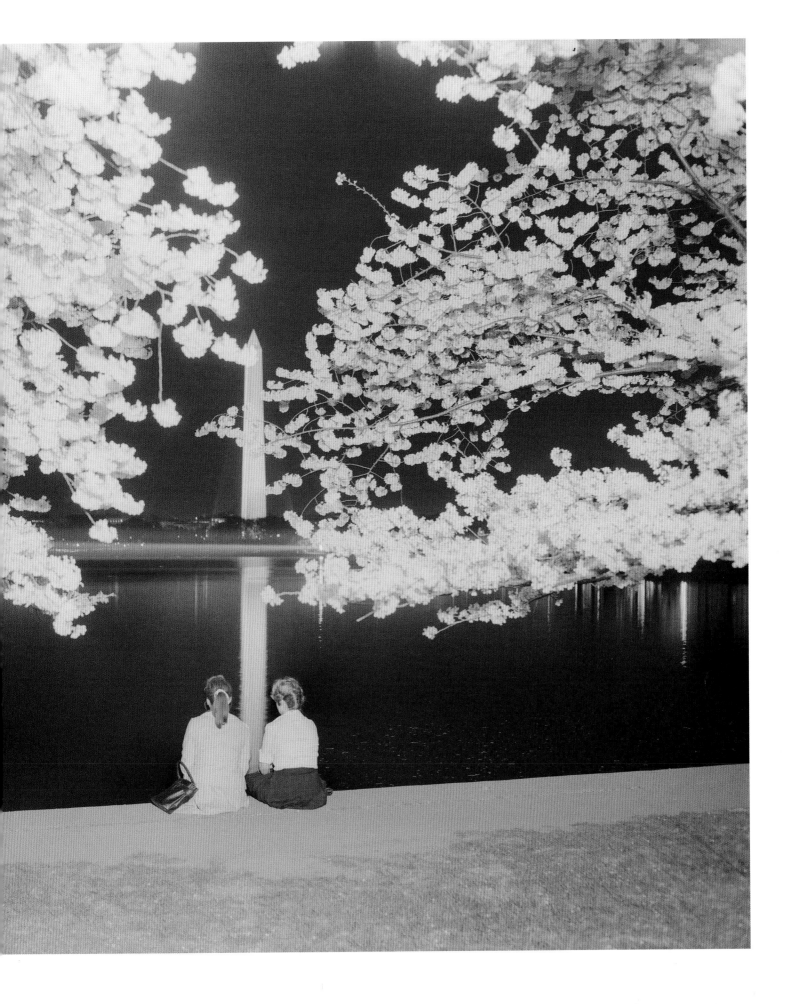

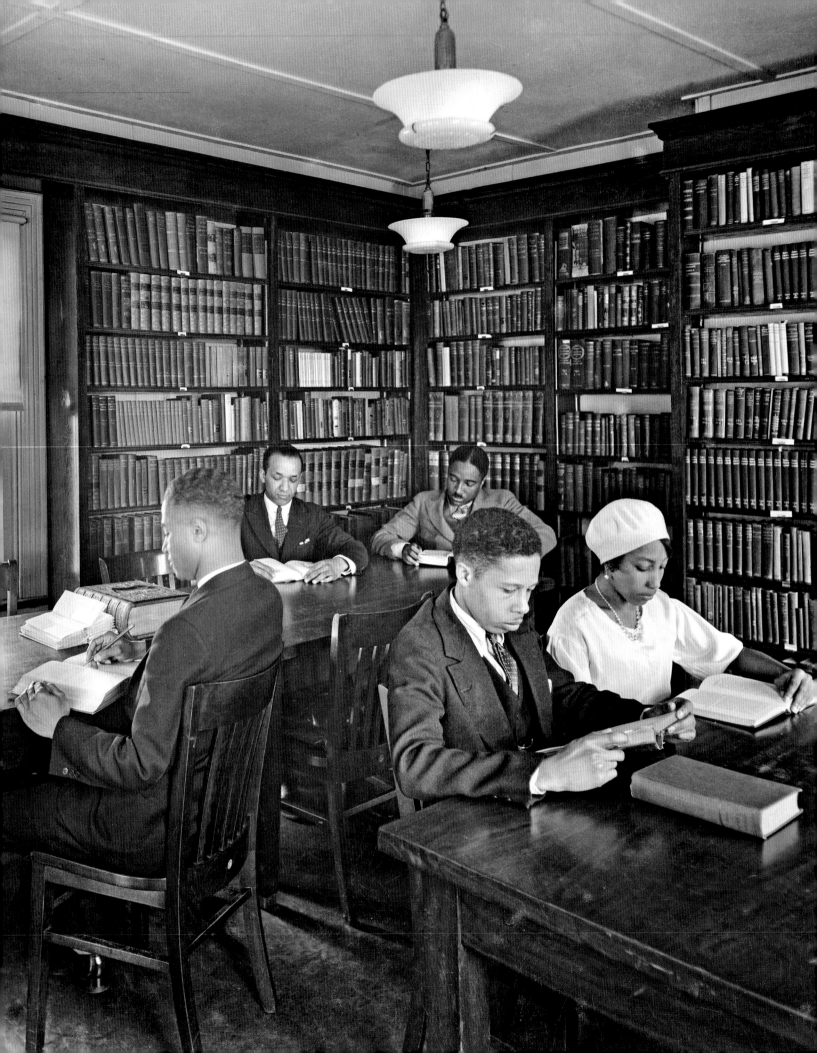

HOWARD UNIVERSITY

with reflections by

JONATHAN HOLLOWAY

CHARLENE DREW JARVIS

MARVIN MCALLISTER

MARYA A. MCQUIRTER

E. ETHELBERT MILLER

HILARY SCURLOCK

Howard University Law Library (detail), c. 1930s

For nearly all of its existence since it was founded in 1867, Howard University has been considered the "capstone of black education" in the United States. While other excellent historically black colleges and universities—including Fisk, Atlanta, Morehouse, and Spelman—also gained prominence over the course of the twentieth century and emerged as important regional centers of learning, none attained the size or breadth of Howard. The university's organizational success, especially in the first half of the twentieth century, was due in part to its unique location in the nation's capital, with its large African American population, and to its special relationship with the federal government, which has always provided funding.

Howard's strength was its ability to shape a much larger world than other universities managed to do. It was the "institutional base and reservoir for the New Negro movement," according to historian David Levering Lewis, and it was the laboratory for twentieth-century civil rights law, including the strategy that resulted in *Brown v. Board of Education*. Howard also constituted the proving ground for world-class physicians, scientists, social scientists, and statesmen, and it came to embody the best in black and in American higher education. Situated on top of a hill that overlooks the bustling business district of U Street and the prominent middle-class enclave of LeDroit Park, Howard literally was at the summit of opportunity for the black community in Washington.

For nearly ninety years, Howard University retained the Scurlock Studio as its official photographer. After establishing his business on Ninth and U Streets in the early 1900s, Addison Scurlock forged professional relationships with various Washington businesses, organizations, and institutions. None, however, would be bigger, longer lasting, or more beneficial than the agreement reached with Howard University. The Scurlocks depicted all aspects of life at the university—intellectual, athletic, social, and political. Ranging from individual portraits of presidents, administrative deans, and faculty members, to group photos of academic departments and social clubs, to candid views of classrooms, graduations, and picturesque campus landscapes, Scurlock photographs constitute the visual history of Howard in the twentieth century.

The resulting body of work presents Howard as a vibrant place, with a diverse cultural life and an intellectual vigor that both produced the highest degree of scholarship and attracted the world to its campus. Moreover, it verifies the unique role that Howard had in shaping Washington, D.C., and affecting the struggle for racial and social change in America.

During the 1910s and 1920s, Scurlock depicted the rise of the institution to national prominence through portraits of campus luminaries, such as biologist Ernest Everett Just, first winner of the NAACP Spingarn Medal, or Rhodes scholar Alain Locke, father of the Harlem Renaissance. Howard took seriously the role of creating the "Talented Tenth" from its student body, fostering in its young men and women a responsibility as race leaders and social activists for the betterment of the nation.

Particularly significant are the Scurlock photographs that coincide with the presidency of Mordecai Johnson, whose forty-year tenure began in 1926. During those decades both the university and the Scurlock business gained recognition

in Washington and aided each other's reputations. Johnson shaped Howard into a modern world-class university, with a full slate of undergraduate and graduate programs and professional schools. He also influenced the intellectual atmosphere of the university, creating a haven for research and scholarly independence. Johnson's leadership attracted the best and brightest activist intellectuals, scholars, and artists to the school, and Scurlock captured them all on film, including Sterling Brown, Ralph Bunche, Charles Hamilton Houston, Lois Mailou Jones, Charles Drew, and E. Franklin Frazier, among others.

Throughout this time, the Scurlocks' visual documentation of Howard extended beyond campus luminaries to include dignitaries who visited and spoke on the campus, such as Martin Luther King Jr. and Marian Anderson, the Roosevelts and the Kennedys, Mary McLeod Bethune and Jackie Robinson. Until the 1960s, Howard was the only black university that drew a truly national and international student body, and the scope of its academic and social activities was wide. The Scurlocks photographed hundreds of clubs and innumerable sporting events and teams, as seen in group portraits of the Dramatic Club and the annual Howard-Lincoln Classic. They also depicted organizations, such as the ROTC, of which Robert and George Scurlock, both Howard graduates (in 1937 and 1940, respectively), were members. Their works were not only published in the university's yearbooks and hung on the walls of departmental buildings, but many—especially those of national political events and race leaders at the university—were also widely distributed in the black press. This exposure promoted Howard's status as the nation's premier black university.

It is important to remember that as official photographers, the Scurlocks provided a portrait of Howard that illustrated the vision of the university and its intellectual and social life as determined by the administration of the school. This carefully constructed image was designed to attract benefactors, alumni, and political power brokers. The Scurlocks provided an image of Howard in a uniformly positive, noncontentious light that was often divided strictly along gender lines.

Through their scholarly work, athletic prowess, and patriotic duty, Howard men were consciously portrayed by the university and thus by the Scurlocks' camera as the future leaders of the race and of the nation. Images of female students often convey an idealized and circumscribed notion of black womanhood in which young women were being prepared to "mother" the impending changes necessary for social and racial transformation. Female deans, professors, and visiting dignitaries are respectfully depicted, but in Scurlock images female students are typically shown as dancers, musicians, or beauty queens—far removed from the worlds of science, politics, and defense that men inhabit. Such images omit the reality of the increasingly active role Howard women played in campus intellectual life and in wider political action from the 1930s forward.

Ultimately, however, the most important and lasting image of Howard University that the Scurlocks constructed was of its academic rigor and intellectual enlightenment. Much like Addison's visual constructions of black middle-class men and women, the Scurlock depiction of Howard's activist intellectual community showcased the university's promise to the black community, the nation, and the world.

Howard University at night, n.d.

The Scurlocks photographed the landscape and architecture of Howard University many times over the years. They documented buildings, such as Andrew Rankin Memorial Chapel, Frederick Douglass Hall, Freedmen's Hospital, and Founders Library, and in the process they mastered techniques in architectural photography for use in day or night scenes. Photographer Bernie Boston, an assistant at the Scurlock Studio in the late 1950s, recalled photographing with Robert Scurlock at night by "painting" buildings with large flashbulbs to achieve the proper light exposure. Such a technique may have been employed for this scenic night-time image of Howard University as seen from across McMillan Reservoir. The end result evokes the first stanza of Howard's *Alma Mater*: "Reared against the eastern sky/ Proudly there on hilltop high,/Far above the lake so blue/ Stands old Howard firm and true...." Here, Scurlock depicts Howard as a beacon of light—a symbol of the university's description of itself as the "capstone" of black education, one of the nation's finest institutions of higher learning.

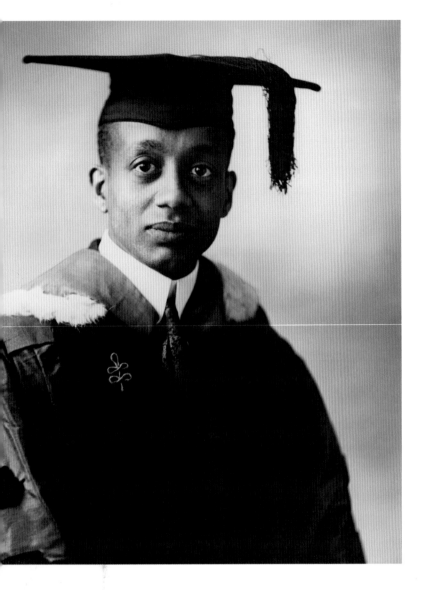

Alain Leroy Locke in doctoral cap and gown, 1918

Alain Locke (1886–1954) is widely regarded as the architect and guiding spirit of the New Negro renaissance. He joined the faculty of Howard University in 1912 and subsequently dedicated his time and energy to turning the university into a potent breeding ground of creative and intellectual activity. Locke organized the *Stylus*, the university's first literary journal, and helped found the art gallery and music department. Describing himself as more of a "philosophical midwife to a generation of younger negro poets, writers and artists than a professional philosopher," Locke promoted scores of black artists and musicians in their careers and encouraged them to study the African sources of their culture. Locke's most famous work is *The New Negro* (1925), the germinal text that ushered in what has become known as the Harlem Renaissance. Despite its emphasis on Harlem, nearly half of the contributors to this foundational twentieth-century text were born, raised, educated, or worked in Washington, D.C., and/or Howard University.

Lucy Diggs Slowe, c. 1920s

Born in rural Virginia, Lucy Slowe (1885–1937) was educated at Howard and Columbia universities. She taught English at Washington's Armstrong Manual Training School from 1915 to 1919 before she became the principal of Shaw Junior High School, the city's first such black institution. In 1922 she was selected as Howard's first dean of women and as president of the National Association of Colored Women, a position she held until her death. A champion of equal rights for female students at Howard, Slowe clashed with university president Mordecai Johnson over views of women's roles and authority on campus. Much earlier, as a student at Howard, Slowe helped found the Alpha Kappa Alpha sorority, the first Greek-letter organization established by African American women. The long string of pearls she wears in this portrait might refer to her sorority, whose founders, original members, and incorporators were known as "the twenty pearls." In 1942 the United States government built and dedicated Lucy D. Slowe Hall in her honor (at Third and U Streets, NW) as housing for single African American women doing wartime work for the federal government. Slowe Hall exists today as a university dormitory.

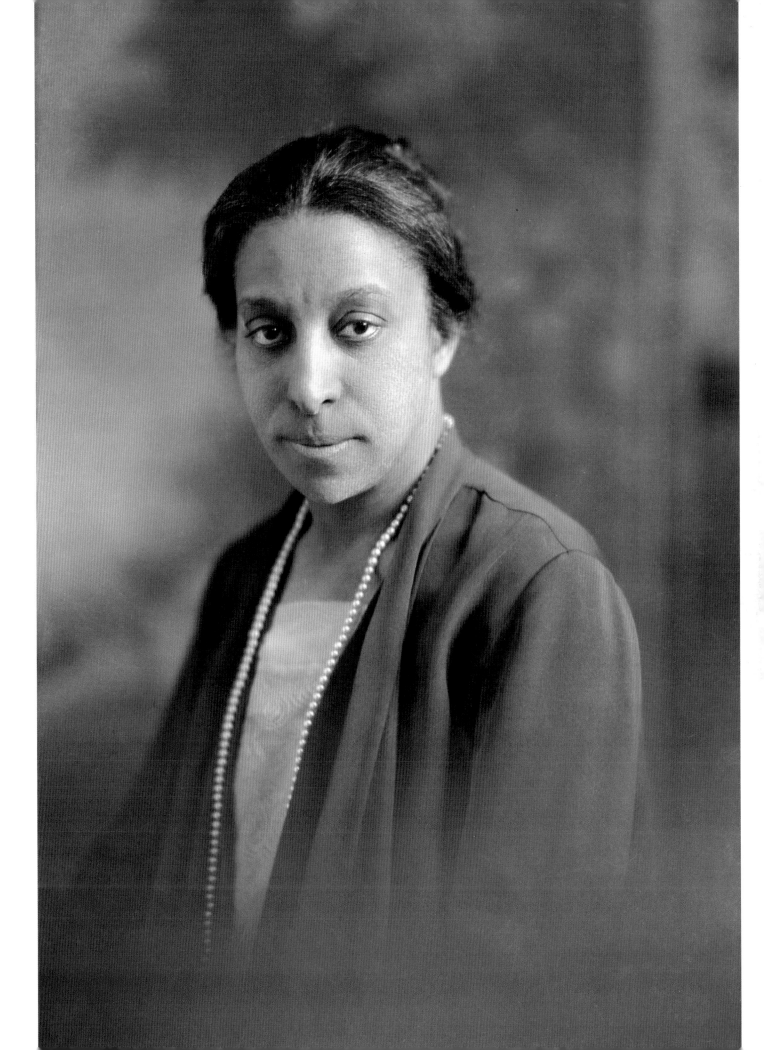

Howard College Dramatic Club, 1911

In 1909 Ernest Everett Just, a Howard University English instructor destined to become a world-famous biologist, convinced a group of enthusiastic freshmen to create a dramatic society on the hilltop. Under Professor Just's faculty leadership, the Howard College Dramatic Club identified two campus missions: "to present each year one of the classic plays of some well known playwright of established fame" and "to firmly and permanently establish the dramatic work among the students of the University." Their classical productions earned Howard University recognition and respect from the most progressive and "best thinking men and women" in Washington, D.C., and the nation.

Scurlock photographed the club in Elizabethan costume for their March 1911 production of Shakespeare's *The Merry Wives of Windsor.* In the third row to the far left appears the club's latest advisor, Benjamin Griffith Brawley, in a bow tie and a handsome mustache. An expert in English literature, Professor Brawley elected to direct this lesser-known Shakespearean comedy because its middle-class themes, setting, and tone resonated with student actors and audiences at Howard. In the same row to the far right is William Gilbert, the club's first business manager, who was responsible for financing productions and promoting its classical agenda on campus and beyond.

The star of this production of *Merry Wives* sits front row center: E. Clayton Terry portrayed Falstaff, a comical and mildly lecherous old man who is soundly duped. Perhaps the most remarkable company member sits to the immediate right of Terry. Look closely. Is that a male or female co-ed costumed in a jeweled necklace and a powdered face? In a bold casting decision, Professor Brawley enlisted student Benjamin Locke to cross-dress as Mrs. Ford, one of the cunning merry wives.

Around 1921 the Dramatic Club was reorganized under the new leadership of faculty advisor Montgomery Gregory and renamed the Howard Players. Gregory, a Harvard-educated English professor, shifted the club's focus from classical drama to race drama and established a degree-granting dramatic arts program. In the words of Professor Gregory and Howard University philosophy professor Alain Locke, a refocused campus theatrical society and a new drama program would "establish on an enduring basis the foundations of Negro drama through the institution of a dramatic laboratory where Negro youth might receive sound training in the arts of the theatre." These significant curricular and extra-curricular innovations helped advance Locke's developing ideas on New Negro culture, which eventually flourished into the legendary Harlem Renaissance.

MARVIN MCALLISTER

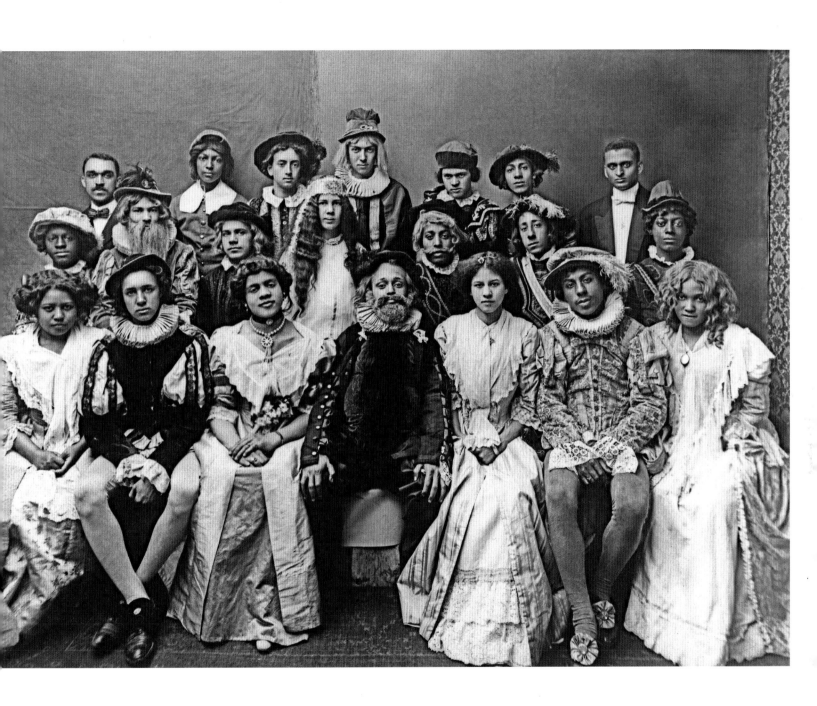

Ernest Everett Just, 1916

This image helps to recall an individual whose exploits are, today, undervalued. Ernest Everett Just (1863–1941), newly minted with a degree from Dartmouth, was initially hired by Howard University as an instructor of English. He later accepted a full-time appointment as an instructor in biology, and in 1912 he established and became the head of Howard's Department of Zoology. Addison Scurlock photographed Just several times at the beginning of his illustrious association with science, yet his career was hampered by the limitations of racism and segregation. One of Scurlock's formal portraits of Just was reproduced in 1996 as a first-class stamp in the Black Heritage series issued by the United States Postal Service. This 1916 image of a pensive Just surrounded by equipment in his lab presents the young biologist at a momentous time in his life. After many delays and obstacles, he obtained his PhD, summa cum laude, that year from the University of Chicago. The year prior, the NAACP had awarded Just its first ever Spingarn Medal for outstanding achievement by a black American. His award was profiled, along with this photo, on the pages of the *Crisis*.

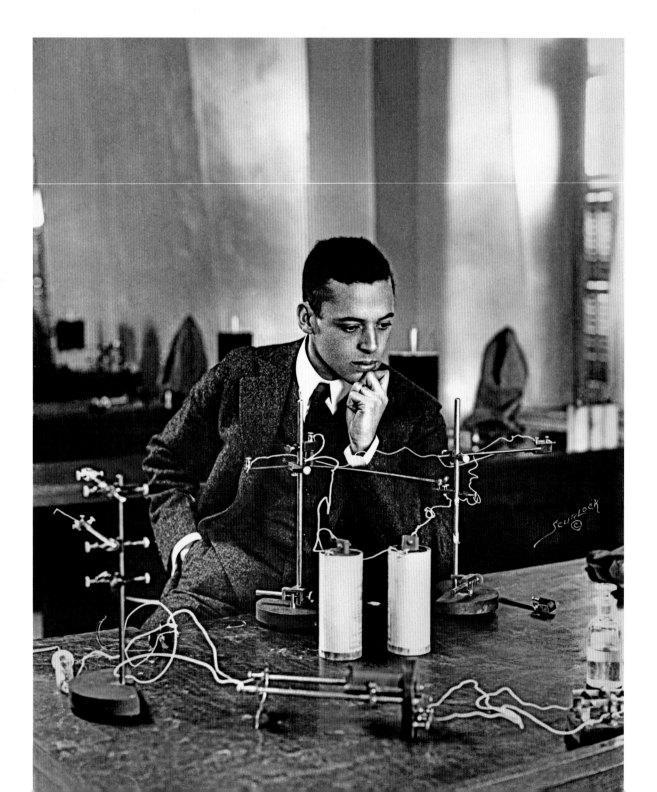

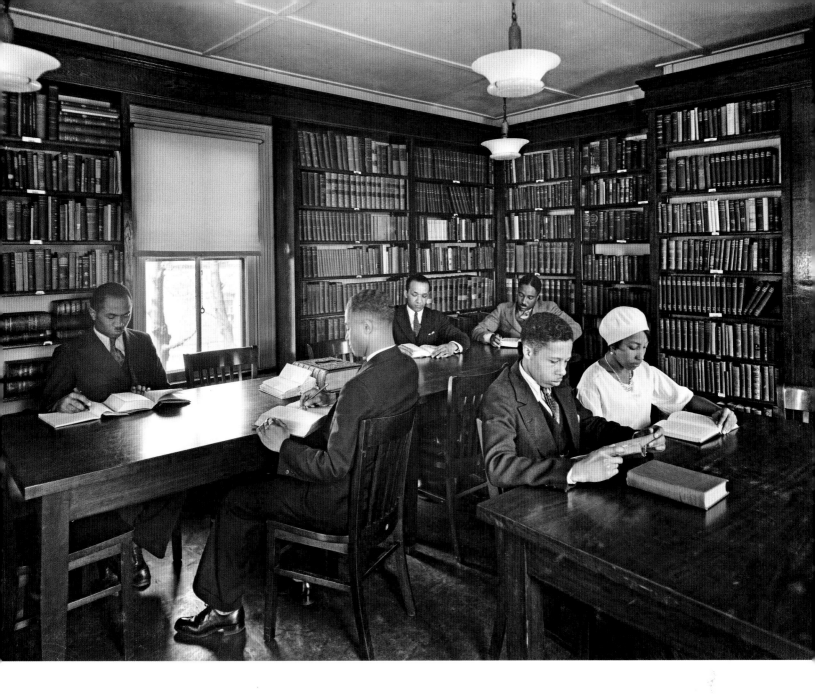

Howard University Law Library, c. 1930s

Founded by John Mercer Langston in 1869, Howard University's School of Law reached its "golden age" during and following the tenure of Charles Hamilton Houston in the 1920s. There, along with William H. Hastie, he transformed the school into the nation's preeminent laboratory for civil rights law. The library, then staffed by Allen Mercer Daniel, served as an important site that helped produce many of Houston's "social engineers"—lawyers who, according to Houston, were "skilled, perceptive [and] sensitive...who [understood] the Constitution and [knew] how to explore its uses...in bettering conditions of underprivileged citizens." Houston's most famous protégé, Supreme Court Justice Thurgood Marshall, later wrote,

Charlie Houston was training lawyers to go out and go in the courts and fight and die for their people. He had courses that never had been heard of before, and he trained and he went for perfection. He would tell us in class,...privately in the library, publicly when he would break up a poker or crap game... "Men, you've got to be social engineers. We've got to turn this whole thing around. And the black man has got to do it; nobody's going to do it for you."

Engineering lab, 1941

Beginning with his tenure as university president in 1926, Mordecai Johnson, the first African American to head Howard University, championed the school as the seat of the best and the brightest of intellectual thought and academic rigor across all disciplines. As the university's photographer, Scurlock expertly constructed the public image of Howard University to correspond with Johnson's vision of it as an educational center whose mission was to serve African Americans as well as the nation. Scurlock achieved this in part by photographing the university's sophisticated world-class and world-renowned faculty. Yet, Scurlock's representation of Howard as an academically elite institution also extended to non-famous academics and departments. This posed image of two unidentified faculty members at work in the university's engineering lab shows an industrious department contributing to the well-being of the nation.

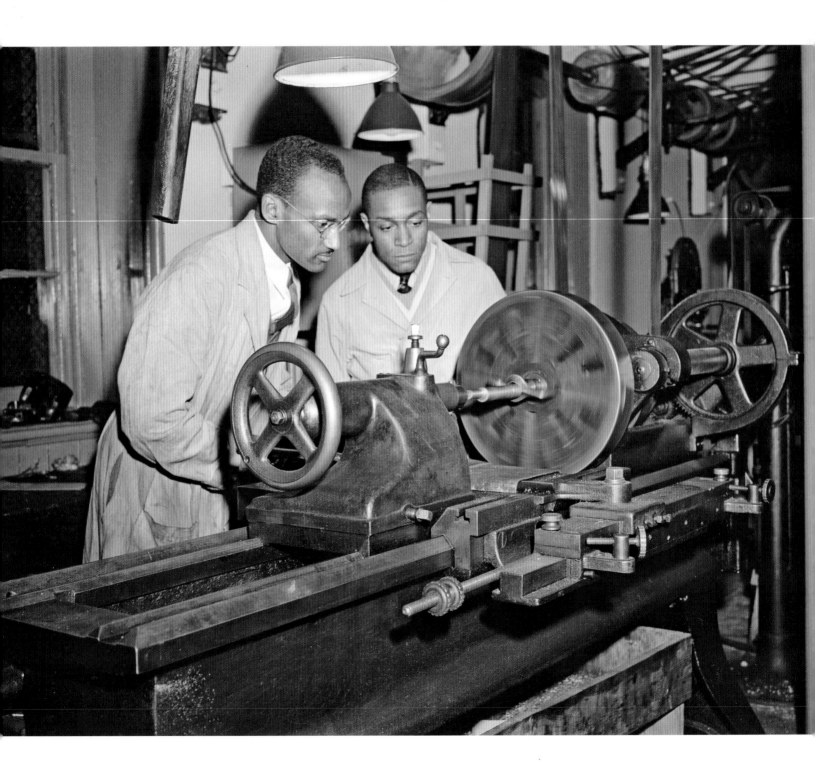

May Pageant, n.d.

At mid-century the image of the serious academic at Howard was, almost exclusively, constructed as male. Scurlock's photographs of the university's female students during these years were frequently depictions of women in non-academic settings, such as this wonderful group portrait taken during Howard's annual May Festival, at which the May queen was crowned. Even though the Scurlocks did not thoroughly document them, Howard's women in both the faculty and student body were engaged in rigorous academic pursuit as well as campus activities dealing with local, national, and international issues.

133

Mordecai Johnson and Eleanor Roosevelt, 1938

As the unofficial "official" photographer for Howard University, Addison Scurlock assumed the task of creating a very specific image of the black intellectual at the university. This was especially apparent during the tenure of Mordecai Johnson (1890–1976), who took it upon himself to transform Howard into a national paragon of black education set to rival the Ivy League.

In 1926 Johnson inherited a Howard University that some still considered a glorified "finishing school" for the children of D.C.'s black families. Johnson quickly set to work strengthening the academic caliber of Howard's scholars and making the institution a national center of black intellectual and political thought. Scurlock supported the activist intellectual image through photographs of the university and its scholars. While many of Scurlock's works include the iron gates and brick clock towers that define images of premier "white" universities, they also frequently document Johnson and his many guests.

As the face of Howard University, Johnson further increased the school's presence by meeting with such national figures as First Lady Eleanor Roosevelt. A strong proponent of civil rights and a great influence on her husband, Mrs. Roosevelt made multiple visits to Howard. In fact, Scurlock photographed both Eleanor and Franklin Roosevelt at the university on several occasions. While Johnson and the Roosevelts, particularly Eleanor, maintained a mutual friendship, a subtle power play was at work, in which neither Johnson or Roosevelt held rule.

Both Johnson and Roosevelt stood to gain from their relationship. In the 1930s, communism quietly began to grow as an ideology among the nation's educated blacks, and Johnson was immediately identified for his outspoken support of communist ideas. Since Howard relied heavily on federal grants, and Congress controlled much of the university's funding, Johnson made extra efforts to repair his image by welcoming both Roosevelts. The timing was especially crucial, as Johnson's left-leaning politics (as well as the ideologies of many others at Howard) stood diametrically opposed to beliefs circulating on Capitol Hill at the verge of World War II. The presence of national figures on campus also verified Howard's position as a national university.

Additionally, Eleanor Roosevelt could use her presence at Howard to forward her own civil rights agenda and that of the president. Several historians regard her as the conscience behind many of FDR's civil rights decisions. She masterminded the establishment of the Black Cabinet that included her friend Mary McLeod Bethune. Her very public support of the black community solidified her stance on race relations and forced President Roosevelt's position as well. With Mrs. Roosevelt personally supporting the nation's leading black university, Americans could not deny the intellectual power of a then-segregated community.

This Scurlock image records Eleanor Roosevelt's visit to Howard in the late 1930s to view an art exhibition organized by Washington curator Alonzo Aden, cofounder of the Barnett Aden Gallery, the first privately owned African American art gallery in the United States. The photograph presents the relationship between Johnson and Roosevelt, two powerful figures circumscribed by racism and sexism. While their facial expressions suggest a familiar, amiable relationship, their distant body language hints at a mutual competition between the two.

HILARY SCURLOCK

Charles Hamilton Houston, 1939

Born in Washington, Charles Hamilton Houston (1895–1950) served as professor and vice dean of Howard University's School of Law. In the late 1920s he reshaped the law school into an important training ground for a generation of civil rights attorneys who later transformed America. In 1935 Houston left Howard to serve as special counsel to the NAACP, where he developed the legal strategy that led to the seminal case *Brown v. Board of Education*. In this photo, taken in March 1939 after his tenure at Howard, Houston argues forcefully—yet futilely—before the District's Board of Education, entreating its members to approve the use of

Central High School's auditorium for an upcoming concert by Marian Anderson. Ultimately, Anderson performed from the steps of the Lincoln Memorial (see pages 80–85) in a public demonstration that in some ways inaugurated the use of the National Mall as a site for civil rights protest. Of Houston's argument that day to the Board, the Howard *Hilltop* reported, "Schools belong to the community, and after school is out, any citizen has a right to use any school!" One of Robert Scurlock's photographs of Anderson's concert at the Lincoln Memorial shows Houston proudly seated on stage, listening.

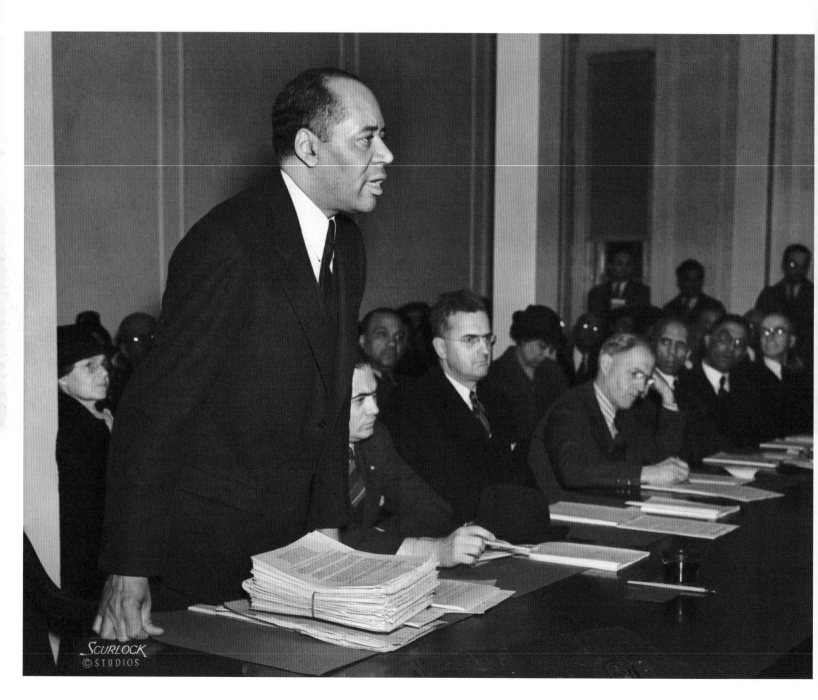

Rayford W. Logan, 1948

Best known for coining the term "the nadir" to describe race relations and the historical and social position of African Americans between Reconstruction and World War I, Rayford Logan (1897–1982) was an historian, civil rights activist, and pan-Africanist who served as professor and later as chair of the Department of History at Howard University (1938–65). The son of domestic laborers, Logan was born and raised in Washington. As an adult he coordinated voter registration drives and citizenship training sessions in Atlanta in the 1920s. He was a member of FDR's Black Cabinet, an informal group of African American policy advisors who urged the president to draft the executive order that prohibited blacks from being excluded from service in World War II. This Scurlock photograph was taken when Logan served as an advisor on international affairs to the NAACP. He also worked for the United Nations in his specialty fields of colonialism and Latin America, providing social, racial, and economic analysis on South American countries. This address on Washington's WWDC radio station was likely connected to one of those reports.

Charles Drew and Red Cross medical team, c. 1940–41

The accidental boundaries of race, religion, nationality or language do not limit the spread of disease. No such boundaries must hinder the work of the men and women anywhere in the world who would fight this worldwide enemy, disease.

CHARLES R. DREW, M.D.

My father, Charles Richard Drew (1904–1950), renowned medical researcher, surgeon, and professor, was the product of a family with a strong intellect and demand for achievement. The Foggy Bottom community in Washington, D.C., in which he grew up also had high expectations for him and his age-mates. Highly trained and demanding teachers at Dunbar High School were educated at fine universities but were limited in job opportunities. The paradoxical beneficiaries of this concentration of talent in the African American community were students like Charlie Drew.

Imbued with drive, athletic ability, and scientific curiosity, Charlie Drew went on to Amherst College, where he was the Mossman Trophy winner as the most valuable athlete and a four-letter man in sports. Excluded from the housing and eating facilities of his teammates, Charlie nonetheless excelled athletically and scholastically.

Admitted to McGill Medical School in Canada, Drew excelled and persevered in his studies, despite the extraordinary impact of the Depression on his family's finances and their ability to support his medical training.

Exposed once again to limited expectations surrounding African American scholars, Drew completed his doctor of science degree at Columbia University and produced a thesis titled "Banked Blood." This work demonstrated the power of blood plasma to be used as a life-saving substitute for whole blood, and it required no refrigeration and no need for blood typing.

His efforts led to the development of the first Red Cross blood bank and to his appointment as director of the Blood for Britain program. He is shown here (on the far left) with his team, collecting blood for the war effort.

Drew's career path led to Howard University, where he became the chair of the Department of Surgery and a highly respected, forceful, and demanding teacher of young surgeons. His expectations of medical students reflected the same high standards of performance that he had experienced with his family and community. Residents who completed their surgical training under Drew placed first and second on their national surgical boards.

My father challenged his surgical residents to go to other hospitals throughout the country, learn the very finest surgical techniques, and bring them back to Howard University's Medical School. In this way, he ensured patients received the very best care, despite being in a segregated health care system.

Although his life was cut short by a tragic automobile accident, Drew's legacy lives on in the surgeons whom he taught and in their students. It also lives on at Howard Medical School, an institution to which he contributed so much.

CHARLENE DREW JARVIS

Freedmen's Hospital, Howard University, 1939

The federal government established Freedmen's Hospital in 1862 to treat the masses of former slaves who poured into the District of Columbia as a result of the Civil War. Soon after the war ended, the institution was officially affiliated with Howard University and became a teaching hospital. Eventually rebuilt on the site of Griffith Stadium at Florida and Georgia Avenues, this hospital trained generations of black doctors when many medical schools were closed to African Americans.

 This image of Freedmen's underscores the symmetry of the bare men's ward in 1939. Intern Vance Marshbanks looks over a patient's chart while men wait patiently for the camera from their hospital beds. Burke Syphax, a young surgeon at the time, remembers that all four wards of Freedmen's looked the same, with a sun porch at one end. Ellen Robinson David's father graduated from Howard's Medical School and was starting his own private practice in the late 1930s. She recalls that as a young girl, she visited the men's ward and accidentally sat on an unoccupied bed, much to the chagrin of the nurses who took very seriously their duty of keeping the hospital clean and orderly.

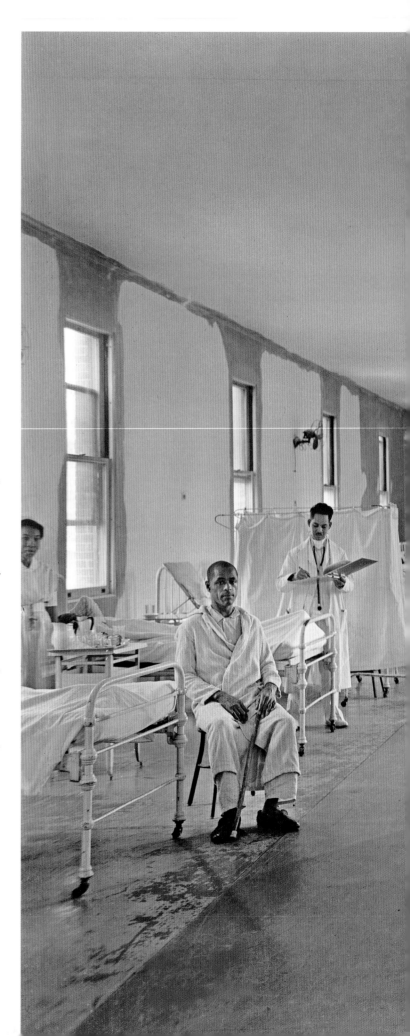

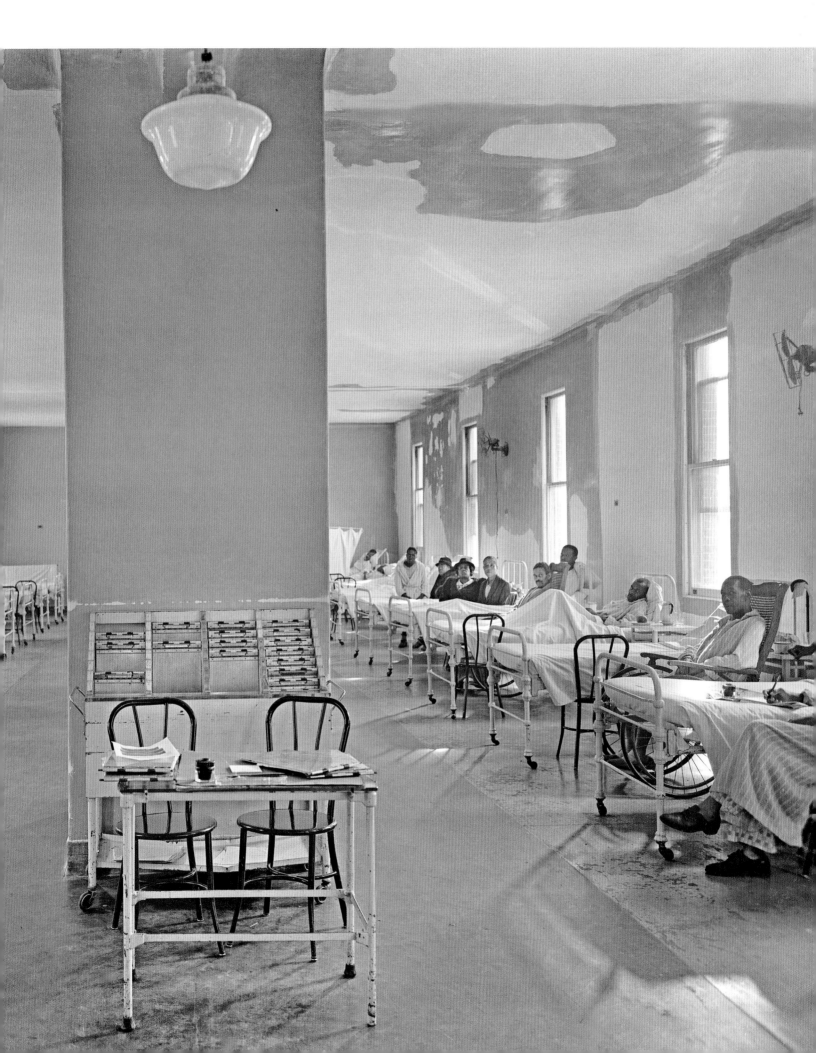

E. Franklin Frazier, c. 1940s

What memories were conjured up for E. Franklin Frazier (1894–1962) when he looked at this photograph of himself holding his new book, *The Negro Family in the United States*?

Perhaps he thought about how the creation of his book and using his name in print was relatively easy in late 1930s Washington but an impossibility in late 1920s Atlanta. In an autobiographical sketch titled "How Edward F. Frazier Became E. Franklin Frazier," he recounted that prior to moving to Atlanta he was known as Edward F. Frazier. After he moved in 1922, he began writing about racism in the South. He decided that writing truthfully about white people was a dangerous act because of their history of terrorizing truth tellers. Since not writing truthfully was out of the question, he decided that it would be best if his words were decoupled from his widely known name. The subterfuge worked for five years until he wrote "Psychology of Race Prejudice," an article that analyzed white people's racism as a pathological illness. The problem was not the veracity of his assertion but that the editors of the *Forum* signed his name as E. Franklin Frazier. According to Frazier, "Some white person called my house and asked my wife [Marie] if E. Franklin Frazier was the same person as Edward F. Frazier. When she innocently answered in the affirmative, that was the signal for whites to force me to leave the city for safety."

Perhaps he remembered that as an undergraduate student at Howard University, he did not have a single class with the word "Negro" in its title or a single class in sociology. In less than twenty years, he changed the lives of future students by returning to his alma mater in 1934 to chair the Department of Sociology and to create and teach such courses as Sociology 198, The Negro in America. (A memo rial editorial in Howard's *Hilltop* newspaper shared the popularity of Dr. Frazier's class. Taking it was a kind of intellectual hazing ritual—Frazier was truthfully blunt to black folks, too—that registered and "sitting in" students did not want to miss.)

Considering how Scurlock staged this photograph, I wonder how much he knew about Frazier's memories and the scarcity of "Negro" titles by "Negro" authors. Frazier sits so close to the bookcase full of (white-authored?) books that the chair appears to be actually welded to it. Or is it some newfangled bookcase chair, one that has only one arm and allows the reader-sitter to explore closely and comfortably the contents of the shelves?

Perhaps Scurlock was trying to make a point about how the scarcity of black-authored books on bookshelves necessitated that the bodies as well as the names of the authors be visible.

MARYA A. MCQUIRTER

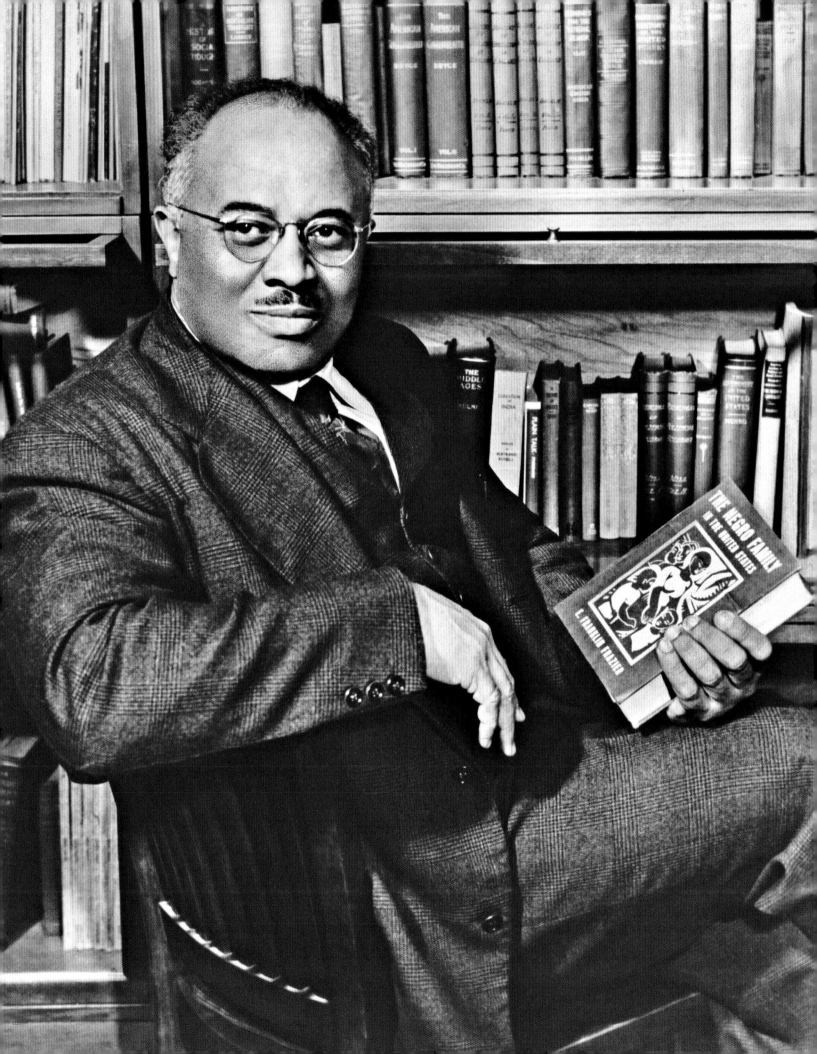

Sterling A. Brown, 1944

Poet and essayist Sterling A. Brown (1901–1989) had a life-long affiliation with Howard University. Born on campus, Brown later served as professor of English from 1929 to 1969. In the late 1930s, just prior to the time of this portrait, Brown also worked as a senior editor for the Federal Writers Project, part of the cultural arm of FDR's New Deal. There, among other activities, he wrote candidly in 1938 about issues of race and class in the city.

When the outsider stands upon U Street...and watches the crowds go by, togged out in finery...he is likely to be unaware...of aspects of life in Washington of graver import to the darker one fourth....

Around the corner there may be a squalid slum with people jobless and desperate; the alert youngster, capable and well trained, may find on the morrow all employment closed to him. The Negro of Washington has no voice in government, is economically proscribed, and segregated nearly as rigidly as in the southern cities he condemns. He may blind himself with pleasure seeking...he may point with pride to the record of achievement over grave odds. But just as the past was not without its honor, so the present is not without bitterness.

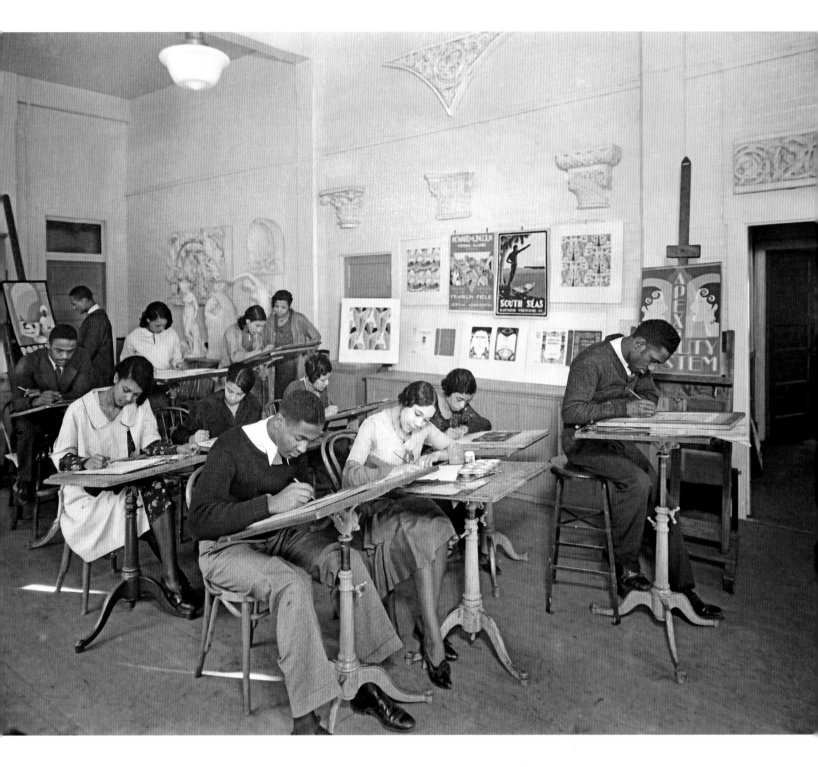

Class led by Lois Mailou Jones, c. 1930s

Here, world-renowned painter Lois Mailou Jones (1905–1998) stands beside a student at work in what appears to be a design class. Advertising posters for the Howard-Lincoln Classic at Franklin Field, Apex beauty products, and travel to the South Seas decorate the wall. Jones exemplified the intellectual and artistic leadership that graced Howard University for decades (see page 195). "The Scurlocks excelled at this type of photography and depicted many classroom scenes over the years at the University," writes Jeffrey John Fearing, who took classes with Professor Jones. "They adjusted camera swings and tilts to assure a sharply focused image from foreground to background. Shards of sunlight are seen on the floor, indicating partially obscured windows unseen to the left, but every subject is lighted evenly, without unwanted shadows or glaring hotspots."

Ralph Bunche, c. 1940s

United Nations Blue. Whenever I see a picture of Ralph Bunche (1903–1971), I immediately think "United Nations Blue." This is a particular blue—the name of which is my own creation, at least that's what I've been telling myself for decades now—that I had linked to Ralph Bunche somewhere deep in the recesses of my childhood's mind.

When I was four or five years old, my mother read to me Margaret Young's *A Picture Life of Ralph Bunche*, one in a series of children's books on famous black Americans. I would be lying if I claimed to be able to recall anything of substance about the book over the next two decades beyond the facts: the cover featured a picture of this very famous black man named Ralph Bunche, and the cloth-covered book was United Nations Blue.

During my first year of graduate school I stumbled again into Ralph Bunche. I began a research paper in which I explored the start of his teaching career at Howard University and his efforts to make a name for himself as one of the radical young scholar activists of the early 1930s. I vividly remember being floored to discover this latter aspect of Bunche's history. After all, he had been passed down to me not as a radical but as an international mediator, as a fighter for world peace, and as a "great man of history."

But Bunche during the 1930s was something else. His class-based politics crackled throughout his writings and his speeches, and he pointedly criticized black leaders whom he found too cautious or focused on race. Fast forward a few decades to the 1960s. This earlier radicalism was forgotten by others or either left behind or hidden by Bunche. Depending upon your world view, he was by the mid-1960s either the embodiment of the establishment or its mere tool.

What we have in this portrait by Robert Scurlock is neither the angry "Young Turk" of the 1930s or the "International Uncle Tom" of the 1960s. Instead, we see Bunche, still at Howard, prior to his winning the Nobel Peace Prize in 1950 on behalf of the United Nations, leaning over the globe in his office and standing in front of packed bookshelves. The globe rests next to the recently published *Behind God's Back* by Negley Farson—a 1940 book that not only provides a sweeping narrative of contemporary Africa and its political struggles but here also serves as a reminder that Bunche was a scholar who specialized in African colonial systems. (Is it coincidence that the only readable book title on the shelves is *Africa* and on the globe Africa faces *Behind God's Back*?) At the time this photograph was taken, Bunche was one of the few Africanists of any sort in the United States, and his expertise became invaluable as rival countries vied for land on the "Dark Continent." Is it any wonder that the United Nations soon came calling?

In Scurlock's vision, Bunche is posed as if he is ready to take over the globe. If only for the sake of consistency with my childhood association, I cannot help but think that if this photograph were in color we'd see hints of United Nations Blue.

JONATHAN HOLLOWAY

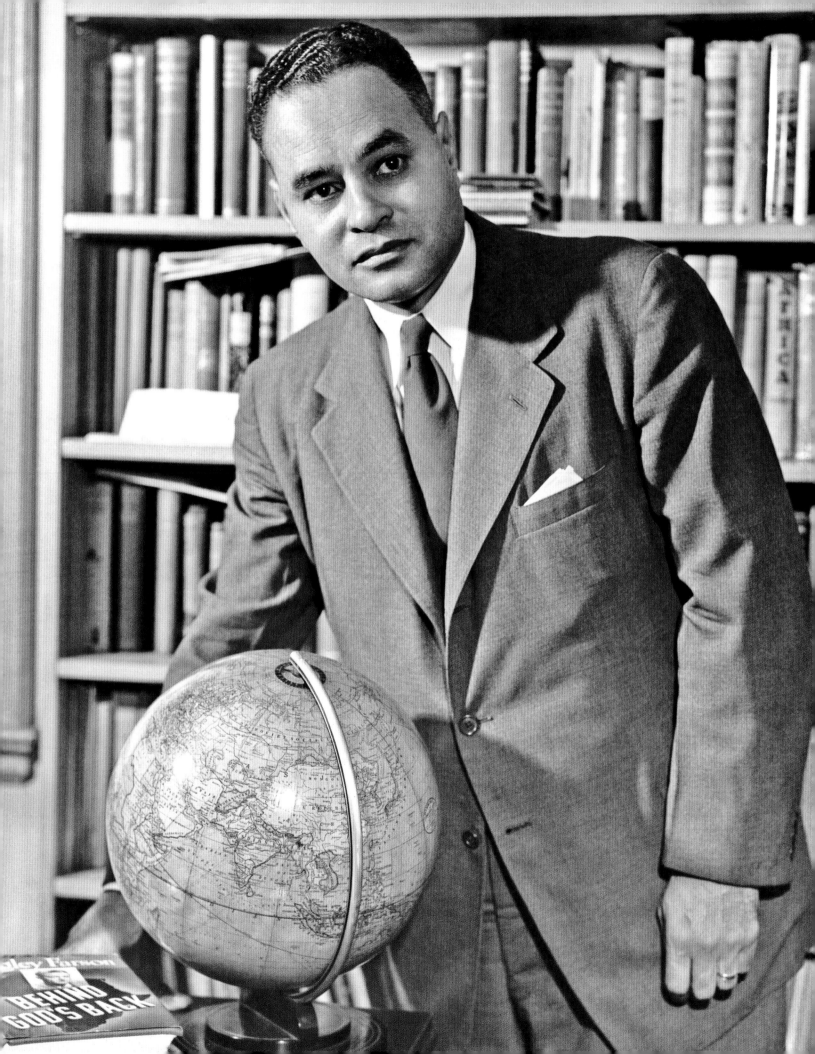

Mary McLeod Bethune at a Women's Day banquet, 1949

Mary McLeod Bethune (1875–1955), founder of the National Council of Negro Women, addressed the young women of Howard University for its Women's Day banquet in 1949. An activist, Bethune (see page 183) challenged them to become involved in the surrounding city.

Washington offers you a superb opportunity to see how the theories and principles which you study in your classrooms apply to real life situations.... Washington is the world in microcosm. Located here is our own national government; here are representatives from the many governments of the world; here are national and international organizations as well as organizations of special interests. And yet here also are the problems of the people of the world; from the poverty and blight seen in our wretched slums to the homes of great comfort and beauty...to the luxurious estates which display the concentrated wealth of their owners....If you have intellectual curiosity, if you want understanding... and if you want to make this a better world for your future children, I cannot urge you too strongly to study and participate in the Washington community...creating a new society where social justice, equality, freedom, and brotherhood are real, where democracy is a way of life.

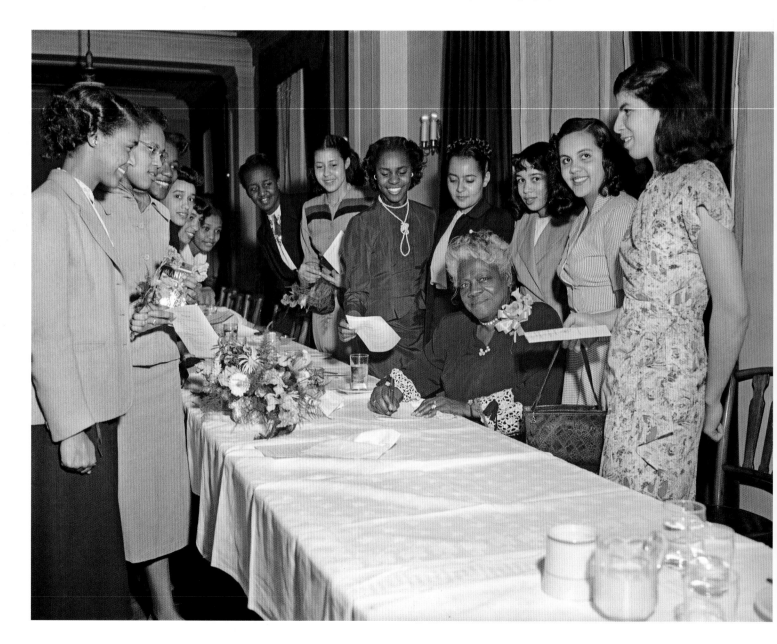

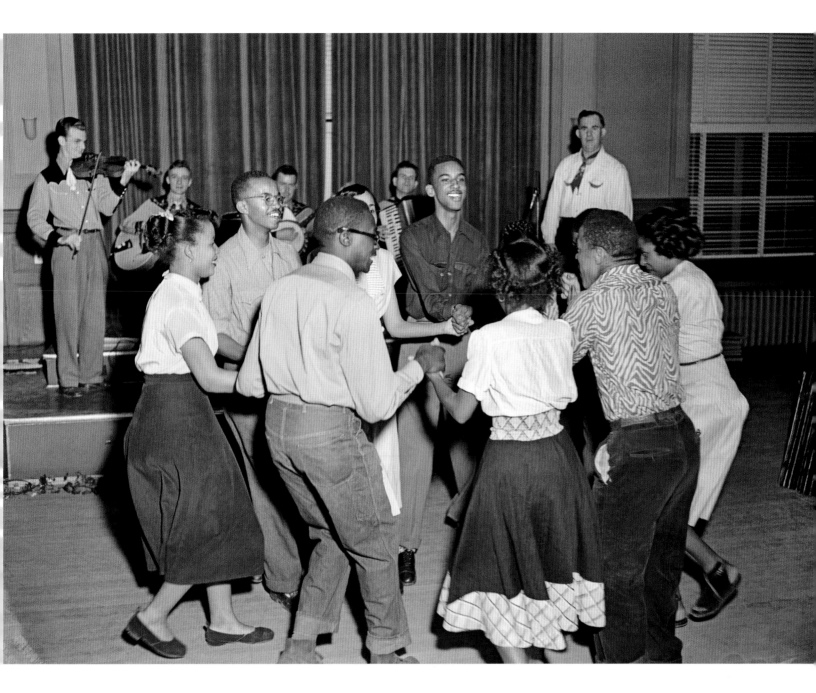

**Square dance at Howard University,
following reception for Mary McLeod Bethune,**
1949

Mary McLeod Bethune's presence at the seventh annual
undergraduate Women's Day conference, where she was
"besieged by autograph seekers," underscores Howard
University's ability to introduce its students to the leaders
of the African American community and thus awaken the
students' commitment to racial and social change. Here,
students celebrate their guest of honor with a square dance.
Afterward, they serenaded Mrs. Bethune with a version of
"Let Me Call You Sweetheart," reported Howard University's
Hilltop.

Howard-Lincoln Classic at Griffith Stadium,
Thanksgiving Day, 1948

Due to the inherent inequality of segregation, black colleges and universities operated their sports programs with meager budgets, inadequate equipment, and poor facilities. Despite these hardships, Howard and other universities developed some of the best players and coaches in the country. More than that, they initiated their own conference systems and postseason championships, bowl games and All American teams, mascots, bands, and intercollegiate rivalries. One of the most memorable was the Thanksgiving Day rivalry between Howard and Lincoln University in Pennsylvania. In 1927 Howard University sociologist William H. Jones claimed, "Through its annual Thanksgiving football classic with Lincoln University, [Howard] has given to the Negro life of Washington a prestige among other cities... which no other field of Negro life in the capital can approximate....It draws to Washington more than ten thousand people from other sections of the country....Every day for approximately a week scores of important social affairs are held....Two gigantic spectator crowds, totaling approximately 20,000 people, wild with enthusiasm, assemble at the stadium to witness the classic." Scurlock captured this same enthusiasm twenty years later with his action shot of Coach John Burr's team, including fullback Sandy Green and co-captain Jug Marshall, during the 1948 game.

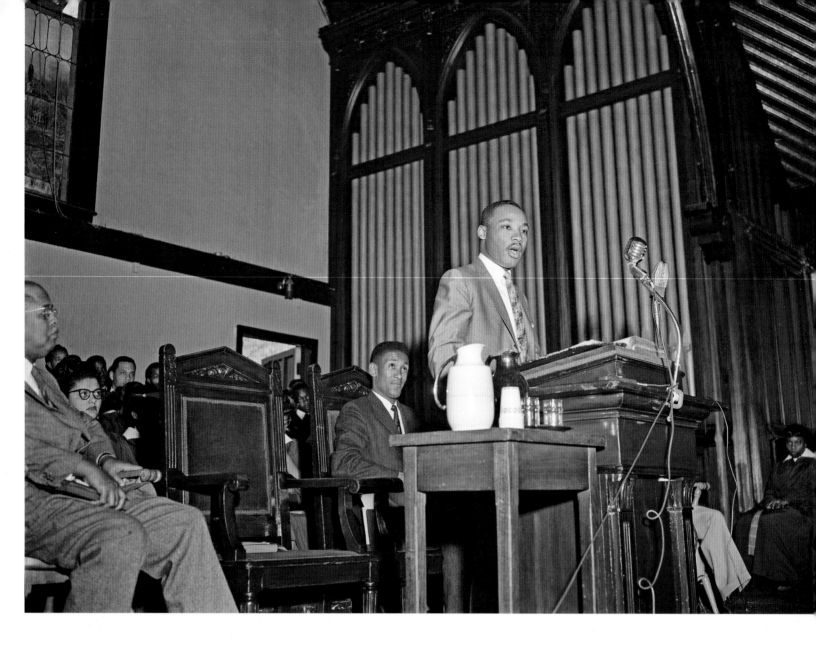

Reverend Dr. Martin Luther King Jr., 1956

The Scurlocks documented several of Dr. Martin Luther King Jr.'s visits to Howard University. Here, King speaks at Rankin Chapel in December 1956. The woman seated behind him to the left is Patricia Harris, who later became Secretary of Labor in the Carter administration. This photograph was taken at the bitter end of the successful Montgomery Bus Boycott that thrust King into the national spotlight. Just a few months later King took his first trip to Africa, where he celebrated the declaration of independence of Ghana. There, along with a delegation of African American civil rights leaders that included Howard's president Mordecai Johnson and Ralph Bunche, King witnessed the inauguration of Kwame Nkrumah, Ghana's new president. In early June, soon after his trip to Africa, King returned to Howard, where the Scurlocks again photographed him alongside baseball star Jackie Robinson as he received an honorary Doctor of Letters degree.

Jacqueline Bouvier Kennedy and John F. Kennedy at Howard, 1960

George Scurlock photographed Senator John F. Kennedy and Jackie Kennedy at Andrew Rankin Memorial Chapel on October 7, one month before JFK was elected president. He appeared at Howard after his second debate with Republican presidential nominee Richard Nixon. There, he gave a short speech to the Leadership Workshop of the American Council on Human Rights. The theme of the two-day event was "A Political Primer for the 1960s: Education–Understanding– Action." The Howard *Hilltop* reported that Kennedy received a standing ovation from the audience, and before he entered, "he was met with an enthusiastic welcome from the crowd of students that surrounded the Chapel." Here, JFK shakes hands with Spotswood W. Robinson III, a Howard law graduate and professor who was the first African American to sit as a federal district judge and serve on the Federal Court of Appeals in the District of Columbia. On the far right may be Lorraine Williams, who became chair of Howard's Department of Social Sciences in 1962. George Scurlock's more formal portrait of Kennedy speaking from the podium that night—where he claimed, "When Negroes have the opportunity to vote unrestrictedly, they must fully exercise that right!"—became the most requested image of the photographer's career.

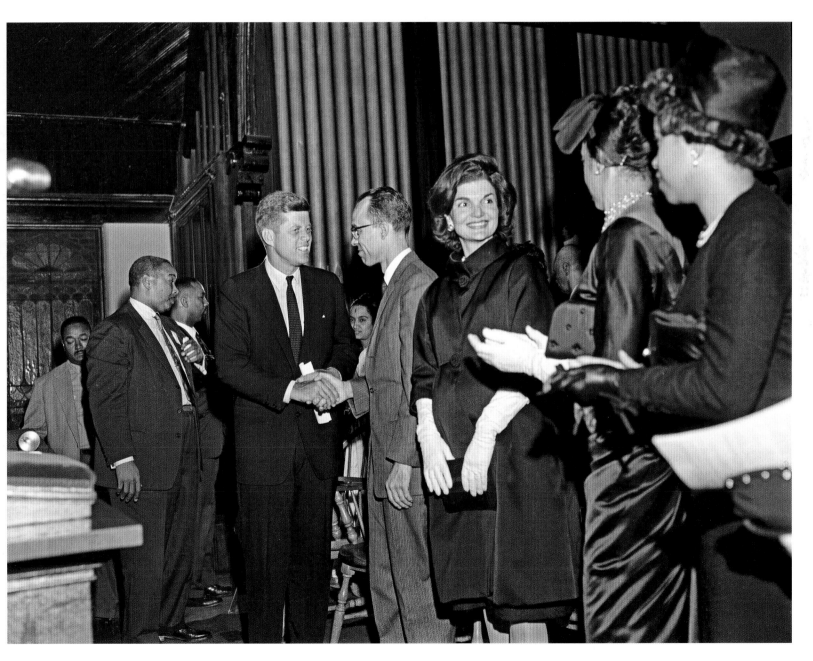

Students outside Founders Library, c. 1960s

When I arrived on the campus of Howard University the afros were there. Students had taken over the administration building a few months before I dropped my foot locker in a Cook Hall room. My primary reason for coming to Howard was to find a wife. I had no idea of what to major in. I did make the mistake my freshman year of running for class treasurer. By the time I received a third letter from home I had resigned from student government. Why? After a rowdy meeting in Locke Hall and being threatened by hostile members of the black middle class, I was forced to spend the entire class budget on a social event. I think someone might have voted for square dancing. There was a revolution going on around Fourteenth Street, and folks at Howard wanted to party. So much for Black Power. Needless to say, the whole thing left me angry and flabbergasted by my own people. What were the women with the big afros doing? Where were my revolutionary sisters?

I found "black womanhood" to be standing around on campus like Motown singing groups. Every girl had a way of opening my nose a little wider. I quickly discovered that large afros left hair grease on one's glasses after a serious embrace. I also learned that the place where guys went to meet girls was Founders Library. The building with the clock tower was how it was often described. There was a folktale or myth about how the clock stopped every time a virgin walked by. No one knew if the virgin was male or female.

Scurlock's Howard photos remind me that I might still be too young to go steady. So much of my life was spent walking across the campus yard. On Fridays students watch the Greek organizations perform their rituals. Others simply stand, posing as if Howard was Harlem and it was the 1920s again.

In this photograph I can see my office window. From 1974 to the present, I've worked at Howard University. The third floor of Founders Library is where the Afro-American Studies Department is located. The creation of the department was a student demand. How could anyone say no to an afro? Once, Michelle (the girl who became my first wife) came by my dorm and surprised me—she was wearing one of her roommate's afro wigs. We immediately had an argument, and I told her to take it off. There was something phony about wearing an afro wig. It was like holding up one's fist and thinking you could knock out racism. I don't think the women in the Scurlock photograph are militants. They seem to be wearing fashionable outfits. Where are their blue jeans, army jackets, and berets? Why are they looking in different directions and not upholding a circle of black unity? Might they be wearing wigs? What time is it on the clock? I suspect it's not Nationtime!

E. ETHELBERT MILLER

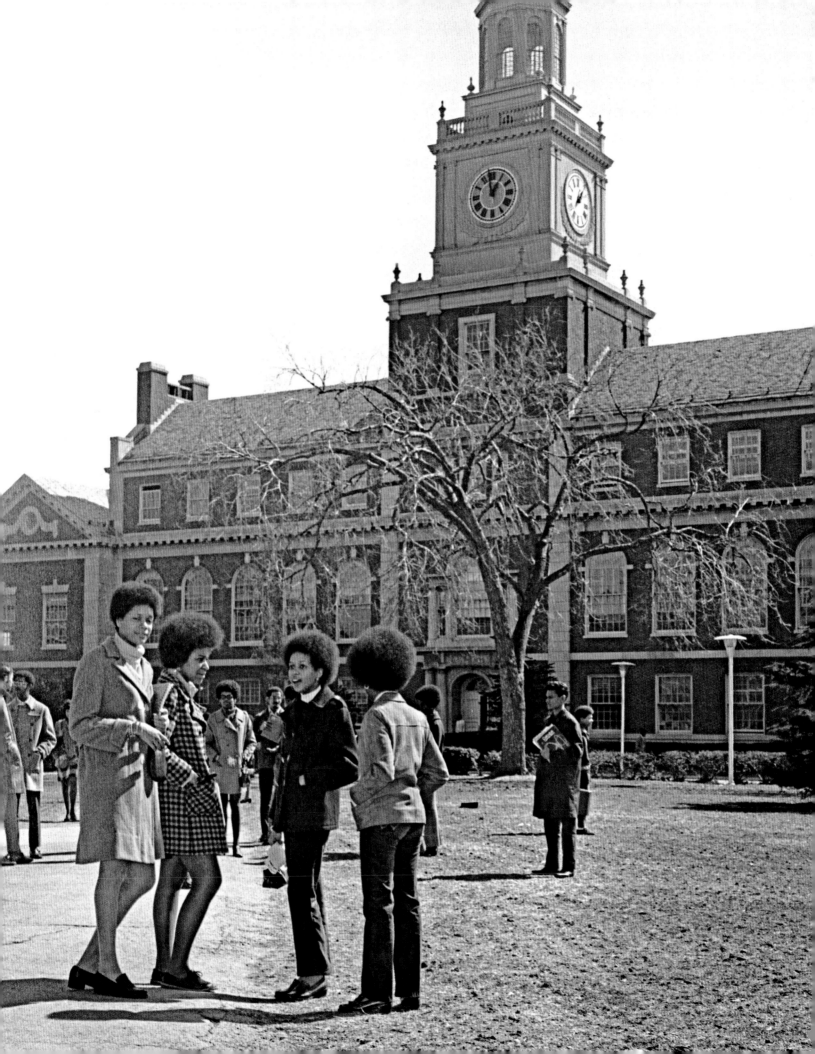

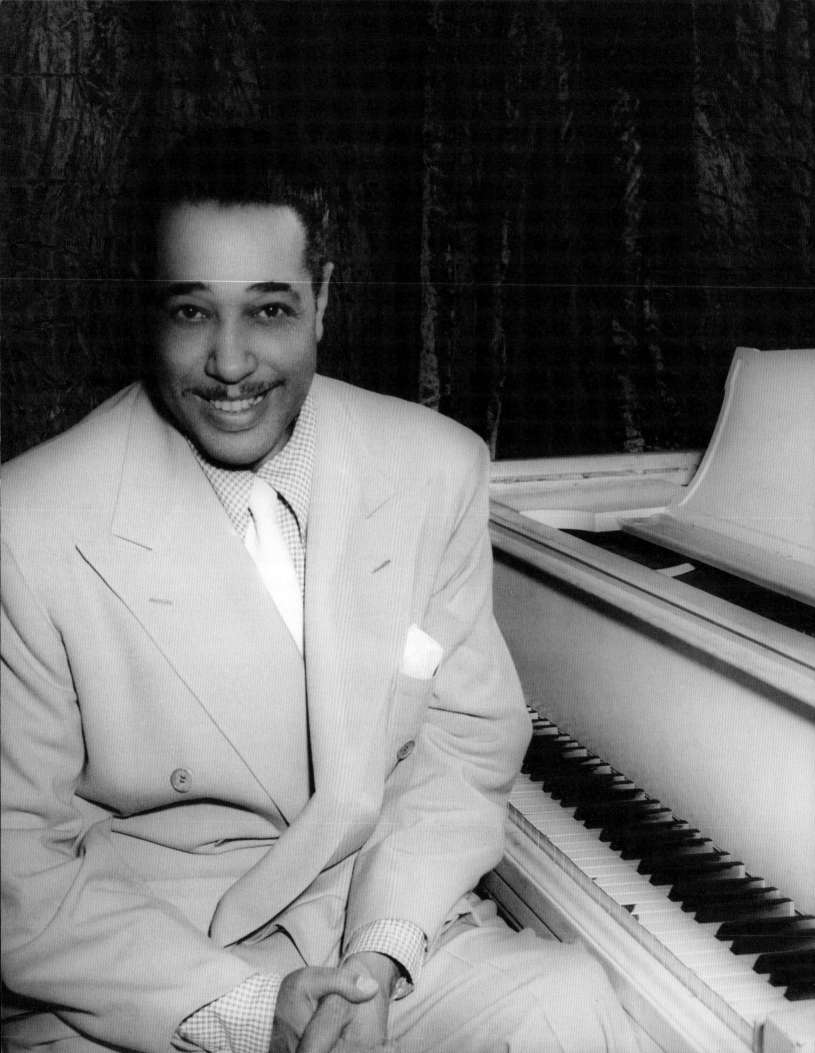

LUMINARIES

TULIZA FLEMING

DOROTHY HEIGHT

JAMES A. MILLER

JENNIFER MORRIS

DARYL MICHAEL SCOTT

HILARY SCURLOCK

Duke Ellington (detail), c. 1930s

Protest courageously with dignity and Christian love. History will then say there lived a great people—a black people—who injected new meaning into the veins of civilization. This is our challenge and overwhelming responsibility.

GORDON PARKS

Washington, D.C., is often seen as the center of national politics and diplomacy, but it was once the epicenter, the capital of black America. Since the late nineteenth century, the nation's capital has been an essential and frequent destination for African American politicians, civil rights activists, African and Caribbean leaders, intellectuals, authors, artists, and entertainers. This was a result of the location of the federal government and Howard University. As word of Addison Scurlock's style and expertise in portraiture grew, a visit to his studio at Ninth and U Streets became a regular stop for a dizzying array of luminaries. By the dawn of World War I, Scurlock's technique was significantly influenced by the prominent pictorial or art photographers of the era. His distinctive use of a dignified soft focus, artful bust length compositions, and color-conscious lighting soon attracted this important clientele.

The Scurlock Studio operated in the midst of the historic black neighborhoods surrounding U Street and Howard University. Even though this community existed a short distance from the White House and Congress, segre-

gation imposed a racial divide in the city throughout much of the twentieth century. Despite this, the Scurlocks, like so many other African American families, were part of a rich and viable community enlivened by its proximity to the campus of Howard University. Addison Scurlock's local portrait business and his work as the official photographer for Howard successfully launched his career and secured his prominence in the community. The Scurlock Studio also belonged to the White House press corps and photographed presidents from Calvin Coolidge through JFK.

In 1896 the halftone process was perfected for reproducing photographs in newspapers, magazines, and journals. Photographers soon replaced the work of illustrators and artists. Addison Scurlock took advantage of this new technology and from early in his career had images published in leading African American newspapers, including the *Afro-American, Washington Tribune, Norfolk Journal and Guide, Pittsburgh Courier, Cleveland Call and Post*, and *New York Amsterdam News*. The most important national exposure for portraits and photographs from the Scurlock Studio was the publication of images in the *Crisis*, the journal of the National Association for the Advancement of Colored People. Respected scholar, author, and activist W. E. B. Du Bois served as the journal's editor.

Addison Scurlock and Du Bois were clearly linked by their commitment to racial uplift through education and community cohesiveness. Both recognized the power that visual culture could play in crafting a modern black identity. Scurlock's portraits of influential local and national leaders within the black community, as well as his photographs of community businesses in the District, illustrate numerous

articles in the *Crisis*. Du Bois frequently used Scurlock's images of African American high schools in the nation's capital, of Howard University college athletes, students, and graduates, of those who received the highly respected NAACP Spingarn Medal for achievement, and of local Washingtonians to fill the journal's pages.

One hundred years later it is difficult to recreate the circumstances by which Addison Scurlock determined his personal definition of "fine photography." He certainly used the term when he referred to the photographs created in his studio. Was he aware of the work and writings of other emerging art photographers in New York, Boston, and Philadelphia? Did he read the influential *Camera Work* journal edited by powerhouse New York photographers Alfred Stieglitz and Edward Steichen? Or did he refer to other magazines that advanced opinions on American portrait photographers and their best works? Did he know of the local D.C. camera clubs? Did he visit the Smithsonian's photography exhibitions held in the National Museum building beginning in the 1910s? Did he follow the developing careers of other African American photographers, especially those associated with the Harlem Renaissance of the 1920s?

Regardless of the answers, the Scurlock Studio obviously photographed almost every nationally significant African American figure of the period. No other photographer comes close to sharing that distinction. From 1904 until 1994, the Scurlock Studio photographed African American luminaries and newsmakers with a distinct artistic quality. The composition, focus, and lighting techniques of the Scurlock portrait, as initiated and later taught by Addison to his sons and others, defined the studio's best work across the years. These portraits represent the combined work of all three Scurlocks—Addison, Robert, and George. The classic "Scurlock look," evident in many of these images of luminaries, firmly establishes the studio among the best commercial portrait studios of the twentieth century.

This work also demonstrates the impressive array of political and educational leaders, intellectuals, artists, and writers who were drawn to Washington, D.C., and the Scurlock Studio. These portraits convey the intellectual depth and political acumen that characterized the era. Despite the challenges posed by segregation, racially driven poverty, and the struggle for civil rights, these individuals—heroically photographed by the Scurlocks—developed strategies, crafted educational initiatives, and confronted discrimination in ways that changed America forever.

Grant's Rear Guard, 1905

Pinckney Benton Stewart "P. B. S." Pinchback (1837–1921), in the center, served as a Union officer in the Civil War and later as the first African American governor of Louisiana for a short period during Reconstruction. A Republican and a supporter of President Ulysses S. Grant, Pinchback studied law at age fifty and moved to Washington, D.C., where he continued to be active in politics. He posed here with Jim Lewis of Arkansas, on the left, and Judge Mifflin Gibbs, the first municipal judge of Little Rock, Arkansas. Pinchback's custom-built house on Bacon Street in Washington's Columbia Heights neighborhood became a meeting place for generations of black leaders until his death in 1921. His grandson, author Jean Toomer, wrote about the setting in his journals, which were published posthumously as *The Wayward and the Seeking*. Addison Scurlock's informal portrait of aging Civil War–era leaders was probably taken in front of the Pinchback home.

Paul Laurence Dunbar, c. 1900

This portrait of poet and author Paul Dunbar (1872–1906) is among the earliest images in the Scurlock Studio Collection. Research shows it is a halftone print, a photomechanical reproduction of the frontispiece portrait in Dunbar's 1905 publication of *Lyrics of Sunshine and Shadow*. This portrait by an unknown photographer was frequently requested for local use. The Scurlocks probably rephotographed the original book portrait and then distributed the print as ordered. Not only did this type of copy work provide clients with reproductions of prints, but it was also a lucrative part of the studio's business and may have helped Addison develop his own style of portraiture.

A gifted poet, Dunbar sought dignity and meaning by creating poetry that included southern or "Negro" dialect. Yet poems such as "When Malindy Sings" (1896) reveal the skill and depth of beauty that shaped much of his writing (see page 98). Dunbar achieved significant success in his short life before he died of tuberculosis at age thirty-three. His parents escaped slavery and raised Dunbar in Dayton, Ohio, where he actively participated in the local high school. Despite being the only African American, he befriended fellow students (and future pioneer aviators) Orville and Wilbur Wright. As a young man, Dunbar associated with both Frederick Douglass and Booker T. Washington.

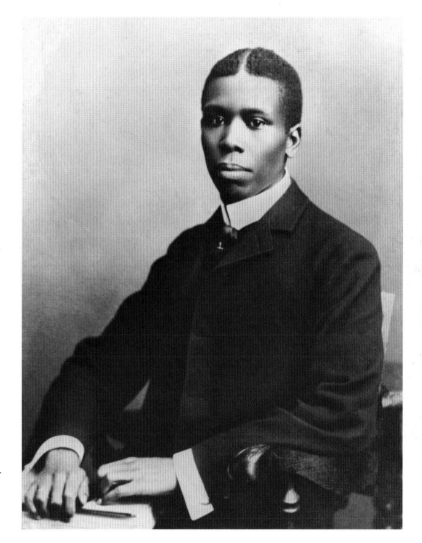

NAACP Midwinter's Ball, Baltimore, Maryland, 1912

Time appears to have stopped at this formal Midwinter's Assembly Ball for the National Association of Colored People (NAACP) in Baltimore, Maryland, which Addison Scurlock photographed sometime before February 1912. The elegantly dressed African American couples gaze at each other or look off into the distance—but no one acknowledges the camera. Each person is frozen in place, as if waiting for the music to begin again so the evening's grand celebration can continue.

How did young Addison Scurlock successfully pose such a large group? Even though he was still in his first year of operating his own professional photography studio, he already commanded the advanced skills needed to achieve this expertly focused group portrait using a panoramic banquet camera and flash lighting. W. E. B. Du Bois, a founding member of the NAACP, is present (lower left center), as are many of the most influential African American leaders of the early twentieth century. Researching the *Crisis*, the monthly publication of the NAACP, it is quickly apparent that Scurlock's work was hightly valued by Du Bois, the publication's editor. The first issue of the *Crisis* was printed in November 1910, and the first Scurlock photograph appeared in the July 1911 issue. Scurlock images were prominently used throughout the journal for the next twenty-five years, until Du Bois stepped down as editor in 1935. The work of Addison Scurlock and other African American photographers published in the *Crisis* capture "The Social Life of Colored America," as the caption for the Midwinter's Assembly states in the February 1912 issue of the magazine.

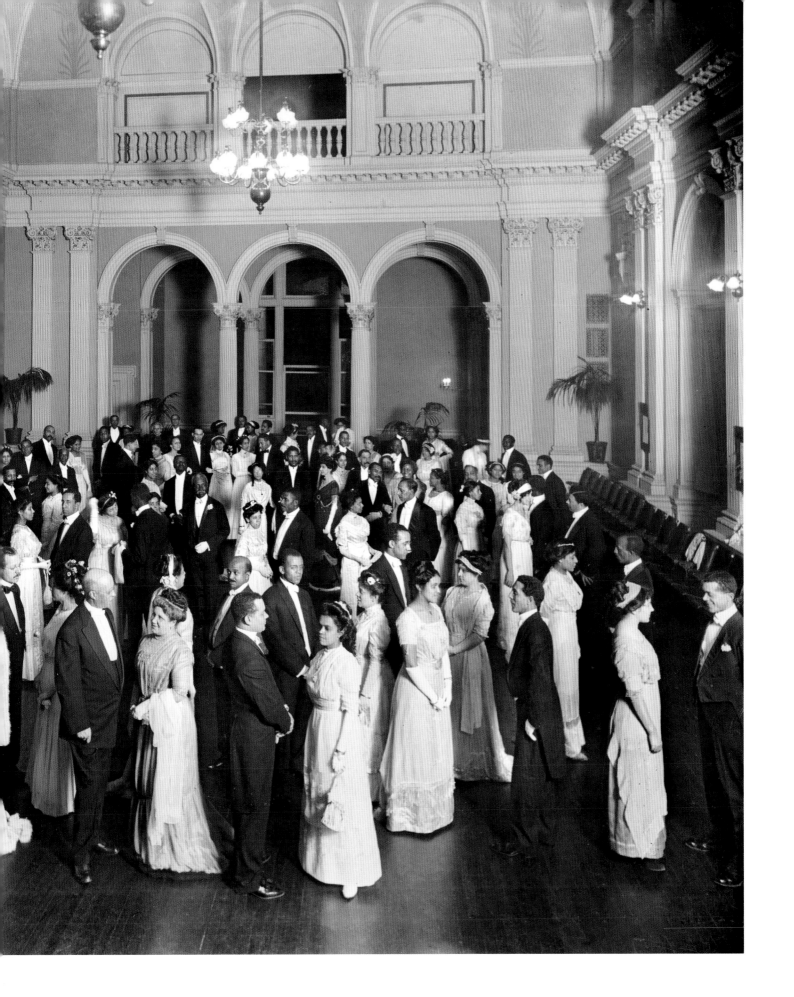

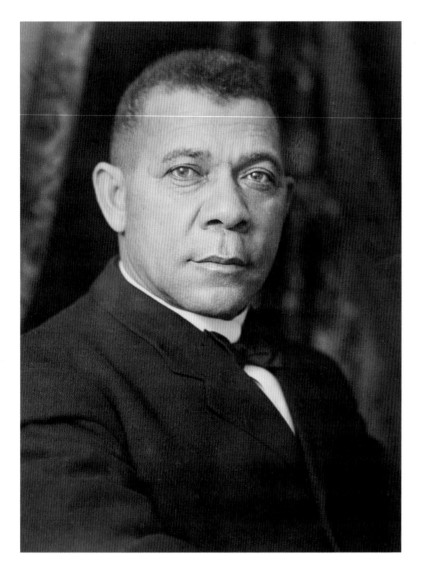

Booker T. Washington, 1910

Booker T. Washington (1856–1915), educator and founder of the Tuskegee Institute in Alabama, was arguably the most influential African American leader of his era. At the time of this photograph, Washington's emphasis on vocational education and accommodation with white racial prejudice was being challenged by a new generation of leaders, including W. E. B. Du Bois, who sought more direct confrontation with the racism that limited the black community. In his autobiography, Washington offered his own "portrait" of black Washington at the turn of the century.

> *During the time I was a student...the city was crowded with coloured people, many of whom had recently come from the South. A large proportion of these people had been drawn to Washington because they felt that they could lead a life of ease there....All this tended to make Washington an attractive place for members of the coloured race....I took great interest in studying the life of our people there closely at that time. I found that while among them there was a large element of substantial, worthy citizens, there was also a superficiality about the life of a large class that greatly alarmed me.*

Mary Church Terrell, c. 1920s

A staunch advocate and activist for women's rights and integration, Mary Church Terrell (1863–1954) was the founding president of the National Association of Colored Women and served as the first African American woman on D.C.'s Board of Education. Terrell's community work in supporting the enforcement of antidiscrimination laws ultimately contributed to the important Supreme Court decision in 1954 that ended legal segregation. She represents a generation of black women who not only stressed education and middle-class values but also confronted discrimination by demanding justice through legal means and direct action. In 1940 Terrell wrote powerfully about Washington's inequality to blacks.

> *Surely nowhere in the world do oppression and persecution based solely on the color of the skin appear more hateful and hideous than in the capital of the United States, because the chasm between the principles upon which this Government was founded, in which it still professes to believe, and those which are daily practiced under the protection of the flag, yawn so wide and deep.*

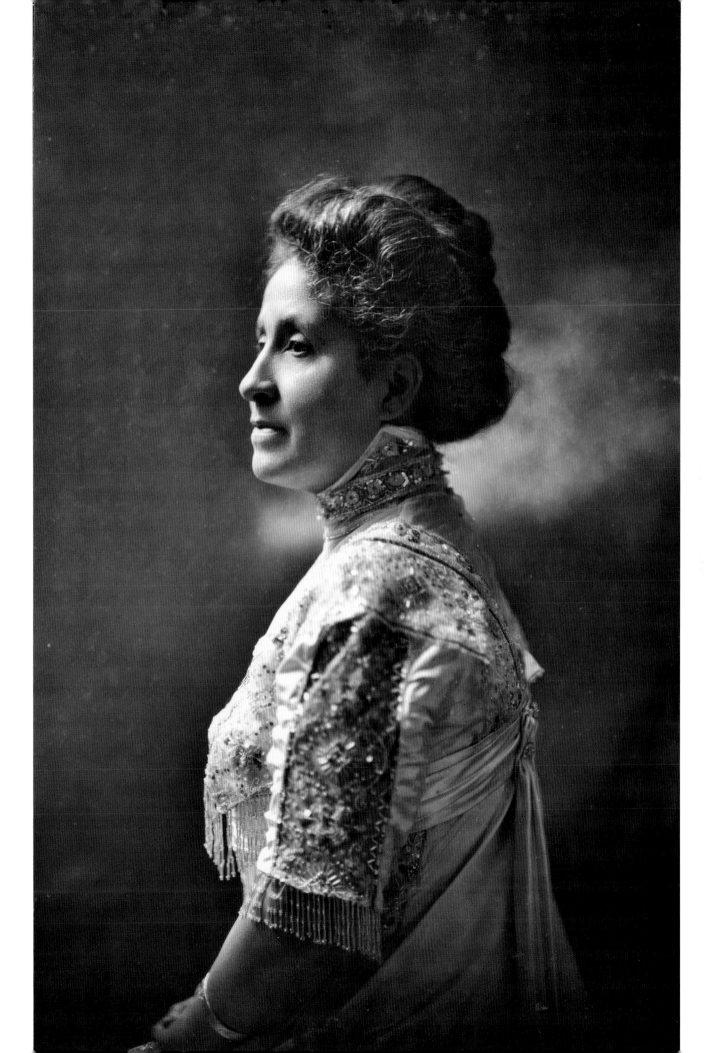

Carter G. Woodson, 1915

Taken in 1915, Scurlock's portrait of Carter G. Woodson (1875–1950) shows him at age thirty-nine, during the defining year of the scholar's career. In the same year that film director D. W. Griffith maligned African Americans with his movie *The Birth of a Nation*, Woodson dedicated himself to changing how the world viewed Africans and peoples of African descent. In September he embarked on his life's work: the creation of the Association for the Study of Negro Life and History (ASNLH). This led to the establishment of the black history movement.

Holding a doctorate in history from Harvard University, Woodson was a teacher in the D.C. public schools system in 1915 when G. P. Putnam's Sons published his first book, *The Education of the Negro Prior to 1861*. That summer Woodson was in Chicago, staying at the YMCA and manning a display on black history at Chicago's Negro Exhibition. On September 9, Woodson gathered at the YMCA with four other men—James Stamps, George Cleveland Hall, W. M. Hargrove, and Alexander L. Jackson—and formed the ASNLH. During the late fall, Woodson solicited scholarly articles on the Negro, and then edited and published the first issue of the *Journal of Negro History*, which was formally launched in January 1916. For Woodson, 1915 was a critical year!

Scurlock depicts a man transformed by education and the urban experience. Born and raised in Buckingham County, Virginia, Woodson spent much of his youth in rural areas and small towns. He mined coal in West Virginia, attended Berea College in Kentucky, and taught in rural areas of the Philippines. His study at the University of Chicago in 1908 initiated him into urban life. Yet it was Washington, D.C., that changed the country boy, who arrived in the city dressed like a "hayseed," into the urbane figure who frequently traveled to Paris in the 1930s. Notably, Scurlock photographed him in a formal shirt and tie.

This serious portrait became the dominant public image of Woodson for most of his career. It was also the image that Woodson used during the late 1920s and 1930s when he worked as a regular columnist for a number of black newspapers, including two with national circulation, the *Chicago Defender* and the *Pittsburgh Courier*.

The ubiquity of the portrait suggests this was the self-image Woodson preferred. Even though he sat for several studio portraits over the years, this remained the dominant one until Woodson entered into his sixties and could no longer convincingly present himself as a young man. This dapper image was replaced by a more avuncular Woodson, who posed for a group of images taken in his library. The man long suspended in his prime was transformed into the "father of black history." Not surprisingly, Scurlock created that image, too.

DARYL MICHAEL SCOTT

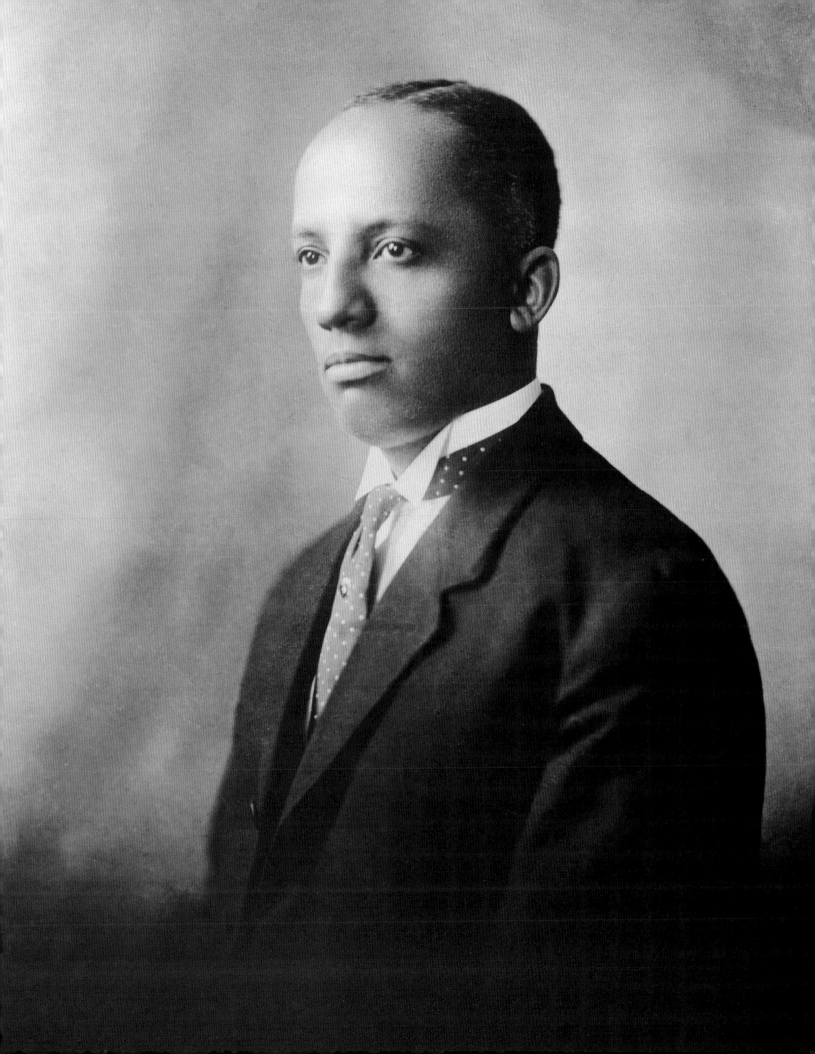

Madam C. J. Walker, 1915

A prominent businesswoman, Madam C. J. Walker (1867–1919) visited Washington as she toured the nation promoting her salons and hair care products for African American women. She successfully forged a market by servicing the beauty interests of women who were traditionally ignored by white purveyors of beauty products. On at least one occasion Walker visited the Scurlock Studio for her portrait. Addison created a stunning image that became familiar to many through its frequent use in Walker Company advertisements. In 1998 this portrait was included in the Black Heritage stamp series issued by the U.S. Postal Service.

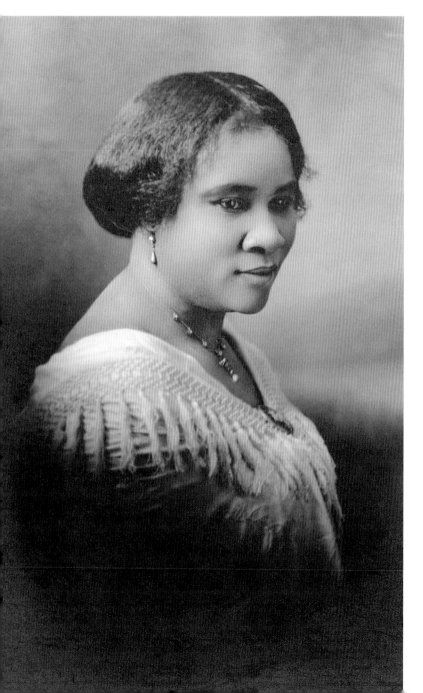

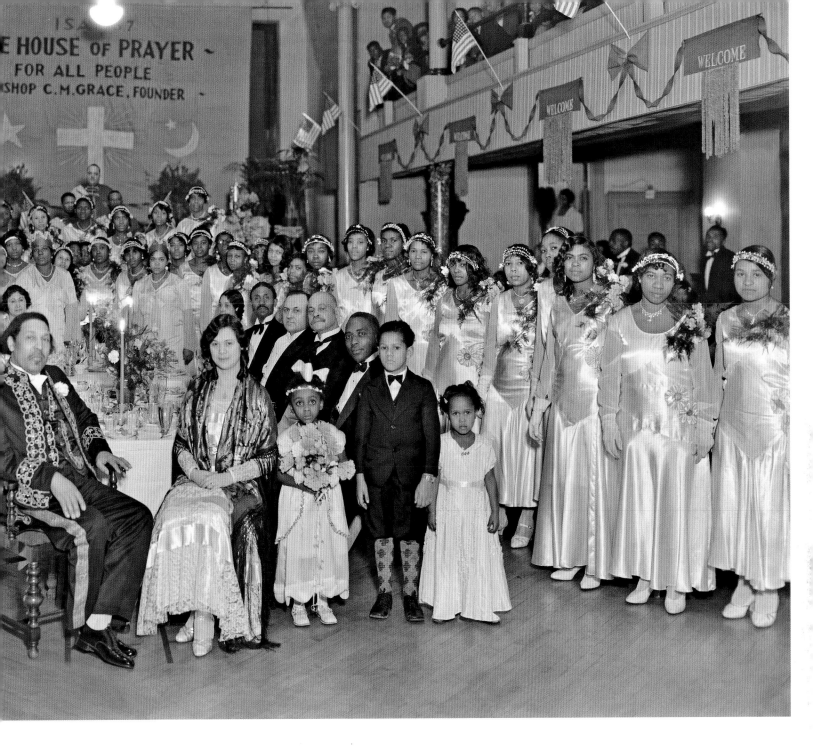

**Bishop C. M."Sweet Daddy" Grace and
his congregation of the United House of Prayer
for All People,** c. 1930s

Addison Scurlock photographed many events for the United House of Prayer, including this large group portrait. Scurlock Studio group portraits had a signature format, one Addison perfected in the 1930s and 1940s by using a large banquet camera. Charles Manuel Grace (1881–1960), known to his followers as "Sweet Daddy," moved the national headquarters of his United House of Prayer for All People from Massachusetts to Washington, D.C., in 1927. A truly charismatic leader and sensational figure in the black community, Grace established a huge following for the church based at 601 M Street, NW. Ceremonial parades and baptisms, enlivened with pageantry and music, appealed to many of the recent black migrants to Washington and provided an alternative to traditional Protestant religion. Today, the United House of Prayer boasts 1.5 million members in twenty-five states.

Madame Evanti as Lakmé, 1925

Lillian Evans Tibbs, known professionally as Madame Evanti—a name suggested by the author Jessie Fauset—was the first African American to sing in an organized European opera company. In 1925 Madame Evanti made her operatic debut in Nice, France, in the principal role of Léo Delibes' *Lakmé*. Before her retirement in the 1950s, Evanti received acclaim in Europe, South America, Africa, and the Caribbean for her operatic talents. Celebrated internationally, she was denied the opportunity to perform at many venues in her native country, including the prestigious Metropolitan Opera. This continued until 1943 and her performance in Verdi's *La Traviata* with the National Negro Opera Company at Washington's Watergate Theater, a moored barge that floated on the Potomac River. The audience sat along the riverbank to watch the performance. During a career that spanned some thirty years, Madame Evanti was decorated by several countries, performed at the White House during the Roosevelt administration in 1934, served as a goodwill ambassador, and composed ten songs that were published by W. C. Handy.

Born Annie Lillian Evans in a highly educated, prominent middle-class family, the lyric soprano thrived as a member of Washington's black elite. Her father, Dr. Bruce Evans, was a founder of Armstrong Technical High School and served as its first principal. Her mother, Anne Brooks Evans, was a music teacher in the public schools system of Washington. Joseph Brooks, her maternal grandfather, served in the D.C. Territorial legislature in the 1870s. Hiram Revels, the first African American senator in the United States Congress, was her great-uncle, and two relatives took part in John Brown's raid on the armory at Harpers Ferry in West Virginia. Perhaps Lillian Evanti's pride in her rich heritage contributed to her determination to rise above adversity and to pursue a musical career. She married Howard University music professor Roy Tibbs.

Addison Scurlock's portrait of Lillian Evanti dressed as *Lakmé* conveys the beauty, dignity, and elegance she exuded to all. According to Dorothy Porter Wesley, librarian and archivist at Howard, "She had a very pleasing personality." She first met Evanti as a student at Miner Teachers College, where Evanti was an instructor in music. Wesley served as an accompanist to Evanti at school assemblies and selected church appearances. Local churches hosted and supported her concerts as early as 1915.

Beyond her beauty and charming personality, Madame Evanti's confidence, courage, and faith enabled her to achieve success despite the odds against her. Like her ancestors, she was a trailblazer whose efforts paved the way for others to pursue their operatic dreams. Lillian Evanti embodied the values that many African Americans held dear in the early twentieth century, namely, self-determination and empowerment.

JENNIFER MORRIS

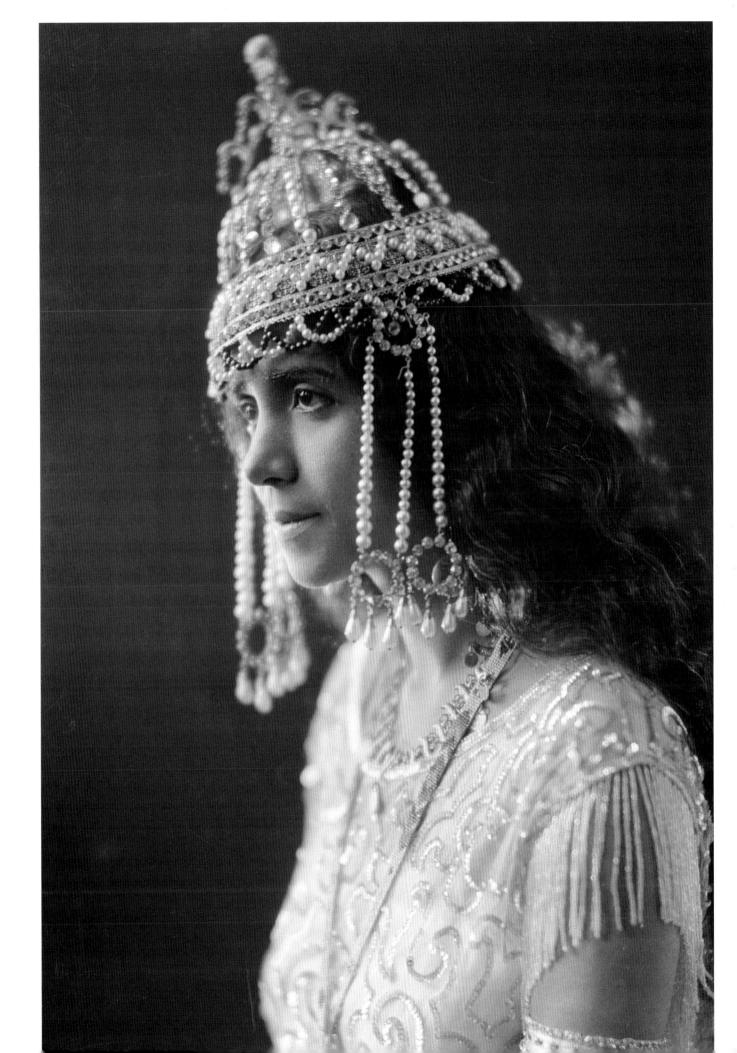

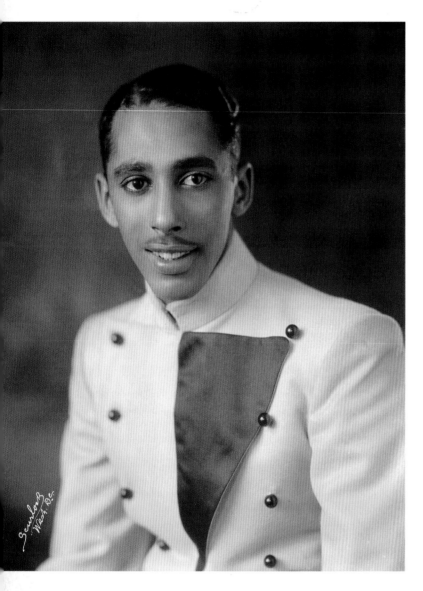

Elmer Calloway, 1932

Addison Scurlock photographed the lesser-known Elmer Calloway, Cab's younger brother, in his studio and with the orchestra at D.C.'s Club Prudhom, where his band had a regular radio broadcast on WOL. Scurlock composed and retouched most negatives to achieve "the Scurlock look" of this type of striking portrait. Celebrity sitter or not, the Scurlock Studio provided each individual with the same high-quality attention to detail. The Calloway family lived in nearby Baltimore, Maryland. Elmer's sister Blanche was the first to succeed in the music business and inspired both her brothers, Cab and Elmer, to pursue careers in music. Washington, D.C., rivaled and occasionally surpassed Harlem as a site of black theater and musical entertainment.

Robert Todd Duncan, 1930

The Scurlock Studio Collection holds several portraits of Todd Duncan (1903–1998) and his son Charles Tignor Duncan (see page 32). Addison always posed his subjects carefully to produce the desired look for a portrait. Here, studio lights, the backdrop, and Duncan himself were positioned to produce a more theatrical setting. A professor at Howard University from 1931 to 1945, Duncan was a trained actor and opera singer originally from Danville, Kentucky. In 1935 he originated his most celebrated role as Porgy in George Gershwin's opera *Porgy and Bess*. When the production came to the National Theatre in Washington, D.C., that year, Duncan, along with his colleagues at Howard, successfully worked to desegregate the theater for the run of the production. The National quickly reverted to its official policy afterward, however, and remained segregated until the early 1950s. Later in his career, Duncan was well known for his international concerts and for performances at the Washington Performing Arts Society and the Kennedy Center. A longtime District resident, Duncan opened his own voice studio in Washington, and his home on Sixteenth Street was a center for many in the black cultural community.

Dr. Anna Julia Cooper, 1934

The respected Washington educator and author Anna Cooper (1858–1964) dedicated her life to educating blacks, especially the poor and unemployed. Cooper deserves recognition as an important, albeit largely ignored, voice in the turn-of-the-century debate regarding the social and political future of black Americans. Her arguments against Booker T. Washington's model of vocational education, as described in her 1892 text *A Voice from the South*, predated many of the same sentiments raised more famously by W. E. B. Du Bois. Cooper served as a teacher and principal of M Street School, before it was renamed Dunbar High, and she later helped found and administer Frelinghuysen University, which provided education programs as well as training and social services to working-class black adults.

Scurlock photographed Cooper on numerous occasions. This image was taken on the porch of her home at 201 T Street, NW, in LeDroit Park, from where she operated Frelinghuysen University toward the end of her life. In 1892 she described her beginnings in the city: "In 1887 I received, unsought, through the kindly offices of my Alma Mater, an appointment to teach in a Washington high school....The very next year...I immediately began, like the proverbial beaver to build a home, not merely a house to shelter the body, but a home to sustain and refresh the mind, a home where friends foregather for interchange of ideas and agreeable association of sympathetic spirits." Cooper never lost her love of learning. She earned a doctorate from the Sorbonne in 1924, at the age of sixty-five.

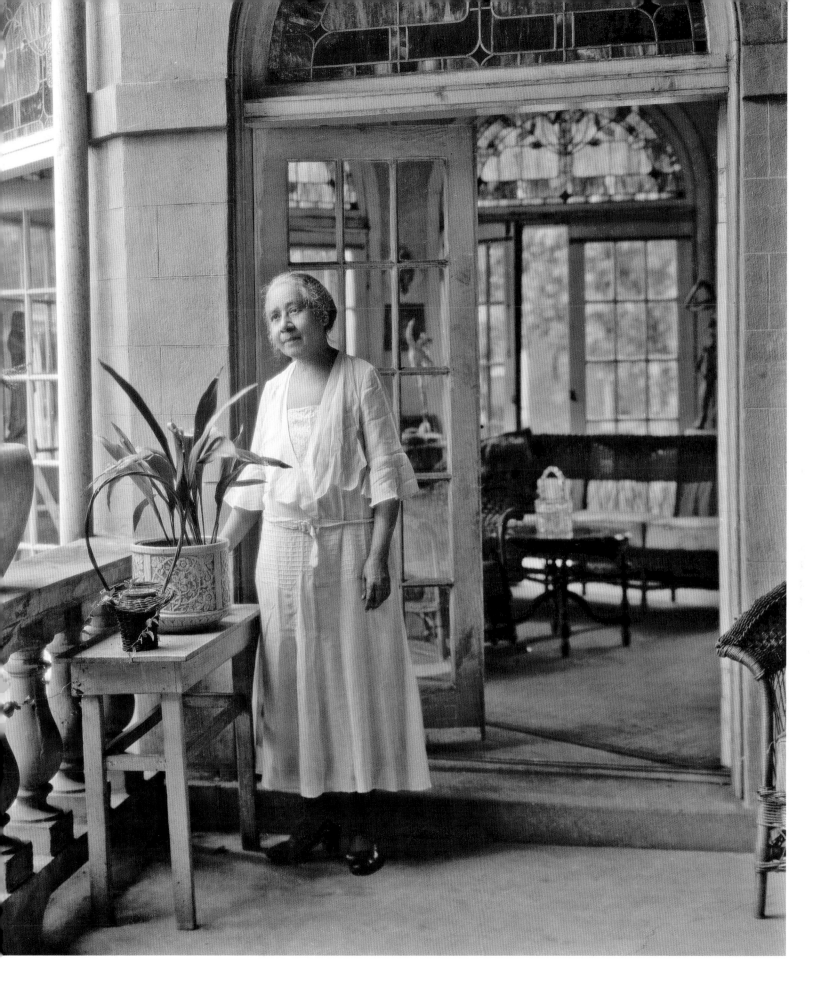

Scottsboro mothers with Julia West Hamilton and Ruby Bates, 1934

The Scottsboro Case began on March 25, 1931, when nine young black men traveling on a freight train were arrested in Paint Rock, Alabama. Local authorities had received an earlier report about a fight between blacks and whites on the train. When the officials discovered two white women (dressed in men's overalls, which was a common practice for women hopping trains during the Depression) on the same train, the black men were immediately charged with rape. On April 9, after four separate trials were held before all-white juries in the northern town of Scottsboro, Alabama, eight of the defendants, now known as the "Scottsboro Boys"—Andy Wright, Eugene Williams, Haywood Patterson, Ozie Powell, Clarence Norris, Olen Montgomery, Charlie Weems, and Willie Roberson—were found guilty as charged and promptly sentenced to death. The case of the ninth defendant, thirteen-year-old Roy Wright, ended in a mistrial when the jury refused to accept the prosecutor's recommendation that his life be spared because of his youth.

One of the most dramatic racial spectacles of the early twentieth century, the Scottsboro Case quickly became the center of national and international demonstrations and protests, including protracted struggles among the communist party, the International Labor Defense (ILD), and the NAACP over which organization could best represent the interests of the Scottsboro Boys. It also led to two major Supreme Court decisions. Ruby Bates, one of the two women who accused the Scottsboro Boys of rape, recanted her testimony in 1933, but it had little immediate impact on the outcome of the case. Four of the "boys" were released in 1937. Others were released, jumped parole, or—in the case of Haywood Patterson—escaped during the 1940s. When Clarence Norris, "the last of the Scottsboro Boys," received a pardon from George Wallace, then the governor of Alabama, on October 25, 1976, the Scottsboro Case officially ended.

In the 1930s, during the heyday of mass demonstrations about the Scottsboro Case, strategists from the ILD and the communist party often enlisted the cooperation of the mothers of the defendants—a presence they regarded as indispensable for their appeals. After her recantation, Ruby Bates often accompanied the Scottsboro mothers at the head of demonstrations and delegations. They led a march to Washington in May 1933 and the next year headed a delegation to the White House, appropriately on Mother's Day, in an unsuccessful attempt to meet with President Franklin Roosevelt. During the 1934 trip they also met with Julia West Hamilton (1866–1958), a leader in charitable, civic, and political affairs in Washington.

Among the many roles she played, Hamilton was the president of the Phillis Wheatley YWCA, which was organized in 1905 to meet the housing needs of young black women who came to the District seeking work. In Scurlock's photograph, Hamilton greets Ruby Bates and the Scottsboro mothers at the YWCA headquarters at 901 Rhode Island Avenue, NW. The endless travel, rallies, speeches, and demonstrations undoubtedly took their toll on the women. Although some of them look tired here, they all appear composed and dignified—and dressed in a manner that far exceeded their humble socio-economic circumstances. The fact that this meeting occurred at the YWCA, an important site of black achievement in Washington, D.C., offers insight into the ways in which the campaign to free the Scottsboro Boys mobilized all sectors of the black community.

From left to right: Ruby Bates, Mamie Williams Wilcox (mother of Eugene Williams), Viola Montgomery (mother of Olen Montgomery), Julia West Hamilton, Janie Patterson (mother of Haywood Patterson), and Ida Norris (mother of Clarence Norris).

JAMES A. MILLER

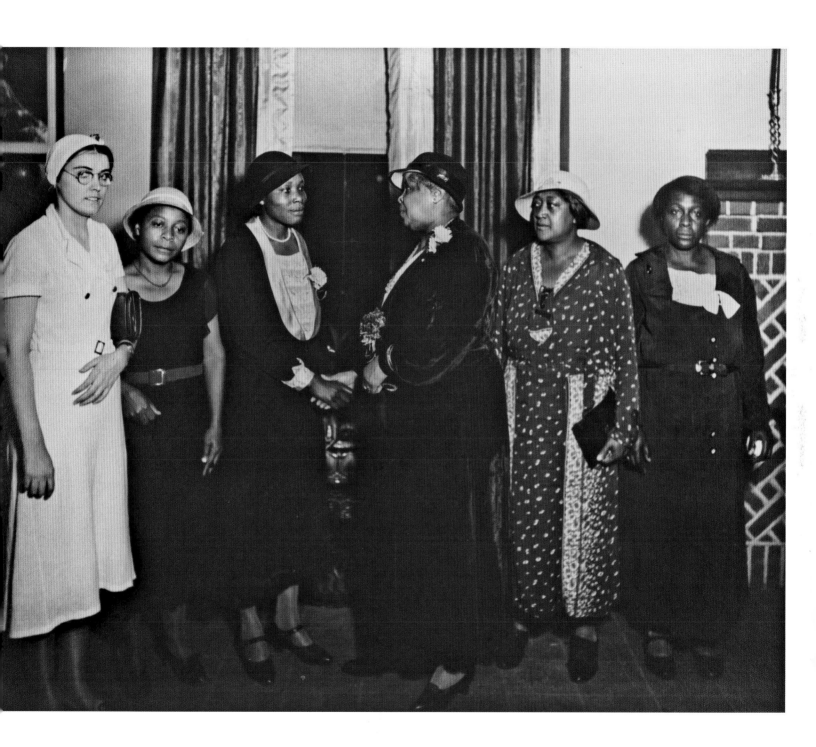

Fats Waller with Shep Allen, 1939

Jazz musician and composer Thomas Wright "Fats" Waller (1904–1943) poses with Shep Allen, manager of the Howard Theatre, as he presents a check to a representative of the local Police Boys Club. A gifted songwriter and enthusiastic performer, Waller is known for such songs as "Ain't Misbehavin'" and the hilarious "Your Feets Too Big." Waller had toured Europe earlier in 1939, but he returned home due to the outbreak of World War II. In his role as a theater man-ager, Allen was responsible for securing performances by Fats Waller, Duke Ellington, and other national names. He also introduced an amateur talent contest at the Howard and helped launch the careers of Pearl Bailey and other local black entertainers. After Addison Scurlock apprenticed his sons Robert and George into the family business in the 1930s and 1940s, the studio increased its coverage of news-worthy community activities, such as this Washington event.

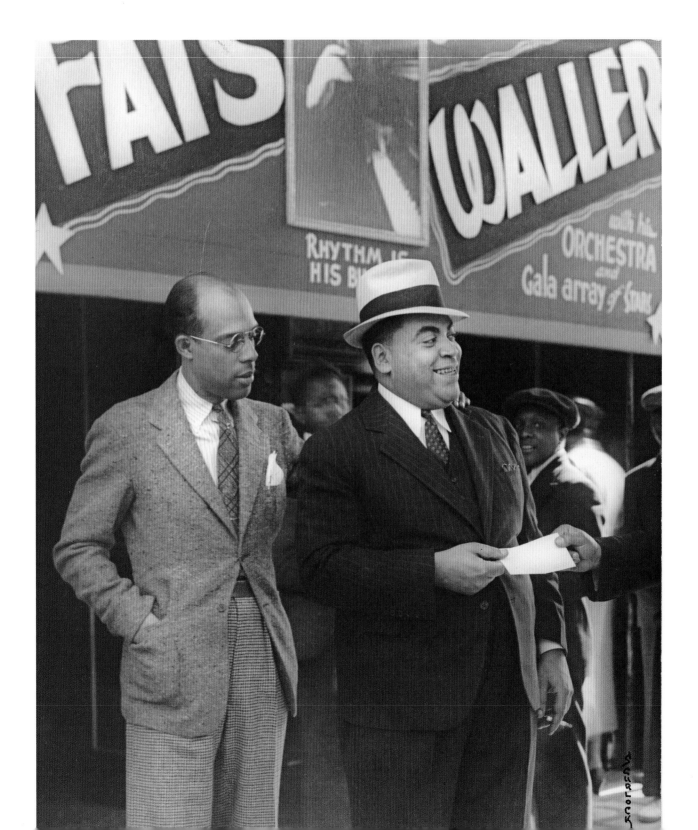

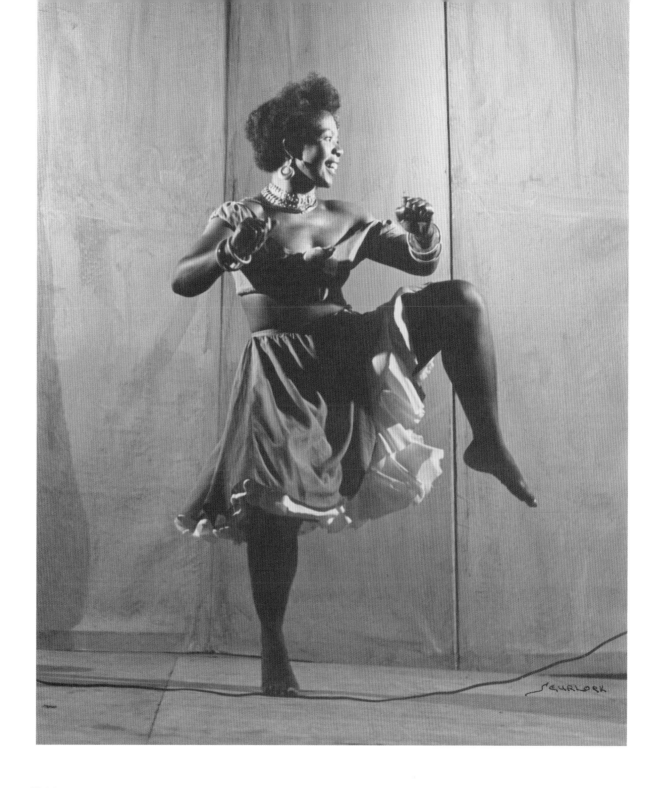

Pearl Primus, 1945

Addison Scurlock maintained a tradition of photographing African American entertainers who performed in Washington, D.C. Like visiting statesman and scholars, these actors, dancers, artists, and musicians took time from their busy schedules to have their portraits taken on location or in the Scurlock Studio located at 900 U Street, NW. Dancing in costume, Pearl Primus (1919–1994) posed for Scurlock early in her professional career as a choreographer and performer whose work was a weapon in the struggle for social justice. Primus' choreography was based on racial issues and black culture, as well as on influences from her Caribbean homeland, her upbringing in New York City, and her visits to the African continent. As she once put it, "Dance has been my freedom and my world. It has enabled me to go around, scale, bore through, batter down, or ignore visible and invisible social and economic walls. Dance is my medicine."

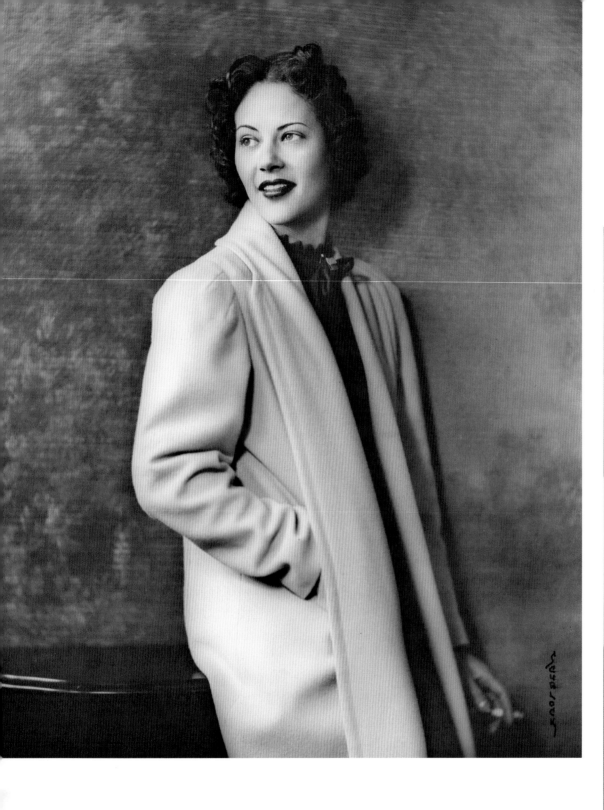

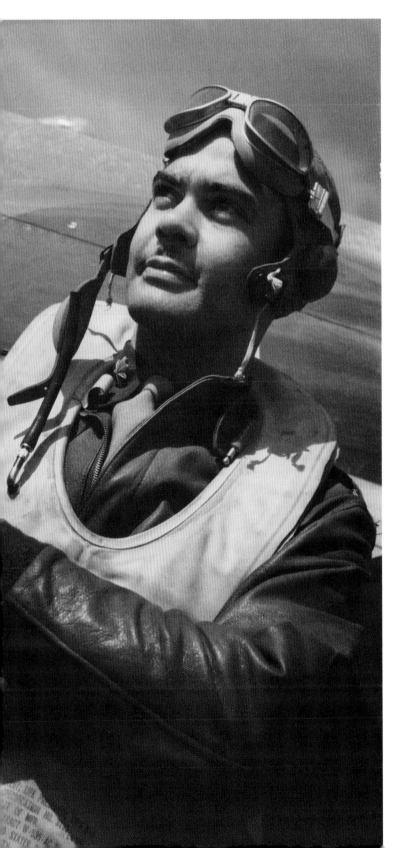

Fredi Washington, 1934

Robert Scurlock was still a teenager when he photographed actress and activist Fredi Washington (1903–1994), star of the 1934 film *Imitation of Life*. This was his first studio assignment. Like most black celebrities who visited D.C., Washington stopped by the Scurlock Studio for her portrait when she was in town. Despite her beauty and talent, Washington's film career stalled when she refused to limit herself to playing the roles of domestics. Robert incorporated into his own portraiture many of the techniques he had learned from his father. In an interview in the *Washington Post Magazine* in 1990, Robert explained, "My father knew how to place the light so it was just right. And once he got it right, there would be no excessive shadows. But then he would see the negative and see it could be helped [by retouching].... He wanted the person in their Sunday best, their best face forward."

Benjamin O. Davis Jr., c. 1940s

Robert Scurlock took this photograph while he was serving under Benjamin O. Davis Jr. (1912–2002) as a Tuskegee Airman, a segregated aviation unit that earned respect (grudgingly) for its tenacity and accomplishments during World War II. Under the leadership of Davis, the son of the first African American general in the military, the undeniable success of the Tuskegee Airmen helped integrate the armed forces in 1949. General Davis, who grew up in Washington, offered these recollections in 1991.

> *My memories of life at 1830 Eleventh Street are undoubtedly a mixture of things I can actually recall and other things that people have told me. I remember the icehouse directly across the street, its small buildings in which blocks of ice were stored....I remember the streetcars that passed our house going south to downtown Washington and north toward Walter Reed Hospital. I remember Katzman's Grocery on the corner of Eleventh and T Streets, only a few doors from our house....I remember quite well the Lincoln and Republic theaters on U Street, and the hill on Thirteenth Street where I took my sled when we had snow.*

181

W.E.B. Du Bois, 1943

As the founding editor of the *Crisis*, the monthly magazine of the National Association for the Advancement of Colored People, Harvard-educated writer and activist William Edward Burghardt Du Bois (1868–1963) frequently selected Addison Scurlock's photographs as cover images and illustrations. Scurlock's photographs not only documented accomplished individuals and successful black enterprises in Washington, but they also captured the spirit of Du Bois' efforts to end the myth of racial inferiority. Photographer and historian Jeffrey John Fearing analyzed this portrait's "Scurlock look," noting it "exemplifies all the hallmarks that made a Scurlock portrait special. Du Bois is meticulously posed, shoulders faced to one side of the camera-subject axis, the eyes gazing slightly to the other side of it. The background is simple and uncluttered, gradations of grey. The subject is the sole focus of the photograph, without distractions. The soft lighting gives the subject the 'glow' for which the Scurlock portrait is noted, and the soft-focus lens is set to diffuse the shoulders, ears, and crown, so that only the face is sharp and focal, the eyes piercing off into the distance."

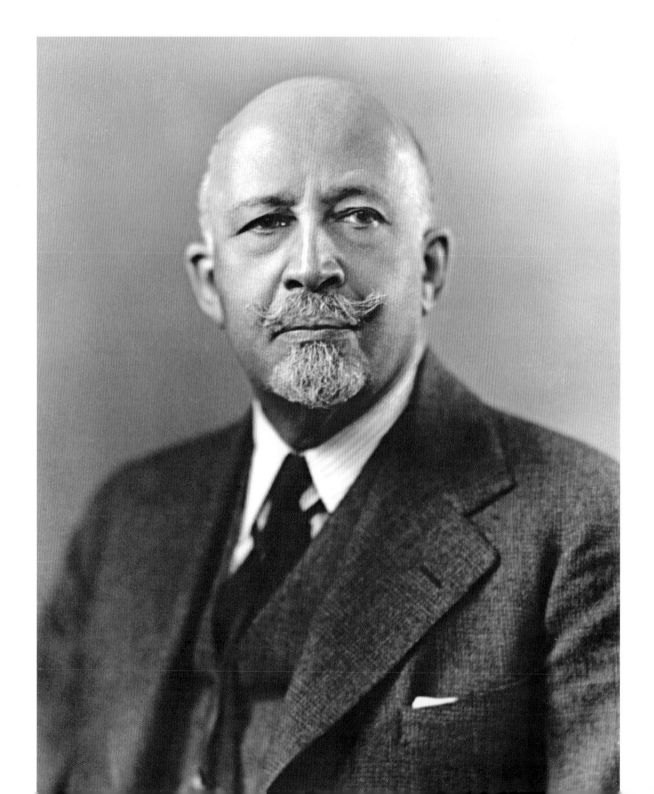

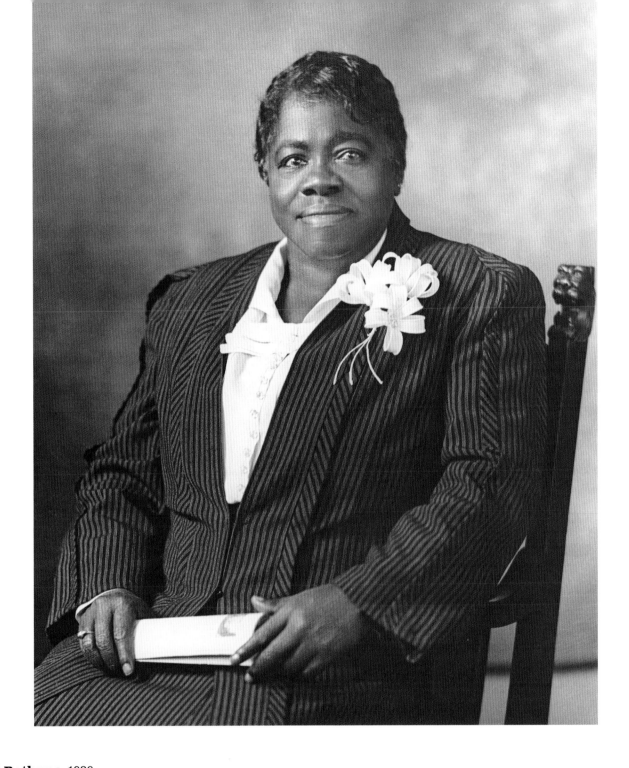

Mary McLeod Bethune, 1939

After she moved to Washington, D.C., in the 1930s, the Scurlock Studio frequently documented the life and work of Mary McLeod Bethune (1875–1955). An educator and political activist, Bethune founded the Bethune-Cookman College in Florida and earned the NAACP Spingarn Medal for her work in education. She joined black residents of Washington in their campaign to protest segregation and especially policies in store employment. In 1935 she founded the National Council of Negro Women (NCNW), headquartered in her home. She also served Presidents Herbert Hoover and Franklin Roosevelt as an advisor on child health and minority issues. As a member of FDR's Black Cabinet and through her friendship with Eleanor Roosevelt, Bethune was able to shape much of the New Deal programs that affected black Americans. Dorothy Height, NCNW president emerita, remembers that even though Mrs. Bethune stood "only five feet, six inches tall, [she] was majestic. *Here I am!* she always seemed to be saying to the camera, *proud and beautiful.*"

This meeting of the National Council of Negro Women was held in the conference room of the Council's house at 1318 Vermont Avenue, NW. That was our first national headquarters—and Mary McLeod Bethune's last residence. Although she had retired as Council president in 1949, passing her mantle to Dr. Dorothy Bolding Ferebee, Mrs. Bethune was still deeply involved with the organization until her death in 1955.

Mrs. Bethune founded the NCNW two decades prior, in 1935, when she called together twenty-eight national women leaders to form "a national organization of organizations" to represent the national and international concerns of black women. She saw the need to harness the power and advance the leadership of African American women through united, constructive action on issues of civil and human rights, social justice, education, and poverty.

Mrs. Bethune was a powerful woman, both personally and politically. I met her two years after she formed the NCNW. In 1937 the Harlem branch of the YWCA offered me the job of assistant executive. I'd been employed there for one month when I received an assignment to escort First Lady Eleanor Roosevelt to a meeting that Mrs. Bethune was hosting. This event turned out to be a meeting of the National Council of Negro Women. I escorted Mrs. Roosevelt in, and when the meeting finished, Mrs. Bethune asked me my name. I told her, and she said, "Come back. We need you." By the time I returned from bringing Mrs. Roosevelt to her car, Mrs. Bethune had already appointed me to the resolutions committee of the NCNW. I remember how she made her fingers into a fist to illustrate the significance of working together to eliminate injustice. "The freedom gates are half ajar," she said. "We must pry them fully open." That was November 7, 1937, and I have been committed to that calling and active in the Council every week of my life since that day.

From that time we met, Mrs. Bethune made sure to keep up with me. She kind of just moved into my life and drew me into her dazzling orbit of people in power and people in poverty. It was overwhelming, but what a wonderful experience to have her as a friend and guide and mentor. In 1939 she succeeded in bringing me to Washington. I took a job with the Phillis Wheatley YWCA here in the city. I worked there for several years, and in 1942 at a meeting in Chicago, Mrs. Bethune praised Director Florence Norman for her wonderful job at the Wheatley Y. She followed quickly with, "But now I'm sure she would like to have a younger woman do it, and Dorothy Height, would you be willing to be the Executive?" Well, before God and Mrs. Bethune you don't say "No." So I said "Yes."

That meant I was employed by the YWCA, but I worked for Mrs. Bethune and the NCNW at night and on the weekends. I would go to her house after nine o'clock meetings, and we'd work until one or two o'clock in the morning and then walk through the street home. I didn't even look at a shadow. That tells you how the streets have changed since that time. The YWCA was at Ninth Street and Rhode Island Avenue, NW. Mrs. Bethune lived at Ninth and Westminster, and I lived on Tenth Street, fortunately not far away. It was hard work, but I've always said that through Mrs. Bethune I learned to be an "any kind of hour person"—any time of day for me.

This photograph was taken the year before Mrs. Bethune passed away, and although she is not pictured here, her presence is strongly felt in this room. This looks like it was a special working meeting of the Council, with mostly national officers there, although I can't recall the occasion. I think Scurlock came because it was a special meeting. Scurlock was very popular. I took a number of pictures with him over the years. Sitting at the head of the table is Dr. Ferebee with the flower on the white collar of her light-

colored dress. To her right is Vivian Carter Mason with the dark jacket and white collar. Dr. Ferebee was the second president of the National Council, Mrs. Carter Mason was the third, and in 1958 I followed as the fourth president. At the time of this picture I was chairman of personnel for the Council. I am seated on the right side of the table, third from the end, wearing my own hat. Just behind me, the third person to the left, is Jeanetta Welch Brown. She was the first employed executive of the NCNW. The only man in the photo was from Minnesota. He started the program of bringing in men as associate members to the Council.

When I look at this picture, I remember the friendships that I shared with all of these women. Mrs. Bethune's death the following year came as a shock to us all. Though she was old, she died suddenly. She was asthmatic. But the women rallied. It was interesting after she died. We all pulled together and worked even harder. Some of the older women were helpful in stabilizing things. There was a tendency to say things like, "Well, Mrs. Bethune wouldn't let us get away with that," and we would go on.

Mrs. Bethune's dedication and remarkable achievements continue to inspire our mission and work. Today, the National Council of Negro Women is a council of thirty-nine affiliated national African American women's organizations and more than two hundred forty sections connecting nearly four million women worldwide.

DOROTHY HEIGHT

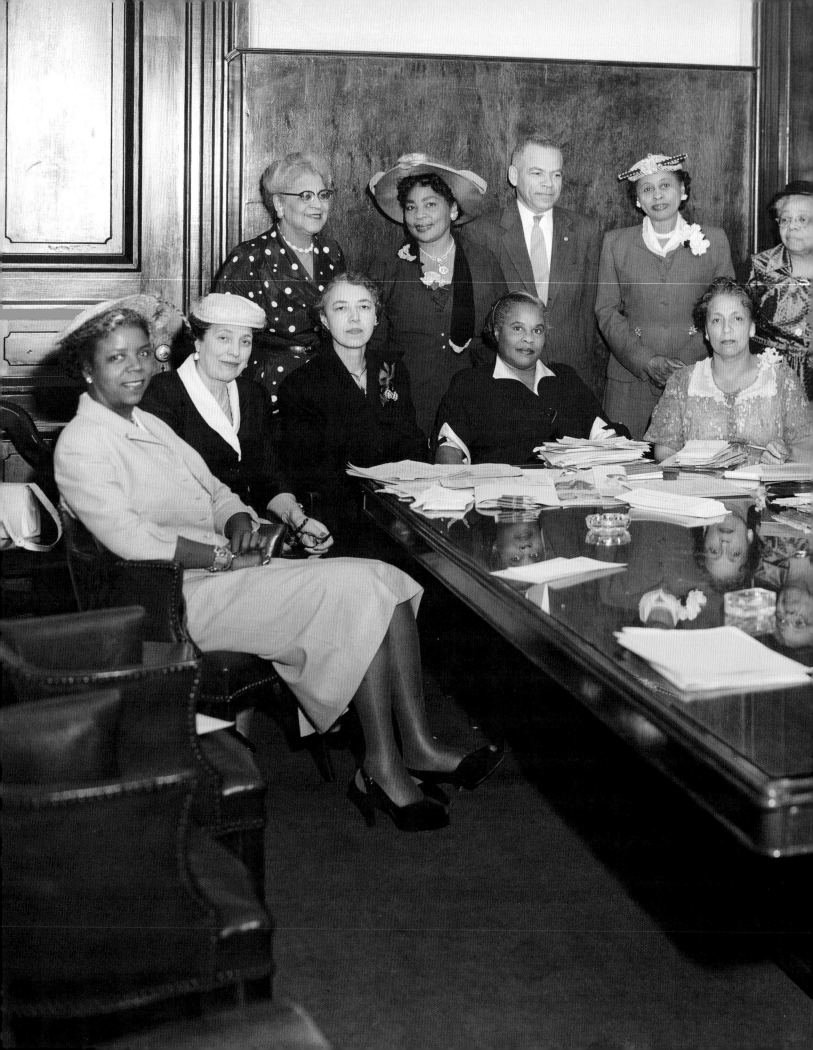

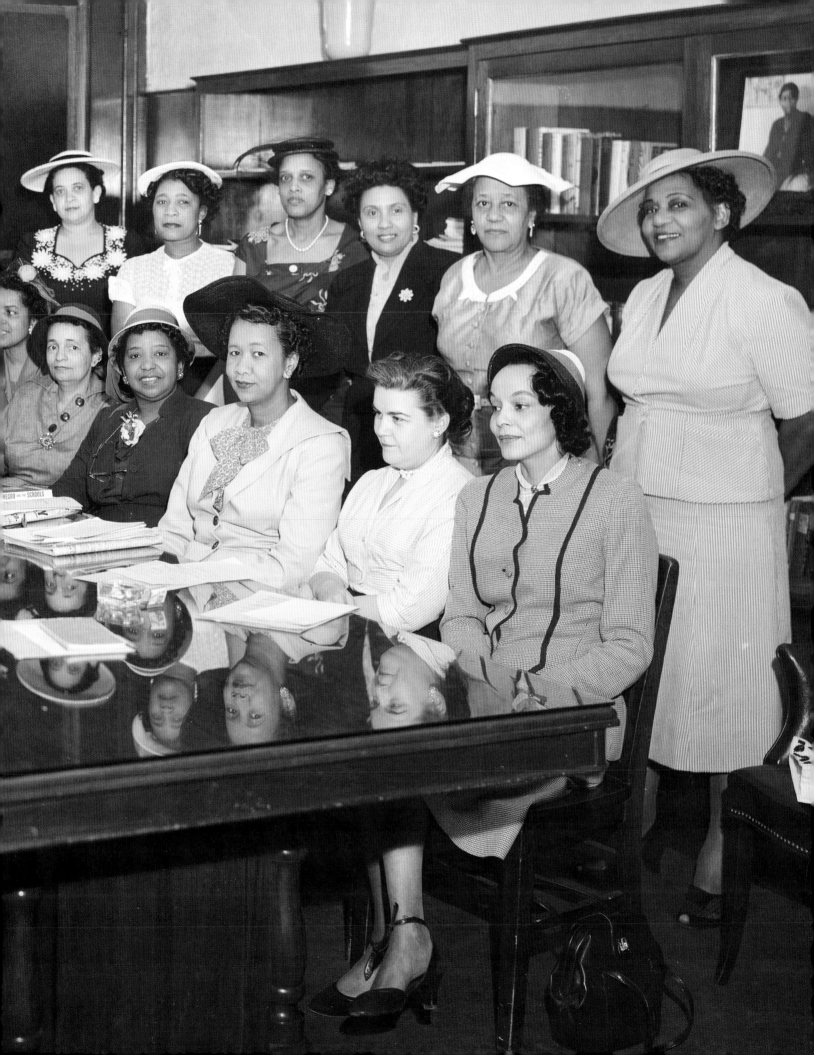

Duke Ellington at a party with the Scurlocks, 1956

My grandfather, George Scurlock, often told stories of when they were kids and would go three doors down to his friend Mercer's house to play. During Mercer's birthday parties, Mercer's father would always gather the guests around the family's piano to sing "Happy Birthday." Mercer's father was Duke Ellington. For many years the Ellingtons were neighbors and friends of the Scurlocks on the 1200 block of T Street, yet George was too young at the time to realize he was singing "Happy Birthday" to his friend and neighbor alongside arguably the greatest American composer of all time.

Like the Scurlocks, Edward Kennedy Ellington grew up in the black community of Washington, D.C. His parents were solidly working class, and he worked as a peanut vendor in Griffith Stadium as a child. His parents also gave him a clear understanding of some of black Washington's intraracial class lines, which may ultimately have helped push him to the more cosmopolitan atmosphere of Manhattan as it did with other black D.C. artists in the 1920s and 1930s.

In his autobiography *Music is My Mistress*, Duke gave a pointed description of the social climate among D.C.'s blacks: "I don't know how many castes of Negroes there were in the city at that time, but I do know that if you decided to mix carelessly with another you would be told that one just did not do that sort of thing." Ellington went on to explain that at times, however, the classes did mix, citing a pool hall where Dr. Charles Drew played alongside the rest of the neighborhood. In the largely segregated residential communities of black D.C., the doctor shot pool alongside the cook—and the photographer lived alongside the musician.

Yet, as Duke pointed out in his autobiography, members of the community were careful to pick their social company. In the case of this image, George Scurlock photographed a 1956 Ellington party he attended as an adult with his wife Natalie (standing, in the white dress) and their

friends and neighbors, the Reids and the Rands. Judging by the memories recalled by my grandfather and father George Jr., this was a tightknit group of friends.

Joining the group on this occasion is Billy "Sweet Pea" Strayhorn (standing center, with bowtie and glasses), a songwriter, musician, and Duke Ellington's longtime collaborator. Although gifted in his own right, Strayhorn's successes were overshadowed by those of Duke. Around the time of this photograph, he attempted to work as a solo musician, but some argue that he preferred to stay out of the spotlight, as he was a gay artist in a largely homophobic era. This is especially significant considering Duke's apt categorization of District blacks: this group welcomed Strayhorn into their social circle.

By the time this photo was taken, Duke Ellington was a nationally renowned musician, and he spent much of his time touring the United States and Europe with his band. Yet, when he came home from a tour, he looked forward to relaxing on T Street with his wife Edna (seated, second from right), son Mercer (third from left), and their close friends. Carl Reid (far left) and Addison Rand (second from left) were longtime friends of George Scurlock and Mercer Ellington, and their wives were friendly as well. As this image and the social circle suggest, Addison Scurlock and his sons more than captured the dynamic of this vibrant community—they lived it.

HILARY SCURLOCK
(WITH THANKS TO DAD AND POP POP)

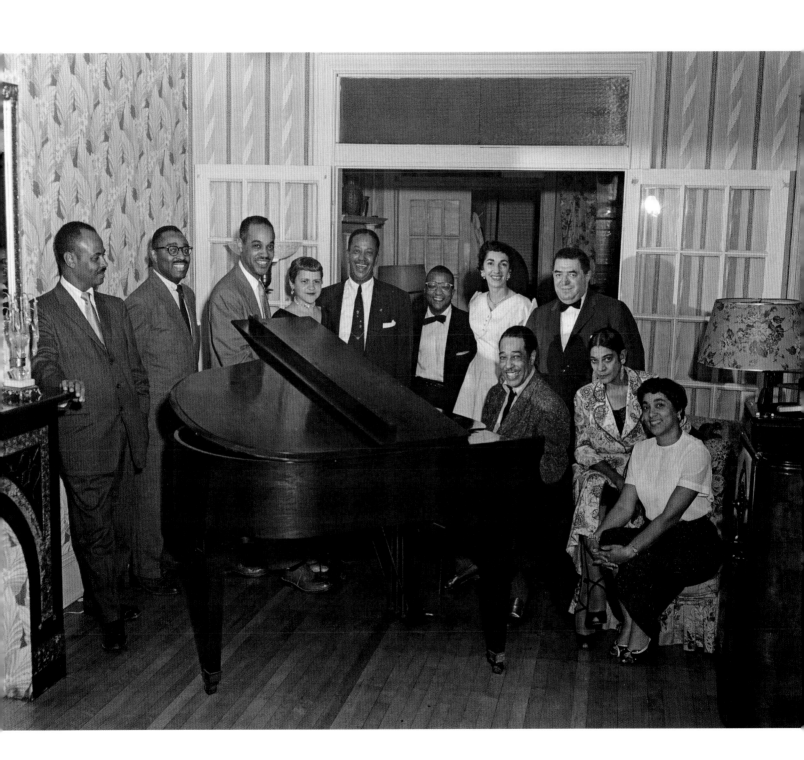

Jackie Robinson, 1947

The Scurlocks photographed baseball phenomenon Jackie Robinson (1919–1972) while he was in Washington to perform at the Howard Theatre's footlight revue in October 1947. A momentous baseball season had just ended, and Robinson had broken professional baseball's color barrier with Branch Rickey's Brooklyn Dodgers, enduring racial taunts on ball fields across the nation. His dazzling play earned him rookie of the year honors. Robinson's actions that season contributed to the creeping process of integration that would eventually transform America. Part of Robinson's allure was based on the black community's knowledge of the discrimination, hatred, and danger that he endured during his initial season with the Brooklyn Dodgers.

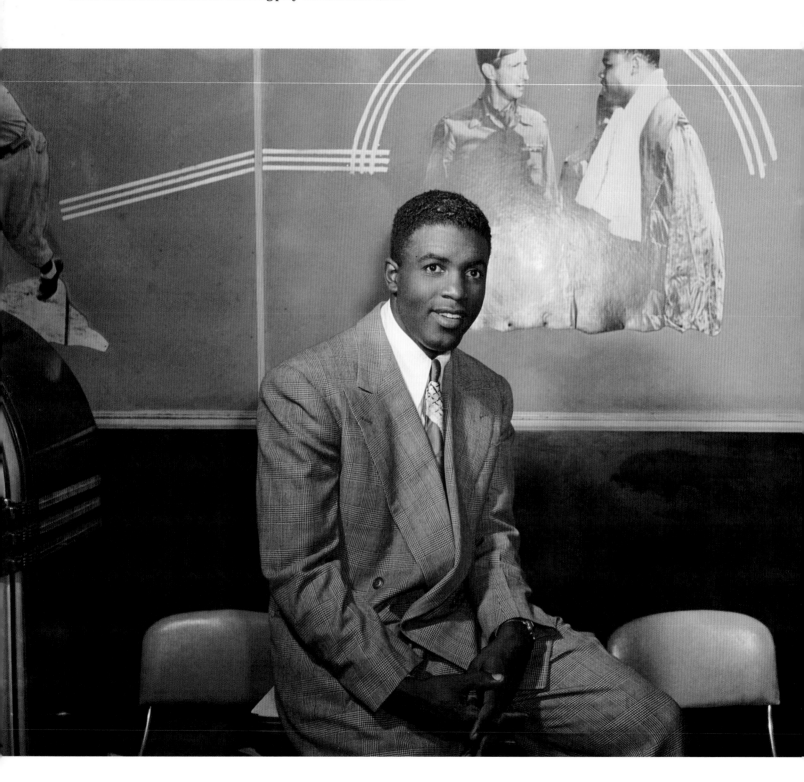

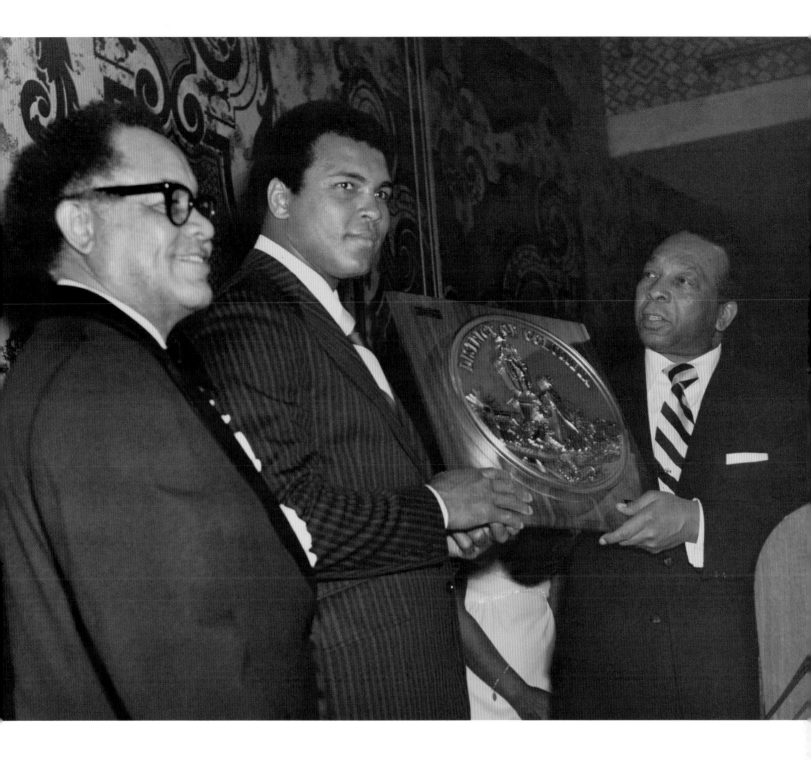

Muhammad Ali and Mayor Walter Washington,
c. 1970s

The District of Columbia's Chamber of Commerce Thirty-seventh Annual Installation Dinner honored champion boxer Muhammad Ali (born 1942), shown here receiving an award from Walter E. Washington (1915–2003), the first home-rule mayor of the District of Columbia. Ali's celebrity transcended his boxing success. His stance against the Vietnam War, the subsequent professional sacrifice that stemmed from his refusal to serve in the military, and his outspoken support of black pride and solidarity all elevated Ali's notoriety and garnered him awards such as this one. Robert or George Scurlock would have covered this type of photojournalist assignment. The brothers operated separate studio locations following the death of their father Addison in 1964.

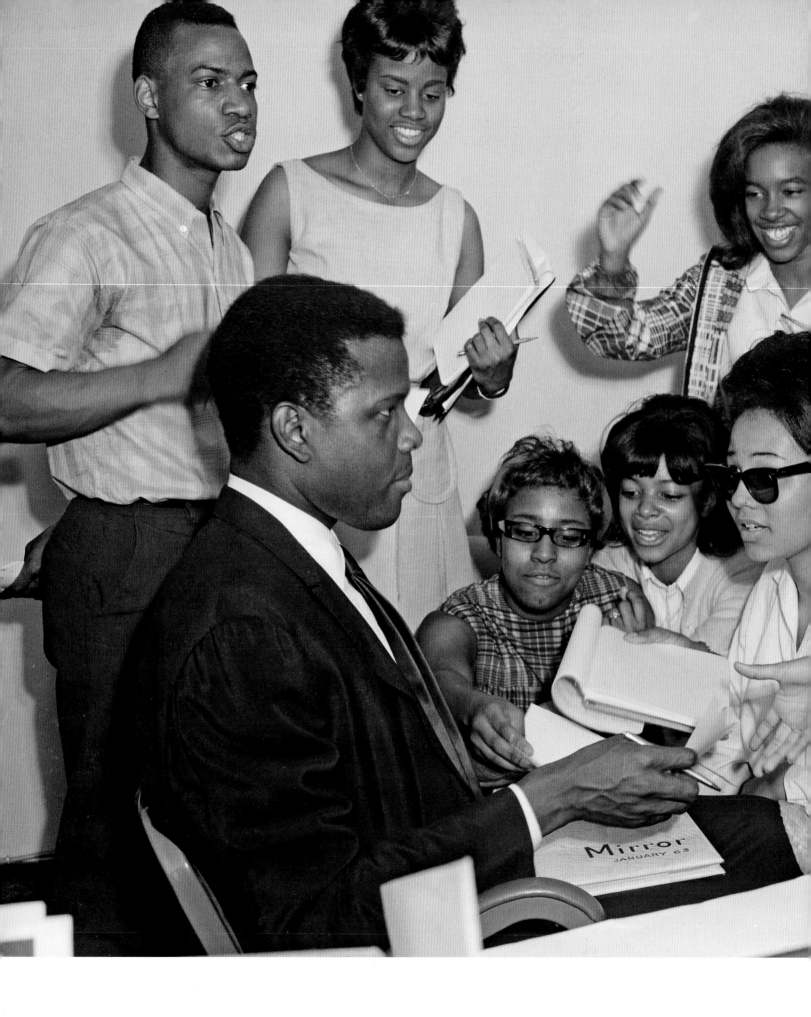

Sidney Poitier signing autographs, 1977

Possibly in Washington, D.C., to promote his film *A Piece of the Action*, Sidney Poitier (born 1927) is besieged by adoring fans as the Scurlocks captured the moment on film in February 1977. Poitier played the role of Walter Lee Younger in the first Broadway production of Lorraine Hansberry's *A Raisin in the Sun* in 1959, and he later starred in the film version released in 1961. Two years later, in 1963, he was the first African American male to win the Academy Award for Best Actor for the film *Lillies of the Field*. Later that year he attended the March on Washington for Jobs and Freedom, where he publicly demonstrated his commitment to racial equality. Poitier represented a new generation of black actors who refused demeaning roles and who attempted to enrich American culture by creating meaningful and complex characters on stage and screen. His early films—from *Raisin* to *The Defiant Ones* to *Guess Who's Coming to Dinner*—signaled a new visibility for black actors that paralleled changes brought by the civil rights movement.

Lois Mailou Jones, 1980

Lois Mailou Jones (1905–1998) was involved in the art world for seventy years—as an art professor, a scholar, a book illustrator, a textile designer, and above all, as an artist. At the time this photograph was taken, Jones was at the pinnacle of her career. Scurlock's portrait of Jones in her Washington, D.C., home studio is the modern version of an age-old visual tradition of depicting the artist at work. Posing confidently, brushes in hand, Jones is surrounded by the tools of her trade and the art that defined her greatness. Her crowded bookshelf underscores her interest in scholarship. The palette, paint tubes, and brushes to the left and right confirm Jones as a dedicated practicing artist. The artwork and images in the studio represent distinct periods in her career: her early years in Paris during the late 1930s; her Haitian art period; and her 1970 journey throughout the continent of Africa. In addition to this view of Jones in her studio, the Scurlocks photographed the artist a number times, including her instructing students in a design class (see page 145).

In 1937 Jones was awarded a general education fellowship to study for a year at the Académie Julian in Paris, her first sabbatical since she began teaching at Howard University in 1930. During the 1937–38 academic year, she lived in Paris, enjoying a brief respite from Jim Crow policies and relishing the absolute freedom to live and eat wherever she chose. Jones loved France and its people so much that she returned there to paint each year for two decades, except during World War II. She completed forty paintings in Paris and developed her own post-impressionist style, as seen in *Le Model, Paris* (1938), located in the upper left corner of Scurlock's photograph.

Jones was again in Paris in 1966 when the Galerie Soulanges hosted a solo exhibition of her paintings. To the right of Jones's head is a poster announcing the exhibition, with the graphic illustration being *Marché, Haïti*, one of her

Haitian paintings from 1963. She created these paintings of Haiti's people, landscape, and religion after she married Haitian artist Louis Vergniaud Pierre-Noel, and they took annual trips to the island beginning in 1954. From that summer to 1969, Jones's art was transformed in both palette and style. With her post-impressionist technique now seeming passé, Jones used vivid colors, hard-edged lines, decorative patterns, and flattened perspective to express the lively tropical culture of Haiti.

Four years after her solo exhibition at Galerie Soulanges, Jones received a grant from Howard University that enabled her to visit and research eleven countries in Africa. She photographed contemporary works of art and compiled biographical materials on several African artists. Jones was deeply affected by this trip. "By combining the motifs from various regions of Africa," she said, "I try to explore on canvas a sense of the underlying unity of all of Africa." Visible in Scurlock's photograph are two paintings from 1980 that were influenced by her African experience: *Damballah* (located to the left of the artist), and *Symboles D'Afrique I* (at the bottom right).

"As Professor of Design and Watercolor painting at Howard University for 47 years, Lois Mailou Jones touched the lives of legions of students in the arts, and across the disciplines," recalls Tritobia Hayes-Benjamin, associate dean of the Division of Fine Arts, College of Arts and Sciences, professor of art history, and director of the Gallery of Art at Howard University. "Here in the Department of Art, she charted, shaped, and codified the instructional program and its curriculum in design. A lucky group of students today count themselves among the privileged few to have benefited from the vitality, warmth and color that characterize her oeuvre."

TULIZA FLEMING

THE SCURLOCK STUDIO: A BIOGRAPHY

Addison N. Scurlock, through his talents for portraiture, lighting, and panorama-like views, constructed an important visual record of black modernity in the twentieth century. He was born on June 19, 1883, in Fayetteville, North Carolina, and it is unclear where he developed his interest in photography before he moved to Washington, D.C., with his family in 1900. Yet in the census for that decade, at the young age of seventeen, he is listed as a photographer. From 1904 until his death in 1964, Addison Scurlock was the preeminent African American photographer in the nation's capital and one of the most significant photographers in the United States, a position his sons, Robert and George, sought to uphold until the studio closed in 1994.

Each of the Scurlocks excelled in a particular area. Addison was a master of many aspects of fine photography but particularly portraiture and lighting. Both sons learned their father's techniques. George was especially known for his skills in retouching and tinting, while Robert was attracted to photojournalism. Robert also expanded the commercial side of the studio's services by introducing color photography to the business. The Scurlock Studio's exceptional reputation continues to inspire many of today's African American photographers.

The history of the studio, melded with the family history, allows an intriguing opportunity to trace the role African Americans have played as both subjects and creators of images during most of the twentieth century. In *The Negro Professional Man and the Community*, Carter G. Woodson states that "in order to study the professional man, one must first understand the environment that created

him."[1] By exploring the changing craft, aesthetics, and business of the Scurlocks and their photography studio, we can learn a great deal about the state of black photography in the last century. We can also learn about the Washington community of which they were a part and which they, with care and artistry, in turn made visible.

BEGINNINGS

Prior to their move to Washington in 1900, the Scurlocks lived and worked successfully in Fayetteville, North Carolina. Before the Civil War, Fayetteville was a major hub of commerce and trade for the region. The city was home to both a slave and a vibrant free black population through the course of the war. The first church in town, the African Meeting House, was built in 1796 by a free Methodist-ordained minister named Henry Evans and was open to both slave and white worshipers. Due to the destruction of businesses and city buildings as a result of the war, Fayetteville was more like a small town after 1865. Nonetheless, facilities for African American education grew considerably and included the Howard School, which was established in 1867 and later became Fayetteville State University.

Addison's father, George Clay Scurlock, was born free in November 1851. He was a successful blacksmith, like his father Neil Scurlock. George's wife Nannie, born in 1857, worked as a housekeeper. The Scurlocks were married in 1874 by the Reverend J. A. Tyler at Cross Creek, a Fayetteville neighborhood close to the family home.

On October 14, 1891, President Benjamin Harrison appointed George Scurlock as the first African American postmaster of Fayetteville, an appointment he held for one

by DONNA M. WELLS with DAVID E. HABERSTICH

year.[2] Later in the 1890s, George ran, unsuccessfully, for a seat in the North Carolina state senate. In 1900 he moved his wife and three children to Washington, D.C., soon after Addison had completed high school. At the turn of the century, the District had the highest concentration of African Americans of any city in the nation. One-third of the city's population was black in 1880, and the percentage remained nearly the same through 1910. Federal and clerical jobs, quality education for students from young age through college, social and intellectual stimulation, and entrepreneurial opportunities attracted thousands of blacks to the city following the Civil War and Reconstruction. Nannie continued to care for the family while George worked as a messenger for the United States Treasury Department and studied law in the evenings. He opened a law office in the 1100 block of U Street in the heart of Washington's African American business district. The family quickly inserted itself into Washington's elite black society, which by the turn of the century saw a significant number of African American families prospering despite the restraints of the Jim Crow environment. Not only was Washington the nation's capital, but it was also a cultural and intellectual center for thousands of African Americans.

Now ensconced in the U Street community, all of the Scurlock children were successful. Herbert, the eldest (born 1875), graduated from Livingston College in Salisbury, North Carolina, in 1895 and from the Howard University Medical School in 1900, where he taught for forty years. He published two medical books that were used in the Howard

Addison Scurlock in North Carolina, with camera case, 1900

curriculum. Mattie, the only daughter, was born in 1887. After graduating in 1907 from Miner Teachers College in Washington, she taught in the D.C. public schools system until her retirement. Addison pursued his interest in photography and launched his career by entering into an apprenticeship with white photographer Moses P. Rice.

Moses Rice and his brother Arthur operated a photo supply store and a photographic studio on Pennsylvania Avenue, which was dubbed "photographer's row" because of the number of studios, including that of Mathew Brady, located along the avenue at Seventh Street, NW. Like Scurlock, several aspiring African American photographers, encouraged by the business opportunities that the growing profession provided, apprenticed under white photographers in the late nineteenth century. Joseph Bruce, Henry Lacy, and Jeremiah Simms all worked on Pennsylvania Avenue in white-owned studios. Only a few aspiring blacks took on photography full-time, with John B. Washington becoming the most successful. Even fewer entered the field after Washington died in 1888, and by the last years of the nineteenth century the city was left without a viable photographer to serve the black community.

The D.C. business community recognized the need for black photographers. African American businessman and entrepreneur Andrew F. Hilyer founded the Union League around 1893, a Washington-based business organization established to help promote the city's entrepreneurial spirit. Following a survey of black businesses in the District, Hilyer stated in a speech before the first organized meeting of the Union League in 1894:

There are yet a number of branches of businesses in which we have not yet been able to find any colored person engaged as proprietor. Among the more important, we would name the following, and we will thank anyone to tell us of any colored person who is conducting any of the following branches of business: auctioneers, bankers, book-binders, dealer in boots and shoes, engravers and lithographers, florists, gent's clothing, lumber dealers and builders' supplies, marble workers, stone cutters, milliners, paper-box makers, photographers, homeopathic physicians, picture frame makers and veterinary surgeons. Among these, it would seem to us that there is a splendid opening for a first class Afro-American photographer as we all like to have our pictures taken. It is hoped that another year will see this list of business enterprises in which we, as a class, are not represented, largely reduced.[3]

The League published several business directories beginning in 1894, but not until six years later, in 1900, did the directory list its first black photographer, Daniel Freeman, who became Addison's friend and stiffest competitor until Freeman's death in 1947. The two dominated the photography business in Washington during the first half of the twentieth century, in some ways mirroring the competing philosophies of racial uplift held by Booker T. Washington and W. E. B. Du Bois.

Born in 1868 in Alexandria, Virginia, Daniel Freeman came to Washington in 1881 at the age of thirteen. He

attended public schools, where he studied drawing and painting, before he apprenticed under photographer E. J. Pullman, whose studio was located at 459 Pennsylvania Avenue, NW. During his years of apprenticeship, Freeman advertised his services as an artist, art instructor, bicycle repairman, art framer, and occasionally, photographer. In 1895 he was chosen to develop and install the Washington, D.C., exhibit in the Negro Building at the Cotton States and International Exposition in Atlanta, where he displayed his photographs of the District's black schools. This was his introduction to Booker T. Washington's racial philosophy

that advocated hard work, self-help, and economic improvement within a socially segregated environment. After that experience, Freeman devoted his entrepreneurial spirit entirely to photography. He established his own studio, and his clientele soon included a number of prominent local residents, businesses, Masonic groups, and schools. Often he and Addison crossed paths socially and professionally. Both exhibited their work at the Jamestown Exposition in 1907 to celebrate the three hundredth anniversary of the town's founding. Addison won the gold medal for his portraits of Washingtonians, and Freeman received the bronze for his photographs of school scenes.[4]

Addison's apprenticeship with Moses Rice lasted from 1901 to 1904. He then opened the first Scurlock Studio out of his parent's home on S Street in Northwest Washington. From there, the family moved to nearby Florida Avenue in 1906 and to 1202 T Street two years later. Although segregation was already socially entrenched by this time, it was later federally sanctioned through government policy during Woodrow Wilson's administration. Despite these difficult circumstances, an African American enclave rapidly developed within this region of Northwest Washington, which was later labeled a "secret city" by historian Constance Green.[5]

Addison worked diligently to establish his business in the midst of this community. In 1907 he wrote to the D.C. Commission of Engineering, requesting permission to construct a display case for photographs at the corner of the family's front lawn on Florida Avenue. The proposed showcase measured 42 by 29 by 24 inches and was meant to provide a means for Scurlock to attract potential clients who passed by. The request was denied because of the case's proximity to public space. Years later, when Addison opened a studio at 900 U Street in 1911, the display case was a prominent feature, mounted outside at one of the busiest intersections in the heart of black Washington. This studio storefront became a longstanding popular attraction, with everyone curious to see the clients and images that Scurlock had selected to grace the window display.[6]

At this time, the U Street corridor, affectionately known as Black Broadway, emerged as the leading business and entertainment district for black city residents. Due to their geographic confinement, African Americans of all classes shared the same spaces. "All together," writes historian Jonathan Scott Holloway, "aristocrats, politicians, store owners, professionals, domestic workers, students, and professors made their homes in the neighborhoods" surrounding the Scurlock Studio.[7] Addison quickly acquired a local client base that grew to include many from the city's burgeoning black middle class. The studio's strategic location

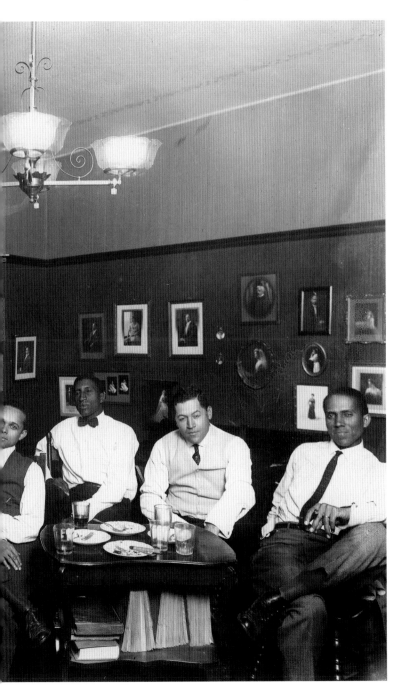

Scurlock Studio dinner meeting, 1913

anchored its visibility at two major transportation corridors—the intersection of U and Ninth Streets—and enticed new clients to come in and have their photograph taken. This very visible location bolstered Scurlock's widely circulated advertisements that appeared in newspapers, school yearbooks, printed programs of national and local organizations, and in the brochures of print material of other local businesses. Addison did the photography while his wife, Mamie Estelle Fearing, worked as the receptionist and business manager.

In the beginning of the twentieth century, the number of African American photographers servicing Washington's black community remained relatively small. Daniel Freeman was president of the city's chapter of the National Business League, organized by Booker T. Washington in 1900 to promote African American business enterprise. In a 1915 speech before the national convention in Baltimore, Freeman could only account for four successful African American photographers: Edward Johnson, Jerome O'Hagan, Addison Scurlock, and himself. Business appeared to be profitable, especially for Freeman and Scurlock, the two competing and better-skilled photographers. Freeman told of his personal rise to success:

> I started in one room, but now I am doing business in one of the most prosperous business streets in Washington, D.C. [U Street, NW]; my studio building is four stories high with sixteen rooms; hot water, heat, with four other valuable pieces of property. Paying taxes on about $30,000 worth of real estate in the District of Columbia, I have a wife but no children. My wife takes photos also; I have two automobiles.[8]

Addison Scurlock's own work quickly fell in line with an emerging ideology, more clearly associated with the thought and writings of W. E. B. Du Bois, that called for racial justice through the leadership of an elite component of African American society. Du Bois labeled this segment of the population the "Talented Tenth." Early in his career, Addison became a member of the D.C. chapter of the National Association for the Advancement of Colored People (NAACP) and provided photographs for the organization's monthly publication, the *Crisis*. His skills eventually helped his business to outstrip that of even Freeman.

Within sixteen years of opening his first studio, Scurlock was recognized as a master in the art of portraiture, with a growing client base who could afford to have a fine photograph taken. Most of the earlier Scurlock portraits were photogravures characterized by a soft focus, dramatic lighting, and sepia toning. More personal techniques, such

as introducing lighting, composition, and posing that flattered black features and depicted them with refinement and dignity, were soon recognized as characteristics of a Scurlock portrait. District residents and many socially elite African American clients who visited the city flocked to the Scurlock Studio.

Besides portraiture, Addison Scurlock was one of the first area photographers to learn panoramic photography. This late nineteenth-century technological advance required specially manufactured cameras with lenses or bodies that rotated in order to capture sweeping vistas and large groups in one take. Annual class pictures, attendees at conferences, religious congregations, and sporting events, such as early black golf tournaments, were photographed in panoramas by Scurlock's camera. These popular new techniques brought the studio business from African American organizations across the country. Addison developed relationships with prominent Washington businesses, Howard University, and the YMCA on Twelfth Street. Like his contemporaries C. M. Battey of Tuskegee and Arthur Bedou of New Orleans, Addison also supplied photographs for the black press, and reproductions of his work appeared in books, magazines, and newspapers throughout the nation.

PICTURING THE "NEW NEGRO"

Scurlock's work was rooted in his neighborhood and home community, but it quickly gained a national scope, both because he was based in Washington, D.C., and because of the photographs' affiliation with the ascendant ideas of racial pride and progress. Addison Scurlock's chosen career was well matched with the needs and desires of the city's black elite. They recognized the power and importance of photography in the new century, and in Scurlock they saw a talent that could help to shape their public image positively.

Individual clients, such as W. E. B. Du Bois, Booker T. Washington, Robert and Mary Church Terrell, and Carter G. Woodson, all drawn by the studio's reputation, catapulted Scurlock to national prominence. Woodson, as president and founder of the Association for the Study of Negro Life and History, distributed Scurlock's photographs of prominent African Americans in kits to school children around the country in early promotions of Negro History Week.[9]

Du Bois, a founding member of the NAACP, published many Scurlock photographs when he became editor of the *Crisis*, the organization's official periodical. When "The Star of Ethiopia," Du Bois' spectacular black history pageant, came to Washington, D.C., in 1915, Scurlock, along with fifteen other prominent black men and women of the Washington community, joined the pageant committee. Members worked

to produce an extravaganza that involved hundreds of actors and promoted the history of Negro religious faith, education, and racial pride. Scurlock's panoramic group photographs of the massive stagings in Washington and later in Philadelphia appeared in the August 1916 issue of the *Crisis*. In this way the magazine's wide readership, beyond the tens of thousands who witnessed the pageant in person, was aware of the event's success.

Addison was also a member of the elite Mu-So-Lit Social Club and took photographs of the group. A nationally recognized cultural organization, Mu-So-Lit included leading local residents, mostly professional men. They could join either as a social or a stock-holding member, although Scurlock's status in its membership rolls is not indicated. Lawyers, physicians, teachers, policemen, and many businessmen, including Ambrose hotel owner Tally Holmes, architect John A. Lankford, printer George H. Murray, and Addison Scurlock, were members.[10]

This founding base of black middle-class clients—both socially elite and non-elite individuals and organizations—afforded Scurlock the wherewithal to expand continually the reach and scope of his photographic operations. The studio flourished through the 1910s, just as the Scurlock family began to grow. All of Addison and Mamie's children—Addison Jr. (born 1914), Mabel (born 1915), Robert (born 1916), and George (born 1919)—were born before 1920. The youngest, George, was born one month after brutal race riots during the Red Summer of 1919 enveloped Washington as well as many other cities. White mobs violently attacked African Americans, and they were sometimes met with organized and armed resistance by black citizens just blocks from the studio on Seventh Street, NW.

Social and legal segregation spread during the early years of the Great Migration in the 1910s. In the District and other urban centers, blacks of different economic and social classes, and of different ethnic and cultural backgrounds, all lived in similarly restricted environments and experienced discrimination to some degree. These riots made visible the vulnerability of all classes of African Americans to capricious white violence. They also demonstrated, to some in black Washington's highly class-stratified and politically conservative environment, the strength that a consolidated black community could muster in resistance.

In response to specific events, such as the Red Summer riots of 1919, as well as broader social trends, Washington, D.C., emerged as an important catalyst for the New Negro Renaissance, which marked the intellectual, cultural, artistic, and social transformation of the black community.[11] Through the print media, African Americans across the country came to share common reference points by the mid-1920s. They read stories about community leaders, schools and new educational programs, and local and national activists, and they were exposed to the writings and art of African American poets, philosophers, activists, and artists. Scurlock and other photographers participated in and extended the aesthetics and politics of the burgeoning New Negro movement. Not only did they observe the events taking place around them, but they were also involved in and influenced by them, carefully and consciously constructing the African American image. With advances in both publishing and distributing print media, they found a welcome vehicle to disseminate examples of their craft.[12]

TWO GENERATIONS

Scurlock's photographic expertise and his business acumen created an environment in which his children could excel and emulate his success. Addison and Mamie's children followed the professional track and attended Dunbar High School, one of the top schools for African Americans in the country. At the time Dunbar's curriculum centered on the classics, and its graduates were destined for college and professional careers, as opposed to students who attended the city's two other black public high schools, Cardoza and Armstrong. Addison Jr., president of the school's camera club, graduated from Dunbar in 1932, and Robert graduated the next year. George managed the basketball team and was a member of the school's cadet team. He graduated with the class of 1936. After high school, all four children entered Howard University. The three sons assisted their father in the studio and had aspirations to be photographers. Robert graduated from Howard in 1937, George in 1941, and Mabel finished in 1936. Addison Jr. died tragically of scarlet fever during his sophomore year at the university. This loss deeply affected the family. Mamie Scurlock rarely talked about her eldest son.

Both surviving brothers were active in social activities at the university while they completed their education, with Robert studying economics and George taking business courses. They were members of the Beta chapter of the Alpha Phi Alpha fraternity, and both joined the ROTC program. Both also became members of the What Good Are We social club, with Robert serving as the group's president in 1937. The "Whats," as it was affectionately dubbed by the press, was one of the city's many clubs popular with former Howard students in the 1930s and 1940s. Club members staged public dances in the Lincoln Colonnade, a popular hall located below and behind the Lincoln Theatre on U Street.

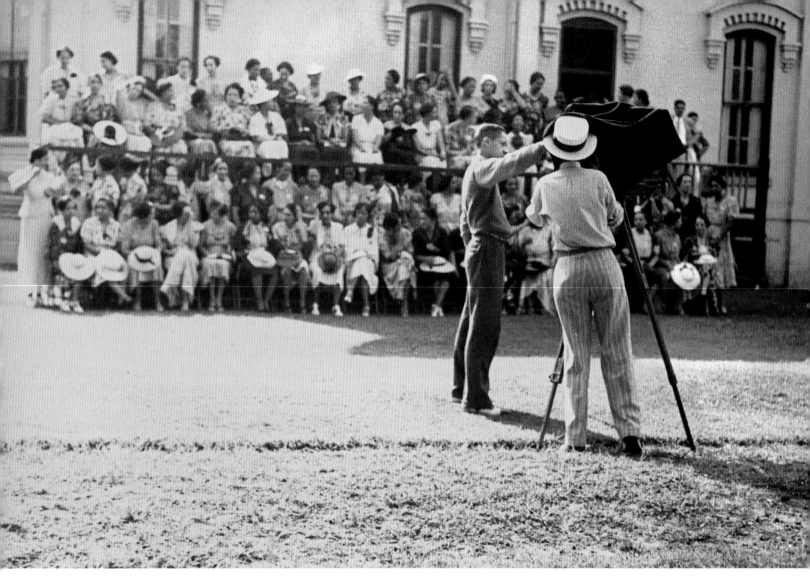

After graduation, Robert went to work in his father's studio. He concentrated on photojournalism and stock photography, two areas in which he thought he might eventually make his mark. Addison taught his sons the intricacies and skills of formal portraiture, the bread and butter of the Scurlock enterprise, but the work could be formulaic and repetitive. Robert and George absorbed their father's lessons in lighting, posing, and retouching and learned how to achieve the "Scurlock look" that ensured dignified likenesses of their African American customers. Several years older than George, Robert clearly wanted to distinguish himself as a photographer in his own right, rather than just follow in his father's footsteps as a studio portrait photographer. Addison, to be sure, also photographed on location and was never totally immured in the studio. Even so, some of his most impressive informal studies of large groups were achieved through careful composition. While Robert appreciated his father's technique and attention to detail, he also sought greater freedom of expression by experimenting with different approaches.

Addison and George Scurlock photographing the National Association of College Women at Howard University, c. 1930s, by Robert H. McNeill, copyright The Estate of Robert H. McNeill

According to Carter G. Woodson, photography was introduced into the public schools system in the early 1930s. Artists and critics of the previous decade's Black Renaissance believed that, in the instruction of photography, greater detail should be given to the artistic study of a black look, a black culture, and a black aesthetic. "It has turned out, however," he said, "to be a development of teachers of art imitating what they have seen among whites rather than Negroes who get their inspiration from within and try to give thereby a new picture of the soul of the race." According to Woodson, black photographers should direct special attention to their subject's "color and oriental setting," thereby creating a more accurate likeness than white photographers were able to do.[13]

Photojournalism developed into a discipline in the 1930s, partially due to the influence of the Farm Security

Administration (FSA) and its charge to document the plight of Americans during and after the Great Depression. Simultaneously, the establishment of the first picture magazines, *LIFE* and *Look*, generated a demand for candid photographs to record the dynamic events of the time as they unfolded before the photographer's trained eye. The massive record of the FSA and the distribution of picture magazines created both a taste and a need for additional visual records and depictions of a wider variety of life in a multiplicity of venues.

Robert was clearly impressed with the expanding role of photography and how it was beginning to be understood as a medium that not only could capture and reveal history as it was being made but could also affect change. His approach and his eye for capturing a different ethos and melding it with lessons learned from Addison perhaps reached its zenith when, at age twenty-three, he documented Marian Anderson's historic, triumphant concert on the steps of the Lincoln Memorial on Easter Sunday 1939. It was also largely through Robert's initiative that, beginning in the late 1930s, the family business started to enjoy new outlets for publication in magazines and newspapers nationwide.

During their early years, magazines such as *LIFE* and *Look* did not include photographs of African Americans. A number of Southern newspapers published a separate "black page" of news that was distributed only in the African American communities they served. Many Northern papers deemed newsworthy only those stories that dealt with black crime. The exclusion of images that bolstered black culture, combined with white newspapers' negative portrayal of blacks, contributed to the development of magazines and the growth of existing newspapers by, for, and about African Americans.

Most famously, perhaps, the Johnson Publishing Company published *Jet* magazine, a weekly depicting African American social life, and *Ebony* magazine emerged as the black counterpart of the glossy *LIFE* and *Look*. Along with those well-known periodicals issued during the 1940s, several other black picture magazines were launched, including *Newspic, Our World, Sepia,* and *Flash!* in an attempt by the black community to present a more positive image of African Americans. Focusing on news for blacks by blacks, the magazines mostly catered to the middle class and featured profiles of race leaders and articles on black social life. Washington's U Street and its surrounding neighborhoods offered a rich source of material.

Photography increasingly played an important part in a shifting agenda for racial equality. Robert McNeill, a contemporary of Robert and George Scurlock who found work with the Federal Writers' Project of the Works Progress Administration of Virginia in the 1930s, said of black photographers during those decades, "We lifted the curtain so that people could see behind it."[14] In other words, with the dawn of picture magazines and other means of mass-producing photographs and distributing them all over the country, black photographers played a major role in exposing a seemingly invisible culture. They created images of the latest dances and fashions, movers and shakers in medicine and education, activities of national and local organizations, and the work of activists fighting for civil rights. Robert Scurlock provided images for a number of major black press outlets, including the *Afro-American* newspaper, the *Pittsburgh Courier, Ebony,* and the *Chicago Defender*.

One of the most influential periods for the use of photographs in the press and its influence on the way African Americans viewed themselves occurred after World War II. John H. Johnson, CEO of Johnson Publishing

Robert Scurlock holding a Graflex press camera with the U.S. Capitol building in background, c. 1940s

Company, suggested that the early picture magazines of the 1930s and 1940s, like television, expanded world views and visually presented accomplishments among all people. For *Jet*, *Our World*, *Flash!*, *Ebony*, and other African American picture magazines, this meant emphasizing positive aspects of African American life. As Johnson pointed out, "People wanted to see themselves in photographs...and black people wanted to see themselves in photographs. We were dressing up for society balls, and we wanted to see that. We were going places we had never been before and doing things we'd never done before, and we wanted to see that." While the black press reported on discrimination and the struggle against segregation, black magazines played an alternative role. "We needed, in addition to traditional weapons, a medium to make blacks believe in themselves, in their skin color, in their noses, in their lips, so they could hang on and fight for another day."[15]

At the start of World War II, both Robert and George expected to join the service. George, however, did not pass the physical examination and stayed behind to work in the family photography business. Robert left to serve with the 301st Fighter Squadron in Italy—the squadron of the famed Tuskegee Airmen. He took dramatic portraits of his fellow airmen and documented their activities. He also managed to photograph fine views of Italy, imbued with a pictorialist sensibility, in a kind of homage to his father's aesthetic. Upon his discharge, Robert returned to Washington and organized what may have been his first solo exhibition. In Howard University's art gallery, Robert presented thirty photographs taken while he was a soldier in Europe and the United States.

During Robert's absence, Addison and George continued to operate the business, with George accepting an ever greater degree of responsibility. For the better part of the war years and afterward, George ran the commercial aspects of the studio by covering commencements, programs, and reunions at most of the schools, while his father handled studio work, particularly graduation portraits. In addition to his sons, Addison Scurlock influenced several young men to enter the field of photography. Harrison Allen,

although several years behind Robert while at Dunbar High School, sometimes accompanied the Scurlock boys home and assisted in the studio. He later turned to photography after he served as an apprentice under local photographer Robert McNeill. Addison helped McNeill himself get his start by advancing him money to purchase commercial photographic equipment. McNeill was a member of the FotoCraft Camera Club, which started in a local YMCA around 1938. Most of the club's members were hobbyists, but several, like McNeill, were full-time photographers.

A returning veteran, Robert took advantage of the G.I. Bill to purchase a building and open the Capitol School of Photography in 1947. He knew that black veterans needed education and practical skills to find employment. He reasoned that he was in a unique position to formulate a lucrative addition to the family business while he also fulfilled the worthy goal of training young African American veterans as photographers. George taught evening courses and continued to work in his father's studio during the day. During its four-year tenure, the school graduated some of the area's top African American photographers, among them Maurice Sorrell, Clifton "One Shot" Cabell, and Ellsworth Davis.

The handsome twelve-page brochure of the Capitol School of Photography, printed in black and white with topical headings and accents in red, was illustrated with photographs of the school's physical plant. It showed exterior and interior views of the newly purchased building at 1813 Eighteenth Street. Among the illustrations were an array of enlargers in the darkroom, the studio, retouching stations, and a variety of photographs—presumably of student work—that included portraits, still lifes, and architecture. Gracing the front cover was a dramatically lit portrait of a stunningly beautiful young woman, evidence of the brothers' arrangement with a black modeling agency to supply the school with attractive models. By photographing the models, the students learned how to render with skill the varying shades of black skin tones. The brochure's back cover boasted an equally dramatic image of the Capitol building with the motto, "The nation's capital...a photographer's paradise." Although the brochure was primarily directed toward men, judging by its emphasis that students could enroll under the veterans' program, a photograph of a young woman in dark glasses adjusting the lens of a press camera was accompanied by the statement, "Photography offers an excellent opportunity for women. They have demonstrated exceptional skill in Child Photography, Fashion Work, Retouching and Oil Coloring."

Capitol School of Photography students with their cameras,
c. 1947–52

Set-up for photographing a model in the Scurlock Studio,
c. 1947–52

Operating out of the second floor of the studio, the school had three primary instructors. Other photographers served as guest lecturers, but Robert and George were the mainstays. Class sessions were held both morning and evening to accommodate students' work schedules. These teaching activities, combined with their regular studio responsibilities and Robert's ventures into photojournalism, resulted in long hours of work for both brothers. Although numerous students completed the full three-year cycle of coursework, some attended the school only briefly or opted for abbreviated training. Years later the brothers loved to talk about their most illustrious short-term pupil, Jacqueline Bouvier, who went on to work as the "Inquiring Photographer" for the *Washington Times Herald* and met John Fitzgerald Kennedy on one of her assignments.

Former student Ellsworth Davis, the first black staff photographer for the *Washington Post*, remembers about twenty-five members in his class, including several white students. Ellsworth was a self-taught photographer who bought his first camera while he was in the service. At the end of his tour of duty, he took a career test that indicated

photography would be his best choice. Following an interview with Robert Scurlock, Davis enrolled in the program, balancing stints in the military reserves with attending classes from 1947 to 1952 and working in the darkroom at the Department of Commerce. "He was very strict about attendance," Davis recalled about Robert. "He would give us little courses on how to write resumés…in other words, he prepared every guy who graduated from that school to go out and find jobs in the government or wherever in photography." The owners of the Capitol School of Photography knew their clientele, but even more importantly they understood the racial climate they were preparing their students to enter. Loosely emulating the informal instruction in etiquette and work ethics of employees in the black press and other black institutions of the time, the Scurlocks considered their students to be ambassadors in a racially segregated and sometimes hostile world. In addition to learning how to write resumés, students received tips on job hunting and indirect lessons on proper attire and attendance. When prompted about attire, Davis said of Robert Scurlock, "He was there by example." Scurlock sometimes made comments about appropriate dress, but how he carried himself inspired students to conduct themselves according to his personal standards. "Hurry up and wait!" was Robert's motto. According to Davis, that was Robert's way of telling students that it was better to arrive early and wait at the door than it was to leave home on time and risk being late for an appointment.[16]

CUSTOM CRAFT AND BEYOND

The Capitol School of Photography shuttered its doors in 1952. Although dwindling enrollment might have prompted this business decision, it also seems likely that the brothers' grueling teaching schedules (9:00 a.m. to 10:00 p.m. daily, with a four-hour break) could have induced them to embrace a more lucrative and less taxing enterprise after four years. In addition, technological advancements, along with the city's burgeoning tourist industry, attracted more photographers to the field. The *Dee Cee Directory* listed twenty-three studios of African American photographers in 1948, with seven studios situated in and around the U Street corridor.[17]

By the 1950s, the soft-focused, romantic images of Addison's heyday had given way to the more straightforward photography of the early 1940s and the postwar era. Edward Steichen, Edward Weston, Paul Strand, Margaret Bourke-White, Ansel Adams, and others successfully established and popularized a variety of approaches to photographing the realities of life and nature. Many younger African American photographers lived, worked, and socialized in their respective communities while they recorded a vibrant moment in black history. Although vernacular photography was a cornerstone among African Americans during this period, some photographers broke away from that mold and instead found international recognition by introducing an artistic touch to their images or by presenting a different side of black America.

The photography of Roy De Carava, for example, was heavily influenced by artistic nuances of rich tones, dramatic light, and abstraction. De Carava had studied painting and commercial art before picking up a camera. Gordon Parks' decision to study photojournalism was sparked after viewing images of black migrant workers taken by photographers working for the Farm Security Administration. His stark photographs of poverty in the District of Columbia stood in direct contrast with other images of black Washington. Morgan and Marvin Smith of New York, on the other hand, made a conscious effort to photograph only the positive side of black life and shunned views of poverty and degradation. Robert McNeill first received recognition for his photographic essay on domestic workers and laborers in New York in 1938. His photojournalistic approach documented early civil rights events and personalities, such as the Bronx "slave market" in New York or members of the New Negro Alliance in Washington, D.C.

Although Robert Scurlock continued to provide photographs for the press and to take portraits of individuals in the postwar years, he turned to several new opportunities to expand the business beyond the scope of his father's original vision. He excelled in color photography as well as in night lighting, as his exceptional view of Howard University from across McMillan Reservoir attests. Bernie Boston, who worked as Robert's assistant from 1958 to 1961, described a night assignment.

> *I did portraiture with him. I did a lot of the custom color printing and processes for him. We did commercial photography. One [gig] was to photograph the Equitable Life Insurance building up on Wisconsin Avenue…that god awful long building…and we did it at night. We literally had to paint it with light with flash bulbs because strobes were not what they are today. So we'd take large no. 50 flash bulbs and walk along and paint that building. And this was done on 8 x 10 color transparency material.[18]*

These techniques, especially the use of color, attracted a new clientele. Pursuing commercial photography with more dedication, Robert gradually shifted to rely more heavily on corporate and business clients and the federal

government. He also actively pursued magazine work, submitting to *Ebony* photo essays featuring black professionals and businesses.

Long interested in color photography, Robert realized that a growing need existed in the city to supply other professional photographers with color processing and printing. To fill this void, he created Custom Craft, a separate business in the Eighteenth Street facility that took the place of the Capitol School. Considering the work of other African American photographers in the postwar era, Robert's decision to pursue a commercial photographic studio might seem a bit out of step with the ethos of the time. It must be admitted, however, the move also demonstrates a foresight that may have contributed to the staying power of the Scurlock business. Advertising photography was already established by World War II, but the expansion of the industry in the postwar years created large, unprecedented advertising budgets. Money was abundant to hire photographers for big commercial projects, and Robert had the technology and the skills to tap into the market.

By the 1950s technical improvements in color photography had captured the imagination of a growing number of amateur and professional photographers alike. In the twenty-first century, viewers often find the meticulously hand-colored black-and-white photographs of the Scurlocks to appear delightful and charming, but the "natural color" of Ektachrome, Kodachrome, and other color products in the late 1940s and early 1950s clearly provided greater realism and authenticity in an increasingly competitive market. Although art photographers debated the aesthetic merits of color photography well into the 1960s, the demand for "natural color" and laboratories that could process the films and produce the prints in full color was burgeoning.

With Custom Craft, Robert found a unique opportunity to engage in this new specialty, particularly by producing prints for other studios and independent photographers in Washington. His firm provided prints for well-known photojournalist Fred Maroon, who was noted for his books of rich color images of the capital city, and for art photographer Robert Epstein. Robert Scurlock hoped (and gambled) that non-black photographers would need Custom Craft's services. His initiative undoubtedly represented a conscious attempt to make inroads beyond the African American community and more broadly into white Washington. Expanding the business in this way caused a professional rift with his father. Addison still preferred black-and-white photography, and he maintained a focus on individual clients as well as on businesses and institutions owned and operated by blacks. The business split in the 1950s and stayed that way through-out the decade, with Robert running Custom Craft and George staying with his father at the original portraiture studio at 900 U Street.[19]

Despite the new concentration on color processing, the Scurlocks' standard repertoire of photographic assignments continued apace. Portraiture in the studio and in clients' homes and businesses remained important, as did photographing classes, graduations, and activities at Howard University—the studio had served as Howard's official photographers for decades—community events, gatherings, and weddings. Ellen Robinson David, a longtime resident of the Washington area who has helped to identify many individuals in Scurlock photographs, fondly recalls Mr. and Mrs. Addison Scurlock and their sons attending her wedding on December 27, 1955. George had black-and-white film in his camera, and Robert had color film in his.

ENDINGS

Even though the District's racial demographics changed in the 1950s, discrimination and segregation remained a part of black life in Washington. Local activists, including Mary Church Terrell, Mary McLeod Bethune, and Eugene Davidson, organized protests that broke many of the city's social barriers and crippled Jim Crow. As Washington slowly and fitfully desegregated, demographics altered and other social barriers arose. White residents migrated from the city to the suburbs. Despite their own desire to obtain housing outside the city, many black residents were hindered by financial institutions that refused to make loans available. A lack of ample affordable housing, followed by a failed urban renewal program, contributed to the decline of black residential areas. The black economic base also began to shift. As black business owners opened stores throughout the District, black patrons began to spend elsewhere. The economic loss to the Cardoza-Shaw area, especially U Street, was devastating. Competition for clientele was stiff. Robert McNeill and Maurice Sorrell, for example, discontinued freelance work and sought full-time jobs as photographers. McNeill began working for the State Department in 1956, and Sorrell accepted a position as a photographer for the Washington office of *Jet* magazine in 1962.

Change also affected the studio. Addison Scurlock retired in 1963 and sold the business to his sons. He died the following year at the age of eighty-one, and much of his recognition from outside the Washington African American community came posthumously.[20] As the civil rights and antiwar movements challenged the nation, Washington became the focal point for national protests. In April 1968 riots broke out in response to the assassination of Martin

Luther King Jr., whose death marked for many the end of hope and promise for racial justice and freedom. Looting and destruction along the Fourteenth and U Street corridors hit businesses and homes the hardest and further eroded the once-bustling community. With the weakening of strict social segregation, individuals with the financial wherewithal began moving out to the suburbs and taking jobs in the government or private sector. Despite the continued success of the Scurlock enterprise, this changing and challenging environment foretold significant challenges. Portrait photographers, including the Scurlocks, found less time to practice their craft while they devoted more time to the business of photography. As a result, the brothers discouraged George's children from becoming photographers.

Struggling with this wave of change, the business was reincorporated into two divisions under the name Custom Craft Studio, with each son heading a division. Under George's direction, the Scurlock Studio division continued to handle portraiture and photography assignments. Robert covered corporate assignments and color photography through Custom Craft. The Scurlock enterprises became racially integrated in the early 1970s. Answering an advertisement in the *Washington Post* in 1973, Scott Engdahl, armed with a degree in photography from the Rochester Institute of Technology, interviewed for the position of manager of the Custom Craft operation and was quickly hired. Engdahl was white, as was Al Marceron, who managed the portrait studio for Robert. Four employees worked at Custom Craft: Engdahl, Raoul Aramayo, a technician who did film processing, and a secretary. The business had expanded to three locations in Northwest Washington: the original building at 900 U Street, the Custom Craft building on Eighteenth Street, and a studio on Connecticut Avenue. The neighborhood surrounding U Street, however, experienced a serious physical decline due to the riots and the failure of Washington's urban renewal program. The five-year interruption of construction on the Metro's Green Line took its toll on the Scurlock Studio, as it did on numerous other businesses that were disrupted or displaced along U Street. Many local businesses moved or closed their doors permanently.[21] The decision was made to close the Connecticut Avenue studio in the early 1970s, and most of the activities were consolidated in the Custom Craft location on Eighteenth Street. George's role in the business gradually declined after the 1960s, along with the clientele and the neighborhood.

In 1976, in preparation for celebrations of the country's two hundredth anniversary, Robert Scurlock submitted a proposal to the D.C. Bicentennial Commission to establish a free gallery of photography at the Scurlock Studio's original site at Ninth and U Streets. The proposed gallery would serve two purposes: a permanent showcase for the work of his father Addison Scurlock, and a place to educate young people on African American achievement. He also envisioned a traveling exhibition that would feature a gallery of works by aspiring photographers from around the world, in addition to a space to train young people in the field. The proposal was not accepted. Years later, despite Robert's request for Mayor Marion Barry to intercede, the original studio at Ninth and U Streets was forced to relocate because of the extended construction of the Metro's subway system. In 1991, eighteen years after construction began on the Green Line, Metro service was supplied to the U Street corridor, but it was too late for the original Scurlock Studio, which had been razed in 1983.[22] George worked on a part-time basis throughout the 1970s, but he left the photography business in 1977 to become a full-time sales associate for a Chrysler Plymouth dealership in Anacostia. He excelled at selling cars and was named to the Chrysler National Sales Honor Society. After George left, Robert remained the primary photographer at Custom Craft.

In lieu of Robert's grander plans, his father's work was honored posthumously with a one-person exhibition at the Corcoran Gallery of Art in Washington, D.C., in 1976. Working with Frances Fralin, the Corcoran's curator of photography, Robert prepared a loving tribute to his father by organizing a retrospective of Addison's career that featured 122 photographs. Only fifteen prints were vintage works by the hand of the master; the majority of the prints were new, carefully produced by Robert from the studio's vast archive of negatives. Photographs of the opening reception at the Corcoran reveal a happily beaming Robert with his wife Vivian proudly giving a tour of the exhibition to James VanDerZee, the legendary African American photographer of Harlem. A year later, Addison's work was included in another Corcoran exhibition, *The Black Photographer*, an unprecedented undertaking of 150 prints by nearly seventy photographers. Addison's photographs shared a gallery with his contemporaries, including VanDerZee and P. H. Polk from Tuskegee, Alabama. Robert said of his father's work, "His lens focused on the rich and the poor, famous and unknown, athletes and presidents. The Scurlock camera was positive proof of the phrase, 'Black is Beautiful,' and the record is here for future generations to discover and enjoy."[23]

Throughout the 1970s and 1980s Scott Engdahl accompanied Robert in photographing weddings and commercial work outside the studio. The business was "up and

down" in those later years, according to Engdahl, and at times work for the Commerce Department and the National Portrait Gallery largely sustained the studio. Robert was always dapper and immaculately dressed, professional in his demeanor and attitude, and a demanding perfectionist. It was important to him to keep up to date with photography technically, just as his embrace of photojournalism in the 1930s had reflected his intention to keep current with styles and trends. His widow Vivian fondly, and with some amusement, recalled their annual trips to Cologne, Germany, to attend the Photokina fair, where the latest developments in photographic technology and products were on display. The last wedding that Robert photographed was Engdahl's own in July 1994.

George, Robert, and Addison Scurlock looking at photographs, 1950

THE SCURLOCK STUDIO COLLECTION
AT THE SMITHSONIAN

Toward the end of his life, Robert Scurlock sought a permanent home for the historic Scurlock archive, and he discussed with Carmen Turner, Undersecretary of the Smithsonian Institution, the possibility that the Smithsonian might eventually acquire his massive collection. This conversation, unfortunately, occurred only a month before Turner's death in April 1992. After a massive stroke followed by a coma, Robert died two years later in 1994. For over a decade the enterprise had become virtually synonymous with Robert Scurlock as the head, heart, and soul of the operation. With Robert gone, his widow, Vivian Woods Scurlock, decided to close the business and find a home for the studio's contents, including cameras and photographic equipment, but especially the archive of photographic prints, negatives, transparencies, and business records.

The Photographic History Collection at the Smithsonian's National Museum of American History (NMAH) was contacted to discuss the acquisition of the Scurlock Studio Collection. The museum staff arranged visits to the Custom Craft building at 1813 Eighteenth Street and to rented storage spaces at two locations that housed portions of the Scurlock legacy, and they held discussions with Vivian Scurlock and Robert's longtime assistant, Scott Engdahl. Lynne Gilliland, the museum's paper conservator, and conservation consultant Andrew Robb accompanied the staff of the Photographic History Collection and Archives Center to inspect the aquisition. They paid special attention to the cellulose acetate negatives, many of which were in poor condition. Despite his long separation from his family's enterprises, George Scurlock's interest in the business was revived, and he served as a guide by identifying and commenting on photographs. George died of lung cancer in 2005.

On a single hot September day, the Custom Craft building was emptied of its contents—photographs, business records, cameras and studio equipment, darkroom paraphernalia, studio furnishings, and accessories. Nearly the entire staff of the Archives Center was involved in packing and moving most of the photographs and papers, then picking up the negative files housed in the two rental facilities. This massive accumulation, representing the life of the Scurlock Studio, was officially transferred to the National Museum of American History in 1997.

Since that time, the Scurlock Studio Collection has been recognized as a treasure of American history. With more than 250,000 negatives and 10,000 photographic prints, along with cameras, studio and darkroom equipment, and nearly a century's worth of business records, the collection is a massive resource for scholars and the general public alike. Due to its sheer size, the collection's secrets are barely beginning to be uncovered, and its varied challenges can be acute. One continuing concern is the difficulty of dealing with deteriorating acetate negatives. Off-gassing of acetic acid (so-called vinegar syndrome) is a common occurrence with old photographic negatives. This irreversible chemical reaction destroys negatives, damages nearby photographs, and poses health risks. NMAH has entered into two interrelated projects to maintain the photographs and negatives under the best possible conditions and to make them accessible to the widest possible audience.

The Archives Center first received a large grant for a special project to preserve the images, especially the deteriorating acetate (and a few cellulose nitrate) negatives, through a freezing process that drastically slows down further deterioration. Even those damaged items in the worst condition can still yield recognizable faces and events, especially with the help of the most recent digital technology.

The process of freezing negatives was enhanced as well by a Save America's Treasures grant that focuses specifically on digitizing the original negatives in their current condition and cataloging them in the Smithsonian Institution Research Information System (SIRIS). In a race against time, the combined efforts of the scanning and freezing projects have rescued deteriorating negatives and extracted valuable visual and historical information before they become totally unusable.

An added benefit of the Save America's Treasures grant is that the now-digitized images are available to a wider portion of the public. The website Portraits of a City (http://americanhistory.si.edu/archives/scurlock/index.html) links records of images from the scanning project to SIRIS. Anyone with an Internet connection can now search a constantly expanding database of information, with more than 3,000 records at this time. Original prints from the collection can be viewed simply by making an appointment with the Archives Center's reference staff.

Over the years former Scurlock customers have contacted the center, seeking their photographs in the archive and hoping to order new prints of treasured family portraits. Not all the images that people want to see can be located. In fact, the majority remains elusive. Larger mysteries endure as well. For example, David Cole, an alumnus of Storer College, which closed in Harpers Ferry, West Virginia, many years ago, reported that Addison Scurlock was the official photographer for that institution, just as he was at Howard University. The elusive Storer College pictures, however, have not yet surfaced in the Smithsonian's collection,

and a modest amount of detective work has failed to locate them elsewhere. One of the most intriguing requests came from a filmmaker who said George Scurlock had once told her that Addison had made a 16mm motion picture film of a Garveyite parade in New York. No such film has been found to date.

A steady stream of students, scholars, and members of the general public continues to view portions of this important historic resource, and many images have been supplied to authors for reproduction. Exhibitions of photographs, book and magazine publications, video productions, and web-based programming are among the leading methods of telling the Scurlock story. Many of those familiar with these projects have become valuable volunteers at the Archives Center, helping to fulfill a major goal of the Smithsonian to keep the collection a vibrant and accessible national treasure.

The history of the Scurlock Studio and its legacy at the Smithsonian is rich and varied. The Scurlocks set the standard for photography as a business, and their name, work ethic, and the exceptional quality of their photographs

continue to resonate with younger artists practicing today. This studio, established by a determined African American craftsman, artist, and entrepreneur, originally functioned within a segregated enclave in the nation's capital, but it ended its days operated by the sons of its founder, an integrated business within an integrated society. With the advent of integration, the business and the community paradoxically found greater opportunities as they simultaneously lost much of their cohesiveness and independence. Throughout its eighty years of existence, the Scurlock Studio recorded the individuals and events of a vibrant local African American community and documented visits to the city by nationally recognized leaders. More than just a studio, the Scurlock enterprise represents the aspirations of a people. It created a lasting visual record of a separate society and its sometimes turbulent, always dynamic transitions throughout the twentieth century.

Deteriorating panoramic negative from the Scurlock Studio Collection, the Brotherhood of Sleeping Car Porters with A. Phillip Randolph, by Addison Scurlock, c. 1930s

Notes

1. Carter G. Woodson, *The Negro Professional Man and the Community* (Washington, D.C.: Association for the Study of Negro Life and History, 1934), xi.

2. Roy Parker Jr., *Cumberland County, A Brief History* (Raleigh: Division of Archives and History, North Carolina Department of Cultural Resources, 1990), 161.

3. Andrew F. Hilyer, *An Address on the Union League and the Industrial and Organized Status of the Colored People of the District of Columbia*, annual meeting (April 1893), Andrew F. Hilyer Papers, Moorland-Spingarn Research Center, Howard University, Washington, D.C.

4. Giles B. Jackson and D. Webster Davis, *The Industrial History of the Negro Race of the United States* (Richmond: Virginia Press, 1908).

5. Constance McLaughlin Green, *The Secret City: A History of Race Relations in the Nation's Capital* (Princeton: Princeton University Press, 1967).

6. Except for 1904, Addison Scurlock is listed as a photographer in city directories for Washington, D.C., from 1901 until his retirement in 1963. See D.C. Department of Public Works, Engineer Department Classified Files, record group 180, box 103, file no. 56073, District of Columbia Archives, Washington, D.C.

7. Jonathan Scott Holloway, *Confronting the Veil: Abram Harris Jr., E. Franklin Frazier, and Ralph Bunche, 1919–1941* (Chapel Hill: University of North Carolina Press, 2002), 44.

8. As president of the local chapter of the National Business League, Freeman spoke before Booker T. Washington and other businessmen and women about African Americans and the photography business in Washington, D.C., during the League's annual conference in Boston in 1915.

9. Founded in 1915, the organization is now called the Association for the Study of African American Life and History. The first Negro Achievement Week occurred in 1924. Two years later the program was renamed Negro History Week and was launched nationally. Photographs of prominent African Americans were a crucial component of the educational kits.

10. This information was part of a profile of the organization included in sociologist E. Franklin Frazier's research of social stratification for his Negro Youth Study for the Washington Community. See E. Franklin Frazier Papers, box 131–132, folder 2, Moorland-Spingarn Research Center, Howard University, Washington, D.C.

11. The New Negro Renaissance of the 1920s was really part of a movement that had been developing since the turn of the century. In the early decades of the twentieth century, the "old Negro," seen as patient and unquestioning, was replaced with a "new Negro," constructed in defiance of the old. While the literary and arts explosion of this period was later referred to as the Harlem Renaissance, the artists and intellectuals involved were not confined to New York City. Many important figures were based in Washington, D.C. See, for example, James A. Miller, "Black Washington and the New Negro Renaissance," in *Composing Urban History and the Constitution of Civic Identities*, ed. John J. Czaplicka and Blair A. Ruble (Washington, D.C.: Woodrow Wilson Center Press, 2003), 219–41.

12. During the administration of Howard University president Mordecai Johnson, which began in 1926, Addison Scurlock more fully developed his relationship with the university. He became the institution's official photographer and thus secured the studio's biggest client. In a letter to the university's president, Scurlock thanked Johnson for arranging for him to photograph the freshman class of 1930 and presented the president with a complimentary photograph. The letter also mentions the image would appear in the *Washington Afro-American* and the *Washington Tribune* newspapers. In fact, many of the photographs of Howard University events, faculty, and students were published in black newspapers and magazines throughout the country. See E. Franklin Frazier Papers, box 131–132, folder 2, Moorland-Spingarn Research Center, Howard University, Washington, D.C.

13. Woodson, *Negro Professional Man*, 304.

14. Robert H. McNeill telephone interview with Donna Wells, May 30, 2001.

15. John H. Johnson, *Succeeding Against the Odds: The Autobiography of a Great American Businessman* (New York: Amistad Press, 1992), 156.

16. Ellsworth Davis interview with Donna Wells, November 11, 1995.

17. *Dee Cee Directory: A Business, Professional and Social Directory of Negro Washington* (Washington, D.C., 1948). Two entrepreneurs, James T. Terry and Lois K. Alexander, published this directory. Terry was the proprietor of a tourist hotel. At the time, Alexander owned a boutique business, but she later received international recognition for her work on the history of black designers. She founded the Black Fashion Museum in New York and in Washington, D.C. The 1948 directory was the only edition every published. Also note the listing and advertisement for the Allied Photographers Association to which many professionals belonged.

18. Bernie Boston interview with Donna Wells, December 5, 1995.

19. George Scurlock Jr., Tim Scurlock, and Jackie Scurlock Colbert interview by Paul Gardullo and Michelle Delaney, April 13, 2008.

20. Deborah Willis and Jane Lusaka, eds., *Visual Journal: Harlem and D.C. in the Thirties and Forties* (Washington, D.C.: Smithsonian Institution Press, 1996).

22. Numerous newspaper articles discuss the decline of Black Broadway. See Stephen C. Fehr, "Going Was Tough, But Green Gets Going: Northwest Neighborhoods Hope Opening of Metro Line Ends Disruption," *Washington Post* (May 9, 1991), and Edward C. Smith, "Once Upon a Time on the 'Great Black Way,'" *Washington Post*, n.d. Also see the 1994 festival program for *Remembering U Street: There Was a Time*.

22. Jeffrey John Fearing. "Addison Scurlock and The Scurlock Studios of Washington, D.C.," on Howard University ArchivesNet, vol. 6 (November 2000). http://www.huarchivesnet.howard.edu/0011huarnet/november.htm. Accessed May 30, 2008.

23. Robert Scurlock, proposal to the D.C. Bicentennial Commission. See project titled "Scurlock Gallery of Photographs" (August 15, 1974), in the Records of the D.C. Bicentennial Commission, Washingtoniana Division, Martin Luther King Library, Washington, D.C.

AFTERWORD

by BRENT D. GLASS

The exhibition about the Scurlock Studio of Washington, D.C., represents the beginning of a significant collaboration between a venerable established museum and a new museum with a bright and exciting future. This partnership reflects not only the commitment of the directors and staff of the respective museums but also the inherent strength of the Smithsonian Institution. It is through the unique resources of the Smithsonian that curators, educators, and exhibition designers have the opportunity to work together and make accessible innovative research and extraordinary collections.

The Scurlock Studio Collection is remarkable in every respect. The photographs, equipment, and business records span nearly a century of transactions documenting the operations of this unique enterprise that played a pivotal role in Washington's African American community. After the National Museum of American History (NMAH) acquired the collection in 1997, a major grant from the Save America's Treasures program provided funding to digitize glass-plate negatives that were in deteriorating condition. The museum now offers researchers an excellent website, thanks to the dedicated efforts of the staff and volunteers of our Archives Center.

Launching the new gallery on African American history at NMAH coincides with the reopening of the museum after two years of renovation. The effort is part of a larger transformation of the museum that involves ambitious intellectual as well as dramatic architectural changes. Our goal, quite simply, is to shed new light on American history. The exhibitions sponsored by the National Museum of African American History and Culture (NMAAHC)—

beginning with the superb images from the Scurlock Studio Collection—reinforce this goal.

As NMAH moves forward to tell the story of America through research, collections, exhibitions, programs, publications, and websites, the experiences and contributions of African Americans will continue to play a pivotal role in fulfilling this mission. The museum has been a leader in the field, with pioneering exhibitions such as *From Field to Factory* and *Separate is Not Equal: Brown v. Board of Education*; noteworthy collections that include the Woolworth's lunch counter from Greensboro, North Carolina; and innovative programs created by the museum's Program on African American Culture. Through this collaboration with NMAAHC, our efforts in this area will grow in quantity and strengthen in quality.

The significance of the African American experience and the impact of African Americans on our nation's history and culture cannot be overstated. All the core issues of American history—freedom, equality, opportunity, justice, progress—find expression and resonance in the extraordinary stories of African Americans as they have shaped every aspect of this country's political, social, economic, and cultural life. The story of the American Dream—the values, ideals, and traditions that form the foundation of our national experience—is, in many respects, the story of African Americans. It is a story not only of great achievements but also a story of the struggle to overcome enormous barriers. This proud heritage that reflects the promise of American life resonates in the beautiful images produced by Addison Scurlock and his family, now found in this book and proudly displayed at the National Museum of American History.

Acknowledgments

The Scurlock Studio and Black Washington—Picturing the Promise could not have been accomplished without the assistance and good will of many people from within and outside the Smithsonian Institution.

Thanks first go to the staff of the National Museum of African American History and Culture (NMAAHC). Despite being small in number, their dedication, versatility, and hard work make this and so many other projects possible. Numerous staff members and interns from all departments helped to identify images, suggest contributors, develop outreach programs to build content, administer contracts, and edit text. Contributions in these areas and others were made in particular by Kinshasha Holman Conwill, Tuliza Fleming, Michèle Gates Moresi, Esther Washington, Lydia Charles, Lynn Chase, Fleur Paysour, Princess Gamble, Susan Samaroo, April Holder, Debora Scriber-Miller, Taima Smith, Cynthia Smith, Twanita Simpson, T. Shareen Dash, and Hilary Scurlock.

This project would not have been possible without the efforts of the National Museum of American History and its Archives Center staff whose years of work conserving this collection paved the way for this book and its accompanying exhibition. As the custodians of the Scurlock Studio Collection, members of the Archives Center possess the most intimate and detailed knowledge of the Scurlocks' work, and their contributions were many. Present and past staff members, including Susan B. Strange, David E. Haberstich, Deborra Richardson, Faye Winkle, Kay Peterson, and Wendy Shay, helped to locate and digitize images. They also offered advice, conducted research, and provided resources to the project. Dr. Ted R. Hudson and Ellen Robinson David—longtime Washingtonians, Scurlock aficionados, and friends and volunteers of the Archives Center—were crucial in identifying images and contributing historical facts.

Outside of the Archives Center, curators and staff of the National Museum of American History were generous with their expertise and helpful in a variety of ways. We especially want to recognize James Gardner, Fath Ruffins, Omar Wynn, Steve Walczak, and Jane Fortune. We also thank John Dillaber of Smithsonian Photo Services and interns Leana Kruska and Court Brinsmead for their time and efforts spent digitizing the original negatives and prints for reproduction in this book. Portia James, curator, Jennifer Morris, archivist, and Habeebah Muhammad, registrar, at the Smithsonian's Anacostia Community Museum shared their expertise and ideas. Smithsonian librarians Chris Cottrill and Stephanie Thomas at NMAH and Shauna Collier at the Anacostia Community Museum helped to track down sources and provided research assistance.

Beyond the Smithsonian, this project helped us to build new relationships and strengthen old ones within our home community of Washington. The staff of the Moorland-Spingarn Research Center (MSRC) at Howard University, including Thomas Battle, Clifford Muse, Joellen ElBashir, and Ida E. Jones, was especially important in assisting with research and advice for topics related to Howard. Donna Wells, Prints and Photographs Librarian at MSRC, deserves special praise for her knowledge, advice, and generosity during the process of conceptualizing, researching, writing, and editing this book. Thanks also go to the librarians at the Washingtoniana Division of the District of Columbia Public Library, as well as to the Historical Society of Washington, D.C., and its executive director, Sandy Bellamy, and director of the Kiplinger Library, Yvonne Carignan. Cultural Tourism DC, and in particular Jane Freundel Levey, helped to brainstorm programs that could connect Scurlock photographs to people in and around the U Street neighborhood.

The Ali family—Ben, Virginia, Kamal, and Nizam—of Ben's Chili Bowl were generous to host a "Remembrance Gathering" at their establishment, and the attendees that night supplied an array of memories that not only have shaped some of the content of this text but also will continue to bear fruit in the future. In particular, we would like to thank Ellen Robinson David, Lillian Gordon, Ibrahim Mumin, Judith Bauer, Joyce Bailey, Hari Jones, Tyra Fennell, and the other participants and volunteers for their efforts in sharing their memories of black Washington. Special thanks also go to Irene Kellogg, Carl Cole, Lester Lee, Don Valentine, John Pinkard, and the rest of the FotoCraft group, Washington's oldest African American camera club, for sharing the club's story and connection with the Scurlocks.

Burke Syphax and Charlene Drew Jarvis culled through many selected images with us to identify people, places, and events. Susan McNeill furnished a beautiful photograph, used within these pages, that her father, Robert McNeill, took of the Scurlocks working at Howard University.

Mr. Butcher's dramatics class, Howard University, n.d

She and Suzanne Jenkins provided important historical information and helped identify images, as did photographer Marvin T. Jones.

Twenty-five wonderful scholars, artists, activists, and professionals contributed to the writing of this book. All of them deserve a special word of thanks for their excitement in the project and their good humor in dealing with incredibly short deadlines and editorial adjustments. In turns personal, humorous, provocative, and enlightening, their contributions have enriched this volume beyond measure. Special thanks go to Dorothy Height and Charlene Drew Jarvis for making time in their schedules to participate. Four other contributors—Jeffrey Fearing, Jonathan Holloway, Marya McQuirter, and Hilary Scurlock—also deserve special recognition. Their scholarship on the Scurlock Studio, the city of Washington, D.C., and/or African American history and culture was influential in shaping the book's content.

Some of the contributions sprang from "Inspired by Scurlock," a workshop for Washington writers and photographers that was conceived by E. Ethelbert Miller and sponsored by NMAAHC. Thanks are extended to Derrick Brown and Karen Evans, two workshop participants who helped shape that creative and productive conversation but were not able to contribute to the final product. Steven Cummings, Sharon Farmer, and Roy Lewis not only participated in the conversation that day but also continued to support the project. They enthusiastically met two more times with the curatorial staff to share their expertise on photography and their unique perspectives on the Scurlocks. A. J. Verdelle skillfully composed those conversations into prose for this book. Special thanks also go to Caroline Newman and Carolyn Gleason of Smithsonian Books, editor Nancy Eickel, and designer Bill Anton of Service Station for helping to bring this text to life.

Final thanks must go to the Scurlock family, whose generosity, enthusiasm, and support for this project have been truly inspirational. The three children of George Scurlock—George Scurlock Jr., Jacqueline Scurlock Colbert, and Addison (Tim) Scurlock III—identified photographs, lent objects, shared stories, and provided advice. They are a testament to the fact that the Scurlocks did not just make beautiful photographs—they also created a wonderful, caring family.

June 2008, Washington, D.C.

Sources

ARCHIVES

Moorland-Spingarn Research Center, Howard University, Washington, D.C.
 Eugene Davidson Collection
 E. Franklin Frazier Papers
 Andrew F. Hilyer Papers
 Charles H. Houston Papers
 Alain Locke Papers
 Lucy Diggs Slowe Papers
 Carl Van Vechten Collection

Smithsonian Institution, Washington, D.C.
 Accession files, Photographic History Collection, National Museum of American History

 Evans–Tibbs Collection, Anacostia Community Museum, Smithsonian Institution

 Scurlock Studio Collection, Archives Center, National Museum of American History

District of Columbia Archives, Washington, D.C.

NEWSPAPERS AND JOURNALS

Baltimore Afro-American
Camera Notes
Camera Work
Chicago Defender
Crisis
Flash! Weekly Newspicture Magazine
Hilltop (Howard University)
Journal of Negro Education
LIFE Magazine
Look
New Masses
New York Amsterdam News
Opportunity
Pittsburgh Courier
Washington Post
Washington Tribune

BOOKS AND ARTICLES

Alexander, Elizabeth. *The Black Interior*. St. Paul: Graywolf Press, 2004.

Baker, Lee D. *From Savage to Negro: Anthropology and the Construction of Race, 1896–1954*. Berkeley: University of California Press, 1998.

Banks, Shirley Ridgeley. "Memories of a Girlhood in Shaw." *Washington Post* (August 8, 1985), D.C. 1, 3.

Bennett, Tracey Gold. *Black America Series: Washington, D.C., 1861–1962*. Charleston, SC: Arcadia Publishing, 2006.

The Black Washingtonians: The Anacostia Museum Illustrated Chronology, 300 Years of African American History. Smithsonian Anacostia Museum and Center for African American History and Culture. Hoboken, NJ: John Wiley and Sons, 2005.

Borchert, James. *Alley Life in Washington: Family, Community, Religion, and Folklife in the City, 1850–1970*. Urbana: University of Illinois Press, 1980.

Brown, Letitia W., and Elise M. Lewis. *Washington in the New Era, 1870–1970*. Washington, D.C.: National Portrait Gallery, 1972.

Brown, Sterling A. "The Negro in Washington," in Federal Writers' Project, *Washington, Capital and City*. New York: Viking Press, 1938.

Brown, Tamara. "Highlights from America's Black Broadway." *Negro History Bulletin* (January–September 1996).

Bunch, Lonnie. *The Tradition Continues: California Black Photographers*. Los Angeles: California Afro-American Museum, 1983.

Clark-Lewis, Elizabeth. *Living In, Living Out: African American Domestics in Washington, D.C., 1910–1940*. Washington, D.C.: Smithsonian Institution Press, 1994.

Cripps, Thomas. *Making Movies Black: The Hollywood Message Movie from WWII to the Civil Rights Era*. New York: Oxford University Press, 1993.

Davis, Benjamin O. *Benjamin O. Davis, Jr., American: An Autobiography*. Washington, D.C.: Smithsonian Institution Press, 1991.

Dee Cee Directory: A Business, Professional and Social Directory of Negro Washington. Washington, D.C., 1948.

Ellington, Edward Kennedy. *Music is My Mistress*. Reprint. New York: Da Capo Press, 1976.

Everett, Anna. *Returning the Gaze: A Genealogy of Black Film Criticism, 1909–1949*. Durham, NC: Duke University Press, 2001.

Fabre, Genevieve, and Robert O'Meally, eds. *History and Memory in African American Culture*. New York: Oxford University Press, 1994.

Fearing, Jeffrey John. "African American Image, History, and Identity in Twentieth-Century Washington, D.C., as Chronicled Through the Art and Social Realism

Photography of Addison N. Scurlock and the Scurlock Studios, 1904–1994." PhD diss., Howard University, 2005.

Freeman, Daniel. "Photography as a Business." Boston: National Business League, 1915.

Gaines, Kevin. *Uplifting the Race: Black Leadership, Politics and Culture in the 20th Century*. Chapel Hill: University of North Carolina Press, 1996.

Gaither, E. Barry. "Imagining, Identity and African American Art, or, It's Me You See!" in *Convergence: 8 Photographers*. Boston: Photographic Resource Center, Boston University, 1990.

Gatewood, Willard B. *Aristocrats of Color: The Black Elite, 1880–1920*. Fayetteville: University of Arkansas Press, 2000.

Green, Constance McLaughlin. *The Secret City: A History of Race Relations in the Nation's Capital*. Princeton: Princeton University Press, 1967.

Harris, Joseph E. *African American Reactions to War in Ethiopia, 1936–1941*. Baton Rouge: Louisiana State University Press, 1994.

Harris, Michael. *Colored Pictures: Race and Visual Presentation*. Chapel Hill: University of North Carolina Press, 2003.

Height, Dorothy. *Open Wide the Freedom Gates: A Memoir*. New York: Public Affairs Press, 2003.

Hirsch, Marianne, ed. *The Familial Gaze*. Hanover, NH: Dartmouth College, 1999.

The Historic Photographs of Addison N. Scurlock. Washington, D.C.: Corcoran Gallery of Art, 1976.

Holloway, Jonathan Scott. *Confronting the Veil: Abram Harris Jr., E. Franklin Frazier, and Ralph Bunche, 1919–1941*. Chapel Hill: University of North Carolina Press, 2002.

Hughes, Langston "Our Wonderful Society: Washington." *Opportunity* (August 1927): 226–667.

_____. *The Big Sea, an Autobiography*. New York: Hill and Wang, 1963.

Hutchinson, Louise Daniel. *Anna J. Cooper: A Voice from the South*. Washington, D.C.: Smithsonian Institution Press and the Anacostia Neighborhood Museum, 1981.

Jackson, Giles B., and D. Webster Davis. *The Industrial History of the Negro Race of the United States*. Richmond: Virginia Press, 1908.

Johnson, John H. *Succeeding Against the Odds: The Autobiography of a Great American Businessman*. New York: Amistad Press, 1992.

Jones, William H. *Recreation and Amusement Among Negroes in Washington, D.C.: A Sociological Analysis of the Negro in an Urban Environment*. Washington, D.C.: Howard University Press, 1927; reprinted, Westport, CT: Negro Universities Press, 1970.

Krasner, David. *A Beautiful Pageant: African American Theatre, Drama, and Performance in the Harlem Renaissance, 1910–1927*. New York: Palgrave MacMillen, 2002.

Landis, Kenesaw M. *Segregation in Washington: A Report*. Chicago: National Committee on Segregation in the Nation's Capital, 1948.

Lemert, Esme Bhan, eds. *The Voice of Anna Julia Cooper: including A Voice from the South and other important essays, papers, and letters*. Lanham, MD: Rowman and Littlefield, 1998.

Levey, Jane Freundel. "The Scurlock Studio," *Washington History Magazine* 1, no. 1 (spring 1989).

Lewis, David Levering. *W. E. B. Du Bois: Biography of a Race, 1868–1919*. Vol. 1. New York: Henry Holt, 1993.

_____. *When Harlem Was in Vogue*. New York: Penguin, 1997

Lewis, Earl. *In Their Own Interests: Race, Class, and Power in Twentieth-Century Norfolk, Virginia*. Berkeley: University of California Press, 1991.

Litwak, Leon. *Trouble in Mind: Black Southerners in the Age of Jim Crow*. New York: Knopf, 1998.

Locke, Alain, ed. *The New Negro*. New York: Simon and Schuster, 1997.

McQuirter, Marya Annette. "Claiming the City: African Americans, Urbanization and Leisure in Washington, D.C., 1902–1954." PhD diss., University of Michigan, 2000.

_____. *American Heritage Trail, Washington D.C.* Washington, D.C.: Cultural Tourism DC, 2003.

Miller, James A. "Black Washington and the New Negro Renaissance," in *Composing Urban History and the Constitution of Civic Identities*. Edited by John J. Czaplicka and Blair A. Ruble. Washington, D.C.: Woodrow Wilson Center, and Baltimore: Johns Hopkins University Press, 2003.

Miller, Kelly. "Where is the Negroes' Heaven?" *Opportunity* (December 4, 1926): 370.

Moore, Jacqueline M. *Leading the Race: The Transformation of the Black Elite in the Nation's Capital, 1880–1920*. Charlottesville: University of Virginia Press, 1999.

Pacifico, Michele. "Don't Buy Where You Can't Work: The New Negro Alliance of Washington," *Washington History* 6, no. 1 (spring-summer 1994): 66–88.

Parker, Roy, Jr. *Cumberland County, A Brief History*. Raleigh: Division of Archives and History, North Carolina Department of Cultural Resources, 1990.

Perl, Peter. "The Scurlock Look." George Scurlock as interviewed by Peter Perl, *Washington Post Magazine* (December 2, 1990): 20-7.

Quander, Reverend James W. Evans-Tibbs Collection, Anacostia Community Museum, Smithsonian Institution, tape recording, July 30, 1984.

Rice, Anne P., ed. *Witnessing Lynching: American Writers Respond*. New Brunswick, NJ: Rutgers University Press, 2003.

Ritz, David. *Divided Soul: The Life of Marvin Gaye*. New York: Da Capo Press, 1985.

Roses, Lorraine Elena, and Ruth Elizabeth Randolph, eds. *Harlem's Glory: Black Women Writing, 1900–1950*. Cambridge, MA: Harvard University Press, 1996.

Sandage, Scott A. "A Marble House Divided: The Lincoln Memorial, the Civil Rights Movement, and the Politics of Memory, 1939–1963." *Journal of American History* 80, no. 1 (1993): 135–67.

Scurlock, Hilary Jordan. "Imaging the 'Secret City': Addison Scurlock's Visual Narrative of Washington, D.C.'s Black Middle Class in the 1930s and 1940s." BA thesis, Harvard College. 2007.

Smith, Eric Ledell. "Lillian Evanti: Washington's African-American Diva." *Washington History* 2 (1999).

Smith, Kathryn Schneider, and Marya McQuirter. *A Guide to the Historical Resources of Shaw*. Washington, D.C.: Thurgood Marshall Center for Service and Heritage, 1996.

Smith, Shawn Michelle. *American Archives: Gender, Race, and Class in Visual Culture*. Princeton: Princeton University Press, 1999.

Snyder, Brad. *Beyond the Shadow of the Senators: The Untold Story of the Homestead Grays and the Integration of Baseball*. Chicago: Contemporary Books, 2003.

Teal, Harvey S. *Partners with the Sun: South Carolina Photographers, 1840–1940*. Columbia: University of South Carolina Press, 2001.

Terrell, Mary Church. *A Colored Woman in a White World*. Washington, D.C.: Ransdell Inc., 1940.

Toomer, Jean. *Cane: An Authoritative Text, Backgrounds, Criticism*. Edited by Darwin T. Turner. New York: W. W. Norton, 1988.

_____. *The Wayward and the Seeking: A Collection of Writings by Jean Toomer*. Edited by Darwin T. Turner. Washington, D.C.: Howard University Press, 1980.

Tushnet, Mark V, ed. *Thurgood Marshall: His Speeches, Writings, Arguments, Opinions, and Reminiscences*. Chicago: Lawrence Hill Books, 2001.

Trescott, Jacqueline. "Love of the People, Control of the Craft." *Washington Post* (June 13, 1976), K1–3.

Wald, Gayle F. *Shout, Sister, Shout!: The Untold Story of Rock-and-Roll Trailblazer Sister Rosetta Tharpe*. Boston: Beacon Press, 2007.

Washington, Booker T. *Up from Slavery, an Autobiography*. Garden City, NY: Doubleday, 1963.

Wesley, Dorothy Porter. Evans-Tibbs Collection, Anacostia Community Museum, Smithsonian Institution, tape recording, August 17, 1984.

Whitehead, Henry P. *Remembering U Street: There Was a Time*. Washington, D.C.: Remembering U Street Festival, 1994.

Williams, Paul K. *Images of America: Greater U Street*. Charleston, SC: Arcadia Publishing, 2002.

Willis, Deborah, and Jane Lusaka, eds. *Visual Journal: Harlem and D.C. in the Thirties and Forties*. Washington, D.C.: Smithsonian Institution Press, 1996.

Willis, Deborah. *Black: A Celebration of Culture*. Irvington, NY: Hylas Publishing, 2004.

_____. *Reflections in Black: A History of Black Photographers 1840 to the Present*. New York: W. W. Norton, 2000.

Woodson, Carter G. *The Negro Professional Man and the Community*. Washington, D.C.: Association for the Study of Negro Life and History, 1934.

Contributors

Lonnie G. Bunch III is Founding Director of the National Museum of African American History and Culture, Smithsonian Institution.

Steven Cummings is a Washington, D.C.-based photographer, whose most recent exhibition *D.C. Undercover* was shown at the Smithsonian Institution's Anacostia Community Museum in 2007.

Michelle Delaney is Associate Curator of Photography at the National Museum of American History, Smithsonian Institution.

Sharon Farmer is a founding member of the Exposure Group. She is a member of the White House News Photographers Association and was Director of Photography for the White House during the Clinton administration.

Jeffrey John Fearing is Senior Medical Photographer, Adjunct Professor of Photo History, and Adjunct Professor of Film Studies at Howard University.

Tuliza Fleming is Museum Curator at the National Museum of African American History and Culture, Smithsonian Institution.

Paul Gardullo is Museum Curator at the National Museum of African American History and Culture, Smithsonian Institution.

Brian Gilmore is a poet and writer born and raised in D.C. and is a contributing writer for *Ebony-Jet* online as well as a regular columnist with the Progressive Media Project.

Brent D. Glass is Elizabeth E. MacMillan Director of the National Museum of American History, Smithsonian Institution.

David E. Haberstich is Associate Curator of Photography at the Archives Center, National Museum of American History, Smithsonian Institution.

Dorothy Height is Chair and President Emerita of the National Council of Negro Women. She has received thirty-six honorary doctorate degrees, and her numerous awards include the Congressional Gold Medal, the Presidential Medal of Freedom, the National Women's Hall of Fame, and the NAACP Spingarn Medal.

Jonathan Holloway is Professor of African American Studies, History, and American Studies at Yale University.

Charlene Drew Jarvis is President of Southeastern University in Washington, D.C. She was a neuroscientist at the National Institute of Mental Health before serving as a D.C. city councilmember for more than two decades.

Roy Lewis is a founding member of the Exposure Group and a freelance photographer who has received numerous awards for his photojournalism, including the Maurice Sorrell Lifetime Achievement Award.

Marvin McAllister is Assistant Professor in the English Department at the University of South Carolina–Columbia.

Marya A. McQuirter, an independent scholar, is the author of *African American Heritage Trail, Washington, D.C.*

E. Ethelbert Miller, poet, is Director of the African American Resource Center at Howard University and board chairperson for the Institute for Policy Studies. He is the former chair of the Humanities Council of Washington, D.C.

James A. Miller is Professor of English and American Studies and Chair of the American Studies Department at George Washington University.

Jennifer Morris is Archivist at the Anacostia Community Museum, Smithsonian Institution.

Daryl Michael Scott is Professor and Chair of History at Howard University and Vice President of Programs for the Association of the Study of African American Life and History (ASALH).

Hilary Scurlock is a curatorial intern at the National Museum of African American History and Culture. She is the great-granddaughter of Addison N. Scurlock.

Jacquelyn D. Serwer is Chief Curator at the National Museum of African American History and Culture, Smithsonian Institution.

A. J. Verdelle is a Washington novelist and essayist, whose first novel, *The Good Negress*, was a finalist for the Pen/Faulkner Award and the Los Angeles Times Book Award for first fiction.

Donna M. Wells is Prints and Photographs Librarian at the Moorland-Spingarn Research Center at Howard University. She is co-author, along with Thomas C. Battle, of the award-winning book *Legacy: Treasures of Black History*.

Deborah Willis is Professor and Chair of the Department of Photography and Imaging at the Tisch School of the Arts, New York University. The recipient of a MacArthur Fellows Award, she is a member of the Scholarly Advisory Committee of the National Museum of African American History and Culture.

Index

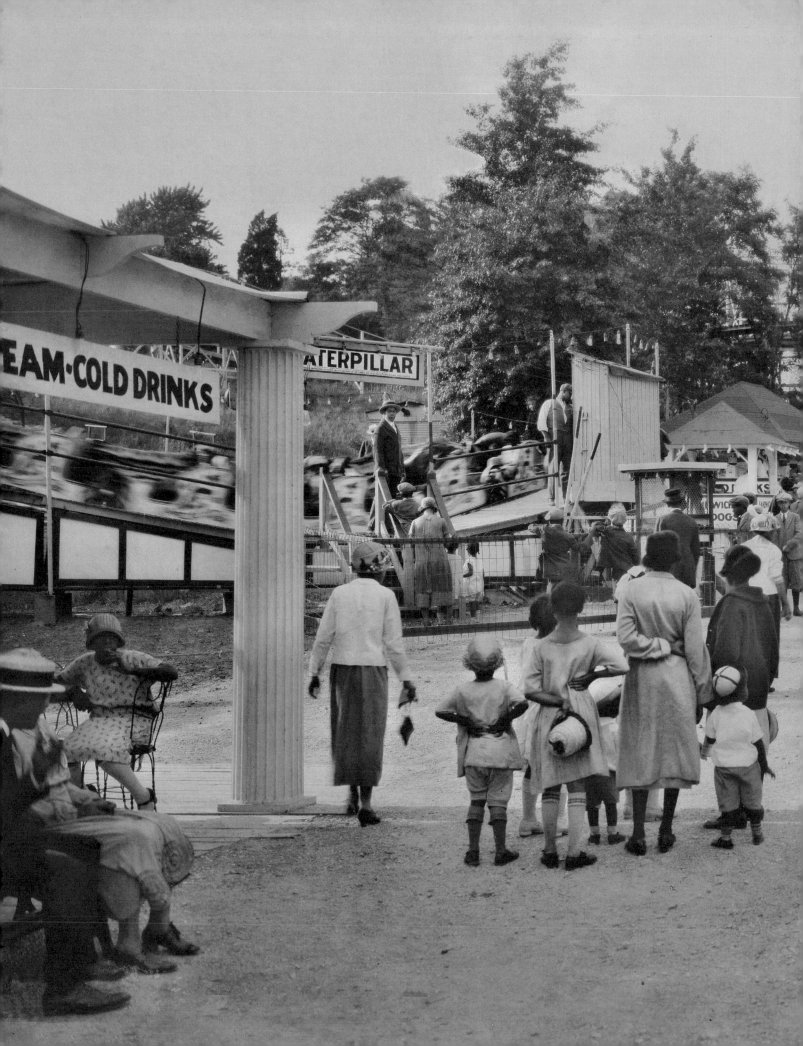